77 DANCES

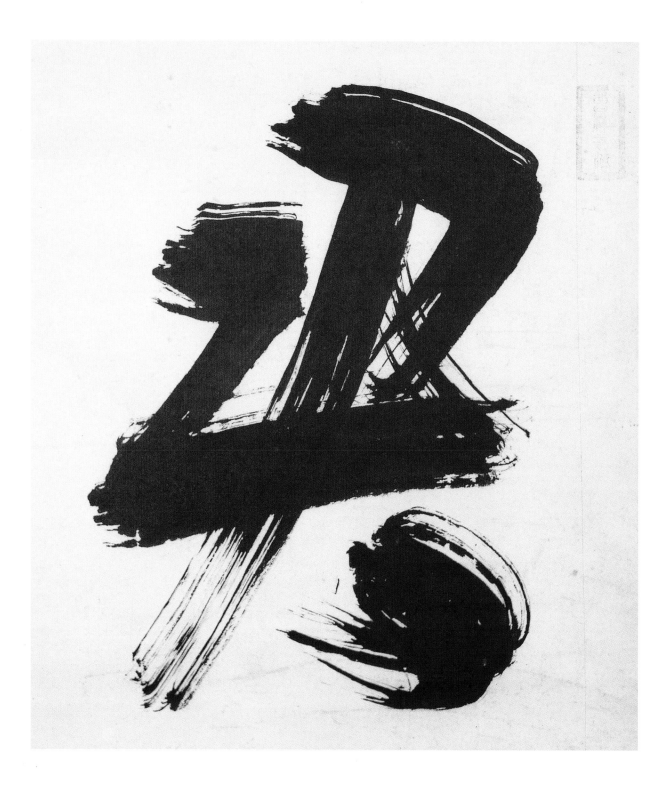

77 DANCES

Japanese Calligraphy by
Poets, Monks, and Scholars,
1568–1868

STEPHEN ADDISS

Foreword by Richard Waller

Weatherhill
Boston & London
2006

Weatherhill
An imprint of Shambhala Publications, Inc.
Horticultural Hall
300 Massachusetts Avenue
Boston, Massachusetts 02115
www.shambhala.com

Frontispiece: Detail of #59, Kōgetsu Sōgan, *Kimi* ("You").

9 8 7 6 5 4 3 2 1

First Edition

Printed in Singapore

♾ This edition is printed on acid-free paper that meets the American
National Standards Institute z39.48 Standard.

Distributed in the United States by Random House, Inc.,
and in Canada by Random House of Canada Ltd

Designed by Margery Cantor

Library of Congress Cataloging-in-Publication Data
Addiss, Stephen, 1935–
77 dances: Japanese calligraphy by poets, monks, and scholars,
1568–1868 / Stephen Addiss; foreword by Richard Waller.—1st ed.
p. cm.
ISBN-13: 978-0-8348-0571-2 (hardcover: alk. paper)
ISBN-10: 0-8348-0571-5
1. Calligraphy, Japanese—To 1600. 2. Calligraphy, Japanese—Edo
period, 1600–1868. 3. Calligraphy, Chinese. I. Title. II. Title:
Seventy-seven dances.
NK3637.A2A33 2006
745.6'19956—dc22
2006042062

To Audrey Yoshiko Seo

CONTENTS

F. Zen Calligraphy 185

FOREWORD

The University of Richmond Museums is pleased to be instrumental in the organization and national tour of this important and stunningly beautiful exhibition of Japanese calligraphy, *77 Dances: Japanese Calligraphy by Poets, Monks, and Scholars, 1568–1868*, which presents seventy-seven objects that let us explore the remarkably creative flowering of the art of writing during Japan's early modern period. On loan from several public and private collections in the United States, the objects were selected not only because the artists are historically important but also because the works exemplify the varieties of scripts and brushwork so beautifully employed in the calligraphy of the period. The traditional belief that the freedom of the brush inherently reveals one's inner character encourages us to consider each of these works as a unique expression of the artist's personality as well as collectively giving us a glimpse into the culture that held calligraphy in such high esteem. Opening at the Joel and Lila Harnett Museum of Art of the University Museums, the exhibition will go on national tour to several other museums, including the Birmingham Museum of Art, Alabama; the Herbert F. Johnson Museum of Art, Cornell University, Ithaca, New York; and the Morikami Museum and Japanese Gardens, Delray Beach, Florida.

The Momoyama and Edo periods (1568–1868), when Japan was ruled by powerful shoguns, were a time of great variety in the arts, including a renewed interest in calligraphy. In this "early modern" period, peace and relative prosperity replaced the civil warfare of the previous century, and artistic production and patronage spread through the population more than ever before. Calligraphy was practiced by classical-style poets, poets in Chinese style, Confucian scholars, literati artists, haiku poets, and Zen Masters, as represented in this exhibition. Furthermore, they wrote their texts on a number of media including screens, hanging scrolls, hand scrolls, albums, fans, and ceramics, all of which can be seen here. For the first time, the full range of early modern Japanese calligraphy is available for Western audiences, and we hope this will stimulate further scholarship and exhibitions.

To the author, our colleague Stephen Addiss, we are indebted for introducing us to this intriguing area of Japanese culture and for curating this exquisite exhibition. In addition to his unexcelled knowledge of Japanese art, he brings both enthusiasm and a refreshing originality of thought to the exhibition and its catalogue essay. As part of the faculty of the University of Richmond as the Tucker-Boatwright Professor in the Humanities–Art and Professor of Art History, he continues to enrich the study of art and art history for our students as well as enriching the entire university community with his intellectual curiosity and energetic pursuance of scholarship. This current project is the latest addition to the fascinating exhibitions Dr. Addiss has curated for our museum.

At the University of Richmond, our special appreciation goes to Dr. William E. Cooper, President; Dr. June R. Aprille, Provost and Vice President

for Academic Affairs; and Dr. Andrew F. Newcomb, Dean of the School of Arts and Sciences, for their continuing guidance and support of the University Museums, comprising the Joel and Lila Harnett Museum of Art, the Joel and Lila Harnett Print Study Center, and the Lora Robins Gallery of Design from Nature. As always, we acknowledge our deep appreciation to the staff of the University Museums.

We would like to thank the staff of Shambhala Publications for their faith in this book and their professionalism in realizing it. The exhibition, at the Joel and Lila Harnett Museum of Art of the University Museums, and this accompanying publication are made possible in part with the generous support of the Blakemore Foundation, with additional funding from the University's Cultural Affairs Committee and the Louis S. Booth Arts Fund. We also wish to acknowledge the generous support of the Metropolitan Center for Far Eastern Art Studies in making this publication possible. Finally, we are grateful to all the lenders of the calligraphy included in this exhibition.

The experience of the exhibition's seventy-seven dances is a rare opportunity to revel in the art of beautiful writing of Japan's early modern period. Enjoy the dances!

RICHARD WALLER
Executive Director
University of Richmond Museums

ACKNOWLEDGMENTS

To begin on a personal note, I have been studying calligraphy both historically and in actual practice for thirty-five years. The practice came about, I suspect, because as a child I was sent to schools that emphasized that the best way to learn something was to do it yourself. I'm tempted to say that this has caused me nothing but trouble, but for better or for worse it became a way of life. My initial interest in Zen and literati calligraphy and painting during the 1960s therefore led me to take brushwork lessons, at first from East Asian teachers in New York City, and later from masters in Japan and Taiwan.

I don't think anyone could begin more awkwardly or with less talent than I did in those first few years, but I persevered, convinced that practice would help me to appreciate more fully the work of the masters: in short, to see better. As time went by, I found that I did gain increasing insights; and as a bonus, after some years I reached the point of achieving mediocrity in my own calligraphy and brush painting; it was a relief not to despise what I was creating. As more years passed, people began to take an interest in my work, and in the past decade I have had a number of exhibitions in various countries, but I still believe the greatest advantage of practice has been that I can see more completely when I view a work by a Chinese, Korean, or Japanese master. Does this mean that only someone who practices calligraphy can understand this form of art? Certainly not. But even a brief attempt at wielding the brush can teach both how difficult it is to control and how great a range of personal expression it allows.

I would like, therefore, to begin by thanking Wang Chi-yuan, Ishikawa Kako, Mitani Chizan, and Chiang Chao-shen for their direct instruction in calligraphy many years ago; their skill was exceeded only by their patience. Next, I am grateful to longtime friends Jonathan Chaves, Kwan-shut Wang, Wan Qing-li, Joseph Chang, and Fukushima Keidō Roshi for generously sharing their ideas, comments, criticisms, and encouragement, as well as their depth of knowledge about East Asian calligraphy. Professor Chaves, who is one of the greatest living translators of Chinese poetry, has also graced this book with a number of his superb English renditions of Japanese Chinese-style poems. I must also thank Timothy R. Bradstock and Judith Rabinovitch for their assistance and their fine translation of a long poem by Rai San'yō.

My burgeoning interest in the art of calligraphy was vastly encouraged by the late John M. Crawford, who often showed and discussed with me his magnificent collection of Chinese masterworks. In 1981, I had the good fortune to assist in an exhibition and catalogue of his Sung- and Yuan-dynasty calligraphy. This Crawford collection, now housed in the Metropolitan Museum of Art in New York City, continues to amaze and delight with its quality, variety, and artistic importance.

In my studies of Japanese calligraphic history I am indebted particularly to the several important works of John M. Rosenfield, as listed in the bibliography. In this field, as in so many areas of Japanese art, he has led the way with a broad range of artistic analysis and historical interpretation, always presented so directly and unpretentiously that his research is inspiring rather than intimidating.

In Japan I have been encouraged in my studies of painting and calligraphy by Professors Tsuji Nobuo, Sasaki Johei, Kono Motoaki, and the calligraphy expert Shimono Kenji, as well as by scholars, collectors, and dealers including Harry Packard, Sugimura Eiji, Norman Waddell, Janet Ikeda, Yabumoto Shoshiro, Yabumoto Shun'ichi, Tanaka Daizaburo, Mizutani Ishinosuke, Mizutani Shoichiro, Kobayashi Katsuhiro, Maezawa Seiichi, Yanagi Hiroshi, Yanagi Harumi, Yanagi Shigehiko, and Yanagi Takashi.

In America I must thank many people for sharing their stimulating and generous ideas about Japanese art and culture. These include first my teachers at the University of Michigan, Calvin French and Richard Edwards, as well as my talented graduate student colleagues there, and later J. Thomas Rimer, Fumiko and Akira Yamamoto, Howard and Mary Ann Rogers, Paul Berry, John Stevens, Belinda Sweet, and all of my students at the University of Kansas and the University of Richmond, many of whom have made their own impressive contributions to the field of Japanese art history.

I am very grateful for research support provided by the Asian Cultural Council and the University of Richmond Faculty Research Fund. I would like to offer particular thanks to Sylvan Barnet and William Burto for their careful reading of the manuscript and many helpful suggestions.

My sincere thanks go to all the public and private lenders to the exhibition, and I also would like to offer my appreciation to Richard Waller and the entire staff of the Harnett Museum at the University of Richmond for their excellent work in preparing the exhibition. For the handsome publication of this book, I would also like to express my thanks to Peter Turner, Jonathan Green, Steve Dyer, and Kendra Crossen Burroughs at Shambhala Publications; to the designer, Margery Cantor; and to the freelance copyeditor, Jacob Morris.

Above all I am grateful to Audrey Yoshiko Seo, whose incisive mind has kept me from many an error or false path, and whose support and encouragement have enabled me to complete the work that has interested and challenged me for so long. It is my greatest hope that this book will encourage others to study the richness of East Asian calligraphy, and to go far beyond my own efforts in research and analysis in order to share the joys of this magnificent and highly personal art with the broader public.

77 DANCES

INTRODUCTION

Ezra Pound wrote in *ABC of Reading* that "poetry begins to atrophy when it gets too far from music" and "music begins to atrophy when it gets too far from dance." This book is an attempt to investigate, explicate, and ultimately celebrate seventy-seven works of Japanese calligraphy; their scripts and styles will be discussed in historical and cultural contexts, but the primary focus is upon the works as individual dances of line and form in space.

To most Westerners, East Asian calligraphy does not *mean* but *is*. If we cannot read the words, it becomes pure visual experience. And yet, unlike abstract gestural art, we know that it has another meaning, that the written words must signify something to someone. Is this mystery solved by knowing the translation, or will we still miss some of the magic of the characters, in most cases complete words unto themselves? How much would it help to know the stroke order, so we can re-create the calligraphy in our minds? Is it vital to know the Chinese and Japanese historical and stylistic precedents for a work of calligraphy?

If we allow ourselves to be discouraged by such questions, we might never attempt to understand this art. However, the deeper mystery is how directly and strongly calligraphy can reach us when we give it our focused attention. Responding to it as linear movement through space, we may be able to appreciate the art more completely than someone sidetracked into puzzling out the text. Knowing that there is structure and meaning behind the free flow of brush strokes, we can yet see the work as pure visual expression.

In East Asia, calligraphy has been considered the highest of all forms of art for more than fifteen centuries. This appreciation has been in part due to the lofty position held by the scholar-artist, and in part due to the expressive potential of more than fifty thousand Chinese characters that can be written in six different forms of script with a seemingly infinite number of graphic variations. Created with ink on paper or silk by the flexible animal-hair brush that responds to every impulse of the artist, calligraphy remains a highly respected form of artistic expression in East Asia today. In Japan, where a vastly different language had to accommodate the use of Chinese characters (*kanji*), two syllabaries with less complex structural and visual forms (*kana*) were developed to supplement these graphic shapes. Nevertheless, accomplished Japanese calligraphers continue to write in Chinese, largely because of the opportunities for creative artistry.

In the Western world, calligraphy using only ten numbers and an alphabet with twenty-six letters has had a much more modest position in the arts, but interest in East Asian calligraphy has grown tremendously in recent years. This is true both in scholarly and artistic circles, with several major exhibitions, and in popular culture, where Chinese character tattoos have become popular with young people and with professional musicians and athletes. A deeper understanding of calligraphy still eludes us, however, and *77 Dances* is an attempt to make a step in this direction.

This study examines the remarkably creative flowering of the art of writing during Japan's early modern period. In 1568, a new opulent age called the Momoyama period began with the move toward reuniting Japan after many decades of civil wars. The subsequent Edo period (beginning in 1600 or 1615, depending on the historian) consolidated the government in the hands of the Tokugawa Shoguns, who ruled until 1868, when Japan opened to the West. During this "early modern" period of three centuries, the arts—including calligraphy—flourished with a great variety of styles and patronage. Texts ranging from thorny Zen conundrums to gossamer haiku poems were written with verve, energy, and creativity, displaying how deeply calligraphy had penetrated into the social fabric of Japan.

During the three hundred years of relative peace and prosperity, many groups of calligraphers created works for increasingly diverse audiences. A woodblock print by Utagawa Kunisada (1786–1864, fig. 1.1) shows that calligraphy was so popular in the mid-nineteenth century that a mother holds the brush in her mouth so as not to disturb her sleeping baby.

Other practitioners included professional calligraphers, Chinese-style poets, Confucian scholars, painters, Buddhist monks, devotees of courtly *waka* poetry, and haiku masters. Examining the varied threads of the cultural fabric reveals that these artistic worlds maintained their own independence while interacting to create a rich brocade of calligraphic techniques and styles.

Calligraphy is sometimes considered to be a difficult art to understand. Until now, most Chinese and Japanese studies, and the few books in Western languages, have been primarily concerned with providing the historical background and artistic lineage of calligraphers: with whom did they study, by whom were they influenced, and what ancient masters' styles did they follow? While these questions are certainly important, a combination of contextual and purely visual approaches may be more useful. We are past the point where viewers need feel that they must read the calligraphy to enjoy it. In fact, even experts sometimes disagree on which words have been written, especially in cursive script, and one well-known Chinese connoisseur sometimes first views a calligraphy upside down so he can examine and appreciate it purely as art before becoming engrossed in deciphering the text.

This is not to say that the meanings of the words in calligraphy are unimportant, and one of the questions pursued in this book is the controversial issue of how much the text influences the style. Perhaps surprisingly, some experts believe that there is little direct relationship between the two, while others suspect that there are many interconnections to be explored. This issue has to be considered case by case, and readers can have the pleasure of coming to their own conclusions; but we must remember that a mediocre text written beautifully is fine calligraphy, while a superb poem written poorly is not. By avoiding stress upon reading the characters, Westerners may be able to experience the purely artistic values of calligraphy—the choreography of line and form in space—more immediately than many East Asians. It is this sense of movement, ultimately of dance, that gives life to calligraphy, and therefore in this book a good deal of visual analysis will be added to historical and cultural considerations.

This study begins with basic information on calligraphy for those not conversant with the art. This fundamental information enables viewers to

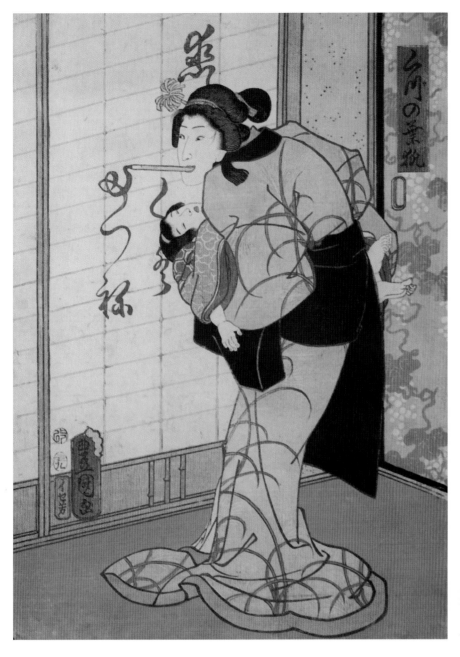

Figure 1.1
Utagawa Kunisada
(1786–1864),
woodblock print.

follow the movement of the brush from beginning to end, just as the work was created. We cannot perceive a painting this way (did the artist paint the house first, or the mountain?), but the experience of viewing calligraphy is much more like the experience of music. They are both arts that move through space-time, and we can sense in calligraphy its faster and slower rhythms, stronger and gentler touches, wetter and drier textures, and even louder and softer tones. With practice, viewers can respond to the artist's breath, follow the movement of the artist's fingers, hand, arm, mind, heart, and body, and ultimately share the special and particular energy that informs and suffuses each work. The seventy-seven examples illustrated and discussed in this book have been chosen not only because the artists are historically important, but also because the varieties of scripts and touches enable them to become artistic recordings of personal character and individual expression.

FUNDAMENTALS OF EAST ASIAN CALLIGRAPHY

Calligraphy, like dance, is an interaction of movement and pause, energy and stillness. When we see a completed work, we may assume it is fixed in time, permanent, unchanging, and therefore quiet and still. But as soon as we examine it more closely we can see it is full of motion, with freely brushed lines starting, continuing, and stopping only for another line to begin that relates to the previous ones even as it moves out in new directions.

Like a dancer, calligraphy breathes, but this life-breath, in all its gestural movement and pause, depends upon several factors. Some of these are characteristic to the type of script, while others are personal to the artist and the moment in which he or she worked. Examining some of the fundamentals of calligraphy can help in distinguishing between its formal aspects and the individual character of each artist.

First, East Asian calligraphy is normally written from top to bottom in columns from right to left. Thus we begin at the top right, move down the column, and then return up to the top of the second column. Some Japanese calligraphers, however, have played with this expectation by using other forms of composition, particularly when writing Japanese poems; but even in these cases the movement is primarily vertical. Quite different from the horizontal path of Western writing, this verticality is usually enhanced by the placement of one seal of the artist at the beginning of the work (top right) and two more at the end (bottom left) after the signature.

Second, each character is composed of a specific number of strokes made in a specified order; knowledge of this process can be important in one's appreciation of the art. In general, individual characters are written from the left side to the right, and from top to bottom, in special rhythmic patterns developed for the various script forms. For example, the standard script stroke order for the word "hermit-sage," (仙) is made up of the graph for "person" (人) on the left and "mountain" (山) on the right. The brush starts on the left, the upper stroke first, and then completes the word on the right. Verticals and diagonals are brushed from top to bottom, and horizontals from left to right.

Third, there are basically six forms of script used in Japanese calligraphy. The first five came from China, in which each character indicates an entire word, while the sixth is specifically Japanese as a syllabary. In other words, each syllable in Japanese, such as *ya* (や) or *ma* (ま), has a specific symbol. Together, *yama* means mountain, so the word may be written either in a Chinese character (山) or in Japanese syllables (やま).

If the Chinese character is used, it can be written in five different scripts and a wide variety of styles. This multiplicity of forms may seem intimidating for Western viewers, but in fact we have many varieties of scripts and styles ourselves. We usually take for granted that we have both capital and small forms of letters (*A* or *a*), but we have several scripts, ranging from the

historical "Ye Olde Tea Shoppe" style to different forms and fonts of printed script, to quicker and less formal writing (which is what we usually practice ourselves for everyday use), to fully cursive script (when we are in a hurry and continue from letter to letter without lifting the pen or pencil from the paper). The latter can be difficult at times to read, even with only twenty-six letter possibilities, so we can imagine how difficult East Asian cursive writing can be to decipher, with more than fifty thousand possible characters. The five Chinese scripts can be described as follows:

Seal script (tensho) developed from the first forms of Chinese writings carved on oracle bones used for divination and also engraved upon bronzes. It emphasizes even-width—often curved—lines, somewhat pictorial shapes and maintains a balanced and formal quality that allows it still to be chosen today for the seals (or "chops") that are stamped in red on both artistic works and everyday receipts. See numbers 19, 20, and 21 for examples of seal script by Japanese artists.

Clerical script (reisho) is said to have been developed by government clerks as a quicker form of writing than seal script. The characters are more squared off than in seal script, sometimes in a slightly short and squat format, and the lines are even in width and usually straight. The only exception is the "na" stroke ⟍, often at a diagonal and usually the last stroke of a character, which thickens and then thins elegantly to a point in a somewhat triangular form. Like seal script, clerical script has been primarily used for formal purposes in China and Japan for more than a thousand years, giving a flavor of the antique; see numbers 24, 25, and 39.

Standard (regular, printed) script (kaisho). As in the Western world, standard script is used in printing books, newspapers, and other documents for utmost clarity; it has also been used for Buddhist writings (sutras) for the same reason. It resembles clerical script in maintaining squared-off forms, and each stroke is clear and distinct from the others, although now they all may show thickening and thinning of the brush; see numbers 15, 27, 34, and 76.

Running script (gyōsho). This is the most commonly used form of Chinese script both in general use and for calligraphy, since it combines the structure of regular script with some of the ease and fluency of cursive script. In running script, individual strokes may be joined by the brush, but the forms are still recognizable. This script may be compared with the handwriting of most Westerners—not as formal as printed script, but with a general clarity of line and shape. Most Chinese-style works of calligraphy in this book use running script, such as numbers 44 and 45.

Cursive (grass) script (sōsho). The most rapidly written of the scripts and the most difficult to read, cursive script tends to break free of most of the norms of the other scripts. For example, characters are often quite different in size; they may be extremely tall or broad; and the structures of the graphs may not seem to relate to those in other scripts. Where running script generally keeps the standard order of strokes but frequently joins them together, cursive script seems to have its own (and frequently mysterious) rules. For examples of this script, see numbers 14, 17, 22, 32, 35, 64, and 74.

Each of the five Chinese scripts has its own rhythm, whether it's the formal minuet of seal script or the wild jitterbug of cursive writing. They exhibit different kinds of beauty, ranging from that of balance and structure

to more overt expressions of emotion, and from serenity to dynamic activity. It is important to realize the different potentials of each script, within which there are abundant opportunities for varied personal styles. For example, seal script can be either thickly architectonic or slenderly graceful, while cursive script can be angular, creating a good deal of visual tension, or rounded, leading to an effect of gentle flow.

Chart 1 shows the five scripts (with two versions of seal script) in a favorite text for calligraphers, the opening of the "Thousand-Character Essay," in which no character repeats. We may note that at times the combination of two characters can have a different or extended meaning when compared with the two individual words of which they are composed.

That this text was also popular in Japan is clear from chart 2, Hosoi Kōtaku's[1] woodblock version of these characters in which he presents several

Chart 1.
The first ten characters of the "Thousand-Word Essay" in seal script, by Chao Meng-fu (1254–1322).

CURSIVE SCRIPT	REGULAR SCRIPT	RUNNING SCRIPT	CLERICAL SCRIPT	SEAL SCRIPT	SEAL SCRIPT		
						HEAVEN	THE UNIVERSE
						EARTH	
						OBSCURE	THE COSMOS
						YELLOW	
						APPEARANCE	ALL OF CREATION
						INFINITY	
						IMMENSE	PRIMITIVE CHAOS
						DESOLATE	
						SUN/DAY	TIME
						MOON/MONTH	

7

variations of each character of the essay in seal script (see #14 for more information on Kōtaku).

The way in which each script has its own canons of beauty is shown in chart 3. Here the character for "dragon" is presented in different scripts and styles, each with its own sense of action and pause between each stroke or within larger patterns of gestural expression. It is important to remember, however, that as in music and dance, continuous movement in calligraphy would soon lose its interest. The importance of pausing, just like the importance of the empty space between the lines, is crucial to the rhythmic success of any work of calligraphy; see number 22 for an example of "dragon" in cursive script.

Chinese characters were adopted by the Japanese as a way of writing a language that is totally different from Chinese in structure. In Chinese, each word consists of a single syllable, perfect for a writing system that has a separate symbol for each word; in Japanese, however, the conjugation of verbs and adjectives results in changed word endings. How could the Japanese use Chinese characters, each a total word as well as a syllable, for a language in which a verb might have as many as nine or ten syllables? Over a period of several centuries, an ingenious system was worked out in which some Chinese characters were used for their meanings, such as at the beginning of a verb, and others were added merely for their sounds. This form

Chart 2.
The first ten characters of the "Thousand-Word Essay" in seal script, from a woodblock book prepared by Hosoi Kōtaku (1658–1735).

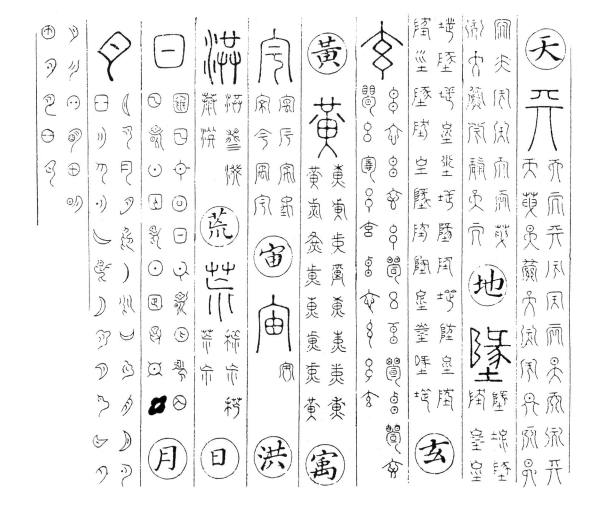

8

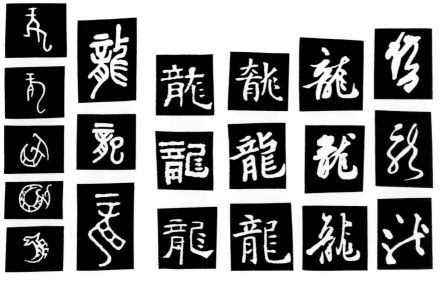

EARLY SEAL
SCRIPT

FORMAL SEAL
SCRIPT

CLERICAL
SCRIPT

STANDARD
SCRIPT

RUNNING
SCRIPT

CURSIVE
SCRIPT

Chart 3.
The character for
"dragon" from its
original semipictorial
origin to its develop-
ment in the five
Chinese scripts.

of writing, called *man'yōgana* after the first compilation of Japanese poetry,
the *Man'yōshū*, was eventually supplanted, but it has remained in occasional
use up to the present day in the writing of *waka* poetry.

Eventually, in order to make writing their own language easier, the Japa-
nese simplified a limited number of Chinese characters as sound elements
(*kana*), while continuing to use the original Chinese characters (*kanji*) for
their meanings. Japanese children are now expected to learn a minimum
of 1,850 *kanji* in order to read newspapers, textbooks, and the like, and two
forms of *kana*, *hiragana* (for Japanese syllables) and *katakana* (mostly for
words borrowed from foreign languages other than Chinese). The works of
calligraphy in Japanese discussed in this book are written in the combina-
tion of *kanji* and *kana* that has constituted written Japanese for a thousand
years. Chart 4 shows the Chinese *kanji* from which Japanese *hiragana* were
derived. Despite this solution to developing their own written language,
Japanese calligraphers have continued to be fascinated with the task of writ-
ing only in Chinese characters, and several sections of this book will show
their prowess in the five Chinese scripts.

In Japanese calligraphy there are six basic script forms: the five Chinese
scripts plus Japanese itself. We should not fall into the trap of calling them
six styles, however, since any of the six scripts can be written in a great vari-
ety of styles. But the scripts themselves have a strong influence upon artistic
expression, and a calligrapher's choice of script is an indication of what he
or she is interested in communicating. A scroll in seal or clerical script is
very likely to evoke the past and convey a sense of formality, while a work
in running or cursive script has a much more fluid and rapid feeling. Cal-
ligraphers often combine scripts, and occasionally an artist may deliberately
use a script "against type" by finding something new to express by breaking
down clichés of interpretation; but even in these cases the initial choice of
script strongly influences the total artistic expression of the work.

Many calligraphy texts are poems, or in the case of long Chinese verses,
sections of poems. One of the interesting devices that calligraphers have at

Chart 4.
Kana syllabary
derived from
Chinese characters.

a あ＝安	i い＝以	u う＝宇	e え＝衣	o お＝於
ka か＝加	ki き＝伎	ku く＝久	ke け＝計	ko こ＝己
sa さ＝佐	shi し＝之	su す＝寸	se え＝世	so そ＝曾
ta た＝太	chi ち＝知	tsu つ＝川	te て＝天	to と＝止
na な＝余	ni に＝仁	nu ぬ＝奴	ne ね＝禰	no の＝乃
ha は＝波	hi ひ＝比	hu ふ＝不	he へ＝部	ho ほ＝保
ma ま＝末	mi み＝美	mu む＝武	me め＝女	mo も＝毛
ya や＝也	yu ゆ＝由	yo よ＝与	ra ら＝良	ri り＝利
ru る＝流	re れ＝礼	ro ろ＝呂	wa わ＝和	wo を＝遠
n ん＝无				

their disposal is the arrangement of the lines of the poem into columns of calligraphy. The most obvious combination, one column for each line, is occasionally used, as in numbers 27 and 42, but far more often the artist creates a second rhythm by not matching the poetic line. For example, in number 32, Ogyū Sorai divides two poetic lines of seven characters each into columns of 8-6, and in number 36, Koga Seiri arranges his four-line 7-7-7-7 word poem into three columns of 10-10-8 characters.

Another choice that calligraphers make is when to redip their brushes with ink, making heavier and wetter characters that become visual accentuations in their work. These often create patterns that do not match either the lines of the poem or the number of characters per column, thus establishing a third rhythm. Since Chinese *kanji* and Japanese *kana* vary in complexity as well as shape, the opportunities for variety within the basic structure of each work are endless.

Writing in Japanese, however, tends to have less potential variety than calligraphy in Chinese because of the limited number of *kana* and less use of the larger number of *kanji*. For this reason, calligraphers have sometimes utilized two further devices that can add visual interest. One is to write upon decorated paper, which is much more common for *waka* and haiku poets (see #1, #3, #6, #7, #52, and #53) than for artists writing in Chinese. A second option is to begin the columns of calligraphy at varied places on the paper or silk, rather than at or near the top (see #3, #47, and #51).

Several elements of brushwork can give very different visual effects. For example, when the brush is fully saturated with ink, it can produce a fuzzing effect beyond the actual brushstroke, especially on high-quality paper. In contrast, when the brush is less full of ink, and/or when it is moved very quickly, one may see how the hairs have split during the stroke so that some of the paper shows through the actual line. This effect, called "flying white," gives an impression of speed and energy. The differences between "wetbrush" and "dry-brush" techniques, both of which may appear in a single work, also add variety to the basic rhythms of the calligraphy.

Another contrast occurs between "open tip" and "closed tip." These terms refer to how the calligrapher begins and ends a brush stroke. If the brush

comes directly down on the surface, this action reveals itself on the paper or silk as "open tip" and creates an impression of spontaneity. However, the calligrapher may also circle the tip of the brush at the beginning and ending of a stroke, rounding out the form in a technique called "closed tip." These effects relate both to the speed of the brushwork and the formality of the visual expression; for instance, seal script is usually done with "closed tip" and cursive script with "open tip."

Finally, calligraphers may choose between black ink, which was almost always used in Chinese works, and tones of gray. As might be expected, these give different visual weights to the calligraphy, and some Japanese masters deliberately used gray ink to add touches of subtlety or modesty to their work (see #30 and #73). In the single-character calligraphy by the Zen Master Hakuin (#68), the varying tones of ink are especially resonant.

All of these possibilities offer calligraphers an amazing range of artistic choices. Combined with the gestural action of the writing itself, created with a flexible brush that responds to the artist's every pulse of breath and movement, the result is an art that has been long admired in East Asia and is now coming to the West. *77 Dances* represents the calligraphy of Japanese monks, poets, and scholars over a period of three hundred years, demonstrating the full potential for personal expression within a traditional art.

NOTES

1. Following Japanese practice, family names are given first, followed by the best-known art name. In the case of Zen monks, both names are Buddhist names, the first of which is how the monk is usually known.

The Revival of *Waka* Calligraphy

At the start of the early modern period, in 1568, the Japanese were reunited after almost a century of civil wars and political upheaval. Brimming with energy and confidence, they were ripe for new artistic accomplishments and eager for reminders of great eras of the past, such as the glories of the courtly Heian period (794–1185). The subdued Zen-influenced arts of the Muromachi era (1392–1568) no longer remained dominant, and patronage from both the court and newly wealthy merchants encouraged a return to earlier Japanese aesthetics.

One of the most notable revivals was of Japanese-style *waka* calligraphy, at first primarily using famous poetry of past epochs as texts but eventually featuring newly composed verses as well. This classical form of poetry, also called *tanka* and *uta*, consists of five sections of 5-7-5-7-7 syllables. Its golden age was the Heian period, when it was written by emperors and princes, courtiers and court ladies, and even high-ranking monks.

Waka are usually based upon an image from nature that evokes a human emotion, frequently love or longing. Skill in this art, along with skill in calligraphy, was a prerequisite for prestige in the imperial court. As warriors ascended to power in succeeding centuries, *waka* poetry lost some of its luster, but it never completely died out. As the early modern era began, the tradition was continued by Emperor Goyōzei (1571–1617, #1) and dramatically revitalized by the "Three Brushes of Kan'ei"—Konoe Nobutada (1565–1614, #2), Hon'ami Kōetsu (1558–1637, #3), and Shōjō Shōkadō (1584–1639, #4).

The epithet "Three Brushes of Kan'ei" is actually a misnomer, since Nobutada died ten years before the Kan'ei era began in 1624. Furthermore, another master deserves to be included in this group: the courtier Karasumaru Mitsuhiro (1579–1638, #5). These four men, the finest calligraphers in Japanese script of their time, created bold new variations of early traditions, often on decorated paper, that have not since been equaled for resplendent vitality.

Konoe Nobutada was a member of one of the leading families in Japan; the Konoe were descended from the noble Fujiwara clan and traditionally served the court in high-ranking posts. Nobutada created not only his own style of calligraphy but also Zen paintings in a strong minimalist style. In contrast, Hon'ami Kōetsu came from the artisan class; his father was a connoisseur of swords, and Kōetsu became a practitioner of many arts, including Noh drama, ceramics, lacquer, swords, and the tea ceremony; in collaboration with the artist Sōtatsu (died 1640), he created painting-calligraphy works of great beauty.

Shōjō Shōkadō was also a member of the Kyoto cultural elite, although he lived most of his mature years as a monk of the esoteric Shingon sect at a subtemple south of Kyoto on Mount Otoko. Shōkadō participated in many cultural activities, including painting, poetry, flower arranging, and garden design; he was also noted as a master of the tea ceremony. Karasumaru Mitsuhiro is sometimes called the "fourth brush." Like the Konoe family, the Karasumaru were hereditary courtiers of high rank, and Mitsuhiro held several distinguished posts at court despite being involved in a scandal in his younger years. He also studied Zen, which remained a cultural force, but his own calligraphy shows a highly personal and dramatic style, well suited to decorated paper backgrounds.

The fact that the four men did not all come from the same social class demonstrates how *waka* calligraphy was gaining new strength by being practiced both by courtiers, who had dominated it in the past, and by others who carried this tradition into a broader context. The widening range of *waka* poet-calligraphers was to become an increasingly important feature of calligraphy in Japanese during the following centuries. While later masters may not have equaled the sumptuous style of the "four brushes," many poet-artists created calligraphy of interest and beauty. Among these was Konoe Iehiro (1667–1736, #6), the leading later Konoe master, who had a successful career at court; in 1709 he became the youngest man ever appointed regent. Unlike his ancestor Nobutada, Iehiro did not develop a highly personal style; instead, he became a master of many scripts and styles, always exhibiting an elegant and refined sensibility.

As the early modern period advanced, the shogunal support of neo-Confucianism greatly increased interest in Chinese literati culture, including calligraphy in Chinese. However, during the eighteenth century a reaction against this strong Chinese cultural and artistic influence took place, and a number of scholars and poets found their sources in early Japanese traditions. Interest in both the Shinto religion and Heian-period Japanese literature revived, leading to the *kokugaku* (National Learning) scholarly movement. This trend encouraged both poets and calligraphers to write in Japanese, an interest that circulated to classes of people who previously would not have participated in *waka* poetry.

Among the commoners who excelled in *waka* and calligraphy were the "Three Women of Gion," who for three generations ran a tea shop in Kyoto's Gion Park. The three poets were Kaji (n.d., #7), her adopted daughter Yuri (1694–1764, #8), and Yuri's daughter Gyokuran (1728–1784, #9). Each had a different poetic persona, from the passionate Kaji to the renunciatory Yuri to the painterly Gyokuran, and all three contributed to the artistic and cultural world of their time. Although the legal and social position of women was at a low point during Japan's early modern era, the "Three Women of Gion" were able to add individual voices to the age-old *waka* poetry and calligraphy tradition.

Another development in poetry took the form of comic *waka* called *kyōka* (mad poems), satiric verses that became very popular in the late eighteenth and early nineteenth centuries; the greatest master was the literatus Ōta Nanpō (1749–1823, #10), who called himself Shokusanjin. *Kyōka* were not usually written out as elegantly as *waka*, but they contributed to the

liveliness of calligraphy in Japanese at a time when much writing was still done in Chinese scripts.

During the nineteenth century, the emergence of nonaristocratic *waka* poets continued with such masters as the Shinto priest Kamo Suetaka (1751–1841, #11) and, a generation later, the Buddhist nun Otagaki Rengetsu (1791–1875, #12). Twice widowed in her youth before taking Buddhist ordination, Rengetsu created some of the most appealing poetry, calligraphy, and pottery of her age, with a graceful touch that is supported by internal tensile strength. Her artistry demonstrates the continued vitality of the *waka* tradition, which had begun in courtly circles and, by the end of the early modern period, had become thoroughly integrated into every level of Japanese society.

おほゐ河の
すみにすむ
ちとりのな
にしおはは
われにもの
おもへ

On the Ōi River

Tanzaku, ink on decorated paper, 36.8 x 5.5 cm.

The Ruth and Sherman Lee Institute for

Japanese Art at the Clark Center, Calif.

Goyōzei's father was the prince Yōkō-in, and his mother came from the noble Konoe family. He reigned as the 107th emperor of Japan from 1586, at the age of fifteen,[1] until 1611, when he retired at the age of forty; he died six years later. Despite his exalted position, his political power was extremely limited. To his distress, he was twice countermanded by the Tokugawa government—first in 1609 when he wanted to execute five of his consorts and seven courtiers who had secretly become lovers, and again in the following year when he wanted to abdicate.[2]

Instead of ruling, even within their own domain, emperors and other aristocrats were mandated by the shogunate to focus their attention on cultural attainments. Goyōzei studied both the Chinese classics (particularly the "Four Books" of Confucianism) and Japanese masterpieces such as *The Tales of Ise* and *The Tale of Genji*. He was a noted *waka* poet; and in an effort to foster education, he commissioned woodblock editions of important early texts so they could be more widely read and taught.

Goyōzei seems to have enjoyed both calligraphy and painting, and he wrote in both Chinese and Japanese scripts in a variety of styles. For example, he occasionally practiced calligraphy in the Zen tradition of large, bold Chinese characters, and he also wrote out Buddhist sutras in small regular script on dark blue paper.[3] Most often, however, he brushed five-line *waka* poems on various formats, including tall, thin *tanzaku* poem cards. This typically Japanese medium had proven ideal for short poems, serving as a small but elegant format for brushwork on an intimate scale.

Here his poem is written in the traditional 5-7-5-7-7 syllables:[4]

Ōigawa	On the Ōi River
suzaki no ashi wa	a drifting net of reeds
uzumorete	is completely covered
nami ni ukitaru	as it floats down the waves
yuki no hitomura	by a single clump of snow

Goyōzei has written some of the Japanese syllables with Chinese characters instead of *kana* (a form of writing called *man'yōgana*, after the first Japanese poetry anthology), giving more physical structure and visual weight to the calligraphy and also allowing possible double meanings to become more explicit. For example, the word *mura* (clump or patch) at the end of the poem is written with the character that also means "village" (村), perhaps suggesting the encroachment of human settlement on nature. The final line can therefore be translated as "[like] a single village in snow." This interpretation provides a secondary reading, a characteristic of much Japanese poetry. The idea of reeds or a village being covered—possibly even smothered—by snow may also be an indirect reference to repression of the court by the Tokugawa government.

The calligraphy follows the fashionable Oie style of the time, with its wide range of thin-to-thick brush lines and a sense of movement that is generally curving rather than angular.[5] The first three characters, literally meaning "big well river" (大井河), are given prominence both in terms of placement and the use of heavier ink; the third character, meaning "river," is especially curved and flowing compared with the first two. The next most visually stressed character in the *tanzaku* is "snow" (雪) near the bottom of the second column. Even a quick viewing therefore reveals the main theme of the poem: the Ōi River in snow.

Between these two visual accents there is a great variety of brushwork, ranging from thin and delicate (most of the second column) to graceful but more forceful (as at the end of the right column). This variety of brushwork, however, takes place upon decorated paper, which serves both as a unifying element to the meaning and a contrast to the brushwork. The primary pattern on the paper is that of waves, sometimes almost still and sometimes curving, with a secondary element of reeds appearing several times. Near the top, however, a heavier undulating line in blue suggests possible islands in the river or perhaps even the nest of reeds covered with snow. If the latter, it is done in a semiabstract manner, since too much visual correspondence with the poem might be considered vulgar by refined court aesthetes.

We are left with the question: did the emperor order the paper specifically for this poem, or did he decide to write this poem because of the design on the paper? Whichever came first, Emperor Goyōzei's elegant *tanzaku* of *waka* calligraphy testifies to his lofty cultural attainments.

NOTES

1. He was fifteen in Western count; the Japanese would say he was sixteen since they count babies as one year old at birth.

2. For further discussion, see Lee Butler, *Emperor and Aristocracy in Japan, 1467–1680: Resilience and Renewal.* Harvard East Asian Monographs no. 209 (Cambridge, Mass.: Harvard University Asia Center, 2002).

3. For other examples, see Shigemi Komatsu, *Nihon shoseki taikan,* vol. 14 (Tokyo: Tankōsha, 1979), nos. 1–8.

4. As is usual with calligraphy by emperors, there is no signature on this work; attributions are based on provenance and style. The translation is by Stephen Addiss, as are all translations not otherwise credited.

5. The Oie style was established by Prince Son'en (1298–1356), the seventeenth abbot of the Shōren-in in Kyoto; for more information and examples of his writing, see John M. Rosenfield, Fumiko E. Cranston, and Edwin A. Cranston, *The Courtly Tradition in Japanese Art and Literature* (Cambridge, Mass.: Fogg Art Museum, 1973), pp. 110–113.

Letter of Congratulations

Hanging scroll, ink on paper, 17 x 65.6 cm.

Konoe Nobutada is one of the most interesting and paradoxical figures in Japanese cultural history. Born into the most elegant of noble families, he wished to be a warrior; rising to the highest court position, he created deliberately rough and simplified Zen-style paintings; a student of Heian-period calligraphy, he pioneered new brush-work styles; often writing on highly decorated *shikishi* and *tanzaku* poem cards, he also sometimes chose worn or recycled paper. We may well ask, who was this man?

It is a tenet of East Asian artistic belief that one's true self always appears in calligraphy. Even when copying another style or work, individual character will emerge. To see calligraphy is to see the person; the style is the man. This is one reason why calligraphy by well-known poets, monks, and scholars has been so highly appreciated in Japan through the ages. In addition to whatever beauty such a work may hold, it is also the record of an extraordinary individual human being. Furthermore, of all calligraphy, it is often thought that a letter can reveal the personality most clearly, because the informal nature of a letter allows the character of the writer to come forth with little or no attempt at creating "a work of art." A biography of Nobutada can teach us a great deal about his life in the context of his times, but a sense of the man himself may come through more clearly in a letter he wrote to a friend.

Nobutada was born into one of the highest-ranking noble families in Japan, descending from the ancient Fujiwara clan, which dominated many aspects of court life in the Heian period (794–1185). Nobutada's sister became the concubine of one emperor and the mother of another, so he traveled in the highest circles of a distinguished court, albeit one that was losing whatever remnants of political power it once possessed. His father, a major collector of earlier calligraphy, amassed more than ten thousand examples of writing in both Chinese and Japanese. Following the custom of the times, he separated pages of albums and cut apart sections of hand scrolls to create composite albums *(tekagami)* that would cover much of the history of Japanese calligraphy. These commonly begin with sutra sections, such as by the Emperor Shōmu (reigned 724–749), and continue with masters of *kana* such as Ki no Tsurayuki (868?–945?). Access to his father's collection enabled Nobutada to study the work of early Chinese and Japanese masters thoroughly. Not neglecting his courtly education, he received his first position at the age of thirteen and at twenty-one was appointed *saidaijin* (Minister of the Left), a high ceremonial position.

Many men might have been satisfied with the life of a leading courtier; Nobutada was not. He studied Zen at the leading Kyoto temple Daitoku-ji, and among his teachers was the monk Takuan (see #58). When Japan invaded Korea in 1592, Nobutada asked the emperor for permission to join the army. When his request was refused, he traveled to Nagoya to ask the army commander to let him enlist. For this display of independence he received an imperial censure and was banished in 1594 to the southernmost tip of Japan:

the island Kagoshima, off Kyushu. There he discovered the life of rural Japan, a far cry from courtly existence in Kyoto.

Pardoned in 1596, Nobutada returned to Kyoto, regained the title of *saidaijin* in 1601, and four years later was made *kampaku* (senior regent), the highest court title. Again dissatisfied, he resigned in 1607 and traveled to the new capital of Edo (Tokyo) to live as a literatus, writing poetry in many styles as well as lecturing on classical Japanese literature. He also became known for his love of *sake* (rice wine), and especially for his superb brushwork. His prowess in calligraphy led him later to be designated as one of the "Three Brushes of Kan'ei," along with Kōetsu (#3) and Shōkadō (#4), despite the fact that Nobutada died in 1614, a decade before the Kan'ei period (1624–1644) began.

What can we learn from Nobutada's calligraphy that biographical facts alone cannot convey? This letter was written to a friend:

> I have surely received your letter of the ninth; I congratulate you on being granted an increased stipend in Yoshū [Io, Ehime, Shikoku] from the Shogunate. Awaiting the time in the near future when you can come up to our province, I was much pleased to receive your good letter— congratulations, congratulations!
>
> —Ninth month, twentieth day

The text is written in twelve columns followed by an abbreviated salutation, the month and day, and a cipher-signature. Letters seldom mention the year, so we don't know at what point in Nobutada's life this was written, but the style indicates a mature work. Written in Japanese, the letter combines Chinese *kanji* (such as the first five characters in the opening line) with Japanese *kana* (ending the fourth column and beginning the fifth). However, since Nobutada has written many of the *kanji* in cursive script, there is less contrast between *kanji* and *kana* than might have been evident if he had used regular script. Nevertheless, a distinct rhythm is created by the contrast of more architectonic *kanji* (such as the final character in the third column) with fluid *kana* (beginning the tenth column).

A second rhythm is produced by the visual accents of more heavily inked characters, written after Nobutada redipped his brush (the final character in the second column and the final two in the third, for example), which create a form of visual counterpoint over the total surface—how much less interesting it would be if he had dipped his brush at the beginning of each column! To increase the contrast, the more heavily inked characters also tend to show slightly fuzzing "wet brush" technique, while the *kanji* and *kana* where the brush has partially dried out demonstrate "flying white," with the paper showing through the brush strokes. Further, the sixth and ninth columns are not straight but dogleg slightly to the left, adding still another visual rhythm and sense of flow to the middle of the work.

The sense of continuous movement in this calligraphy is broken from time to time to give a feeling of pause that helps to structure the work. Examining the first column, for example, we can see the first three words (ninth 九, day 日, and the possessive 之) flow into one another, as do the next three characters. The final graph is given a broad base, as though it constitutes a stand upon which the column rests. Nobutada felt no need to continue this

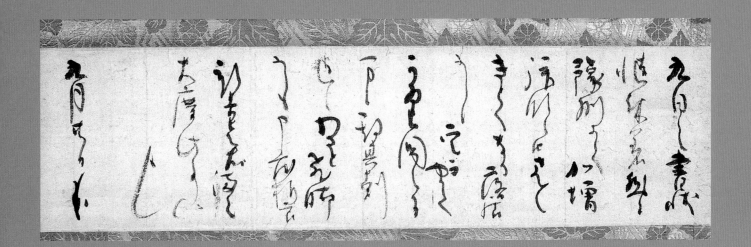

compositional effect in the other columns, and in fact he frequently gives more weight to the right-side bottom of the column-ending characters, balanced at the end by the hooklike salutation that curves back left to right. A sense of balance is also suggested by the strong opening to the seventh column, creating a central point of focus to the work when seen as a whole.

This letter reveals several characteristics of Nobutada's brushwork beyond the varied rhythms that he creates. The brush line itself tends to be more thick than slender; and although there are graceful curving lines, a sense of structural "bone" is created by the more compressed characters. These are enhanced by an occasional dry angularity seen particularly at the end of the tenth column. The total ambience is not overly delicate or the least bit effete, qualities evident in some courtier calligraphy, but rather exhibits a sense of muscle and slightly rough energy. These elements match what we know of Nobutada's life; refusing to be satisfied with courtly refinement, he actively sought a more complex, active, and adventurous life.

What about that most controversial of calligraphy topics, the relationship between the meaning of the text and the style? We can compare Nobutada's letter to another calligraphy of his, one featuring two *tanzaku* mounted on a hanging scroll (fig. 2.1). Here we find the powerful but refined

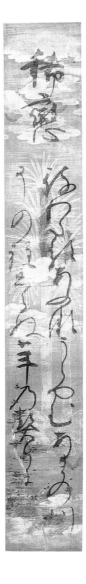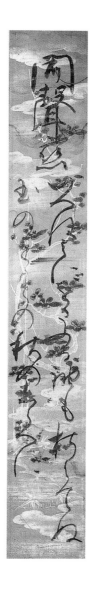

Figure 2.1.
Konoe Nobutada,
Two Waka Tanzaku.

22

calligraphy fulfilling its new context, as the more even flow of the strongly brushed *waka* poems occupy the total space effectively over the highly decorated paper. Nobutada's forceful personality is clear in both works, but in the letter his relatively even spacing of columns, his bold use of ink accents, and the overall sense of confidence may convey Nobutada's pleasure at his friend's good fortune and perhaps a visual hint of the congratulations that he was expressing in his words.

3 HON'AMI KŌETSU (1558–1637)
Poem on Decorated Paper
Ink on decorated paper, 28.9 x 40.5 cm.
Barnet and Burto Collection, Cambridge, Mass.

Perhaps the most famous calligrapher in later Japanese history, Kōetsu was a man of many skills, as well as a fervent Nichiren Buddhist. His father was an expert appraiser of swords, and Kōetsu continued this work while gaining renown in calligraphy; he was also talented in several other disciplines, including the designs for lacquer and metal objects and the making of *raku* tea bowls. Loyal to traditional Japanese aesthetics, Kōetsu was distrustful of neo-Confucianism, writing in one of his letters that "evil men become more evil through scholarship, fools only become glib; men who make the essence of learning their own and use it in the affairs of the day are rare indeed."[1]

Kōetsu was given land by the Tokugawa government to establish an art colony at Takagamine, northwest of Kyoto, where religious conviction helped to unite artists and artisans. His most famous works of calligraphy were done in collaboration with the painter Tawaraya Sōtatsu (died 1640); the scrolls and *shikishi* (square poem cards) that they created together are justly celebrated for their bold and sumptuous beauty.

On this separated section of a hand scroll, Sōtatsu's design of large butterflies was printed with mica so that depending on the light source and angle, it can be seen clearly or almost disappear.

Partly to the side of and partly over the stamped design, Kōetsu wrote out a poem by Fujiwara Norinaga (1109–c. 1180) from the *Senzai wakashū* (One Thousand Years of *Waka* Poems, a collection originally compiled in 1188) and then stamped his seal "Kōetsu" in black.

Aki no uchi wa	The autumn having
aware shiraseshi	brought a soft melancholy—
kaze no oto no	the sound of wind
hageshisa souru	now blowing violently
fuyu wa kinikeri	tells us that winter is coming

The poem seems not to match the design, at least as far as the season is concerned, so are we to assume that Kōetsu did not care what image was to be paired with what poem? He certainly was aware of the visual aspect

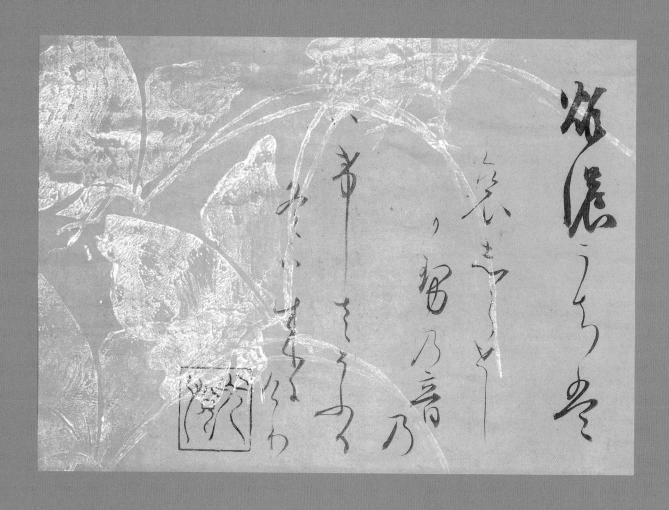

of writing over the image, since he kept most of the calligraphy to the right of the design, and only slightly overlapped the butterflies in the final two columns. Indeed, the placement of the final column, matching the final line of the poem, creates a barrier for the lower butterfly, just as the coming of winter, the final words of the poem, would be a barrier to the life of the beautiful insect. Perhaps, after all, there is more interaction between text and writing than we might at first imagine.

Aside from his fluency of style, the outstanding characteristic of Kōetsu's formal calligraphy is the even spacing of columns in which he provides a strong contrast between thick and thin strokes, lighter and heavier graphs, and stronger and weaker rhythms. For example, the opening two bold Chinese characters contrast remarkably with the thread-thin *kana* that end the second column.

To balance these contrasts, Kōetsu writes the five lines of the poem in five columns of calligraphy. This means that aside from the uneven beginning points of each column, which is typical of *waka* calligraphy, the visual counterpoint is entirely contained in the brushwork as it plays against the design on the paper. Kōetsu puts his artistic focus on the harmony between the appearing and disappearing butterflies and his own thickening and thinning strokes. In its contrasts—both of image to text and of brushwork—this hand scroll section well demonstrates Kōetsu's bold design and fluent grace, which are now celebrated not only in Japan but also in the Western world.[2]

NOTES

1. Quoted in Shuichi Sato, *A History of Japanese Literature: The Years of Isolation,* trans. Don Sanderson (Tokyo and New York: Kodansha International, 1983), p. 37.

2. For further information and excellent illustrations of his work, see Felice Fischer, *The Arts of Hon'ami Kōetsu* (Philadelphia Museum of Art, 2000).

4 SHŌJŌ SHŌKADŌ (1584–1639)

Li Po Preface

Hand scroll, ink on silk, 23 x 364 cm.

A Shingon-sect Buddhist monk who served at a Shinto shrine, Shōkadō became a leader in many aspects of the cultural life of his day, including painting, calligraphy, and the tea ceremony. As a youth he entered the Hachiman Shrine in Otokoyama, northwest of Kyoto, which combined Shinto and esoteric Buddhism; he was given the Buddhist name Shōjō. Thereupon he served the princely Konoe family, especially Nobutada (#2) and his father Sakihisa (1536–1612), from whom he doubtless developed his interests and skills in calligraphy. At this time he also became acquainted with the Zen monks of Daitoku-ji, who had developed their own style of brushwork (see #58, #59, and #60). Starting in 1627, Shōkadō

presided over Takimoto-bō, a small shrine in the mountains near Kyoto. A decade later, he retired to a modest hut he called the "Pine Flower Hall" (Shōkadō 松華堂), by which name he is known today.

Considered the third of the "three brushes of Kan'ei," Shōkadō studied the styles of his own day as well as major artists of the past, and soon became expert both in Japanese and Chinese scripts. For the latter, he sometimes utilized the Daishi-ryū (Daishi school, named after the founder of Shingon Buddhism, Kōbō Daishi, also known as Kūkai, 774–835), with its exaggerated flourishes, particularly in the final stroke of a character. The Daishi tradition at its peak can be seen in Shōkadō's hand scroll of an evocative prose work by the Chinese poet Li Po (701–762).[1]

Preface for a Spring Night's Banquet at My Cousins' Peach Blossom Garden

Now, Heaven and Earth are a wayside inn for the ten thousand creatures. Time is a wanderer through hundreds of ages. And this floating life is like a dream: for how long can our pleasures last? The ancients went out at night, holding candles, and with excellent reason! And then the springtime summons us with misty vistas, the Great Clod of earth provides us with material for writings. Gathered here at the fragrant Peach Blossom Garden, let us enjoy in sequence the pleasures of the heavenly order. My cousins are men of prodigious talent, all of them Hui-liens! As I chant my songs, I alone feel ashamed before K'ang-lo.[2] The mysterious enjoyments not yet over, our noble discourse becomes even purer! We spread our jeweled mats to sit among blossoms, set flying winged cups, and become intoxicated on moonlight! Were there no fine poems, how could we express our elegant feelings? If poems are not written, the penalties should equal the amount of wine drunk at Golden Valley![3]

Shōkadō's expertise with the brush can be seen in every character, but several stand out due to their deliberate exaggerations. For example, the second and third words of the first full column, "heaven" and "earth" (天地), both exhibit wriggly lines, while the fourth column, "hundred generations of" (百代之), ends with a snakelike *kanji* in dry brushwork. Even more amazing is the final character in column seven, "How long?" (幾), which ends with a spiral that rises all the way to the top of the column.

It is not only the flourishes that give Shōkadō's calligraphy its unique rhythm. The asymmetrical placement of larger, heavier characters also imbues the work with a sense of dance, creating a counterpoint with the text as well as with a compositional structure of three or four words per column. Shōkadō dipped his brush for the first word in column one, the second in column three, the first in column four, and the second in column six, creating an irregular pattern of emphasis that contrasts dramatically with dry-brush characters that are often smaller in size.

The text of this work is also significant; the beginning of Li Po's preface influenced Bashō's famous opening to his travel *haibun* (prose with haiku) *Oku no hosomichi* (Narrow Road to the Far North): "Months and days are travelers of a hundred generations, and the passing years are also wanderers." The idea that time itself is akin to a poet wandering through this floating

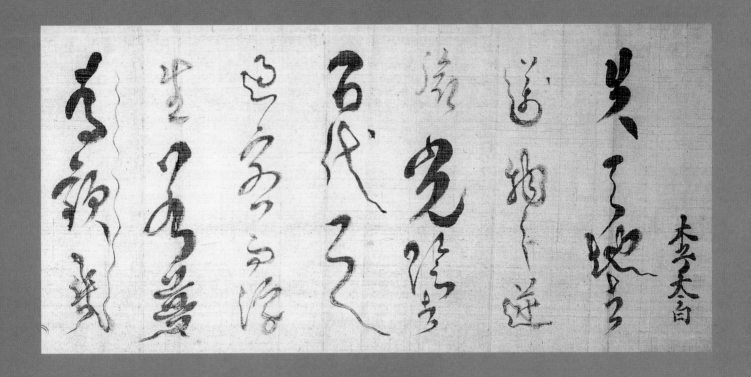

Figure 4.1.
Shōjō Shōkadō,
Calligraphy Screen
(detail).

world became very influential in early modern Japan, combining Buddhist
ideas of impermanence with the literati enjoyment of traveling through
nature for inspiration. The expression of one's feelings, as the end of Li Po's
text suggests, was one way to defeat or at least to ignore the ravages of time.
The great variety and liveliness of this cultural expression is a testament to
the poets and artists who sought out the best of both Chinese and Japanese
traditions and then transformed them to suit their own historical eras and
individual personalities.

An exemplar of early seventeenth-century culture, Shōkadō did not
limit himself to Chinese texts or the Daishi style of calligraphy; he was
perhaps even more celebrated for his brushwork of traditional *waka*. Figure
4.1 shows a section of a screen on which Shōkadō wrote both Chinese and
Japanese poetry over a gold-leaf background. For this *waka* he made use
of another form of calligraphic rhythm, that of gracefully spaced, uneven

columns flowing downward. His more delicate touch with *kana* syllables is balanced by the strong four-word title in *kanji,* all of which express his refined aesthetic as well as exhibiting his skill in brushwork. Because he used a variety of techniques, his individual style is not as immediately recognizable as that of Nobutada or Kōetsu, but the sense of personal rhythm that informs Shōkadō's work is the hallmark of his calligraphy in all forms and formats.

NOTES

1. Translation by Jonathan Chaves.

2. Hui-lien; K'ang-lo: Hsieh Hui-lien (397–433) was the younger cousin of Hsieh Ling-yün (K'ang-lo, 385–433). Both were outstanding poets, with Hsieh Ling-yün being one of the chief architects of Chinese nature poetry in its earlier stages. He was Li Po's favorite poet.

3. Golden Valley was the extravagant garden estate of the rich and famous Shih Ch'ung (249–300). In the *Preface for the Poems Written at Golden Valley,* itself a fine example of early nature prose in Chinese literature, Shih states, "So we each wrote a poem, to set forth our inner feelings; those who could not were fined three gallons of wine." This is in accordance with the favorite practice of penalizing losers in various games by forcing them to get inebriated and make fools of themselves.

5 KARASUMARU MITSUHIRO (1579–1638)

Waka on Decorated Tanzaku

Tanzaku mounted on a hanging scroll, ink on decorated paper, 36.7 x 6 cm.

One of the outstanding court nobles of his day, Mitsuhiro led an adventurous life. His father had served the court in an exalted position, and Mitsuhiro was brought up to excel in the arts of the nobility, particularly *waka* poetry and calligraphy. He composed verses in both Chinese and Japanese at a public gathering at the age of ten, and only seven years later he was appointed private secretary to the shogun. He studied classical poetry with Hosokawa Yūsai (1534–1610), learning much about Heian-period traditions, and married Yūsai's daughter in 1606. The following year, however, he was arrested with several friends for sexual indiscretions with mature court ladies, and he was exiled until 1611. Soon back in favor, he made eleven trips between Edo and Kyoto as a liaison between the shogunate in Edo and the court in Kyoto; he was, however, unable to avert the wholesale shift of political power to the shogun that took place during this time. At the center of artistic activities of his day, he was a friend and colleague of many leading poet-calligrapher-painters, including the courtier Nobutada (#2), the Shinto-Buddhist monk Shōkadō (#4), and the Zen Master Takuan (#58).

Mitsuhiro's own calligraphy is somewhat bolder and freer than that of most *waka* poets, testifying to his great confidence and independent spirit. His works include several hand scroll records of his journeys to Edo,

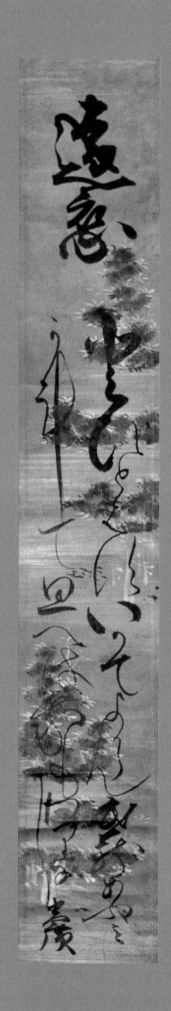

inscriptions on paintings and screens, *shikishi* (square poem-sheets), and *tanzaku* (narrow poem-sheets). His style is well suited to decorated paper backgrounds, which he utilized brilliantly for works such as this poem:

Enren	Longing from Afar
Toi towazu	Should I ask or not ask,
ika de yokaramu	would it be useful like
Musashi abumi	stirrups from Musashi?
kanete omoeba	I have thought for a long time
ware mo wari nashi	but I am still at a loss . . .

Mitsuhiro's two-character title is brushed with powerful curves at the top of the scroll, and the opening of the poem also begins with thick lines that change almost instantly to gossamer brush strokes. This sudden contrast is typical of Mitsuhiro; the second and third lines of the poem, all contained in the right column, also begin with heavier strokes and change to thinner swirls of the brush.

The fourth poetic line, beginning the left column, is different; the first three syllables extend downward in medium-weight lines, contrasting with the thicker brush strokes on the right. The left column continues with the *kana "shi"* (し) extended on the left; the work then concludes with the signature "Mitsuhiro" in *kanji* at the bottom.

Rhythmically, the calligraphy exhibits unusually strong and rapid contrasts of size, speed, and weight, adding visual drama to the poem. In particular, the constricted space at the bottom of the columns creates tensions that visually reflect the uncertainty of the poem, while the variations of heavy and light forms give the work movement and energy. This individualistic brushwork, carried out with both skill and verve, is characteristic of Mitsuhiro's bravura style. Set against the decorated paper of the *tanzaku*, his exuberant flow of line and form demonstrates that the revival of classical poetry styles was not just an antiquarian undertaking, but the expression of new artistic vitality.

6 KONOE IEHIRO (1667–1736)

Heart Sutra (1715)
Hand scroll, ink on sutra paper, 31.3 x 197.2 cm.

"Form is emptiness, emptiness is form." This famous statement, which applies to all phenomena, including calligraphy, comes from the Heart Sutra, the shortest and most powerful of Buddhist sacred writings. Frequently chanted and written out with the brush, the Heart Sutra is considered a summary of the *Daihannya-kyō* (Perfection of Wisdom Sutra), which has six hundred chapters.

The Bodhisattva of all-seeing and all-hearing [Avalokiteshvara, Kwan-yin, Kannon], while practicing deep *Prajnaparamita* [wisdom-meditation], perceives the five elements in their self-nature to be empty.

O Sariputra, form is emptiness, emptiness is form; form is nothing but emptiness, emptiness is nothing but form; that which is form is emptiness, and that which is emptiness is form. The same is true for emotion, conception, activation, and discrimination.

O Sariputra, all things are by nature empty. They are not born, they are not extinguished; they are not tainted, they are not pure; they do not increase, they do not decrease. Within emptiness there is no form, and therefore no emotion, conception, activation, or discrimination; no eye, ear, nose, tongue, body, mind; no shape, sound, scent, taste, touch, or principle; extending from no element of seeing to no element of consciousness; from no knowledge and no ignorance to no old age, no death, and no extinction of old age and death. There is no suffering, no accumulation, no annihilation, no path; there is no cognition, no attainment, and no realization because there is no attainment.

In the mind of the Bodhisattva who dwells in the *Prajnaparamita*, there are no obstacles and therefore no fear, no delusion, and nirvana is attained. All Buddhas of the past, present, and future through *Prajnaparamita* reach the highest all-embracing enlightenment.

Therefore, know that *Prajnaparamita* is the great Mantra, the Mantra of great clarity, the unequaled Mantra that allays all pain through truth and not falsehood. This is the Mantra proclaimed in *Prajnaparamita*, saying *Gate gate paragate parasamgate bodhi svaha* [Gone, gone, gone to the other shore, reaching the other shore, enlightenment, all hail!].[1]

A leading member of the noble Konoe family, Iehiro was given court positions from the age of seven, married an imperial princess (who died four years later), and eventually rose to the high courtly rank of regent. He retired in 1825 to become a monk under the name Yoraku-in. Known for his cultural activities, he became the most famous Konoe calligrapher since Nobutada (#2). Unlike his ancestor, who developed a unique personal style, Iehiro was master of many scripts and styles, making copybooks in a number of traditions that strongly influenced later generations. He is credited with being the major calligrapher of the *Koten-ha* (Classical school), and his work has been highly admired since his own day.

Buddhist sutras as translated into Chinese characters are usually copied in regular script, presumably for clarity. Iehiro has here written primarily in running-cursive script, although a few characters approach regular script (reading from the right, in column 2, word 6) and others are fully cursive (3/2), and all of column eleven. The nine-character title, "Prajnaparamita Heart Sutra," occupies the first column; subsequently there are six to nine characters per column, with the exception of column eleven, where there are only four words because Iehiro has dramatically extended the vertical line of "within" (中).

Iehiro's calligraphy is elegant but not showy, generally with thin lines and, especially as it develops, a continuous sense of flow, perhaps influenced by his expertise in *kana*. He establishes a personal sense of rhythm through a

摩訶般若波羅蜜多心經
觀自在菩薩行深般
若波羅蜜多時照見
五蘊皆空度一切苦
厄舍利子色不異空
不異色色即是空空
即是色受想行識
亦復如是舍利子是
諸法空相不生不滅
不垢不淨不增不減
無色無受想行識
善哉善哉
般若波羅蜜多

摩訶般若波羅蜜多心経
観自在菩薩行深般若波羅蜜多時照見五
蘊皆空度一切苦厄舎利子色不異空空不
異色色即是空空即是色受想行識亦復如
是舎利子是諸法空相不生不滅不垢不浄
不増不減是故空中無色無受想行識無眼
耳鼻舌身意無色声香味触法無眼界乃至
無意識界無無明亦無無明尽乃至無老死
亦無老死尽無苦集滅道無智亦無得以無
所得故菩提薩埵依般若波羅蜜多故心無
罣礙無罣礙故無有恐怖遠離一切顛倒夢
想究竟涅槃三世諸佛依般若波羅蜜多故
得阿耨多羅三藐三菩提故知般若波羅蜜
多是大神呪是大明呪是無上呪是無等等
呪能除一切苦真実不虚故説般若波羅蜜
多呪即説呪曰
羯諦羯諦 波羅羯諦 波羅僧羯諦 菩提薩婆呵
般若心経

Figure 6.1.
Anonymous,
Heart Sutra (763).

combination of factors: first, the varying number of characters per column; second, the asymmetrical redipping of his brush and subsequent stronger graphs (such as 3/6, 5/2, 8/3, 10/5,); and third, the script gradually becoming more fluid as the text continues over the tan, thick sutra paper. The tendency for characters to become more cursive is especially notable when they repeat, as with the significant words "form" (色), from 5/5 to 6/3 to 7/3, and "emptiness" (空), from 4/3 to 5/8 to 6/7 to 11/3 (just before "amid"). Until the end, however, graceful and curving strokes are punctuated by sharper and tenser strokes, giving the work its own characteristic rhythm. When the sutra is complete, Iehiro ends the hand scroll with the date, the twenty-sixth day of the fourth month of 1715, and his signature.

The Heart Sutra had been copied frequently in Japan as far back as a millennium earlier; for example, a thousand copies are known to have been made in the year 763. These were brushed with great care and reverence in regular script, and for additional brilliance they were often written in gold and/or silver on paper dyed blue or purple (fig. 6.1). By comparison, Iehiro's work may seem very relaxed and informal, but it testifies to his Buddhist beliefs as well as to the refined excellence of his calligraphy.

NOTE

1. The original Chinese translation was made by the T'ang-dynasty monk Hsuang-chuang; this English translation is by Stephen Addiss.

34

Waiting for Blossoms

Shikishi mounted as a hanging scroll, ink on decorated paper, 17.2 x 15.8 cm.

Although classical *waka* poetry had long been a courtly tradition, during the early modern period everyday people took it up to an extent never seen before. For example, one of the leading *waka* poets of the early eighteenth century was a woman named Kaji who started a tea shop in Kyoto's Gion Park, where she sold cups of steeped tea to passersby for the modest price of one *sen*. After she gained fame as a poet,[1] her customers would sometimes request a *waka* from her, which she would usually write in the format of a *tanzaku* (thin poem card) or a *shikishi* (square poem card).

Compared with most courtly writing of *waka*, Kaji's calligraphy is extremely bold and free, corresponding to her character as seen through both her independent life and her often passionate poetry. At the age of thirteen, for example, she wrote the following *waka*:

Koi koite	I loved and yearned
mata ichitose mo	but again another year
kurenikeri	draws to a close
namida no kohori	and all my frozen tears
asu ya tokenamu	are sure to melt tomorrow

Not many of Kaji's works survive, perhaps because they were treated as ephemera; this example, mounted as hanging scroll, bears the title "Waiting for Blossoms":

Matsukoro wa	Even as I wait
nado mubatama no	in the darkness
yume ni sae	of my dreams—
Katano no Mino no	the visage of blossoms
hana mo omokage	of Katano no Mino

The word *hana* literally means flowers and almost always indicates cherry blossoms. Here, since the use of the final word *omokage* (visage) usually refers to a person, we may also imagine that Kaji is dreaming of a lover, as represented by her "waiting for blossoms" or "waiting for blossoming."

This calligraphy might be considered the Japanese equivalent of Chinese "wild cursive" script because the characters vary greatly in size and seem to run into each other, if not overlap; brush lines vary from thick to extremely thin, and the total rhythm of the work seems almost chaotic. On closer examination, however, an underlying structure can be discerned. The boldly brushed two-character title "Waiting for Blossoms" is set distinctly apart on the right, with the small "Kaji" signature in the simplest of *kana* placed well below it. Her five-line poem is then written in four columns that seem to rub up against each other, with the final column corresponding to the final line of the poem.

The strongest two characters in the calligraphy are the two different cursive versions of the word *hana* (花, blossoms): the second word of the title on

the right and the first word of the final column. In the title, *hana* curls around upon itself and ends with a single dot, while later it is more expansive with dots flying out to either side, one even touching the next column to the right. Another *kanji* that is used for both sound and meaning—*yume* (夢, dream)—ends the second column of the poem (the third column overall).

Instead of using simplified *kana* for all the Japanese syllables, Kaji often chooses more complex *kanji* forms used merely for sound, such as *mu* (無, which as *kanji* would mean "no" or "nothingness") at the start of the poem's second column. More complex than *kana* and requiring more space, these forms lend rhythmic variety to the work; this can be seen at the end of the first poetic column where three simplified *kana*, *wa nado* (はなど), follow a more strongly brushed *kanji* used for the sound *ro* (路).

Even when using *kana*, Kaji changes size and shape continuously so that some forms are large and bold with thick lines while others are written with thinner lines in much smaller size. For example, the penultimate column of calligraphy (the fourth line of the poem) ends with four of its five syllables pronounced "no," which could be a challenge to a calligrapher. Might Kaji write the same *kana* four times? Certainly not; she uses two forms of *kana* plus two repeat marks, the second abbreviated, to create visual variety. She begins with a *kana no* (ノ)) that resembles the letter *R*, then adds a squiggle repeat mark on the right; next she writes a *kana* on the left that consists of three horizontal dashes and represents *mi* (ミ); completing the column are a circular *kana* form (の) that also signifies *no* and a final squiggle that is again a repeat mark; thus her *no no mi no no* becomes a constantly changing flow.

While Kaji's use of decorated paper harkens back to the aesthetics of courtly elegance, her combination of boldness of brushwork and occasional compression of forms gives this *shikishi* drama, energy, and passion that is often lacking in later *waka* calligraphy. This work shows how nonaristocratic poets, both in their verse and in their calligraphy, helped to keep the classical poetry tradition vital during an age when the arts were patronized and practiced by everyday people rather than merely the elite. While courtiers were mostly repeating the styles of the past without adding significant new elements, poets like Kaji breathed new life into *waka* verse and calligraphy.

NOTE

1. A book of 120 of Kaji's *waka*, *Kaji no ha* (Mulberry Paper [Kaji] Leaves) was published in 1707 in Kyoto with illustrations by Miyazaki Yūzen (died 1758), who is also credited with originating or perfecting the form of resist dying that bears his name.

8 GION YURI (1694–1764)

Five Lotus Sutra Waka
Hanging scroll, ink on decorated paper, 31 x 43.3 cm.

The adopted daughter of Kaji (#7), Yuri studied poetry, needlecraft, calligraphy, and music, and assisted her mother at the Gion tea house. She too became known as an outstanding *waka* poet, receiving advice and encouragement from the courtier Reizei Tamemura (1712–1774). The Reizei style of calligraphy, as exemplified in a *tanzaku* by Tamemura (fig. 9.1), features strong contrasts of thick and thin line widths that create heavier and lighter forms; the connoisseur James Freeman once described a Reizei work as resembling "a swarm of bees." Yuri's personality, however, was less dramatic than this style suggests, and her own more restrained writing represents her own character, which is clear also from her life story as told by Rai San'yō (#38).

According to this romantic tale, Yuri had only one lover in her life, a young samurai who did not expect to inherit his father's position in Edo since he was a second son. Coming to Kyoto, he fell in love with Yuri and they had a child named Machi, later known as Gyokuran (#9). However, the elder brother died unexpectedly, and the young samurai was told by his family to return to Edo. He asked Yuri to come with him, but she told him:

> The reason I cannot accompany you is that you have been chosen to carry on the ancestral line of a distinguished family and must select a person of proper standing to be your mate.... I have pondered the matter deeply day and night, and I believe that parting with you today is the best way to insure a fitting close to the love and kindness you have shown me these ten years.... All I have to rely on is this one child, and while I see her I seem to see you as well.[1]

Unlike her more passionate mother in temperament, Yuri seems to have lived a quiet life after her lover left Kyoto, running the tea shop while expressing her serene personality through poetry and calligraphy. Here she has written a series of five Buddhist poems in *waka* format. Each begins with one character from the title of the Lotus Sutra:

MYŌ 妙	HŌ 法	REN 連	GE 華	KYŌ 経
Wondrous	Law	Lotus	Flower	Sutra

These large characters appear, from right to left, at the top of each of the five poems. *Ren* and *Ge,* the two most significant *kanji,* are written in angular running script, with strong horizontals providing the forms a great deal of strength, while the other three characters are written in fluid cursive script.

Each *waka* begins with the same word as above it, but now written in *kana* to be pronounced in pure Japanese rather than Sino-Japanese; *Ge,* for example, becomes *hana* (both meaning "flower").

めぐる道やへぐりおくはな教をも
作らてすはの世に法くん

法乃羅におちをしなくさ連
い祢有乃にちき人そく

蓮をちはし祢乃やせむ世の
とられきるちまつ人それひ

華をはんれ色もるひもちくもに
いつよかうしのり祢そき

始こみえしせ祢ねいるらり
六みとうにまおとろれぬ仕

MYŌ	Ubenare ya toki oku nori no oshie wo mo aogi te zo kiku ato no yo no tame	It is natural that the dharma teachings spoken by a master when listened to respectfully will help us to the next world
HŌ	Nori no michi koto to wa suna omo satori ken kokoro no tsuki no kage wa hisakarade	The way of the dharma should be naturally understood— for the moon-shadow of the mind is not eternal
REN	Hachisuba ni yatoseru tama ni tsuyu no yo no okure kishi ni tatsu hito no nakereba	Like a drop of water momentarily on a lotus leaf in this dewdrop world, so we must come early, not late, to the teaching
GE	Hana no iro no nioi mo michite azuma koto itsu to kakirasu nori no tōto sa	Both the flower's color and fragrance are replete, for in our land the dharma teaching continues without end
KYŌ	Fumi ni mishi yo no hakanasa wa megumi yori shirite mo sara ni odorokarenuru	To see in this sutra the world's fleeting nature is more than a blessing— although I know this teaching I'm still surprised

Yuri's calligraphy is less flamboyant and dramatic than that of her mother, Kaji, more boney than fleshy, yet it conveys both inner strength and creative energy. The flow of the writing down the columns is both firm and fluent, with forms almost touching each other but retaining their own integrity. Most notable are two graphs that stand out because of the greater weight they have been given. The first is *yo* (世, world), which occurs in the first, third, and fifth poems, each time with a thick horizontal that creates a strong visual accent. The second is the *kanji* for "person" (人), which can be seen in the second and especially in the third poem, where its two diagonal strokes give it a strong accentuation. Clearly, for Yuri the task of a human being is to maintain one's own inner spiritual strength in this dewdrop world.

NOTE

1. The entire story, as told by Rai San'yō, is given in Burton Watson, *Japanese Literature in Chinese*, vol. 2 (New York: Columbia University Press, 1976), pp. 162–170. Yuri's poems were published in *Sayuriba* (Leaves from a Young Lily) in 1727.

Three Waka on Flowers

Hand scroll section, ink on paper, 15 x 32 cm.

The granddaughter of Kaji (#7) and daughter of Yuri (#8), Gyokuran followed their tradition by running the family tea shop in Gion Park while composing classical *waka*, but she also became a pupil of the Chinese-style literati painters Yanagisawa Kien and Ike Taiga (#41). She eventually married Taiga and lived in *Makuzugahara* ("arrowroot cottage") next to Gion Park, which she inherited from Yuri in 1761.[1] Artistically a pioneer, Gyokuran brought the *waka* poetry tradition to Japanese literati painting not only in her own works but also by having some of her paintings inscribed by her mother.[2]

Gyokuran's own *waka* were published in a book entitled *Shirofuyō* (White Mallow), but it contains only nineteen verses, in comparison with the books by Kaji and Yuri, with 120 and 159 poems, respectively. But Gyokuran was nonetheless accomplished in poetry as well as calligraphy and painting, and it is instructive to compare her works with those of her grandmother and mother. While Kaji's poems tend to be passionate and Yuri's more renunciatory, Gyokuran's are more likely to focus upon their visual images, expressing more of nature and less of her own emotions. Her calligraphy is also more orderly than Kaji's and more consciously artistic than Yuri's. For example, while Kaji varied her characters in size so that they crowd against each other, Yuri preserved her column structure more clearly, with only occasional accents of larger or heavier forms. In contrast to both of them, Gyokuran maintains clearly separated columns with rhythmically balanced accents, as can be seen in a set of three of her poems about cherry blossoms in spring.

Hana wo Maneku

Miebamuru
hana no sugata wa
yama no ha ni
tsuki no oshiho no
sayo fukete koso

Inviting Flowers

If I could only see
the shapes of the blossoms
at the edge of the mountain
lit by gleaming moonbeams
in the depths of night!

Tsukikage mo
sayaka ni miete
fukuru yo no
hana no iro ka no
nao ya shinoban

By the moonglow
brightly visible
in deepening night,
the color and scent of flowers
that I still remember . . .

Hana kaze wo itō

Matsugae ni
kaze koso tomare
yamazakura
sakari hisashiku
nao miha ya sen

Flowers Detesting the Wind

In pine branches
may the wind stop;
the mountain cherries
are now at their height—
I'd like to see them linger

をり花

そてもちる花のつゝみ
らのゝに月のおもかの
さゝみけてゝゝ
月りにもきゝまゝゝ
ふるゝ夜のむれいるを
わやきのもん
花ばれ
松ゑよれゝえもれ
まさのゝさゝくゝ
るひえゑやゝ

The three *waka* are each given three columns, while the titles for the first and third poem occupy their own spaces, making a total of eleven columns of calligraphy. The training that Gyokuran received from her teacher, the high-ranking courtier Reizei Tamemura (1712–1774), is apparent in her strong contrasts of line width, apparent even in single characters such as "moon" (月; 3/5, 5/1). The *kanji hana* (花, flower or blossom) appears in semicursive form three times (1/2, 2/6, 8/1) but is once rendered in fully cursive style in a single thick brush stroke near the middle of the composition (6/5). This creates a strong accentuation that contrasts effectively with the thinner *kana* above and below it.

Comparing this work with a *tanzaku* by Tamemura (fig. 9.1), the dramatic thickening and thinning of the courtier's brushwork gives his work more immediate visual drama, while the rhythm of Gyokuran's calligraphy seems less virtuoso and more personal. In this way she stays more in the literati tradition, which emphasizes direct but unobtrusive expression.

Several contemporary anecdotes suggest that Gyokuran lived a happy bohemian existence with Taiga. According to one story, they gave a guest their only blanket and Gyokuran slept wrapped up in painting paper; in another, Gyokuran visited the high-ranking courtier Tamemura in a plain cotton kimono and straw sandals. Furthermore, she did not pluck her eyebrows or blacken her teeth, so she was sometimes considered homely. Living very naturally, Taiga and Gyokuran were reputed to enjoy playing music naked, and they sometimes put on each other's clothing when a guest came to visit.[3]

After Taiga's death in 1776, Gyokuran continued to run the tea house for a few years and also gave calligraphy lessons. A view of her later life is expressed in a Chinese-style poem by Taiga's pupil Fukuhara Gogaku (1730–1799):

Visiting the Venerable Gyokuran at Makuzugahara

Amid the arrowroot gourds in the autumn cool is a single rustic retreat;
The grass colors are lonely, their appearance naturally sparse.
After Gyokuran has inscribed a fan with chrysanthemums and orchids,
She brews up mountain tea on her ancient ceremonial hearth.

Figure 9.1.
Reizei Tamemura
(1712–1774),
Waka Tanzaku.

NOTES

1. There is some question whether an actual wedding ceremony ever took place; since they did not have children, they may have considered it unnecessary.

2. Previous to this time, literati paintings were inscribed in Chinese; for Gyokuran *waka* examples, see Stephen Addiss, "The Three Women of Gion," in Marsha Weidner, ed., *Flowering in the Shadows: Women in the History of Chinese and Japanese Painting* (Honolulu: University of Hawaii Press, 1990), plate 7, figures 7 and 8, on p. 256.

3. These legends, among others, are given in Ban Kōkei, *Kinsei kijin-den* (Lives of Modern Eccentrics) (1790; repr., Tokyo: Iwanami Shoten, 1940).

Kyōka: Saigyō's Cat

Framed scroll, ink on silk, 96.8 x 30 cm.
Harnett Museum, University of Richmond, Va.

Humor can occur in calligraphy as well as in verse. Born to a modest samurai family in Edo, Ōta Nanpo received a Confucian education, and by his middle teens he had not only succeeded to his hereditary position as castle guard but also published a study of Ming-dynasty poetic terms. He continued his studies in Chinese literature all his life but became more famous for *gesaku* (writing for fun) under the name "Shokusanjin." He especially enjoyed the humorous five-section *kyōka* (mad poem), which has the same 5-7-5-7-7 syllable structure as *waka* but is satiric in content. Although Nanpō gave up this form for a time when the government forbade samurai to attend *kyōka* parties, he remained the quintessential master of this genre, which required both wit and erudition.

The text of this "mad poem" refers to a famous story in Japanese history in which the wandering monk-poet Saigyō (also known as En'i, 1118–1190), when summoned to meet the shogun Yoritomo in Kamakura, is asked about poetry and archery. Saigyō claims to know nothing special about poetry and to have forgotten everything he once knew about archery, but nevertheless he is presented with a silver cat by the shogun. Caring nothing for worldly riches, Saigyō gives the cat to some children as he leaves the gate of Yoritomo's mansion.

Human Concerns Are All Saigyō's Cat

kono neko wa	That cat—
nan monme hodo	just how much
arō to wa	it weighed
kakete mo iwanu	he'd never tell,
En'i shōnin	the Buddhist saint En'i![1]

The introduction is a pun on the familiar Japanese saying, "Human concerns are all like Saiō's horse." According to a Chinese legend, old man Saiō's horse ran away, but he did not despair, and the horse returned leading a fine stallion. Saiō did not rejoice, and before long his son broke his leg riding the new horse. Saiō again did not grieve, and soon all the young men in the village were conscripted into the army to serve at a distant post— except his son. Saiō, accepting all things with equanimity, and Saigyō, caring nothing for expensive objects, must have been grist to the mill of Nanpō's satiric spirit. Here he beings the two stories together to lampoon the ambitious and avaricious society of his own time.[2]

Nanpō's calligraphy is modest, relaxed, and somewhat eccentric. *Kyōka* are usually about people's foibles rather than the interaction of nature and humans, as in most *waka*, and here the first and largest word is, appropriately, "person/people" (人). The same word appears at the end of the poem and again at the end of the signature, each time further deconstructed.

What is most notable about Nanpō's writing is his use of space. The composition is divided vertically into four sections: the title on the right,

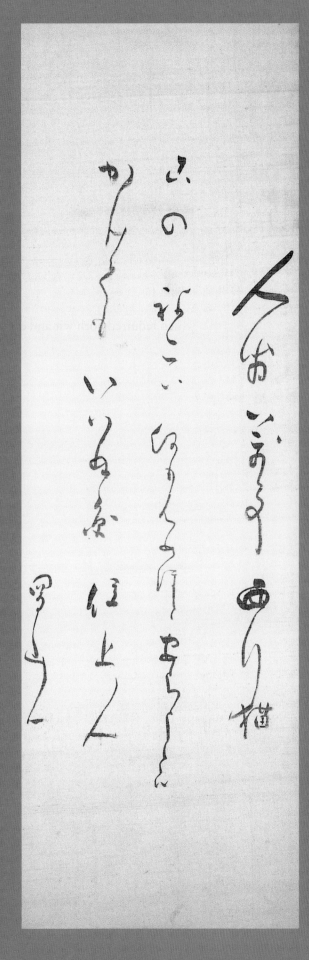

the poem in two columns, and finally the "Shokusanjin" signature. Nanpō's title is rendered in three segments, and the first line of the poem is also divided, here requiring eleven strokes of the brush. The column then continues with the second and third lines of the poem, but each is now created with a single continuous gesture. The next column presents the fourth line of the poem with continuous brushwork, and then concludes with the final line of four *kanji* that are clearly separated from each other to emphasize their more serious nature.

The effect is to make the poem begin slowly—"that cat"—then proceed quickly, segment by segment, until the final line—"En'i Buddhist saint." Despite the satire of the *kyōka*, the cat ultimately becomes the saint and Saigyō becomes what he has given away. In this way Nanpō's calligraphy extends and dramatizes the not entirely humorous meaning of his "mad poem."

NOTES

1. John Carpenter has offered a delightful translation of this poem:

> Just how much
> did that cat
> really weigh?
> Holy Man En'i
> would never say!

2. For Zen images of the legend of old man Saiō, see Audrey Seo with Stephen Addiss, *The Art of Twentieth-Century Zen* (Boston: Shambhala Publications, 1998), pp. 24, 49. For a painting of Saigyō and the cat, see Stephen Addiss, *A Japanese Eccentric: The Three Arts of Murase Taiitsu* (New Orleans Museum of Art, 1979), catalogue no. 9.

11 KAMO SUETAKA (1751–1841)

Chōraku-ji's Cherry Blossoms (1832)
Hanging scroll, ink on satin, 113 × 32.7 cm.
Birmingham Museum of Art, Ala.

Suetaka, the Shinto priest of the Kamo Shrine in Kyoto, was a well-known *waka* poet and calligrapher. He exemplifies the populist directions that courtly poetry was taking toward the end of Japan's early modern period. Here he has brushed an introduction over a *waka*, combining the age-old love of cherry blossoms with a touch of humor.

At the temple of Chōraku-ji, many beautiful women can be seen strolling under the blossoms; a monk looks up from his sutra and peers around at them.

Yamadera no	At the mountain temple
sakura sakura to	when they come to view
mi ni kureba	"cherries, cherries"—
fuku to mesae tada	it's merely a moment of joy
uka-uka no haru	in the idleness of spring

—eighty-two-year-old Kamo Suetaka

長楽寺尓詣天

旅人乃見えわかれつつ
行はるの経天持な
うつりそてきそめ
とこそ

山ぎはにさく向くねて見る桜
初はつにさくさそて
さかくさは

The medium of satin takes the ink differently from paper or silk. Because it has several threads in one direction before being crossed from the other, it reflects light in a "satin sheen" that also allows ink to seep out from the brush stroke when very wet. This effect is particularly evident in Suetaka's strokes just after he dipped the brush, such as the first and third columns of the introduction, but it is even more visually notable in the poem itself.

Suetaka has dipped his brush for the first character, "mountain" (山), and farther down the first column for the first word of the third line of the poem, "view" (景). He does not redip at the top of the second column but waits for the beginning of the final poetic line, about halfway down. Here he writes the first vowel of *uka* by using the *kanji u* (宇), literally meaning "eaves"; this use of *man'yōgana* remains a feature of much traditional *waka* calligraphy. Suetaka then concludes with his signature, writing "82 [years] old" just to its right in small script.

In essence, Suetaka has arranged a five-line poem into two calligraphic columns with three dips of the brush, creating a counterpoint of visual rhythms. Up to this time, *waka* were usually written on horizontal scrolls, square *shikishi* poem cards, or narrow *tanzaku*. The larger space of a vertical scroll, the use of satin, and the bold brushwork allow Suetaka to make a more dramatic presentation. Compared to earlier *waka* calligraphy, it seems rough and sometimes inelegant, but exhibits a great deal of freedom as it moves from fluent to angular and from viscous to scratchy. Part of this style might be attributed to his age, but his earlier works are also decidedly loose and spontaneous.

By this time in Japanese cultural history, *waka* had lost much of its association with the court; refinement was no longer its major aesthetic criterion. Instead, energy and creativity were paramount; while some critics decried the loss of elegance, the poetic form as well as its calligraphic expression might have atrophied without the fresh vitality of poets such as Suetaka. Just as the love of cherry blossoms has been renewed each generation, this poem on satin demonstrates how a Japanese Shinto priest was able to give vigorous new life to an old tradition.

12 OTAGAKI RENGETSU (1791–1875)

Lotus Cup
Inscribed stoneware, 9.2 cm. tall

One of the most notable women in the world of nineteenth-century Japanese art, Rengetsu lived through tragedy to become a major poet-calligrapher as well as a potter and painter. She married young, her husband died, she married again, her second husband and child died, and she then became a Buddhist nun. Supporting herself by making handcrafted pottery and by her calligraphy, she created some of the most personal works of her time.[1] She sometimes combined her skills when she

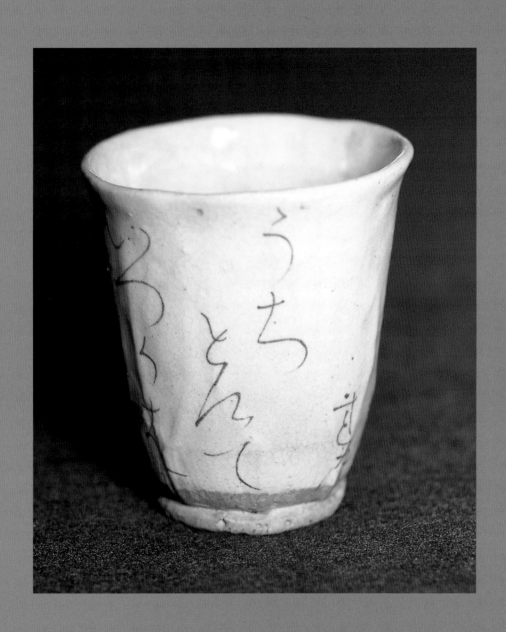

carved her poems, or wrote them in glaze, on her ceramics, such as on this lotus cup. This *waka*, although the title is not here inscribed, is elsewhere in her work entitled "Autumn Yearning."

The cup itself is wondrously made, with the stem of the lotus curving on the base and its veins subtly running up the sides of the cup, which becomes a folded lotus leaf. Its slight asymmetry echoes the Japanese aesthetic of the imperfect, which is enhanced by the changing tones of the glaze from muted pink to gray-blue. The lotus is celebrated in Buddhism, since it rises from the mud at the bottom of a pool to blossom in white purity, and therefore it was chosen to be part of her Buddhist name, Rengetsu (lotus moon, 連月).

Uchitokete	Someday
itsuka wa hito wo	even for those who have
Miwa no yama	opened their hearts,
shirushi no sugi mo	as on the cedars of Mount Miwa,
akikaze zo fuku	the autumn wind will blow

The calligraphy on this cup is typical of Rengetsu's style, which combines elegance and delicacy with confident, open, and rounded forms. Pictured here is the spacious beginning of the poem, *uchitokete* ("opened their hearts"), in *kana* (うちとけて). The five *kana* are divided into two columns, the second starting lower, giving a feeling of movement within tranquility. One may also discern the end of her signature with the *kanji* for "lotus" at the lower right.

Rengetsu's less formal calligraphy appears on a letter to Tomioka Tessai (1836–1924), a young literatus she befriended and helped to support by writing *waka* on some of his paintings. At this late stage of her life, Rengetsu had achieved more fame than she wished (she often moved to avoid admirers), while Tessai, who was later to become the most successful literatus in Kyoto, was still struggling for recognition. Nevertheless, Rengetsu was kind enough to imply that Tessai was doing her the favor of collaboration (fig. 12.1):

> I imagine that you are very busy, but please paint for me on these five sheets of paper. I'm really sorry for the small amount of reward you will receive, but I hope you can grant my request. Please paint bamboo and pine on the marked sheets, and *kinuta* [fulling blocks for pounding cloth] on the two that are unmarked. I will visit before long and talk with you; that's all for now.
>
> —For Tomioka-sama, Rengetsu

Here the columns are slightly disordered and the brush seems to be moving faster than when Rengetsu writes out poetry, the result being an informality that allows her to squeeze some forms together while freeing others to swirl (the first word) or extend (the end of the first column). Rengetsu generally relies upon the flow of *kana* to create a rhythm that continues directly through the Chinese characters. For example, the third column begins with two *kana* reading *"kono"* (these, この); next comes the *kanji* for "five" (五), two *kana* signifying *"mai"* (sheets, まい), and finally two more *kanji* for "paint for me" (代画). Although the *kanji*, even in cursive script, are more complex than the *kana*, they all continue to flow rapidly until the final horizontal hook of the last *kanji*. The main difference is that

Rengetsu's *kana* are often joined without lifting the brush, while her *kanji* are kept separate from each other.

Figure 12.1.
Otagaki Rengetsu,
Letter to Tessai.

In both her more formal calligraphy and her letters, Rengetsu's characteristic style is apparent, including the generally open spacing of her brush lines. Some scholars have attributed this style to her experience of writing with glazes and inscribing her calligraphy directly into clay; in both cases space is needed to keep the lines clear from each other. This serene openness, however, is also a manifestation of her personal character. Surviving the sorrows in her life, Rengetsu was able to blossom through difficulties like a lotus; and in her poetry, calligraphy, occasional painting, and pottery, she created a feeling of pure light like the moon.

NOTE

1. For Rengetsu poems, see *Lotus Moon: The Poetry of the Buddhist Nun Rengetsu*, trans. John Stevens (New York: Weatherhill Inklings, 1994).

Calligraphers in the
Karayō (Chinese) Tradition

In contrast to the poet-artists who revived and transformed the Japanese *waka* tradition in the early seventeenth century, many calligraphers worked to extend the Chinese tradition that had begun more than a millennium earlier. This form of writing had been kept alive during Japan's Middle Ages (1185–1568) primarily by Zen monks, who used it for their own poems as well as Zen texts. In the early modern era, however, the tradition became more broadly popular, and was known as *karayō* (Chinese style). Its renewed success was due in part to the Tokugawa government's support of Confucian studies, which helped lead to great advances in literacy throughout the population. Also significant was the influx of Chinese Ōbaku Zen monks in the second half of the seventeenth century, a time when Japan was otherwise closed off from the rest of the world.

One of these immigrants, the noted literatus Tu-li (Japanese: Dokuryū, 1596–1672), excelled in poetry, seal-carving, and medicine as well as calligraphy.[1] He had first mastered the regular script of Yen Chen-ch'ing (709–785) and the "wild cursive" of the monk Huai-su (725–789), then studied the more individualistic styles of the Sung-, Yuan-, and Ming-dynasty artists. Tu-li wrote in all five Chinese scripts, sometimes moving from one to another within a single hand scroll (fig. B.1).

Tu-li criticized the Japanese calligraphers of his day for not knowing the fundamental etymology of Chinese characters, as well as for not holding the brush in the correct vertical position with the tips of the fingers. He noted that Japanese calligraphers often held the paper up with one hand while writing with the other, which could not produce properly controlled brush strokes. Tu-li did not become an Ōbaku monk until after he came to Japan, and his influence was probably greater on calligraphy than upon religion. His major Japanese pupil, Kō Ten'i (Watanabe Gentai, 1649–1722, #18), helped to spread his influence to Japanese calligraphers, who were increasingly eager to explore the realms both of older and more recent Chinese styles. Above all, it was the artistic potentials of a graphic tradition encompassing more than fifty thousand characters in five possible scripts that appealed to calligraphers and to their audiences.

Perhaps the leading Japanese pioneer in the *karayō* style was Kitajima Setsuzan (1636–1697, #13), who studied with Tu-li, among others. The son of a doctor who served the Kumamoto clan, Setsuzan became fascinated in his youth with Chinese scholarship and calligraphy. Since Nagasaki was the

Figure B.1.
Tu-li (Jpn., Dokuryū, 1596–1672), *Commemorating a Farewell* (1662, opening).

only port open to Chinese merchants and visitors, he traveled there to find teachers. In this city, with its strong international flavor, he was fortunate to be able to study calligraphic styles of the Ming dynasty both from Ōbaku monks and from a secular Chinese scholar who taught him the tradition of the major literatus Wen Cheng-ming (1470–1559). Since previous Japanese calligraphy in Chinese had been primarily based upon much earlier sources, Setsuzan became known for brushwork that helped to start a new tradition in Japan. He spent the rest of his life first back in Kumamoto, then in Edo (where he became known as the leading *karayō* master in the capital), and finally back in Nagasaki.

Setsuzan's leading pupil, Hosoi Kōtaku (1658–1735, #14), helped to spread the new ideas and styles of calligraphy throughout Japan. As well as studying with Setsuzan at the age of twenty, Kōtaku learned a number of other arts and skills, but he was most known for his brushwork. His popularity became so great that several woodblock books were published detailing his calligraphic beliefs and methods, such as the correct method of holding the brush (fig. B.2), and the eight fundamental brush strokes that occur in the character for "eternal" (fig. B.3).

Kōtaku followed Ming-dynasty models such as Wen Cheng-ming, but he also advocated an approach to calligraphy that combined the perfection of form seen in T'ang-dynasty writing with the more lively spirit of the Sung-dynasty masters.

Among the many pupils of Kōtaku was Mitsui Shinna (1700–1782, #19), who became the teacher of Kameda Bōsai (1754–1826, #37), who thereupon taught Maki Ryōkō (1787–1833, #25), whose style was influential in the later nineteenth century. In this way, one direct flow of *karayō* tradition continued through Japan's entire early modern period. However, each artist had his own special features. For example, Shinna became most noted for his seal script, Bōsai for his "wriggling earthworm" cursive script, and Ryōkō for his clerical, standard, and running scripts. Japanese calligraphers, no matter how devoted to their studies of Chinese writing, exhibited their own interests and personalities in their work, confirming the traditional concept that one's individual character is manifest in one's brushwork.

One of the most successful calligraphers in the *karayō* style during the eighteenth century was Chō Tōsai (1713–1786, #21), the son of a Chinese merchant father and a Japanese mother. His dedication to calligraphy led him to study with an Ōbaku monk, and he became proficient in all five

Figure B.2.
Hosoi Kōtaku, 1658–1735, *Holding the Brush.*

Figure B.3.
Hosoi Kōtaku, "Eternal."

Chinese scripts. Making his living in part by selling Chinese medicines, Tōsai exemplified the Chinese-style scholar-artist and influenced several later Japanese painter-calligraphers. His style was based upon the work of Sung and Ming artists, so he became one of the leaders in popularizing the "reformist" style of *karayō*.

Another successful Chinese-style calligrapher during the eighteenth century was Sawada Tōkō (1732–1796, #23), who had studied with the son of Tu-li's pupil Kō Ten'i. Although Tōkō had learned a Ming-dynasty style, he turned away from this tradition in favor of following much earlier Chinese masters such as Wang Hsi-chih (303–379), whose graceful tradition of running and cursive script Tōkō mastered and taught. As the early modern period progressed, debates between the reformist Sung-Ming faction and the classical Chin-T'ang devotees became one of the creative tensions that stimulated the development of Chinese-style calligraphy.

In addition to these reformist and classical traditions of Chinese calligraphy, another style gained prominence that referred back to the Japanese monk Kōbō Daishi (774–835). Also known as Kūkai, he has been most celebrated for bringing from China a form of esoteric Buddhism that has endured in Japan as the Shingon sect. According to legend, it was Kūkai who developed the *kana* system in Japan, and his prowess in calligraphy became famous. Believing that art was important for Buddhist teaching, Kūkai inscribed portraits of Chinese esoteric Buddhist patriarchs with a script that emphasized decorative flourishes, such as extending a final diagonal brush stroke and wriggling it upward. Curiously enough, the Daishi-ryū (Daishi school) did not begin until the seventeenth century, when revivals of various earlier forms of art were taking place.

Several calligraphers followed the Daishi school in at least some of their works, including masters who worked primarily in Chinese, as well as others who also often wrote in Japanese. Among the latter were Fujiki Atsunao (1580–1648), who initiated the school, and Shōjō Shōkadō (1584–1639, #4). Among the calligraphers working in Chinese who were also adherents of the Daishi school was Sasaki Shizuma (1619–1695, #15), who followed tradition in teaching through the use of *tehon*, calligraphy model books that were to be copied by his students. Shizuma's daughter Sasaki Shōgen (n.d., #16) was able to use the Daishi tradition in a creatively personal and powerful manner that demonstrates how significantly women were able to add to calligraphic traditions despite their low legal status in society at that time.

What kinds of texts did these calligraphers write? In some cases it was their own Chinese verses of five or seven characters per line, but more often the professional calligraphers chose well-known Chinese texts. Examples included here are Shōgen's use of a quatrain by the T'ang master Tu Fu and the inclusion by her father, Shizuma, of the famous "Thousand-Character Essay" in his *tehon* album.

In viewing the different styles of the time, it may be helpful to compare different renditions of the same text, in this case the poem "Eight Immortals of the Wine Cup," attributed to Tu Fu. The enjoyment of wine, familiar in the Chinese literati world, also became celebrated by members of the new Sinophile movement in Japan, which included scholars, calligraphers, poets, and painters. In this poem, masters of different aspects of life and culture are praised with a hint of mockery.

Ho Chih-chang rides his horse as though he were on a swaying ship;
If bleary-eyed he should tumble down a well, he would lie at
 the bottom fast asleep.

Prince Ju-yang drinks three measures before going to court;
If he passes a brewer's cart along the way, his mouth waters—
He regrets only that he is not the Prince of Wine Springs.

The Minister of the Left spends ten thousand coins daily,
And drinks like a whale, imbibing one hundred rivers;
Holding his wine cup, he insists, "I drink as a sage and avoid virtue."

Ts'ui Tsung-chih, a handsome youth, is exceedingly refined;
Turning his gaze to the heavens and grasping his beloved cup,
He stands like a tree of jade, swaying lightly in the breeze.

The ascetic Su Chin meditates before an embroidered image
 of the Buddha,
But he enjoys his lapses when he goes off on a spree.

As for Li Po, one measure will inspire a hundred poems;
He sleeps in the wine-shops of the capital, Ch'ang-An.
When summoned by the Emperor, he will not board the
 Imperial barge;
He calls himself "The official who is the god of wine."

Give three cupfuls to the calligrapher Chang Hsu and his writing
 becomes inspired—
He throws off his cap before the officials and his brush produces
 clouds and mist.

After five measures Chiao Sui is so eloquent, he startles everyone in
 the feasting hall.

For his hanging scroll version of this text, Kitajima Setsuzan writes in flavorful, almost quirky, style that moves freely among regular, running, and cursive scripts (#13). He also shows a range between thicker and thinner brush strokes, producing darker and lighter characters. Setsuzan's linear compositions are rather sharp and angular for some graphs and much more rounded for others, giving his calligraphy of this lengthy text an abundant variety that adds asymmetrical rhythms down the scroll.

The same text written by Setsuzan's contemporary Terai Yōsetsu (1640–1711), however, is very different in spirit partly because of the format (fig. B.4). Instead of writing on a hanging scroll with long columns of characters, Yōsetsu chose the hand scroll format, where he would brush four, three, or more rarely two characters per column. In addition, he used cursive script throughout, rather than a mixture of scripts, giving more sense of flow to the calligraphy. There is still variety, but here it is created primarily by different character sizes. For example, the first and third columns of the scroll are made up of three medium-size characters each, the second has four smaller ones, and the fourth and fifth contain two larger graphs each. In the fourth column, however, the first character (井, well) is much larger than the second, so character sizes may vary even within a column. That same large

character is also exceptional in that it is made up of straight rather than curving lines, which are more common in Yōsetsu's style, giving a needed sense of structural "bone" as well as surface "flesh."

Several generations later, Mitsui Shinna wrote out the same text, again as a hand scroll, but with his own style (#19). He opened with the title of the poem in large seal script, for which he was known, with each character occupying an entire column. For the text of the poem, he worked in running-cursive script with usually four, and occasionally three, characters per column (fig. B.5).

Although Shinna's calligraphy is fluid, it is a little more structured than that of Yōsetsu and more varied in line thickness. If we compare the fourth word in the text, "horse," we can see that Yōsetsu wrote it in a single gesture of the brush at the top of the second column. In contrast to this cursive script rendition, Shinna used running script to create the character in seven strokes at the bottom of his first column of calligraphy. Setsuzan's version of this fourth graph is also in running script, but it opens the space up vertically more than Shinna's, and creates a rectangular emphasis until the final stroke. This comparison is merely one example of what could be studied at length, since each character has myriad potentials for composition and brushwork.

Chinese texts offered these professional calligraphers the chance to display their prowess in different scripts; occasionally they would write hand scrolls in which they used two, three, four, or even all five of the scripts. They usually seemed most comfortable, however, in running or running-cursive calligraphy, which gave them ample opportunity for individual expression through rhythmic movements of the brush. Their range can be seen in the work of two later *karayō* masters, who represent two different aspects of Japanese culture in the nineteenth century: Ichikawa Beian (1779–1858, #24) and Tōkai Okon (1816–1888, #26).

Beian was the son and pupil of the Chinese-style poet Ichikawa Kansai (1749–1820), who followed the Hosoi Kōtaku tradition. In order to learn further, Beian went to Nagasaki at the age of twenty-six to study with a Chi-

nese master. When he returned to Edo, his calligraphy was much enjoyed by samurai-officials, and he attracted so many pupils that shops were said to have opened near his house to gain their business. In contrast, Okon was a child prodigy who mastered cursive script by the age of ten. She impressed many literati and demonstrated her prowess before the emperor, who gave her gifts in return. Following the social order of the day, however, she retired from calligraphy when she married and began again only late in life, after her husband died.

Reviewing the work of *karayō* calligraphers over several centuries, we can see that several features distinguished their work from that of Chinese masters. Despite their reliance upon continental models, whether traditional or reformist, Japanese artists tended to emphasize personal expression over perfection of brush strokes. Dramatic mood and individual flavor, although seen in many Chinese works, were especially prized in Japan. For this reason, some artists such as Shizuma used gray as well as black ink in their calligraphy, others such as Setsuzan liked to mix different scripts in a single work, and in general there seemed to be more interest in creative flux than consistency of effect. The result was not only an invigoration of Chinese-style calligraphy in Japan but also a strong and lively addition to Japan's own traditions.

Figure B.5.
Mitsui Shinna,
(1703–1782), *Eight
Immortals of the Wine
Cup* (1770, detail).

NOTE

1. For further information about Tu-li and examples of his calligraphy, see Stephen Addiss, *Obaku: Zen Painting and Calligraphy* (Lawrence, Kans.: Spencer Museum of Art, 1978).

知章騎馬似乘船，眼花落井水底眠。汝陽三斗始
朝天，道逢麴車口流涎，恨不移封向酒泉。左相日興費萬錢，
飲如長鯨吸百川，銜杯樂聖稱世賢。宗之瀟灑美少年，舉觴白眼望
青天，皎如玉樹臨風前。蘇晉長齋繡佛前，醉中往往愛逃禪。
李白一斗詩百篇，長安市上酒家眠，天子呼來不上船，
自稱臣是酒中仙。張旭三杯草聖傳，脫帽露頂王公前，揮毫落紙
如雲煙。焦遂五斗方卓然，高談雄辯驚四筵。

雪山人書

13 KITAJIMA SETSUZAN (1636–1697)

Eight Immortals of the Wine Cup

Hanging scroll, ink on paper, 133 x 59.5 cm.

Born in Kumamoto to a doctor's family, Setsuzan was fascinated with Chinese culture from his youth. He first studied at the temple of Myōei-ji but then traveled in his twenties to Nagasaki in order to have direct contact with Chinese intellectuals. There he studied the revisionist neo-Confucianist thought of Wang Yang-ming, who advocated direct action based upon inner moral principles. However, this school of thought, known as *yōmeigaku,* was considered potentially dangerous by the government; and after returning to take up an official clan position in Kumamoto, Setsuzan was dismissed in 1669 along with other adherents of *yōmeigaku.*

Eight years later, Setsuzan moved to Edo, where he became known as the leading exponent of Chinese-style calligraphy. Helping to spread the interest in *karayō* as a literati art, he taught a number of pupils there, including Hosoi Kōtaku (#14). In his final years, Setsuzan returned to Nagasaki, where he lived in poverty but continued to enjoy the lifestyle of an intense and somewhat eccentric literatus.

During his early years in Nagasaki, Setsuzan studied calligraphy not only with the Ōbaku monks Tu-li (Jpn., Dokuryū, 1596–1672, fig. B.1) and Chi-fei (Jpn., Sokuhi, 1616–1671) but also with the layman Yu Li-te (n.d.), from whom he learned the brushwork techniques of the major Chinese literatus Wen Cheng-ming. Wen had been proficient both in small grass script in the graceful Wang Hsi-chih style and in angular larger-scale running script after Huang T'ing-chien. Setsuzan mastered both traditions as well as all five forms of Chinese script.

Setsuzan was known for his fondness for wine; he is said to have traded his writings for *sake* at so many words per bottle. It is therefore no surprise that he wrote out the lengthy poem "Eight Immortals of the Winecup," attributed to the T'ang-dynasty poet Tu Fu, which is given in translation in the introduction to this section.

Appropriately, the calligraphy is full of life, due to Setsuzan's use of various scripts and rhythms. From right to left, the seven columns contain 20, 25, 23, 23, 22, 24, and 17 characters, alternating among standard, running, and cursive scripts. For example, the final column begins with two characters in cursive, then continues with three in running, four in standard, three in running, two in cursive, and finally three in standard. Setsuzan's brushwork in all three scripts is confident and relaxed, with a characteristic angularity in standard script, including some long thin horizontals, while his running and cursive characters are curved and fluent.

The slower rhythm of the standard characters, alternating with more rapid cursive forms, helps give the scroll its feeling of dance, but this is also created by the contrast between heavier use of ink and thinner, drier characters. Setsuzan does not redip his brush in a regular pattern but ranges from three words (beginning column two) to eleven (ending column six) before refilling the brush. As a result, some characters seem to leap forth from the page, but they are not always words that begin new lines of the poem or even

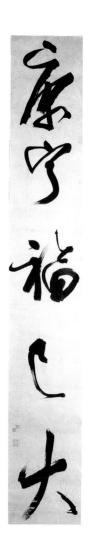

Figure 13.1.
Kitajima Setsuzan,
Peaceful Words.

those that begin a column of calligraphy. Instead, certain words and phrases stand out, such as "one hundred rivers" (百川) in the third column and "Son of Heaven" (emperor, 天子) in the fifth.

In comparison, a five-word single-column calligraphy by Setsuzan in cursive script reads, "With peaceful words, good fortune is already great" (fig. 13.1). Here we can see how the artist has expressed a bold rhythm, both by use of varied spacing (the first two words are closer together) and by making the first, third, and fifth characters slightly stronger through heavier brushwork. In the longer text of the "Eight Immortals," the task of giving life to 154 characters in seven columns was more difficult. By creating a syncopated flow both of scripts and ink accents, Setsuzan has choreographed a sense of natural, subtle, ever-changing movement into his calligraphy; we may say that he, like Chang Hsu in the poem, has "produced clouds and mist."

14 HOSOI KŌTAKU (1658–1735)

The Old Drunkard's Pavilion (1705)
Pair of six-fold screens, ink on paper, each panel 127.3 x 52.9 cm.

Hosoi Kōtaku was the calligrapher most responsible for the spread and development of *karayō* (Chinese-style) calligraphy in early modern Japan. Born in Kyoto to a physician's family, he became a calligraphy pupil of Kitajima Setsuzan (#13) and also studied Confucianism of both the Chu Hsi and Wang Yang-ming schools. Something of a polymath, Kōtaku cultivated a number of different skills, including medicine, *waka* and *kanshi* (poetry in Chinese) poetry, seal carving, mathematics, astronomy, archery, and expertise in firearms. Beginning in 1693 he served the Yanagisawa family in Edo, where he befriended the younger Ogyū Sorai (#32);[1] later, he advised the daimyō at Mito and the Tokugawa shogunate before retiring to Nagasaki.

Kōtaku's calligraphy gained great popularity, and he taught a number of pupils, including Mitsui Shinna (#19). When requests for his instruction became more than he could accommodate, he published his writing methods in woodblock books such as the *Shibi jiyo* (Purple Fern Calligraphy Method) of 1724, which included a preface by Sorai. In this set of two volumes, Kōtaku illustrates the correct method of holding the brush, the eight basic strokes that occur in the character for "eternal" (see figs. B.2 and B.3), and examples of correct and incorrect strokes, before presenting a series of models of well-constructed *kanji*. Relishing the tools of his trade, Kōtaku also wrote an essay on calligraphy brushes in an album now owned by the Tokyo National Museum.

Kōtaku created calligraphy in many formats, including this pair of six-panel screens of *The Old Drunkard's Pavilion*; the text had originally been composed in 1046 by the literatus Ou-yang Hsiu (1007–1072), who refers to himself in the text as "the Governor."

Ch'u has mountains all around it, but the forests and valleys in the southwestern range are particularly attractive. There is one that even from a distance appears to be the most lush and elegant; that is Lang-yeh Mountain. If you walk a few miles into its hills, you gradually become aware of the sound of gurgling water flowing out from between two peaks; this is Wine-Brewing Brook. The road winds past veering heights, and soon you come to a pavilion that spreads out beside the spring: this is Old Drunkard's Pavilion. Who was it that built this pavilion? A monk of the mountains, Chih-hsien. Who named it? The Governor, who named it after himself. The Governor and his friends go there often to drink. The Governor gets drunk on even a small amount of wine, and he is also the oldest in the group; that is why he calls himself the Old Drunkard. However, the Old Drunkard's real interest is not the wine but the mountains and streams. Having caught the joys of the mountains and streams in his heart, he lodges them in wine.

When the sun rises, the forest mists vanish; these alternations of light and darkness mark the mountains' dawns and dusks. As the wild flowers blossom they send forth subtle fragrance, as tall trees bloom they yield deep shade; then the winds and frost are lofty and pure, the rivers dry up and their stones are exposed; these are the four seasons in the mountains. If one spends the day walking in the mountains, one finds that the scenery changes with each season, and the pleasure it provides likewise has no end.

Men carrying heavy loads sing in the valleys, travelers rest under the trees, those in front call out, and those behind yell back. From old men with crooked backs to children led by the hand—people pass back and forth continuously; those are the natives of Ch'u moving along the paths. One may find fish in the brook, which is deep and filled with meaty fish, or one may brew wine from the brook, whose water is fragrant and whose wine is clear. To have, in addition, mountain fruits and wild herbs arrayed before one; this is the Governor's feast.

The pleasures of the feast are not those of strings and flutes. One man shoots and hits the target while another wins at a game of chess. Goblets and tallies are strewn about in the chattering hubbub of men, some sitting and others standing; these are the enjoyments of the guests. Then there is one man with a wrinkled face and white hair who sprawls on the ground; this is the drunken Governor. Later, the setting sun touches the mountains and men's shadows overlap; this signals the Governor's departure, with the guests close behind. Then the forest lies in darkness, with no sound but the chirping of birds; the revelers have left and the birds now are joyous.

But although the birds know the joys of the mountain forest, they do not know the joy of the guests. And although the guests know the joy of accompanying the Governor, they do not know the Governor's joy in their joy. While drunk he shares in their joy, and when he sobers up he records it all in writing; this is the Governor. Who is the Governor? Ou-yang Hsiu of Lu-ling.[2]

Kōtaku's calligraphy fills the pair of screens with dramatic force. The first two panels present the title—literally, "Drunk / old man / pavilion /

14 A

醉翁
亭記

14 B

record"—in four large characters. The following nine panels complete the essay text, while the final panel is an extended signature, including the date, the second month of 1705. What is most notable about Kōtaku's style is its bold confidence. The long Chinese essay is written with great freedom, and no signs of hesitation interrupt the rhythm of the flowing cursive script. There is generous spacing between the columns, but little vertically, so the characters, squeezed together in rows of thirteen to seventeen per column, seem to burst from their confinement, especially when broad horizontals occasionally punctuate the work.

The first four large characters are especially thick, rough, and fuzzing-wet, although there is occasional "flying white" where the brush moved more quickly. These massive characters are saved from seeming overly heavy or stolid by the angles that they present, primarily upward to the right, and by the final strokes of the upper words, a vertical and a hook down to the left, which help to lead the eye to the graphs below them.

In the main text of the essay, Kōtaku shows the potential of cursive script for powerful expression. The forms are full of tensile energy, like springs ready to uncoil and fly into the air. Certain pictographic words repeat through the text, but Kōtaku has written them slightly differently each time, tending toward further simplification and cursiveness. For example, "mountain" (山, originally picturing a central peak and two lower peaks) occurs in panel three, column one, character four, and again in 3/2/12, 4/2/8, 5/2/5, 5/2/9, 6/3/8, 8/2/6, 9/3/10, and 10/2/end. This graph, structurally horizontal, adds to the rhythm of the totality while continuing its sense of movement. The character for "pleasure" (楽, which also can mean "music" and was formed as a picture of an instrument with a wooden base) also recurs, especially toward the end of the essay. It can be seen, gradually deconstructing in form from 4/1/14 to 5/2/12, 7/1/12, 8/3/19, 10/3/9, 11/1/1, and finally 11/1/10.

Kōtaku mastered not only the structural paradigms of T'ang-dynasty calligraphy but also the more individualistic trends of Ming-dynasty brush-work. These screens demonstrate both his expertise and his artistic personality, but was he also influenced by the words he was writing? Like the poem "Eight Immortals of the Wine Cup," this essay praises inebriation, and we may speculate whether the topic influenced Kōtaku's choice of script and style. The continuous and vigorous flow of the cursive brushwork brings forth the lively spirit of the famous Chinese essay, while the compositional strength of the calligraphy supports the inner structure and meanings of the text in which the deeper shared joys of friendship underlie the more immediate pleasures of alcohol. Just as Ou-yang Hsiu shared his pavilion with his fellow poets, Kōtaku shares his calligraphy, both through woodblock books and here in the large-scale format of screens, with all those who can appreciate his dance of line, shape, gesture, and space.

NOTES

1. Kōtaku made the arrangements for Sorai's entry into the Yanagisawa household, as well as for his first marriage.

2. From Ronald D. Egan, *The Literary Works of Ou-yang Hsiu (1007–1072)* (Cambridge, U. K.: Cambridge University Press, 1984), pp. 215–217.

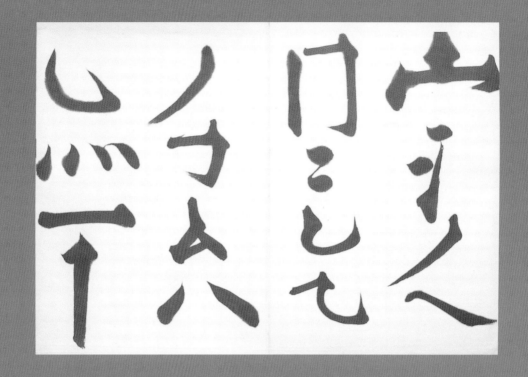

15A

宇字之人

口乙乞

ノ夕久

灬一

天地

玄黄

宇宙

洪荒

15B

15 SASAKI SHIZUMA (1619–1695)

Tehon of the "Thousand-Character Essay"

Two albums, ink on paper, each double-page 29 x 43.5 cm.

Born in Kyoto, Sasaki Shizuma was fascinated by Chinese language and characters from his youth; if he didn't understand a word, he asked someone, and his inquiries persisted over the years until his knowledge exceeded that of almost all his elders. Fiercely determined to become a calligrapher, he first studied with Fujiki Atsunao (1580–1648), a master at both Japanese and Daishi-ryū (see Shōkadō, #4) Chinese techniques. Shizuma then went on to study the calligraphy of Chinese masters of the Sung, Yuan, and Ming dynasties, eventually developing his own *karayō* tradition, which became known as the *Shizuma-ryū*.

Moving to Edo, Shizuma became increasingly famous as a calligrapher, several times fulfilling commissions from the Tokugawa government to execute large characters, such as the word "peace" (平), for public display. He served the Koga daimyo, but maintained his position in Edo as an outstanding artist and teacher. Among his outstanding pupils were his daughter Shōgen (#16) in Edo, Terai Yōsetsu (1640–1711, fig. B.4) in Kyoto, and Araki Zesui (n.d., fig. 25.1) in Ise.

Although expert in many scripts and styles, Shizuma was especially known for his regular and cursive scripts, and for his renditions of the "Thousand-Character Essay," a tour de force originally composed in the early sixth century by Chou Hsing-ssu in which each of the thousand words is different. Enjoyed by calligraphers for more than a millennium, this text was also used in teaching, as in the present example. This pair of albums is a *tehon*, or model book; typically a teacher would write a few pages for a pupil at each lesson, and then the pupil would copy those characters as practice.

Shizuma begins with a double-page of character elements that recur frequently in calligraphy (#15a). These include vertical, horizontal, and diagonal lines as well as curves, hooks, and dots, all rendered in bold, confident regular script. The double-page (#15b) that follows begins the essay, whose first two words fittingly are "heaven" and "earth" (天地). Shizuma's style features strong horizontals that reach out to, and occasionally touch, the characters on either side. His dots tend to be extended into long teardrop shapes, and we may also note how he often begins characters with "rounded tip" when the first stroke is horizontal, or with sharply angled "open tip" when starting a vertical.

As befits a teaching album, the composition of the characters is clearly defined, with nicely proportioned "negative spaces" between lines and forms. These would certainly have aided the pupil for whom this book was made, both in brushwork, with its even and sure strokes, and in structure, with its sturdy and decisive forms.

Later in the pair of albums, however, Shizuma moves away from standard script into something more whimsical (#15c). Either from boredom or a sense of fun, he changes to wriggling lines, still thick and bold, but now creating powerful but somewhat exaggerated forms. Did he expect his pupil to copy these unusual graphs? If so, he was giving a lesson in control of the

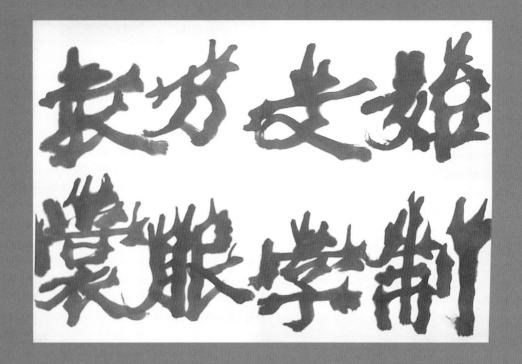

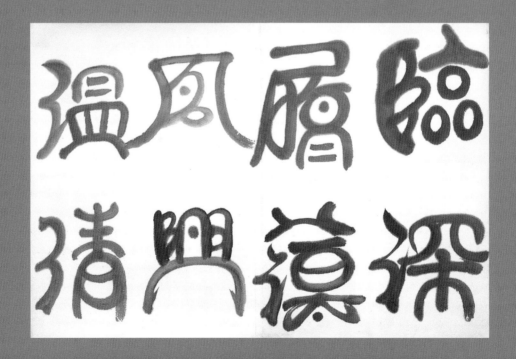

brush, since despite their odd appearance, the characters are well formed in the Daishi-ryū of elaborated brush strokes.

Still further in the albums, Shizuma temporarily moves to seal script (#15d). Here the strokes are generally rounded and formally balanced. Nevertheless, there is a relaxation to some of the brush strokes that suggests Shizuma was enjoying this foray into an ancient script rather than being merely pedagogical. In all the scripts, his own rather chubby personal style emerges, showing a continuity that goes beyond either text or script. It is apparent that even when providing a model book for one of his followers, Shizuma was too creative to stay within the bounds of most *tehon*. Instead, he moved into a free and playful world of line, form, and space—a dance with the brush designed to inspire his student toward art as well as to skill.

16 SASAKI SHŌGEN (N.D.)

Tu Fu Quatrain
Hanging scroll, ink on paper, 130.6 x 57 cm.

Since it has long been believed in East Asia that artists reveal their inner nature in brushwork, some people have thought that gender differences must also appear. Calligraphy by women has often been expected to be delicate, graceful, and modest, virtues that many Japanese males attribute to females. Furthermore, since the Heian period, learning Chinese was considered a male prerogative, and traditionally there was considered a difference between "men's hand" and "women's hand." One of the (doubtless unintended) results was to have women lead the way in vernacular literature, including the world's first novel, *The Tale of Genji*.

These expectations in calligraphy have often acted as a self-fulfilling prophecy, and many women have explored the multiple facets of Japanese *kana* scripts in smaller formats, often with great skill and creativity (see, for example, #7, #8, #9, and #12). But there are many exceptions, notably including Sasaki Shōgen, who in this large Chinese-style work confounds any possible prejudice regarding the ability of women to equal the dramatic power of male calligraphers.

Little is known about Shōgen, not even her birth and death dates. She was the daughter and pupil of Sasaki Shizuma (1619–1695), from whose *tehon* (model book, #15) she may well have learned, and she also followed the broad and confident style of Yen Chen-ch'ing (709–785). None of Shizuma's or Yen's published works seems to be as rough, bold, and dynamic as this scroll, however, so we can imagine that Shōgen's personal character was very forceful. She married a retainer of the Takakura family, but her husband died young, after which she became a nun. She thereupon taught calligraphy—her pupils included an imperial princess—and several woodblock books were published with her calligraphy, probably to be used as models by her pupils.[1]

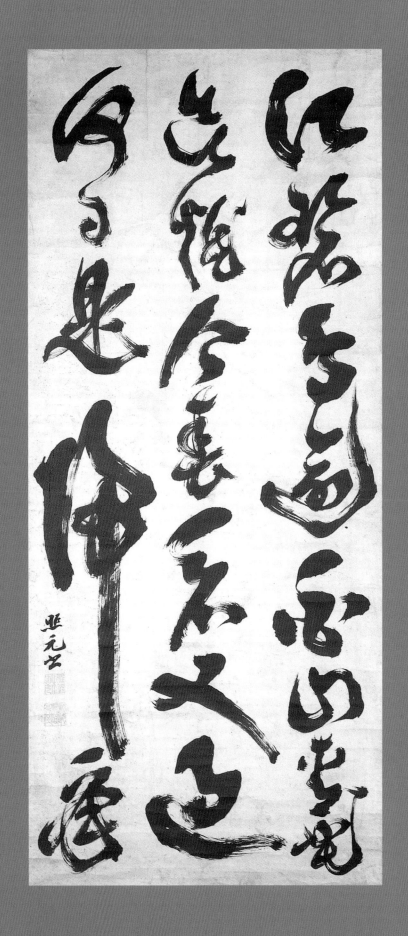

This dramatic work presents a quatrain of five-word lines by the great T'ang-dynasty poet Tu Fu (712–770). It was re-created as calligraphy by Shōgen, almost a millennium later, in columns of 8-7-5.

Over the blue river, birds exceedingly white;
On the green mountains, flowers about to blaze.
This spring we view is also passing by,
When will the time come for me to return?

Chinese literati usually served the government, and they were often posted to remote locales. The wish to return to the capital or to one's home, a frequent theme in poetry, is expressed here by Tu Fu with a melancholy sense of the transience of nature's beauty and the passing of time. The most important word is the penultimate "return" (帰), and Shōgen has written it so large as to take the place of three characters; it also leaves room for, and seems to protect, her signature and closing seals.

Regarding the debate as to how much the text influences a calligrapher, Westerners might assume that the style itself, as well as the emphasis upon certain characters, would follow the meaning of the words being written. In many cases this correspondence cannot be easily detected, as though the text and the calligraphy are separate forms of art that do not directly reflect each other. Here, however, the large scale of "return" makes it clear that Shōgen was emphasizing the emotional heart of the poem, and the long vertical stroke that ends the character might be seen as a pathway, a drawn-out sigh, or both.

Although writing characters in differing sizes is one of the features of much cursive script, Shōgen confounds other expectations. For example, this script is usually written in more fluid strokes in thinner lines, and the movement tends to flow down the paper smoothly and rapidly. One may see some trace of this flow in the first two *kanji* of the left column, "what day" (何日), which are written with a single stroke and gesture. In general, however, Shōgen's calligraphy seems to stop and start rhythmically with very forceful and often blunt strokes of the brush.

One may also see traces of the Daishi-ryū style in the elaboration of some strokes, such as the fourth character of the first line, "exceed" (通), which ends with the brush twisting upward. That Shōgen's teacher Shizuma had been a pupil of Fujiki Atsunao (1580–1648), the founder of the Daishi-ryū, attests to the fact that Shōgen had roots in the past; but these did not prevent her, against cultural expectations, from forming her own dramatic style of cursive script.

NOTE

1. For an example of Shōgen's writing in four Chinese scripts and in Japanese *kana*, see Patricia Fister, *Japanese Women Artists, 1600–1900* (Lawrence, Kans.: Spencer Museum of Art, 1988), pp. 44–45.

Flowery Purity Palace

Hand scroll, ink on paper, 29.2 x 241.4 cm.

Born in Nagaskai, Dōei as a youth became an expert in Chinese language, prose, and poetry. In his late twenties, he accompanied the Nagasaki shogunal administrator on a mission to Edo; but when the high reputation that he earned in the new capital brought him jealousy and possibly danger, he returned to his home city. Dōei was granted land by the Lord of Ōmura and built a second residence there; but Nagasaki remained his home, and he served as a Chinese interpreter from 1663 until his death forty-five years later.

Along with Kō Ten'i (#18), Dōei was celebrated as one of the "two wonders" of Nagasaki for his superb calligraphy; he mastered all five Chinese scripts but was especially known for his powerful cursive writing. It is not known with whom Dōei studied; he probably learned directly or indirectly from Kitajima Setsuzan (#13), and he also seems to have been influenced by the brushwork styles of immigrant Chinese monks such as Tu-li (fig. B.1) and Chi-fei (1616–1671). In general, Dōei followed the Ming-dynasty styles of masters such as Wen Cheng-ming and Tung Ch'i-ch'ang, but his individualistic calligraphy reflects his intense and determined personality.

Here Dōei has written out a three-word title (#17a) and seven-character-per-line quatrain (#17b) in "wild cursive" script. The poem is the very first in one of the most popular books of Chinese verse in Japan, *Poetry Techniques of the T'ang Masters in Three Modes*, edited by Chou Pi of the late Sung dynasty; it is attributed to the otherwise unknown Tu Ch'ang, and is in the style of three similar verses by Tu Mu.[1] Somewhat arcane, this quatrain refers to the T'ang-dynasty "Pavilion That Pays Court to the Origin" within the grounds of the "Flowery Purity Palace." Emperor Hsuan-tsung and his beloved concubine Yang Kuei-fei often visited this palace and hot springs; the emperor would have lichees, her favorite fruit, imported by teams of horsemen from Chiang-nan ("South-of-the-Yangtze"). But while they were amusing themselves, a Turkic general was approaching with an army from the northeast in what was to become known as the An Lu-shan rebellion of 755.

Flowery Purity Palace

They've traveled each of the tens of stages from South-of-the Yangtze,
In morning breeze and lingering moonlight, they enter Flowery Purity!
But to the Pavilion That Pays Court to the Origin, a western wind
 blows sharp,
Filling towering willows with the sound of falling rain.

Each of the three large title characters, requiring ten, eleven, and ten strokes, respectively, in regular script, is written in a single stroke. However, they are not brushed in totally smooth and fluid gestures; instead, Dōei creates unusual visual structures and rhythms in each form. Compositionally, the first character, "flowery" (華), is spacious at the top and more entangled at the bottom; the second word, "purity" (清), is given an unusually generous open space at its left; and the third *kanji*, "palace" (宮), is comparatively

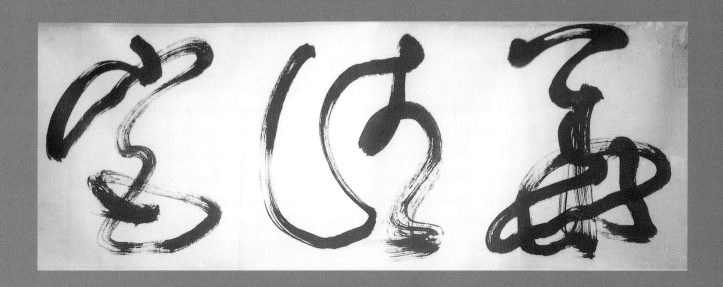

17A

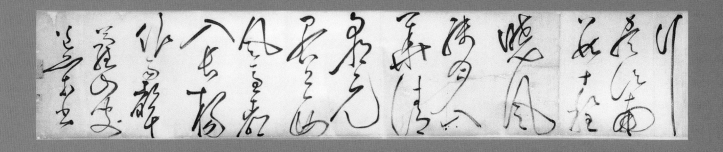

17B

empty in the middle. Imparting a further sense of asymmetrical movement, the first and third characters seem to tilt at a diagonal down to the left, while the center graph is more stable.

In the personal rhythm of his calligraphy, Dōei did not move his brush at an even rate but preferred complex patterns of quicker and slower speeds. This is made evident by the "flying white" that appears at various points in each graph, sometimes even within a single directional movement, such as the final curve at the bottom of the third character. The result is a group of three *kanji* composed in seemingly free, but actually extremely sophisticated and intricate, forms. Following the brush from the top of the first character shows how an architectural shape can be constructed from a multifaceted single line.

After the large three-word title, Dōei's calligraphy then continues on a somewhat smaller scale with the twenty-eight words of the poem, rendered in columns of 1-3-3-2-3-2-2-3-3-3-3 characters. The first two seven-character lines of the quatrain are contained within column units of 1-3-3 and 2-3-2, but the final two poetic lines are broken so that the opening word of the fourth line occurs as the third graph of the ninth column. Each line of the poem, in fact, is treated differently in spatial arrangement.

Another variation in the calligraphy is the degree of cursiveness in each character. For example, the fourth column contains the two words "morning breeze / wind" (曉風), which in regular script require fifteen and nine strokes but are here rendered in a single brush stroke. In contrast, the word "enter" (入), which occurs twice in the hand scroll as 5/3 and 10/1, is written in its full complement of two strokes each time.

By constantly varying the composition and the rhythm of the characters, Dōei has added great vitality to his imagistic but highly referential poem. Through his mastery of cursive script he has created a dance that comes scudding, galloping, and flying across time and space into the palace of our own visual world.

NOTE
1. Translation and literary information by Jonathan Chaves.

18 KŌ TEN'I (WATANABE GENTAI, 1649–1722)

Window Snow
Hanging scroll, ink on paper, 29.1 x 48.5 cm.

Kō Ten'i's father was Chinese, an administrator from Fukien who returned to his native country after fathering a child in Japan. As a young man, Ten'i spent ten years searching fruitlessly in China for his father and then returned to Nagasaki to become an interpreter. There he studied poetry, calligraphy, and also medicine with Tu-li (fig. B.1). In his late twenties, Ten'i journeyed to Kyoto to present Emperor Gomizuno-o with a

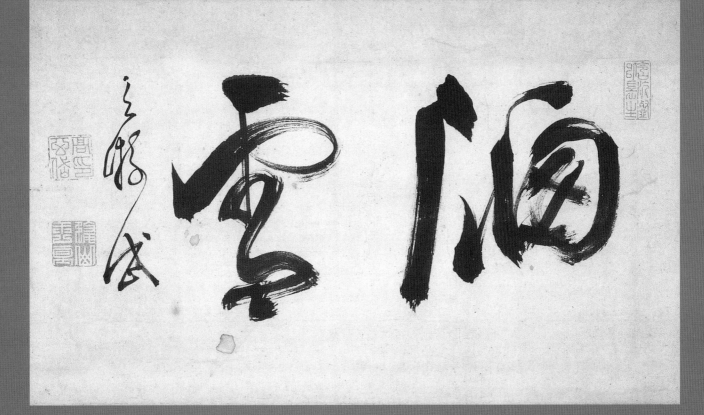

18

manuscript on health care. He then served the daimyo of Satsuma as a health expert but retired in his thirties and moved back to Nagasaki, where he became known for his calligraphy and was called one of the "two wonders of Nagasaki," along with Hayashi Dōei (#17). In 1709, Ten'i was summoned to Edo to serve the shogunate; he retired in 1721 and died the following year.

Although the calligraphy of Ten'i shows the influence of Tu-li, it also exhibits a rough vitality all his own. He was especially known for his cursive script, which exhibits some of the broad curving forms of Ōbaku style while adding a greater sense of visual tension. Here the calligraphy *Window Snow* demonstrates Ten'i's personal touch with the brush, all the more apparent because (apart from the signature) there are only two large characters to examine. Appropriately, the scroll format itself represents a window of white paper framed by the silk mounting, through which we can see the snow.

The two large *kanji* offer strong contrasts. Kō Ten'i's variant of the graph for "window" (窓) on the right is constructed primarily of straight and rectangular lines and shapes, suggesting a man-made structure built by a carpenter, while "snow" (雪) on the left curves and flows like the forms of nature. "Window" is so broadly constructed and powerfully brushed that the vertically oriented "snow" might seem too small in comparison were it not buttressed by the signature "Ten'i" to its left.

The character for "snow" requires eleven strokes in standard script but is here rendered in four: first a short dash, next a sweepingly curving horizontal, then a thin vertical that leads directly to a squished "3" shape, and finally a triangular dot at the bottom. The sweeping horizontal displays a great deal of "flying white," certainly appropriate for the word "snow," and suggesting flakes blown by the wind.

Part of the bristling energy in this scroll comes from the use of "open tip," where the action of the brush is visible striking the paper and then pulling off at the end of the stroke. Even more dramatic is Ten'i's willingness to create forms that are not simply fluent and graceful but that in their seeming awkwardness add forceful impetus to his brushwork. Born to a Chinese father and Japanese mother, Ten'i displays in his calligraphy both his thorough training in Chinese traditions and his Japanese sense of personal visual drama.

19 MITSUI SHINNA (1700–1782)

Eight Immortals of the Wine Cup (1770)

Hand scroll, ink on paper, 42.2 x 673.7 cm.

Born in Nagano, Mitsui Shinna became a leader in Edo of the *karayō* style developed by his teacher Hosoi Kōtaku (#14). Settling in Fukagawa, he was known as "Fukagawa Shinna," and his calligraphy soon became extremely popular.[1] Because he was frequently asked by temples and shrines to create calligraphy for their plaques and festival banners, his writing was visible all over Edo. An illustration from a woodblock book

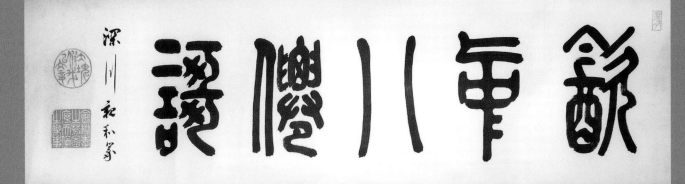

19A

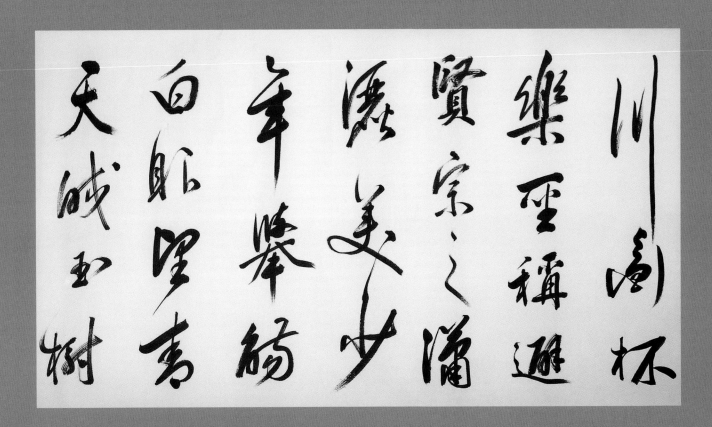

19B

of the time shows his seal-script featured on a banner reading "Kanda Daimyōjin" (Great Deity of Kanda) for a Shinto parade (fig. 19.1).

Similarly, Shinna's seal script characters were adapted for use in fabric design, and "Shinna-dyed" cloth was also often seen throughout the city. He taught a number of pupils, including Kameda Bōsai (#37), and his career demonstrates the increased popularity of calligraphy in Chinese during the eighteenth century.

Many literati had more than one skill, often excelling in painting, poetry, and/or seal carving. An expert in long-distance archery, Shinna once shot one thousand arrows down the 394-foot length of Fukagawa's "Thirty-three Bay Hall," hitting the target an astonishing 480 times.

Shinna's powerful seal script can be seen in the title to his hand scroll version of the Tu Fu poem "Eight Immortals of the Wine Cup" (#19a). These five tall and slender characters are balanced by the central two-stroke word "eight" (八), which is here almost perfectly symmetrical, like reverse paren-

Figure 19.1.
Mitsui Shinna, *Banner for Shinto Parade.*

theses dividing the first two graphs from the fourth and fifth. It is easy to see why seal script by Shinna became so popular; the forms show a combination of strength and elegance that is quite different from the delicate seal script of Itsuzan (#20) and the more fanciful style of Chō Tōsai (#21).

The hand scroll continues with the poem in running-cursive script that reveals Shinna's bold and confident brushwork (#19b). Characters are written in different sizes, the largest being the word "river" (JII, 1/1 of the illustrated section). There are generally three or four graphs per column, and their relative weights change as the brush moves more lightly or heavily, creating thinner or thicker lines. A few of the characters are joined together, but most are separate. Some are rendered fully in cursive with a single stroke, such as the word "few" (少, 4/3), while others are written in running script, such as "pleasure" (楽, 2/1), which here has nine strokes of the original fifteen.

The basic mood of the scroll is strong, almost massive, in its decisive ink tones, yet always moving energetically from one form to the next. Shinna's brush rhythms and gestures display his freedom and confidence; the forms are never either constrained or rushed. Two generations after Kitajima Setsuzan wrote out the same Tu Fu text (#13), the *karayō* tradition was now fully assimilated in Japan, adaptable to the expression of each calligrapher's style and spirit.

NOTE

1. For further information, see Komatsu Masao, *Edo ni sempū, Mitsui Shinna no sho* (Edo Whirl-wind: The Calligraphy of Mitsui Shinna) (Nagano: Shinano Mainichi Shinbunsha, 2004).

20 MORIMOTO ITSUZAN (1702–1778)
Single Line of Seal Script (1771)
Hanging scroll, ink on paper, 111.8 x 14.5 cm.

Born in Osaka, Itsuzan wished to become a monk when he was fourteen, but his parents did not give him permission. Instead, he received a literati education and became especially interested in calligraphy, which he studied in the Sasaki Shizuma (#15) tradition. Itsuzan was particularly interested in the archaic styles preserved in a Chinese dictionary compiled in the year 100 C.E., and he specialized in seal script and seal carving. His skills were recognized early; in 1718, at the request of the head of the government-sponsored Hayashi Confucian Academy, he presented the shogunate his book *Koten rongo* (Studies of Ancient Seals) as well as a volume of his own seal impressions.

At the age of twenty-five, Itsuzan studied Buddhism with the monk Setsuhō and followed him to Edo. Twelve years later he officially took the tonsure and was given the name Itsuzan. At the age of forty he became interested in painting and visited Nagasaki in 1746 to study the colorful

bird-and-flower style of Sh'en Nan-p'in (Shen Ch'uan, 1725–1780).[1] Itsuzan thereupon settled in Kyoto at the temple Seigan-ji, where he responded to myriad requests for his painting, calligraphy, and seal carving.

Itsuzan seems to have moved to Ise at one point, but he died in Kyoto and is buried at Hōrin-ji. In addition to *Koten rongo*, he wrote *Senjibon idōkai* (New Variations on the Thousand-Character Classic) and a number of seal books. Among his art names are Mokuin ("silent and retired"), Jōsoku Dōjin ("always sufficient man of the way"), Ro-ō ("rare old man"), Genchū ("amid the wondrous"), and Kochō-an ("hermitage of ancient melodies").

This single column of eight characters has a Confucian moral:

> Implement benevolent and righteous actions;
> Expand them afar, so the standard is corrected.

> —seventy-year-old Ro-ō Jōsoku Dōjin

The second phrase refers to Mencius, Book 7B: "The gentleman strives only to reinstate the standard. When the standard is corrected, the common folk are stimulated [to virtue]."[2]

Itsuzan's seal script is extremely refined and elegant. Its beauty comes from the character shapes, almost twice as tall as they are wide, and the even, slender lines, created with "hidden tip" so that the beginnings and ends of strokes are gently rounded. Still more important to the total effect may be the generous and consistent negative spaces within the graphs, typically almost double the width of the lines surrounding them.

The calligraphy opens with a symmetrical graph literally meaning "to go" (行) and continues with formally balanced seal script that has just a hint of extra movement, as in the slightly bending vertical and leaning lower horizontals of the fourth word, "thing" (事). Itsuzan also allows a subtle flavor of "flying white" at times, letting the brush lines breathe, but the overwhelming impression is of controlled and graceful sophistication.

During Japan's early modern period, seal script was mastered by a number of different calligraphers, each with a different touch. The broad dynamism of Nakae Tōjū (#28), the architectonic power of Mitsui Shinna (#19), and the more gestural brushwork of Chō Tōsai (#21) all express different cultural and artistic sensibilities. Of them all, however, the seal script of Itsuzan has the greatest sense of unworldly refinement, attesting to his personal combination of antiquarian literati interests and Buddhist vocation.

NOTES

1. See Stephen Addiss, ed., *Japanese Quest for a New Vision* (Lawrence, Kans.: Spencer Museum of Art, 1986), pp. 45–50, for a discussion of Sh'en Nan-p'in's influence in Japan.

2. Translation and literary information by Jonathan Chaves.

花在義事興諸經已

Seal-Script Triptych

Set of three hanging scrolls, ink on paper, each 115.2 x 47.7 cm.

Seal script is the most formal of calligraphic dances, and here Chō Tōsai has created gestural expressions of the brush with the poise and balance of an eighteenth-century minuet. Tōsai was born in Nagasaki, and his interest in Chinese culture was prompted by the fact that he was the son of a Chinese merchant father, Chao (Jpn.,: Chō), and a Japanese mother. Japan was now closed to all foreigners except for Chinese merchants and a few Dutch traders in Nagasaki, the only international city in Japan. It was here that Chinese Zen monks came at the fall of the Ming dynasty, founding the Ōbaku sect, which soon spread through much of Japan.

As a boy, Tōsai was adopted as a Buddhist novice by the immigrant monk Chu-an (Jpn.,: Jikuan, 1699–1756) at Kōfuku-ji in Nagasaki; and when his teacher was made the thirteenth patriarch and abbot of Mampuku-ji in 1727, Tōsai accompanied him there. The Ōbaku monks were considered to be bastions of Chinese culture at this time, bringing with them Ming-dynasty styles and values, and the young Tōsai undoubtedly gained much from his close connections with the immigrant monks. After Chu-an retired in 1739, Tōsai returned to secular life as a literatus. He traveled throughout Japan, eventually settling in Edo for more than a decade, then living in Osaka and Sakai, and finally traveling again. The interest of the Japanese in Chinese medicine allowed Tōsai to make a living selling stomach nostrums while continuing to pursue his literary interests. Known for his landscape painting and seal carving, he was also celebrated for his love of wine, a trait that he shared with many poets before him. His calligraphy was especially admired, and his influence spread to many pupils and followers throughout Japan.

These three seal-script scrolls contain five-character phrases emphasizing the interconnections between man and nature; and while the English language can't be quite as succinct as Chinese, the characters literally read, from the top right:

RIVER WINDS SEEK MY CHANTING
The MOUNTAIN MOON INVITES ME to a FEAST
HEAVEN and EARTH BECOME my QUILT and PILLOW

In this seal script, the beauty comes from the even width of the lines, which allows for balanced spacing, and especially the small and subtle variations in the negative spaces within the characters. For example, on the left side of the fifth character in the central scroll, every element is in complete equilibrium with all the others. Throughout this set of three scrolls, the characters are somewhat extended vertically, but the lines and spaces are nonetheless fleshed out to the sides as well as from top to bottom.

This particular manner of writing seal script, with tall and elegant character formation, harkens back to the mid-eighth-century Chinese master Li Yang-ping, whose style lasted a thousand years and still offered the creative potential that is realized here by Tōsai. His own contribution to this tradition comes in part from the use of "flying white" where the paper shows

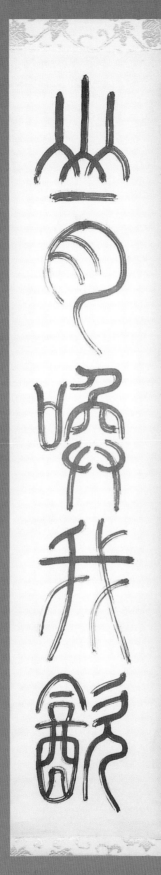

through the dry-brush lines, giving a sense of motion and life to the formal script. This characteristic is especially apparent in the second character of the right scroll, "wind" (風), where the split hairs of the brush flow elegantly around the continuous curves. Next, Tōsai makes sure that these calligraphic curves are balanced by enough straight lines so the result does not become too pretty. In addition, he changes forms when they repeat; for example, the fourth characters in the right and center scrolls are the same word ("my" or "me"), but he composes them differently within the seal-script tradition. Even when a portion of a character repeats, such as the "mouth" radical on the left of the fifth character of the right scroll and the third of the center scroll, he changes the shape by making the upper vertical lines open outward rather than being parallel.

Finally, Tōsai clearly enjoys the pictorial elements in some of the characters, for instance the first two words of the center scroll, "mountain" (山) and "moon" (月). For "mountain," he elongates the verticals rising as three peaks that seem to fly up from the modest horizontal base line below them; usually these lines all touch each other. Various seal-script versions of the word "mountain" from China are given in figure 21.1, including the seventh variation, which is relatively close in structure to the one in this triptych.

In his rendition of "moon," Tōsai manages to suggest both a full and a crescent orb with his continuously curving brush lines. We may not be amiss in sensing, beneath this serious excursion into an ancient script, a touch of fun. For example, on the left side of the very first character, the lines of the "water" radical (itself a flowing river) do not quite continue on the left side; the little hook doesn't lead to the line below it but curves out individualistically to the left. Further, as if swayed by all the motion to its left, the vertical line on the right is not straight but bends away, then back again. The execution of these lines is certainly playful on Tōsai's part, as are several other features of individual characters in the triptych. Surely Paul Klee would have enjoyed the third character in the left scroll, where a sense of stillness in the center is surrounded by a feeling of movement. Although some viewers might expect seal script to be too decorous and solemn for their taste, these scrolls have an inner sense of life that repays repeated viewings.

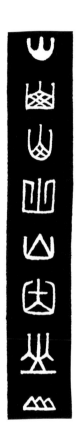

Figure 21.1. Varieties of the character for "Mountain."

22 RYŪ KŌBI (RYŪ SŌRO, 1714–1792)

Dragons Growl

Hanging scroll, ink on paper, 137.3 x 55.5 cm.

Ryū Kōbi was one of the leading scholar-poet-calligraphers in central Japan during the second half of the eighteenth century. Born in Kyoto, he diligently pursued Confucian studies despite family poverty caused by the death of his father when he was still a youth. Although Kōbi thoroughly investigated the "Classics Revival" school of

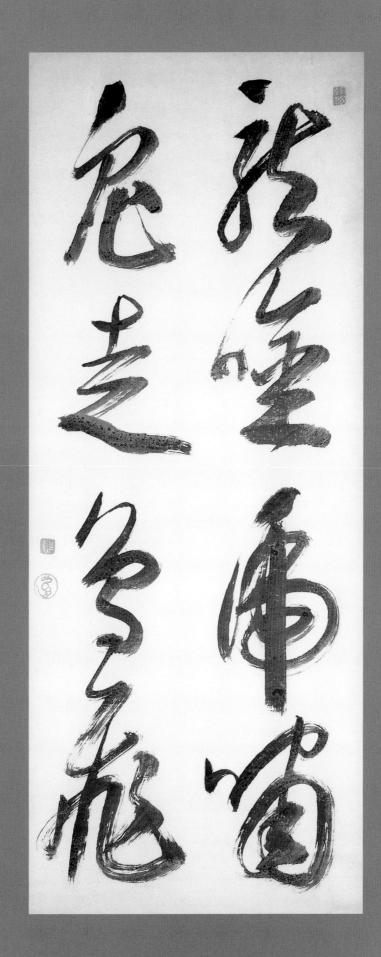

22

Ogyū Sorai (#32), he also studied the more standard Chu Hsi form of neo-Confucianism with Uno Meika (#34). When his training was complete, Kōbi served the daimyo of Hikone as a scholar. He then spent the rest of his life in Kyoto, where he lived near the Kamo River and associated with many literati, including painters whose works he occasionally inscribed. Kōbi also showed a pictorial sense of humor by stamping a seal with the image of a dragon (*ryū*) on many of his works, including this one.

Kōbi was a master of several scripts, imbuing each with a special flavor of his own, as this work reveals.

> Dragons Growl
> Tigers Roar
> Fish Dash
> Birds Soar

The eight characters, written here in bold cursive script, are full of the animistic energy of the creatures described, as a study of each character reveals. "Dragons" (龍) is appropriately sinuous, the brush constantly changing force and direction as it moves. However, the calligraphy is not merely serpentine; there is plenty of structural "bone" in this character as the brush pauses, moves abruptly, and adds weight to the lines, particularly near the end of the word. Next, "growl" (唸) begins with a small, square "mouth" radical (口) on the left, here written as two connected dots, and then ends with the same kind of forceful zigzags that ended the previous word, connecting the two visually.

The next pair of characters is both similar and somewhat contrasting. The word "tigers" (虎) curls around and in upon itself, bolstered by the final strong vertical line that firmly centers the form. The "roar" (嘯) below it at first seems much more compositionally dispersed. The "mouth" radical now leads forcefully to the right side of the word, which again has a vertical stroke, here somewhat less emphasized, and a form that ends by curling inward in an evocative variation upon the previous brushwork.

The second column begins with the word for "fish" (魚), which is actually written cursively but looks more like regular script since the lines are distinctly set off from each other. This composition creates a clearly defined shape that features nicely balanced negative spaces. "Dash" (走), in contrast, is built up of four primarily horizontal lines that get thicker and stronger as the character progresses toward the bottom. Here the zigzag lines, unlike those to the right in "growl," strongly emphasize the horizontals as the brush more lightly moves back toward these left-to-right gestures.

As befits its subject, the character for "birds" (鳥) is written more gently and in slightly smaller size than any other word in the scroll; the brush never leaves the paper as the form is completed in a series of curved movements. Unlike "tigers" to its right, this character never settles or centers, but glides and swoops over the paper surface. "Soars" (飛) is quite different; its form is architectonic, and Kōbi uses dry-brush "flying white" boldly here, suggesting birds flying through the air.

This scroll tells us something new about the script it uses. Cursive writing can often be delicate and light, but here it is thick, strong, heavy, and

blunt. The first two and final two characters lead into one another but do so without the sense of airy fluidity of most calligraphy in this script. Each of the three major dots in the scroll is dramatic, and each is different from the others. The first, which begins "dragons," seems to fly across the paper; the second, at the top of "tigers," sits poised on top of the strong vertical; the third, beginning "fish," cuts decisively down to the beginning of the next stroke. Even more significant, the ink within the brush strokes is uneven, spotted with tiny circles and pustules of darker black.[1] Whether this effect was caused by ink that was not freshly ground or by uneven sizing of the paper (or both) is not known, but the effect is nervous and vibrant rather than continuous and fluent. In this calligraphy, Kōbi has totally eschewed the more usual graceful, charming, and rapid freedom of spirit that can be seen in other cursive-script works (such as #6, #23, and #56). Instead, he has created a scroll that growls, roars, dashes, and soars directly and powerfully into the viewer's consciousness.

NOTE

1. Other examples of this kind of spotted ink include a scroll of bamboo by Tang Yin from the John Crawford Collection, now at the Metropolitan Museum of Art in New York City, and the famous *Mu* single-character calligraphy by Hakuin Ekaku, held in a private collection in Japan.

23 SAWADA TŌKŌ (1732–1796)

On the Riverbank (1781)

Hand scroll, ink on paper, 36.8 x 268 cm.
Herbert F. Johnson Museum, Cornell University, N.Y.

Born in Edo to a family of many generations of merchants, Tōkō showed great talent for scholarship in his youth and was sent to the academy of Hayashi Hōkō for Confucian studies. He also took lessons in calligraphy from Kō Shinsai, whose style he followed initially in his work. However, Tōkō's great interest in Chinese calligraphy led his stylistic interests backward through time: he studied the works of the Ming-dynasty literatus Wen Cheng-ming, then the more orthodox models of the T'ang masters, and finally the surviving traces of the "two Wangs," Wang Hsi-chih (307–365) and his son Wang Hsien-chih (344–386).

Over time, Tōkō was able to develop a fluent and well-balanced style of calligraphy that influenced many Japanese literati of his own and later eras. Tōkō was also known for his literary excellence, and among the books he published were not only several treatises on calligraphy but also a volume of his own Chinese-style poems. Here he has written a twenty-line verse of five words per line in a hand scroll format; the tone is elegiac, with several specific allusions to major Chinese poets of the past.

I've built my hut by the river,[1]
The voice of the stream floats by day and night.
Hunched over, I grieve over those who have passed away,
Why are the days and months so boundless?
Wearing a simple robe, I wander where I like,
Drinking heavily, I can forget my sorrows briefly.
Quietly chanting, I aspire beyond the sky,
Singing long, I yearn for a good friend.
As I go out at dawn, the shallows are lit by the sun,
Strolling in the evening, I become accustomed to the gulls.[2]
Katsura trees are increasingly gloomy over the paths,
Orchids and indigo plants send fragrance over the sandbars.
Looking up, I yearn for the ancient sages,
Flapping my clothes, I imagine floating through the air—
But I have wasted my life, and the land of the immortals
Is far too distant for me to search.
Fluttering, a multitude of birds fly past,
Broadly, shoals of fishes swim by.
In my rambling there is the feeling of truth,[3]
And I return to meditate on the riverbank.

The twenty lines of the poem are written in twenty-five columns of three to five characters each, followed by the signature and date.[4] Tōkō's study of the two Wangs is apparent in the fluency of his brushwork; but instead of purely graceful writing, there is also some tension and release, testifying to his mastery of later Chinese styles.

The calligraphy is composed almost entirely in cursive script, but there are occasional characters in running script, such as "sun/day" (日, 3/1); in contrast, a fully cursive rendition of this character begins column five. Tōkō achieves a personal sense of rhythm not only by the number of characters he writes in each column, which contrasts with the five-word poetic lines, but also by the varying size of the different graphs. One of the largest, the word "voice" (声), fills the entire lower half of the second column.

Even more significant for the total rhythm is Tōkō's use of continuous, as opposed to interrupted, brush strokes. For example, the first three characters in the first column are written in four strokes, but these strokes do not always begin and end exactly with the characters. The first stroke forms the left side of the first word and then moves to the right; the second stroke finishes this form and continues to the dot that begins the second word; the third stroke begins with a strong horizontal and ends midway through this character; and the fourth finishes this graph but does not end until the following word is complete.

This sense of variety continues throughout the scroll. For example, the pictograph "moon" (月), the second word in the fifth column, is written in three (almost four) strokes, while the following word, "why?" (何), is composed of a single stroke that continues on to complete the next word. In this way Tōkō gives his long hand scroll a continuously flowing and changing sense of rhythm, much like the river that he describes in his poem. In

張藐圭法
上云新
日雅深佰
更速去载
乃为乃修

23

a larger sense, this scroll reflects the continuous yet ever-changing flow of Chinese poetry and calligraphy that became such an important part of early modern Japanese culture.

NOTES

1. A reference to the first line of T'ao Yuan-ming's fifth "Poem after Drinking": "I've built my hut where people live."

2. A reference to Tu Fu: "Gulls alone are my daily visitors."

3. Another reference to T'ao Yuan-ming's fifth "Poem after Drinking": "In these things there is a fundamental truth."

4. The date given—"ninth year of An'ei, twelfth month, nineteenth day"—corresponds to early 1781.

24 ICHIKAWA BEIAN (1779–1858)

Ink Bamboo Song
Hand scroll, ink on paper, 37 x 553 cm.

One of the leading Sinophile calligraphers of the mid-nineteenth century, Beian received thorough training in Chinese studies in his youth. His father, Ichikawa Kansai (1749–1820), was a scholar-poet-calligrapher who had studied (and later became a teacher) at the shogunate-sponsored Confucian academy Shōheikō, which had been established by Hayashi Razan (#27). Kansai invited distinguished scholars such as Shibano Ritsuzan (#35) to tutor Beian, and the young man also studied calligraphy extensively from the age of eleven. By the time he was twenty, Beian had published his first book of brushwork techniques, and the following year he established his own school of calligraphy.

Beian especially admired the writing of Mi Fu (1051–1107) and took the word *mi* (米, rice, pronounced *bei* in Japanese) for his own art name. At the age of twenty-two, he published a book of Mi Fu's brush techniques and later produced extensive volumes on Chinese-style calligraphy as well as a ten-volume catalogue of his own collection of Chinese artistic and literary artifacts. At forty-two, Beian was granted a generous stipend to teach calligraphy to those who served the daimyo of Kaga province. He also maintained a residence in Edo, where he was admired as the leading "uptown" Chinese-style calligrapher of his day; Kameda Bōsai (#37) was the "downtown" master, referring to samurai versus merchant areas of the city.

The "Ink Bamboo Song" is a long ode celebrating this "gentleman," which is not a showy plant but remains green through the hard times of winter and bends but does not break in the wind; these are considered attributes of the scholar-sage. The poem, composed by Ch'in Shao-yu (Ch'in Kuan, 1049–1100), a friend and disciple of Su T'ung-po (Su Shih, 1036–1101), begins by mentioning the "Ink Lord," which in this context may refer to Su's friend, the master painter of bamboo Wen T'ung (1018–1079).

秦少游
墨竹歌

墨□□□□
南浮垂雲
舞
風

In China, titles of hand scrolls were often rendered in seal or clerical characters; here Beian has given his six-word title "Chin Shao-yu Ink Bamboo Song" in clerical script, followed by the poem in cursive writing. Although the work is generally rendered in wet-brush, slightly fuzzing ink upon the absorbent paper, the differences between the scripts are clearly established. The six title characters are square, evenly spaced, balanced, and (where possible) symmetrical, and they maintain their positions within the two columns; each brush stroke is separate, and the total impression is one of discipline and control. In contrast, the cursive-script characters in the subsequent forty-two columns of two to four characters vary in size and show "flying white" where the brush moved rapidly. In typical cursive style, the strokes are usually joined together within the words, although in this case one character does not usually continue directly into the next.

We can compare the same character in the two scripts. The second column of the title begins with the word "ink" (墨). Beian has created it with fourteen strokes of the brush in a squared-off symmetrical shape; and although the following character, "bamboo" (竹), is simpler in composition, the two graphs are given equal weight and space. The first word of the poem is also "ink," but now it is rendered in two strokes in a vertical form that leads directly down toward the simpler graph of "heaven/lord" (天), which is much lighter and smaller.

Each script is given its due, and each serves a purpose. Clerical script not only provides the formality and deliberate spacing for the title but also imparts a flavor of antiquity, appropriate for a poem composed approximately 750 years before Beian's calligraphy. His cursive script, on the other hand, brings a faster pace to the ode. The dance has become much faster, and instead of formal balance we now have spontaneous energy. As this hand scroll demonstrates, Beian was able to impart new life to a Chinese tradition that had now become thoroughly assimilated into the Japanese literati world.

25 MAKI RYŌKŌ (1787–1833)

Tea Song
Hanging scroll, ink on silk, 37.5 x 51.3 cm.

A pupil of Kameda Bōsai (#37), Ryōkō took his names from his hometown, Maki, and the water chestnuts (*ryō*) that grew in a nearby lake (*kō*). An assiduous student of calligraphy, he made an extensive study of all five Chinese scripts; and upon his teacher's death in 1826, he took Bōsai's place as the leading "downtown" Edo calligrapher while Ichikawa Beian (#24) remained the favorite of the "uptown" samurai.

In order to learn the sources of calligraphic traditions, Ryōkō particularly studied rubbings of early Chinese masterpieces, which were being printed in woodblock book form in Japan. Later, however, he wrote that he could not match these reproductions with actual brushwork until he was allowed to see the tenth-century grass-script "Canon of Filial Piety" by Ho Chih-ch'ang

日高丈五睡正濃軍將扣門驚周公口傳諫
議送書信白絹斜封三道印開緘宛見諫議
面首閱月團三百片聞道新年入山裏蟄蟲
驚動春風起先子淇睿陽羡茶百草不敢先
開華仁風暗結珠蓓蕾先春抽出黃金芽摘
鮮焙芳旋封裹至好至精且不奢至尊之餘
合王公何事便到山人家柴門反關無俗客
紗帽籠頭自煎喫碧雲引風吹不斷白華浮
光凝盌面一盌喉吻潤二盌破孤悶三盌搜
枯腸惟有文字五千卷四盌發輕汗平生不
平事盡向毛孔散五盌肌骨清六盌通儒靈
七盌喫不得也唯覺兩腋習習清風生蓬萊
山在何處玉川子乘此清風欲歸去山上群
僊司下土地位清高隔風雨安得知百萬億
蒼生命隳顛崖受辛苦便從諫議問蒼生到
頭合得蘇息否

茶歌　菱湖巷大任書

in the Konoe family collection, after which he claimed to thoroughly understand both the structure and the brushwork of the Chin-T'ang dynasty masters. While Ryōkō did not turn against the styles of later masters such as Chau Meng-fu and Tung Ch'i-ch'ang, he preferred the more classical work of earlier artists.

The combination of scholarship and creativity that Ryōkō exhibited in his work greatly influenced later generations. He published a number of woodblock books of his calligraphy; these became standard texts for calligraphy students in the second half of the nineteenth century.[1] In his later years Ryōkō developed a form of palsy that gave a "sawtooth" pattern to his writing, which nonetheless remained highly admired.

Here Ryōkō has written out a famous text on tea composed a thousand years earlier by the poet Lu T'ung (died 835), who in his writing called himself the "Duke of Chou" and "Master of the Jade Stream." Ryōkō's use of clerical script gives this work a sense of tradition and antiquity; an analogous example would be the Gothic script used for a sign such as "𝔜𝔢 𝔒𝔩𝔡𝔢 𝔗𝔢𝔞 𝔖𝔥𝔬𝔭𝔭𝔢." We should note that during the T'ang dynasty tea was pressed into small bricks (see line six of the poem) to be boiled. Whisked tea in powdered form came later and became the basis of *cha-no-yu*, the Japanese Tea Ceremony; steeped tea arrived in Japan last, and this style, called *sencha*, was taken up by the literati. Lu's poem, describing the drinking of tea as both a pleasure and a form of medicine, ends with a Buddhist question.[2]

Thanking Imperial Advisor Meng for the Fresh Tea He Has Sent Me

The sun seemed fifteen feet above me, and I had fallen asleep
When an army officer knocked at the door, waking this Duke of Chou.
He tells me the Advisor has sent me a letter
On white silk with slanting folds and three official seals.
I open the missive—it is as if the Advisor and I are face to face—
And inspect by hand the Moon Brick tea, three hundred pieces of it.
I have heard that early in the year, if one goes up in the mountains,
Hibernating creatures are beginning to move and spring winds are
 starting to blow.
The Son of Heaven, desiring men to taste fine Yang-hsien tea,
All other plants would never dare to blossom first.
A gentle breeze secretly forms buds like pearls;
Before spring actually arrives, they put forth sprouts of yellow gold.
The fresh plants are gathered, the fragrant tea is fire-dried and
 pressed into bricks,
The very best, the most exquisite—no empty luxury.
Aside from the Most Honored, it is suitable for princes and dukes;
So how is it that now it has arrived at the home of a mountain man?
My bramble gate closed tight against vulgar visitors,
Wearing a cap of gauze, by myself I boil and taste the tea.
The blue smoke cloud, drawn by the wind, remains unbroken;
A white froth—floating luster—congeals in the bowl.
With bowl number one, my throat and lips are moistened;
With bowl number two, my lonely sadness is dispelled.
Bowl number three cleans out my withered bowels,

Leaving only five thousand volumes inside!
With bowl number four, I raise a light sweat
And all the worrisome affairs of my entire life evaporate through
 the pores.
With bowl number five, my skin and bones are purified;
With bowl number six, I commune with immortal spirits.
Bowl number seven I can barely get down;
I only feel pure wind blowing, swishing beneath my arms!
The mountains of the P'eng-lai paradise, where can they be found?
The Master of Jade Stream wants to mount this pure wind and go
 there now.
The myriad immortals on these mountains officiate over this
 lowly realm;
Their position is noble and pure, beyond stormy rains.
What do they know of the millions of beings
Tumbling from precipitous cliffs, suffering so much!
Let me question the Advisor about these sentient beings:
Ultimately, should they obtain respite, or not?

Chinese characters are often conceived as occupying squares on an imaginary checkerboard, although cursive script in particular is often written with characters in varying sizes. In practice, writers of seal, standard, and running scripts often add a touch of elegance to the forms by making their characters a little taller than they are wide. The only script that is typically wider than square is clerical, but if the brushwork is well composed it can suggest height as well as breadth and the characters will not seem too broad or squat. In this work, the grid has been ruled onto the silk; instead of squares, it outlines horizontal rectangles. This shape can be seen in the large as well as the small: there are seventeen columns of characters, and seventeen characters per column, yet the total format is also a horizontal rectangle rather than a square.

One feature of clerical script is that even lines are used for all strokes except the diagonal "na" ⟍ that thickens and thins as it moves down to the right. Clerical script was historically the first sustained use of the flexible brush; its historical connotations and stately structure together give clerical script a special elegance all its own. Ryōkō creates nicely triangular "na" strokes and also adds small roundings to the beginnings of his horizontals, but his brushwork is otherwise mostly thin and even.

When a character repeats in the text, Ryōkō sometimes uses the same graphic form and sometimes varies it. The word "wind" (風) occurs as the fourth character in both his fourth and fifth columns, where it is written in extremely similar forms. However, the word "mountain" (山) first has inward-bending verticals (column 3, character 13), next is much more simple (7/8), and then is slightly elaborated (13/1 and 13/15). In another example, the word "pure" (清), made up of the three-dot "water" radical on the left plus "blue-green," has a different configuration in the lower right between 12/13 and 14/7. These changes testify to the artist's creativity, evident even in a work done in formal style.

Comparing this work with the clerical script of Ishikawa Jōzan (#39), we can see that Ryōkō, due to his slightly smaller and less angular forms, has less power but more grace in his style. However, we could also compare this

Figure 25.1.
Araki Zesui (n.d.),
Tea Song (opening).

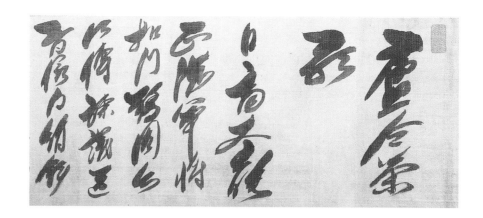

work with a cursive-script hand scroll of the same text by Araki Zesui (n.d.), a pupil of Mitsui Shinna, written in broad, wet, running-cursive script (fig. 25.1). Here the words are expansive rather than contained, and the mood is indulgent rather than refined. Also, Zesui begins with the title, whereas Ryōkō omits it.

Zesui seems to take an entirely different attitude toward the text than did Ryōkō. Since there is no attempt to suggest the antiquity of the poem by using an old-fashioned script and the brushwork is free and idiosyncratic, we might speculate that Zesui's purpose was to make the text seem fresh and up-to-date, while Ryōkō sought to evoke its classical nature. Yet through his individual use of clerical script, he does not merely repeat the past but demonstrates that a master calligrapher can take a seemingly archaic script and create new variations.

NOTES

1. Among Ryōkō's many woodblock books published during and after his lifetime are *Hōō-chō* (Phoenix Album) in large clerical, seal, and running scripts; *Tōshi dainin-chō* (T'ang Poetry Album) in large running script; *Shūsei-fu* (Autumn Voices Ode) in large standard script, *Tōgen-kō* (Journey to Peach-Blossom Spring, 1841) in running-cursive script; and *Yontai senjibon* (Thousand-Character Essay in Four Scripts, with Murata Kaiseki, 1877).

2. Translation by Jonathan Chaves.

26 TŌKAI OKON (1816–1888)

Clouds

Hanging scroll, ink on paper, 111.7 x 57 cm.

Given when and where the life of Okon began, the odds were strongly against her learning to read and write beyond a rudimentary level, if at all. But despite being born in a small, culturally backward mountain village in Niigata at a time in Japanese history when young women were not expected to receive much education, she became a celebrated calligrapher at an early age.

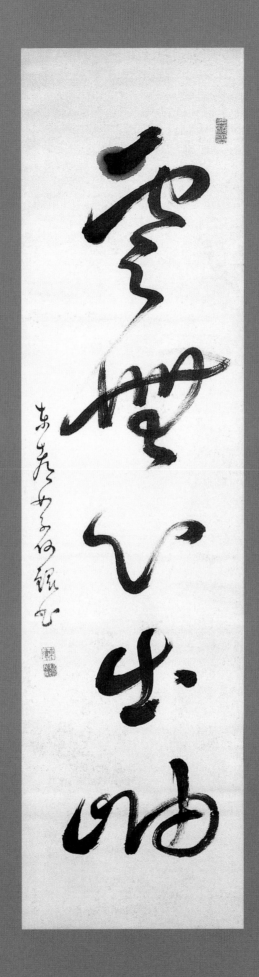

26

Although there was little formal schooling available to her, Okon was introduced to Chinese literature by her father when she was still a young child. Showing unusual aptitude, she memorized Chinese poetry and practiced calligraphy by copying woodblock books; and by the time her family moved to Kyoto in 1825, she had become expert in cursive script. A year later, at the age of ten, she demonstrated calligraphy for the emperor, who gave her the gift of a jade cup. She was praised and advised by several of the leading literati of the day, including Rai San'yō (#38), who wrote, "she is a genius at cursive script," and Shinozaki Shōchiku (#44), who added, "she is of heavenly beauty, and her character is also gentle and graceful."[1] However, as she neared adolescence, Shōchiku and others advised her family that too much attention to Okon's artistic prowess might not be wise if she wanted to find a husband and have a family. As a result, she ceased devoting her life to calligraphy, married a man named Okumura, and retired from public attention. Ironically, in her later years her husband died and she had to sell her calligraphy to survive, as an 1878 hand scroll from her hand attests.[2]

Examples of Okon's work are rare and mostly come from her youth. Here she has written out a phrase from "Returning Home," a poem written by the Chinese recluse-poet T'ao Yuan-ming (T'ao Chien, 365–427) on the occasion of his retirement from an official position.[3]

CLOUDS
 WITHOUT
 MIND/HEART
 COME-FORTH
 MOUNTAIN-GROTTO

The words "without mind" or "without heart" (*mushin*) are important in Zen (see Daidō, #67), alluding to a truth that goes beyond intellection.[4] The image of clouds coming forth from mountain peaks also suggests the natural flow of life, so in this case *mushin* might be translated "without striving" or "without conscious intention."

The first character, "clouds" (雲), begins with a fuzzing of ink as Okon pauses with her suffused brush then continues in a curving and twisting cloudlike form. The opening horizontals bend upward, and then the line spirals down so that the entire (originally twelve-stroke) character is completed in two strokes. The brush does not entirely leave the paper before beginning the second character, *Mu* (無, without), which is written in a continuous gestural movement. While the first word shows a vertical orientation, the second is stretched out into a more horizontal form and leads directly to the third, "mind/heart" (心), which is also completed within the same gesture. In effect, the three words are written with two strokes—the first a simple fuzzing horizontal and the second not ending (although the brush almost leaves the paper) until the third character is completed.

The final two words are more distinct in their rendering. "Come forth" (出) retains some of its original architectonic form, and "mountain-grotto," with its "mountain" (山) form on the left, has a horizontal composition that acts as a visual base for the scroll. The heart of the calligraphy, however, lies in the third character, appropriately meaning "mind/heart." Its almost symmetrical form clearly shows the movement and pressure of the brush as it

enters from the previous word, curves down strongly, thins as it moves up again, and finishes with a powerful hooking motion. Each of the other four characters is full of complex energy, but this word's simplicity of form and balanced sense of movement allows the calligraphy to pause, breathe, and then continue its dance.

Okon's calligraphy is extremely fluent, whatever the size of the characters. For comparison, a scroll done when she was ten years old, which contains the entire "First Prose-Poem on the Red Cliff" by Su T'ung-po (Su Shih, 1036–1101), shows her prowess in a long text with flowing cursive script (fig. 26.1). Okon here wielded the brush with great confidence—often writing several characters in a single gesture—and the rhythm of her calligraphy never ceases. This is a notable achievement for any calligrapher, much less one who was only ten years old.[5]

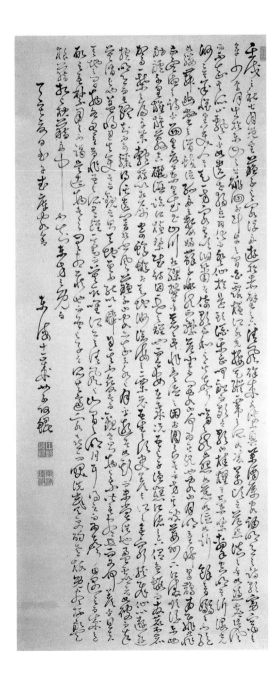

Figure 26.1.
Tōkai Okon,
The Red Cliff (1826).

In comparison, the "Clouds" scroll, probably written a little later, shows more sophistication but an equal sense of energy as the brush twists and turns. The five large words are more individualistically rendered than the smaller characters in "Red Cliff," thereby displaying Okon's full talent as a calligrapher.

NOTES

1. These phrases were written on scrolls presented to Okon in 1826 and 1827, respectively, which are now at the Spencer Museum of Art at the University of Kansas. For more information, see Pat Fister, "Tōkai Okon" in *Calligraphy Idea Exchange* 3, no. 4 (Summer 1986): 26–33.

2. This scroll as well is owned by the Spencer Museum of Art.

3. For a full translation of the poem, see James Robert Hightower, *The Poetry of T'ao Chien* (Oxford: Clarendon Press, 1970), pp. 268–270.

4. This phrase appears twice, with one character added, in a collection of Zen sayings called *Zenrin kushū*, with two different second phrases. The first comes directly from T'ao Yuan-ming: "Clouds without mind come forth from mountain peaks; birds weary of flight also know to return." The second adds a different second line: "Clouds without mind come forth from mountain peaks; water past full tide also flows." For the Chinese characters and slightly different translations, see *A Zen Forest*, trans. Sōiku Shigematsu (New York and Tokyo: Weatherhill, 1989), pp. 41, 128.

5. Okon signs the work as age eleven, but as noted elsewhere, this corresponds to ten by Western count.

Calligraphy by Confucian Scholars

Another stream of *karayō* calligraphy that began in the later seventeenth century was created by Confucian scholars. This category is closely tied to the previous group of artists, since several of those mentioned earlier, such as Setsuzan (#13) and Kōtaku (#14), were also Confucians. Nevertheless, we can divide those for whom calligraphy was the major force in their lives from those who were primarily teachers and scholars. This latter group also produced a significant amount of brushwork, indicating that they took calligraphy seriously, but their primary commitment was to Confucianism.

Chinese ethical philosophy was not new to Japan. Texts including sections of the Confucian *Analects* were introduced at the beginning of the fifth century, if not earlier, by Korean scholars, and Chinese Confucians were teaching in Japan by the year 513.[1] In the seventh century, Prince Shōtoku's "Seventeen Articles," often considered Japan's first constitution, shows a strong influence from Confucianism,[2] and soon thereafter a "Bureau of Higher Learning" was established, with Confucian tenets forming a major part of its teachings. Although Buddhism predominated as a cultural force in the following centuries, Confucianism was not neglected; during Japan's Middle Ages (1185–1568), Zen monks continued to study and teach the Chinese classics, generally following the interpretations of Sung-dynasty scholars such as Chu Hsi (1130–1200). Nevertheless, Confucianism did not reach the height of its influence in Japan until the early modern period.

The Tokugawa government, as mentioned earlier, differed from its predecessors in gradually switching from Zen monks to Confucians as their advisers and as teachers for the highest class of samurai-officials. The samurai headed a four-tiered social system, with farmers ranking second since they produced the necessary food; farmers were especially important because government salaries for some time were based on yearly rice allotments. Third came artisans and craftsmen, who also contributed to society through their work, while merchants were ranked at the bottom, since it was believed that they merely moved goods without producing them. But as Japan's economy became increasingly mercantile, the position of farmers gradually sank while merchants gained in wealth and status. Nevertheless, the shogunate tried to maintain this theoretical four-part division of society until the opening of Japan to the West in 1868.

Not surprisingly, the government showed greatest favor to scholars who taught the neo-Confucianism of Chu Hsi, which emphasized loyalty to the state as well as rational examination of the world. The scholar whom

the regime chose to open its own academy in Edo was Hayashi Razan (1583–1657),[3] who followed Chu Hsi as well as his own teacher Fujiwara Seika (1561–1619) in stressing the primacy of *ri* (Chin. *li*, 理, principle). Razan wrote, "The principle that is ever present, before the emergence of Heaven and Earth as well as after, is called the Supreme Ultimate. . . . The principle which is attached to the human form and resides in the human heart is called Nature Ordained by Heaven. This nature is just another name for principle."[4]

Razan believed that although this principle does not contain evil, it can be obscured in people by their selfish desires.

> Human nature is like water. If it is poured into a clean container, it remains pure; if it is poured into a dirty container, it becomes dirty. . . . If a person cleanses his heart each day, his selfish desires will disappear. This is called renovation. This does not mean that something which was not originally present has been produced. It means that someone who was unaware of illustrious virtue until then has been made aware of it."[5]

Razan also allied Confucianism to Shinto. His teacher Seika had written, "In China, the Way is called Confucianism; in Japan, it is Shinto. The name is different, but the spirit is the same." Razan echoed this view, writing, "They are one in principle. They only differ in effect."[6] This attempted union of the two belief systems, which were quite different in their origin and scope, tried to counter the criticism that Japan was adopting a model entirely from China, and helped reconcile those who were more nationalist.[7]

In China, governmental administrative and teaching posts were earned through competitive examinations. With the Japanese penchant for hereditary positions, however, the Hayashi family continued to run the shogunal school for many generations.[8] Based upon such ideas as Razan's assertion that "if the instruction from above is good, soon the customs of the age will also become good,"[9] many other schools in Edo and in the feudal *han* were also established to be run by Confucian scholars. As a result, there soon became a widespread need for teachers adept in Chinese philosophy and ethics. In studying continental thought, however, the Japanese were aware that the world of the literati included an emphasis upon calligraphy, poetry, and prose, as well as refined styles of painting and the subtle music of the *ch'in,* a seven-string zither.[10] In fact, one could not pass the civil service examinations in China with poor calligraphy and no skills in poetry. Japanese scholars also sought artistic outlets; all the major Confucians took up the brush to express themselves, usually in their own Chinese-style verse, and many developed idiosyncratic calligraphic styles all their own.

"When there is a Way there is culture; when there is no Way there is no culture," according to Razan. "Culture and the Way share the same principle *(ri),* and only differ in manifestation."[11] He himself wrote poetry, often quatrains in Chinese in unassuming regular-running script in small formats (#27). In contrast, the scholar Nakae Tōjū (1608–1648) taught a very different form of Confucianism, and his calligraphy was also quite different (#28).

Tōjū was a follower of the Ming-dynasty philosopher Wang Yang-ming (1492–1529), who absorbed Taoist and Zen Buddhist influences and developed a philosophy that advocated introspection and independent action.[12] Instead of following the Chu Hsi school's focus on *ri*, Tōjū gave precedence

to *shin* (*kokoro*, 心, mind/heart), which he believed could lead through study and self-discipline to "illustrious virtue":

> This is called "the greatest treasure in the world." It is found in every human being, high or low, old or young, male or female, in the inexhaustible treasure-house of the Mind, but not knowing how to seek it, people in their pitiful ignorance go out searching for treasure in external things, only to sink into a sea of suffering. . . . There is no distinction between men, be they sages or ordinary persons, so far as their Heaven-bestowed nature is concerned. They are all gifted with the divine light that tells good from bad. All men hate injustice and are ashamed of evil because they are born with this intuitive knowledge. It is only from the self-watchfulness of the one and the self-deceit of the other that the vast distinction arises between the superior man and the inferior man.[13]

The government was understandably less than fond of this more individualistic philosophy, but Tōjū's way of thought remained influential well into the twentieth century. His direct pupil Kumazawa Banzan (1619–1691, #29) followed his lead, teaching Wang Yang-ming ideals in Okayama. Like Tōjū, he retired early from his position with a feudal lord, supposedly after being slandered.

A third major form of Confucianism in early modern Japan was the Ancient Learnings (*kogaku*) school, which advocated going back to the original Confucian classics rather than relying upon Sung- and Ming-dynasty interpretations. The leaders of this school were Itō Jinsai (1627–1705, #30) and his son Itō Tōgai (1670–1736, #31). Jinsai wrote: "The Sung Confucianists thought that they could explain all worldly things as principle [*ri*]. Rhetorically, their argument sounds reasonable, but when applied to reality it cannot explain many things. . . . Benevolence [*jin*, 仁] is the basis of the kingly way. When even one person is discontented, or when an object is out of place, benevolence is absent."[14]

Jinsai valued the literati arts, believing that scholars who do not partake in them would be unable to fully apply their talents or to understand people. In particular, he favored poetry as the expression of personal character and feelings but warned that "when it is overly polished and grand, it grinds down the inborn emotions and completely strips away one's true energies."[15] Jinsai's poetry tends to be modest and restrained; his rather austere calligraphy, often in regular script, follows classical models. Tōgai, on the other hand, was more free and bold in his writing, often utilizing running and cursive scripts in larger formats. The finest calligrapher of the Confucianists, however, was probably Ogyū Sorai (1666–1728, #32), who established his own school of Ancient Learnings. A prodigious scholar and philologist, Sorai was also a master with the brush. Despite his interest in early philosophy and literature, he followed the reformist calligraphy tradition of Sung, Yuan, and Ming masters to create an individual style of writing with dramatic patterns of tension and release. Sorai's pupil Hattori Nankaku (1683–1759, #33) was even more interested in the arts, and his calligraphy is also very lively and personal in expression.

Most of the texts that Confucian teachers chose to render in calligraphy were their own Chinese-style poems. These often referred to favorite literati themes from nature such as plum blossoms (Jinsai, #30), the setting sun (Sorai,

#32), and autumn colors (Nankaku, #33), although the work by Itō Tōgai (#31) has a phrase from an ancient book of divination, the *I Ching*. It is notable that these scholars, despite the daunting difficulties of studying and interpreting centuries-old Chinese texts, were equally conversant with other aspects of Chinese civilization, including the importance of the arts. A Confucian teacher who had no cultural interests and accomplishments would be considered narrow and one-sided; it was understood that self-cultivation benefits from artistic expression and time spent in nature as well as from academic study.

The later eighteenth and early nineteenth centuries saw a continuation of all three Confucian traditions. Among the notable calligraphers were two scholars of the Chu Hsi school of neo-Confucianism who were chosen to work for the shogunate. The first was Shibano Ritsuzan (1734–1807), whose large-scale poem on Mount Fuji (#35) represents the immense admiration that this national symbol of majesty and power received in early modern Japan; Hokusai's famous prints would come a few decades later. Ritsuzan's calligraphy is idiosyncratic in its wet-ink, slightly blurring strokes of the brush, but the structure of his work is sure and architectonic.

In comparison, the calligraphy of Koga Seiri (1752–1817, #36) is leaner, with more space between the characters, giving it a cool and refined feeling. Seiri had originally studied the Wang Yang-ming tradition but then switched to the Chu Hsi school; for the work shown here he chose a poem by a ninth-century Chinese master rather than his own verse, again perhaps an indication of his restrained but elegant personality.

The later Edo period saw a new eclectic school arise in which students were encouraged to draw the best from differing points of view. One of the leading scholars of this eclectic tradition was Kameda Bōsai (1754–1826, #37), who came from a merchant family but was able to attend a Confucian school in Edo due to his precocious intelligence. Bōsai later set up his own academy, which was extremely successful until the Tokugawa regime issued an edict in 1790 against "alien teachings" that effectively ended his career as a teacher. Becoming a freelance literatus, Bōsai developed his love for calligraphy, which he had first studied with Mitsui Shinna (#19). For Bōsai, calligraphy became a convivial form of personal expression, and he shared his work with fellow artists and poets during his travels as well as in his home city of Edo. While the calligraphy of Ichikawa Beian (#24) was most appreciated by the samurai-official class in "uptown" Edo, Bōsai's work was particularly enjoyed "downtown" by cultivated members of the merchant and artisan classes.

The literatus who had the greatest impact in early nineteenth-century Kyoto was Rai San'yō (1780–1832, #38). His father, Rai Shunsui (1746–1816), had studied calligraphy with Chō Tōsai (#21) and operated a respected Confucian academy in Hiroshima. San'yō, however, rebelled against an arranged marriage, ran away from his domain at the age of twenty, was returned and placed under house arrest, and was disinherited by his father in 1804. Living the rest of his life in Kyoto, San'yō became famous for his book *Nihon gaishi* (Unofficial History of Japan), as well as for his poetry, calligraphy, and (to a lesser extent) literati painting. His calligraphy, like that of his father, is in the reformist tradition, and he developed a personal style featuring sweeping curves that is highly admired to this day. San'yō's

forty-line poem on the Sanjō bridge in Kyoto, written on subtly decorated paper, praises the shoguns who unified Japan before the Tokugawa era, displaying his interest in history and politics as well as his skill in literati arts.

Whatever their Confucian orientation, scholars in early modern Japan all seem to have taken to the brush for personal expression. Less apt than their professional calligrapher counterparts to show off their techniques by writing in several different scripts, they tended to create individual styles that displayed their personalities. By writing out their own poems, they added substantially to the *kanshi* (Chinese verse) tradition in Japan as well as that of *karayō* brushwork. Like the haiku poets and Zen monks to be discussed later, they were amateurs in the best sense, creating calligraphy for love of the art, for self-cultivation, for the expression of their inner feelings, and for the pleasure of continuing an artistic tradition that had been practiced for centuries in China, Korea, and Japan.

NOTES

1. See Felicia G. Bock, *Classical Learning and Taoist Practices in Early Japan* (Arizona State University: Center for Asian Studies, 1985), p. 1.

2. For a translation, see Tsunoda Ryusaku, W. Theodore de Bary, and Donald Keene, eds., *Sources of the Japanese Tradition* (New York: Columbia University Press, 1958).

3. Razan served the Tokugawa government in various roles, including scribe, librarian, adviser on ritual, and companion to the shogun.

4. Quoted in Masao Maruyama, *Studies in the Intellectual History of Tokugawa Japan* (Tokyo: University of Tokyo Press, 1974), p. 35.

5. Ibid., pp. 35–36.

6. Ibid., p. 151.

7. An opposing school of "National Learning" did arise in the next century, however, led by Kamo Mabuchi (1697–1769) and Motoori Norinaga (1730–1801). These scholars, while opposed to Confucianism, adopted several of its methodologies, such as close examination of early texts. However, they insisted that the pursuit of learning was not sufficient for understanding the Shinto gods. Norinaga wrote, "Even the wisest man's intellect is restricted. . . . The Sages used their private intellects to formulate all kinds of theories . . . but these are all fabrications based on blind guesses." Ibid., p. 158.

8. The shogunate officially adopted Chu Hsi neo-Confucianism as its own orthodoxy when it issued a degree against "alien teachings" in 1790, and seven years later it reorganized the Hayashi school into its official academy, called the Shōheikō.

9. Maruyama, *Studies in the Intellectual History of Tokugawa Japan,* p. 36.

10. See Stephen Addiss, *The Resonance of the Qin in East Asian Art* (New York: China Society, 1999).

11. From the *Razan Hayashi sensei bunshū* (Literary Writings of Hayashi Razan), 1662, as quoted in Lawrence E. Marceau, "Ninjō and the Affective Value of Literature at the Kogidō Academy," *Sino-Japanese Studies* 9, no. 1 (1996): 47.

12. See Wing-tsit Chan, trans., *Instructions for Practical Living by Wang Yang-ming* (New York: Columbia University Press, 1963).

13. From *Tōju sensei zenshū*, quoted in Tsunoda Ryusaku, W. Theodore de Bary, and Donald Keene, eds., *Sources of the Japanese Tradition* (New York: Columbia University Press, 1958), pp. 380, 382.

14. Quoted in Tetsuo Najita and Irwin Scheiner, eds., *Japanese Thought in the Tokugawa Period 1600–1868* (Chicago: University of Chicago Press, 1978), pp. 189, 191.

15. From Jinsai's afterword to the *Hakushi monjū* (Collection Works of Po Chu-i), quoted in Marceau, "Ninjō and the Affective Value of Literature at the Kogidō Academy," *Sino-Japanese Studies* 9, no. 1 (1996): 49.

Facing the Moon

Hanging scroll, ink on paper, 30 x 41.4 cm.

Born in Kyoto to a merchant of samurai ancestry, Razan entered the Zen temple Kennin-ji as a novice at the age of eleven but resisted formal ordination, and two years later he returned home. After reading the Confucian classics in an edition by the Sung-dynasty philosopher Chu Hsi, he decided to become a scholar and teacher. In the new capital of Edo, Razan was supported by the shogun Tokugawa Ieyasu (1543–1616), who insisted that he take the tonsure (probably because monks had been the primary advisers to the government in earlier periods); Razan was given the Buddhist name of Dōshun. Later scholars who worked for the regime were spared this ordination procedure, evidence that the shogunate's transition from relying upon Zen advisers to Confucians was gradual rather than abrupt.

Beginning his service for the government in 1607, Razan participated in drafting important documents such as laws for both military clans and the shogun's vassals. Strongly believing that education was a means toward securing peace, he advocated the printing and distribution of books and opened a Confucian school. In 1630 he was given land and funds by the shogunate to build a Confucian academy; called Shōheikō, the academy was to be led by the Hayashi family for many generations, and it became the official shogunal college in 1797.

Although Razan tried to suppress the more individualistic Wang Yangming school of Confucianism and criticized Buddhism and Christianity, he was not completely orthodox as a Confucian. For example, he believed that Shinto was in harmony with neo-Confucian values, equating the Shinto deity Ame-no-minaka-nushi-no-mikoto with the neo-Confucian "Supreme Principle." Nevertheless, Razan began a history of Japan (completed by his son) that offered rational rather than mythical explanations of the past and supported the power of the samurai class. Among his many other books are commentaries on Confucian classics and, in simpler Japanese, explanations of Chu Hsi's basic concepts of a moral and stable society.

On a more personal level, Razan also found time to write poetry in Chinese; he must have been highly skilled since he was able to play a kind of literary game in which a rhyme word is chosen by lottery from a Chinese poem. This character becomes the final word of the new verse and determines the category of the other rhyme words. Here the Chinese character that Razan was given was *hsu* (虛, "empty"), with which Razan ended his poem and rhymed in Chinese with his final words for the second and third columns, *chu* (居, "house") and *ssu* (似, "similar"). Only the first two of these words rhyme in Japanese.

賦對月彈琴不似

詩 分韻 得虛

道春

一片晚烔月

四邊殘菊居

時調渾不似

聲裡塵心虛

Composed Facing the Moon and Playing a Different Tune

One sliver of autumn evening moon,
The house surrounded by chrysanthemums—
Totally different from the melodies of today,
An inner voice empties my heart of dust.

Despite Razan's neo-Confucianism, the concept of emptying dust from the heart has Buddhist overtones, while other themes in the poem have Chinese literati antecedents. The "different melody" suggests the seven-string *ch'in*, a form of zither beloved by scholars for its quiet, subtle, and introspective music. It was believed that playing the *ch'in* could bring serenity and even enlightenment, and its soft sounds had long been contrasted in China with more popular forms of music that were played on distinctly louder instruments. The chrysanthemums in Razan's poem also suggest the poet T'ao Yuan-ming (T'ao Chien, 365–427), who represents the joys of retiring from official life, and whose most famous poem includes the lines, "Picking chrysanthemums below the eastern hedge, I watch the distant southern hills." Because it blooms at the end of autumn, the chrysanthemum especially represents the joys of old age.

Razan is very orderly as a calligrapher. He divides the compositional space equally between title on the right and poem on the left; his columns strictly follow the five-character-per-line form of the poem; and when characters repeat (the final three in the title are the final three in the penultimate column) he writes them with no change of script, composition, or style. But as we examine the work more closely, an individual personality begins to emerge.

Signed with his Buddhist name Dōshun (道春, "Tao-spring"), Razan's poem is written primarily in regular script, but there are exceptions. Within several characters, brush strokes have been joined together in running script, and the second word (裏, "inner") in the final (left) column combines cursive script on the left side with regular script on the right. Furthermore, Razan writes in gray ink rather than the black ink that was almost universal in Chinese calligraphy, and his style of brushwork is soft and relaxed rather than hard; both of these features are well suited to this poem. A sense of individual rhythm results from Razan's choice to make certain characters darker—the first of each column of the quatrain, as well as the second character in column two and the third characters in columns two, three, and four.

Most notable, however, is the way Razan creates his horizontals. Instead of beginning and ending the stroke strongly and slightly raising this line upward to the right, as is common, he prefers a curved line that is widest in the center. This "eyebrow" shape can be seen most clearly in the first word of the poem (一, "one"), but it also appears later, such as in all of the final eight characters. For beginners, this would be considered a mistake, but it allows Razan to present a personal style within the modest format, understated ink tones, and unassuming calligraphic presentation of his poem.

Bring the Ch'in

Hanging scroll, ink on paper, 139.5 × 53.3 cm.

Nakae Tōjū was the most significant Japanese scholar of the Wang Yang-ming (1472–1529) school (Jpn., *yōmeigaku*), which focused upon mind/heart (心), innate morality, and the union of thought and action. He stressed intuitive knowledge in both his prose and poetry, writing, "The sage will be watchful over those inmost thoughts known to himself alone," and "The mind should make tranquility its goal, for then the bright moon will not sink beneath the waves."[1] His school was influenced by Buddhism, especially Zen, but his ideas were never accepted by the shogunal government, which distrusted their emphasis on individual morality and personal decision making.

Tōjū admired filial piety as a primary virtue: "To care for one's moral endowment is to care for one's parents, to respect one's moral nature is to respect one's parents. This is the essence of filial piety in the larger sense. . . . Filial piety is the summit of virtue and the essence of the Way. Therefore those who pursue learning need study only this. Where is filial piety to be found? In one's own person!"[2]

One reason Tōjū has been admired is that he lived up to his beliefs. Born in a village near Lake Biwa, he became a Confucian scholar for a feudal lord in Shikoku but gave up his career and returned to care for his aging mother while teaching in his native village. Despite his modest lifestyle, his writings and personal example had a strong impact in Japan; Tōjū's major pupils and followers include Kumazawa Banzan (#29), and, later, Uragami Gyokudō (#42).

Large-scale calligraphy by Tōjū is rare; this is one of the few surviving examples. Choosing tall and broad seal script, he has brushed two characters in praise of the seven-string zither beloved of poets and sages:

Bring 抱 [the] *Ch'in* 琴

These two words are two of the final characters from a famous quatrain by the T'ang-dynasty master Li Po (Li Pai, 701–762):

Drinking with a Hermit in the Mountains

Two of us drinking together as mountain blossoms open;
One cup, another cup, still one more cup—
I'm feeling a bit drunk and the time has come for you to depart,
But tomorrow morning, if you like, come again and bring the *ch'in*!

The character for "bring," here meaning to carry the instrument in one's arms, can also mean "hold" or "embrace."

The deep and introspective resonance of the *ch'in* is too quiet for public performance, but it is ideally suited to playing for oneself or a close friend. The instrument was known early in Japan (and was played by Prince Genji in the famous novel by Lady Murasaki) but then was forgotten until revived by Sinophiles in the seventeenth century.[3] One wonders if Tōjū ever

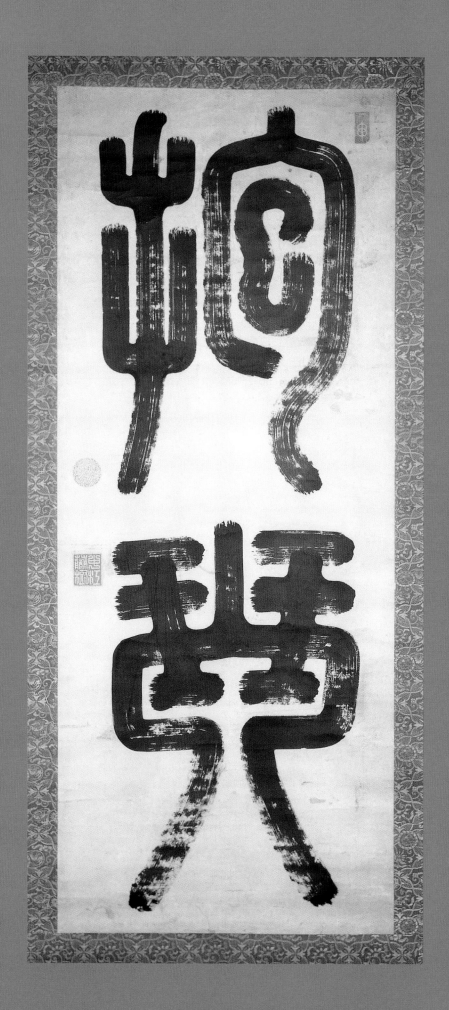

28

heard the instrument in person or simply imagined its sound based upon Chinese poetry. In any case, he has honored an important symbol of the literati cultural world.

Perhaps to evoke the flavor of antiquity carried by this musical instrument, Tōjū writes in seal script, although some features are quite unusual in his brushwork. He maintains two of the most important characteristics of the script—even line widths throughout the characters and a formal sense of balance in the character compositions—but the brushwork shows a great deal of "flying white," which is rare in seal script; also unusual is that all of the strokes begin, and some end, with "open tip." Most calligraphers using seal script preferred to circle the brush and round off the beginnings and ends of their strokes, and Tōjū does finish some horizontals, such as those near the top of the second character, with partial "closed tip." However, the ragged extremities of most strokes, along with the flying white, give more personal expression to his calligraphy than the elegant aesthetic that seal script usually conveys.

In the massive architecture of his forms, Tōjū's expertise with the brush is everywhere apparent, especially in the thick and even lines that create well-coordinated and balanced "negative spaces" within his characters. Yet the open tip brushwork, with extensive use of flying white, allows the work to breathe.

The power and visual energy with which Tōjū has imbued this scroll serve to proclaim the strength and depth of the new Japanese commitment to the poetry, music, and calligraphy of the Confucian tradition.

NOTES

1. From Inoue Tetsujirō, *Nihon yōmei gakuha no tetsugaku* (Philosophy of Japanese Scholars in the Wang Yang-ming Tradition) (Tokyo: Fuzambō, 1932), p. 81. Translation based upon Tsunoda, de Bary, and Keene, eds., *Sources of the Japanese Tradition* (New York: Columbia University Press, 1958), p. 381.

2. Translation by Timothy R. Bradstock and Judith N. Rabinovitch, *An Anthology of Kanshi (Chinese Verse) by Japanese Poets of the Edo Period (1603–1868)* (Lewiston, N.Y.: Edwin Mellen Press, 1997), p. 74.

3. From *Tōjū sensei zenshū*, vol. 1, pp. 217, quoted in *Sources of Japanese Tradition*, p. 384.

29 KUMAZAWA BANZAN (1619–1691)

Letter with a Poem

Hand scroll, ink on paper, 14.7 x 51.5 cm.

Letters are the most personal form of calligraphy, capable of expressing the inner spirit of the writer more simply and directly than larger-scale works done for artistic purposes. While a standard biography of Banzan can give the facts, this letter is perhaps more indicative of his life and character.

Banzan was born in Kyoto to a samurai family without a specific allegiance to any feudal lord. In his youth he studied military arts while serving the daimyo of Bizen (Okayama) and then studied the Confucianism of Wang Yang-ming with Nakae Tōjū (#28) in Ōmi (Shiga). Especially admiring Wang Yang-ming's *Studies of the Heart*, Banzan wrote that when Confucianism is "mostly concerned with the refutation of error, it is called neo-Confucianism; when it is mainly concerned with controlling the heart we call it 'the laws of the heart.' . . . Once error has been refuted we return to the feelings of the heart. . . . What is visible from the outside is behavior; what we perceive inside is the heart and feelings. Heaven and the gods bless those whose hearts are good, even though their behavior may not always be perfect."[1]

Returning to Bizen in 1645, Banzan became chief minister and launched a successful reform program. His increasing fame bred resentment, however, and he was attacked by conservatives who eventually forced him to resign in 1656. He then taught and wrote; although his Confucianism was not radical, his pragmatic approach to societal problems continued to make some officials nervous, and his suggestions for national reform were generally ignored.

This letter, written to a friend named Iwami on the eleventh day of an unknown month and year, expresses Banzan's intimate feelings about his life. It begins in Japanese with three columns of greetings including an inquiry about Iwami's health, and then Banzan writes a quatrain in Chinese of seven words per line that occupies columns four through seven. For a Confucian scholar, the text is remarkably Buddhist, the final two lines being explicitly Zen in spirit:

Man's life is just like a dream within a dream,
Meeting together in this world of dust, who is who?
Before my father and mother were born, who am I?
One breath not yet taken, I am . . . who?

In his second line Banzan refers to the basic Buddhist concept of transience, the "world of dust," while in the third line he rephrases a Zen *kōan*: "what was your face before your parents were born?"[2]

Returning to Japanese for the rest of the letter, Banzan relates that he has given up his official position to become a farmer and that now in the serene spring evenings he no longer hears an inner voice calling for duty to the government. However, he regrets that his heart is still not completely clear of ambition, even though he knows this is nothing but an empty dream. The word for heart/mind, *kokoro* (心), appears four times in this part of the letter, emphasizing how personal a statement Banzan is offering.

Banzan's calligraphy is confident but never showy. The Japanese sections are unhurried, fluid, and relaxed until the end, where the calligraphy tends to lose its clear division into columns, indicating more tension or more speed. Banzan also creates a deliberate visual contrast between the free-flowing Japanese sections and the more orderly Chinese characters. The four lines of the verse are written in four matching columns, and the words are evenly inked, indicating that Banzan did not want to draw attention to this calligraphy with visual accents but rather to allow his friend to focus on the meaning of the poem.

塵世相逢誰是誰
父母未生誰是我
一息不来我是誰

For the first line of the quatrain, Banzan starts by strongly delineating the opening word, "man" (人), and then uses running-to-cursive script for the rest of the column. For the following three columns, however, he moves to standard script and adds Japanese syllables and grammatical marks in small size next to the characters to make the reading of his quatrain easier. In addition, while he leaves very little space between words of the poem, he keeps the columns clearly separated. The result of the script choices, additional marks, and spacing is that the poem stands out distinctly within the letter, expressing Banzan's deepest internal questions as he contemplates his life.

NOTES

1. From Shuichi Sato, *A History of Japanese Literature: The Years of Isolation,* trans. Don Sanderson (Tokyo & New York: Kodansha International, 1983), pp. 52–53.

2. See #66, Kogetsu Zenzai, for further explanation.

30 ITŌ JINSAI (1627–1705)

Ripening Plums
Hanging scroll, ink on tinted paper, 15 x 29 cm.

Born in Kyoto, the son of a lumber merchant, Jinsai showed his brilliance as a young child and was advised to become a doctor. More interested in philosophy, he first studied Chu Hsi neo-Confucianism, then moved to the teachings of Wang Yang-ming, and finally initiated his own school of thought, *kogigaku* (Study of Ancient Meaning), which emphasized going back to the original Confucian texts. He believed that the fundamental Confucian value was *jin* (Chin., *jen*, 仁, benevolence or compassion) and agreed with Wang Yang-ming that it was not sufficient merely to have principles—one must put them into action. He stressed loyalty and truthfulness in both words and deeds, which he believed would lead to love and benevolence.

Unlike most Confucians of his time, Jinsai had no interest in serving a feudal lord or the shogunate; instead, he opened a private academy—the Kogidō (Hall of Ancient Meaning)—that eventually attracted more than a thousand pupils. Jinsai was assisted by his son, Itō Tōgai (#31), who also published his father's writings after his death. The major Confucian philosopher Ogyū Sorai (#32) was just one of many scholars influenced by Jinsai's thought, which became the basis for the broader tradition of the Ancient Learnings school.

Jinsai believed that literature was a device for bringing forth the Way (*tao*, 道). Poetry is important in that it depicts human emotions; rather than advocating morality or simply depicting nature, it expresses genuine feelings. Jinsai's own poetry, as modest and restrained as his character, proceeds directly from experience. In this small scroll, he does not tell the reader what

陪

兵部藤公飲相國寺
梅熟軒呈 琦上人

梅熟軒中梅熟時
曾侵梅雨傍疎籬
定知雪裏花開處
粉瘦瓊寒更自奇

伊藤維楨謹識

to feel; rather, he introduces and describes a scene of springtime rebirth in a way that allows the reader to share his perception.

Drinking at Sōkoku-ji with Lord Fuji[wara], of the military department, and presenting this poem to the monk Ki Shōnin, as plum trees blossom at the eaves of the temple.

> At the Pavilion of Ripening Plums, the plums are ripening,
> Already beset by plum rains at the bamboo hedge;
> I already know that the buds, concealed in snow, are opening,
> But as the powder thins, a cool redness mysteriously appears.

Jinsai's poem is a quatrain with seven words in each line, arranged in four columns. It is usually considered a mistake in this form of Chinese regulated verse to repeat a character; but here the words "plums" and "ripening" occur twice in the first line, and "plum" occurs again in the second line as part of the phrase "plum rains" (gentle late spring drizzles). But because the characters are used differently each time, first as a pavilion name, second as themselves, and finally as a form of rain, Jinsai turns a seeming defect into a point of interest.

Written on orange-red tinted paper with faint horizontal laid-lines, Jinsai's calligraphy in regular-to-running script is unassuming but expresses a gentle flavor. The repeated words "plum" and "ripening" are written similarly each time but with slight variations; for example, the opening word of the poem, "plum" (梅), begins with a stronger brush stroke than when it reappears four and nine characters later. Since the lines of the quatrain are rendered in four matching columns, there is no immediate visual counterpoint; but by emphasizing certain words with heavier ink, Jinsai creates his own sense of rhythm. Specifically, the fourth and fifth characters in column one, the sixth in columns two and three, and the final three in column four stand out with their thicker and darker lines, helping to express Jinsai's character and to give the work its own modest appeal. A calligraphy such as this can easily be passed by; but like the red of the plum blossoms just emerging from the snow, it repays close attention.

31 ITŌ TŌGAI (1670–1736)

Quote from the I Ching
Hanging scroll, ink on paper, 115.6 x 25.6 cm.

Itō Tōgai followed his father Jinsai as a major Confucian scholar and teacher in the Ancient Learnings school. He wrote, "Quietly and surreptitiously the teaching has been altered or done away with throughout ten centuries or more, with the result that present-day teaching is no longer identical with early Confucianism."[1]

Also like his father, Tōgai was greatly interested in the *I Ching*, attempting to interpret this classic not merely as a book of divination, which it had largely become, but as a major early philosophical and ethical text. He wrote

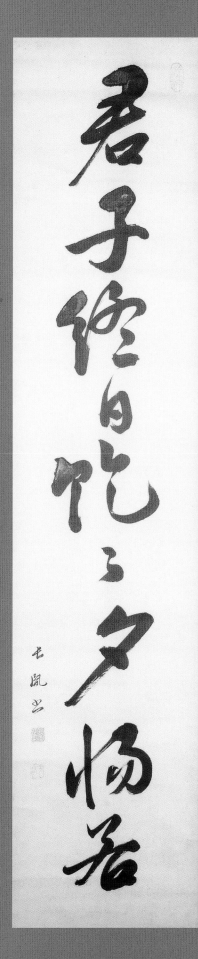

君子終日乾乾夕惕若

長嵐書

31

several books on this theme, including *Tokueki shiki* (Records of My Reading of the *I Ching*) in 1703, in which he argued that the accompanying commentaries were not composed by Confucius, and *Shūeki keiyoku tsūkai* (A Comprehensive Explanation of the Text and Ten Wings of the *I Ching*) in 1728, where he explicated the entire text including commentaries.[2]

The *I Ching* is constructed of sixty-four hexagrams, combining every possible variation of the nine trigrams, which are composed of three lines that may be either solid or broken. For example, three solid lines signify "heaven," while three broken lines indicate "earth." Putting two "heaven" trigrams together creates the first of the sixty-four hexagrams, which can mean both "heaven" and "creative power."

Here Jinsai has written out a line from the primary text on this first hexagram, in which the third of the six lines, reading from the bottom, is given the interpretation:

> All day long the superior man is creatively active;
> At nightfall his mind is still beset with cares.[3]

Other translations of this nine-character phrase are possible; for example, the words "creatively active" can also be rendered as "respectfully attentive." In either case, we may ask why Tōgai chose to write out this text. It might be imagined that Tōgai, or the recipient of this calligraphy, had found this line through divination. More important, however, he very likely found the phrase meaningful in his own life. As a scholar-teacher in charge of the school initiated by his father, he was surely busy during the day; but even at night his duties and responsibilities did not end.

What does the calligraphy itself tell us? The nine characters (the sixth is a repeat mark like our ditto symbol) are written in running-to-cursive script, with the first stroke of each word emphasized through a thicker and heavier line. In the final word, however, the emphasis upon the final strokes at the bottom of the character brings a sense of completion and balance to the work. We can also see that a few of the characters tilt, such as the first and seventh to the right, and the fifth and eighth to the left, giving the scroll a feeling of relaxation and movement. The *I Ching* is often considered a Confucian text, but it also has ties to Taoist thought, and here the mood is not that of Confucian rectitude, but rather a Taoist sense of freedom and natural flow.

Finally, the artist's unusually small and modest signature on the left suggests that Tōgai was much more interested in bringing forth the text than in promoting his own artistic interpretation. The entire basis of the Ancient Learnings school was to emphasize the original texts, and here that is just what Tōgai has done.

NOTES

1. From Tōgai's *Kōkon gakuhen* (Changes in Confucian Teaching), quoted in Tsunoda, de Bary, and Keene, eds., *Sources of Japanese Tradition* (New York: Columbia University Press, 1958), p. 412.

2. For further information, see Wai-ming Ng, "Study and Uses of the *I Ching* in Tokugawa Japan," *Sino-Japanese Studies* 9, no. 2 (April 1997): 35.

3. *The I Ching*, translated by Richard Wilhelm and rendered into English by Cary F. Baynes (Princeton, N.J.: Princeton University Press, 1950), p. 8.

The Setting Sun

Hanging scroll, ink on paper, 127.9 x 29 cm

Born in Edo to a samurai-class family of physicians, Ogyū Sorai was a child prodigy, able to write in Chinese by the age of seven. He began his official studies at the age of nine, at which time he also composed his first poems. His father was exiled to Kazusa (Chiba) in 1679, however, and Sorai lived among and observed the world of farmers; he was later to write that the exodus of rural people into cities was the source of many social problems. Returning to Edo in 1690, Sorai began his career as a scholar by giving outdoor lectures near the temple Zōzō-ji. His career rapidly advanced, and he was soon appointed to the staff of Yanigisawa Yoshiyasu (1658–1714), the chief counselor of the shogun. In 1717, Sorai established his own school, which was very influential both in his own time and beyond.

Perhaps Japan's great philologist, Sorai agreed with Itō Jinsai that Confucianism should be studied from its sources, rather than from later interpretations. He criticized Jinsai, however, writing that this "scholar of great stature . . . has openly divided the Way of early kings and Confucius into two ways, and put the six classics [The Books of History, Odes, Changes, Rites, Music (since lost), and the Spring and Summer Annals] aside in favor of the Analects alone."[1] Sorai's exceptional abilities in the study of ancient Chinese allowed him to investigate all the early Confucian texts thoroughly, and apply them to matters of his own time.

Although Sorai did not follow the official Chu Hsi neo-Confucianism, he was supported by the shogunate, in part because he advocated a strong system of laws. Remembering his experience in the countryside, he recommended that all families should be registered so they would have fixed places of residence, and that the distinctions among samurai, farmers, artisans, and merchants should be maintained. Nevertheless, he insisted that the government itself should be administered by those with the most ability, whatever their social background. Convinced that wisdom develops only through hardship, he wrote that "through the study of history also we may see, as clearly as in a mirror, that men of intelligence and talent have all come from below; rarely have they come from hereditarily privileged families."[2]

Sorai also stressed personal cultivation in the (Chinese) arts; he amassed a fine library, took an interest in literati painting as well as music (about which he wrote four books), and was himself an exceptional poet and calligrapher. Here, in a couplet in bold cursive script, he celebrates the arrival of a poem from a friend; presumably this calligraphy, in true literati fashion, would have been sent back as a return gift.

> Setting sunlight on lingering snow illuminates the studio:
> Suddenly, humbly I receive your new poem, each word full of skill.[3]

The opening character, "setting/slanting" (斜), is strongly accentuated, with a notable slant to its vertical final stroke. Subtle visual echoes of the first two characters appear in the second and third words of the second column, which is organized in a zigzag interaction with the first. There is also a similarity of form between characters 1/4 and 2/5, indicating that Sorai is

科石陶斌窗如楼中坐
枉新诗吏弓

aware of the visual interplay that his calligraphy would create. Although his style at first seems rough and spontaneous, it is never hasty; his alternation of tension and release can be seen in the strokes that bend and twist at different speeds in the second character, "sunlight" (陽). Another example of his personal style comes in the three horizontal strokes on the right side of 2/1, "humbly receive" (枉). Each of these short, dashlike strokes begins differently, from a point to a triangle to a thick slab, and each relates to strokes to its left and right. Sorai's continuously varying brushwork rhythms well express his couplet about winter snow reflecting the setting sun.

Although the two poetic lines are seven characters each, Sorai has written them in columns of eight and six, so that the word "suddenly" (忽) appears at the end of the first column. Following a long and fading vertical stroke, this character has extra impact both because of the space above it and because of its brushwork, opening with a "bamboo-leaf" diagonal and concluding with a rhythmically pulsating horizontal. A similar vibrating stroke ends the fifth character, "shine/illuminate" (照), while an even more strongly articulated horizontal anchors the entire calligraphy just to its left. Although the couplet is written in cursive script, the three strokes of this final word are clearly delineated in diagonally faceted regular script that balances the opposing diagonals of the first character and helps to mark an ending. Despite its apparent freedom, the entire scroll, when examined closely, is rhythmically accented and structured throughout its two-column composition. Sorai's poetic couplet emerges as individualistic calligraphy, each word full of skill.

NOTES

1. From Sorai's *Distortion of the Way through Ignorance of the Past*, quoted in Tsunoda, de Bary, and Keene, eds., *Sources of the Japanese Tradition* (New York: Columbia University Press, 1958), p. 28.

2. From Sorai's *For a Merit System in Government*, ibid., pp. 432–433.

3. Translated by Jonathan Chaves.

33 HATTORI NANKAKU (1683–1759)
Spring and Autumn Quatrains
Pair of hanging scrolls, ink on paper, each 186.3 x 52.7 cm.

Nankaku was born in Kyoto, the second son of a merchant. Gifted from his youth, he moved at fourteen to Edo, where his poems attracted the attention of the senior counselor to the shogun, Yanagisawa Yoshiyasu (1658–1714). Nankaku soon joined his staff and became a pupil of Ogyū Sorai (#32), who was also serving Yoshiyasu at the time. In 1718, four years after Yoshiyasu's death, Nankaku left to found his own Confucian academy; he remained close friends with Sorai, and after the master's death he catalogued Sorai's works. More interested in the arts than in philosophy, however, Nankaku became a leading poet and calligrapher in

the Chinese style; he led a gathering of literati in Edo called the Fukyōsha. In addition to publishing several books, including an influential anthology of T'ang-dynasty poetry and a volume of his own literary works, he became one of the pioneer painters in the Japanese *nanga* (literati) tradition, along with Gion Nankai (#40) and Yoshiyasu's nephew Yanagisawa Kien (1706–1758). Nankaku even painted the walls of his house so that he could lie back and let his imagination wander among his creations.

The poems on this pair of scrolls represent festivities during spring and autumn; and as translator Jonathan Chaves has noted, they use a number of allusions to conjure up an atmosphere of courtly feasting: "Five-Horse Prefect" refers to a high official allowed to use a team of five; "Mount Li" is the locale of the magnificent tomb of China's first emperor; "Orchid Terrace" refers to another venue of courtly pleasures in China; and "pearl-studded slippers" were worn by retainers of a feudal lord known for his magnificence.

> The Five-Horse Prefect rides the spring wind, flowers seem to fly,
> Mount Li in the Second Month, vying in perfumed fragrance!
> If he should spend the next ten days getting really drunk,
> No need to ask for friendship from men of cotton clothes!

> A noble feast among autumn colors, rain densely falling;
> Amber cups so frozen we simply can't get drunk.
> In days of old, we've heard of Orchid Terrace ladies, lovely as jade,
> And now we turn to view pearl slippers, guests numerous as clouds!

For these high-spirited poems, Nankaku has filled two tall scrolls with the lively and dynamic cursive script for which he was especially known. The "spring" (right side) scroll begins with the words "five" and "horse(s)" (五馬), each written in two strokes, although in regular script they would require four and ten, respectively. The next two characters, "spring wind" (春風), move in equally free-flowing cursive script, with "wind" completed in the same stroke that ends "spring." The brush also runs dry for "wind," giving this character an appropriately blown-about feeling. The next word, "flower" (花), is much smaller than the first four but has its own visual intensity, achieved by its use of thick black ink and by the compressed composition in which the left side is balanced by a single dot.

In total, we may note five forms of rhythm in this pair of scrolls. The first is the poetic lineation of 7-7-7-7 and 7-7-7-7. The second is the contrasting structure of the columns, consisting of 11-12-5 and 11-11-6 characters, so that only the first word in each scroll begins a poetic line. Third is the irregular pattern of heavier and lighter characters, the latter created by either thinner lines or dry-brush technique. Fourth is the occasional use of running rather than cursive script, such as the three words "mountain second month" (山二月), which end the first column of the "spring" poem. Fifth is the varying size of the characters, a feature of much cursive script. This is especially notable in the sixth and seventh words of the second "spring" column, "ten days" (十日), which are much smaller than the character below them but perhaps even more forceful because of their angular intensity. One might guess that they are smaller because of their relative simplicity, being usually composed of two and four brush strokes, here reduced to a single gesture. The character that combines the greatest force with the largest size, however,

is a two-stroke word usually translated as "man" but more accurately as "person/people" (人), here referring to women, in the lower middle of the "autumn" poem. The first of the two bold diagonal strokes points to Nankaku's signature to the left, while the second angles to the right and forms a roof for the final three words in this column.

Among the many other energetic forms is the character for "ask" (問), the third word in the third column of "spring." This character is made up of a pictograph of a gate (門) under which there is a mouth (口). The entire "gate" form, usually requiring eight strokes, is here done in one subtly nuanced curved line, while two dots below form the "mouth," usually a square three-stroke form. Appropriately, the pair of poems ends with the word "cloud(s)" (雲), which here begins with strong angular strokes and then fades away into space.

34 UNO MEIKA (1698–1745)

Spring in Kitano
Hanging scroll, ink on paper, 23 x 23 cm.

Although born into a merchant-class shipping family in Kyoto, Uno Meika became a well-known Confucian scholar, as did his brilliant younger brother Uno Shirō (1700–1731). Meika at first followed the orthodox Chu Hsi tradition and later was influenced by the ideas of Ogyū Sorai (#32). Before the end of his relatively short life, however, Meika became a leader in a new eclectic school of Confucianism that encouraged students to select the best from various traditions for themselves. His unassuming but firm personal character is fully shown by this small, modest calligraphy in masterful regular script.

Small-scale standard script, the basis for much calligraphy, is often neglected by viewers since it exhibits neither the bold movement of running and cursive scripts nor the antique elegance of seal and clerical scripts. Furthermore, regular script is surprisingly difficult to write with true distinction, perhaps because—as the usual form of printed script—it may at first seem uncreative. Yet well-written regular script can be an art that provides a special pleasure to viewers when they tire of the more flamboyant scripts. At its best, it expresses a pure and subtle flavor that connoisseurs highly value.

The standards for regular script were set in the T'ang dynasty, and most later calligraphers studied the style of at least one of the three greatest masters: Ou-yang Hsun (557–645), esteemed for his structural compositions; Ch'u Sui-liang (596–658), admired for his lighter and more elegant touch; and Yen Chen-ch'ing (709–785), appreciated for his bolder brushwork and more informal style.

The calligraphy here has been written on a square piece of paper in *shikishi* (poem-card) size. Although extraordinarily delicate, the writing exhibits a firmness of structure that makes each character balance perfectly while still seeming to float weightlessly in space. In accordance with the Ch'u Sui-liang

重奉和

清和僧正歲旦韻

上國風光北野春明時偏借

杖朝人白雲自帶青雲色歲

事同塵同賞新

布衣宇鼎頓首拜書

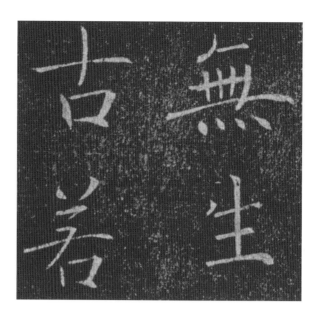

Figure 34.1.
Ch'u Sui-liang
(709–785), *Characters
in Regular Script.*

tradition (fig. 34.1), Meika's writing slightly echoes clerical script, with the line becoming a little heavier on the final horizontals and the diagonals that move down (or lead down) to the right. It is also like Ch'u in that the strokes frequently do not touch each other. The special lightness of touch and the lengthened diagonals, however, are Meika's personal characteristics.

Meika's quatrain praises a retired emperor (the "man-with-cane-at-court"), now a monk, who goes out to celebrate the New Year with common people. Since the imagery implies that the emperor reached eighty years of age, Meika may be referring to Gomizuno-o (1596–1680).

Again Respectfully Echoing the Rhymes of the Poem "New Year's Morn" by the Monk of the Segai-in

Capital country weather, spring comes to Kitano!
Enlightened times, undeservedly shared with this "man-with-cane-
 at-court!"
White clouds naturally tinted with blue-cloud colors:
Yearly festival—mingling in the dust, mingling in celebrating the new![1]

It is a testimony to the mixing of social classes and cultural traditions in Japan's early modern period that this exquisite calligraphy in elegant Chinese, praising a retired Japanese emperor, should have been created by a Confucian scholar born to the merchant class. Merchants were considered to occupy the lowest level of neo-Confucian society, although they increasingly dominated the financial world of the time. Despite the edicts and regulations of the Tokugawa shogunate, the seemingly static society of Japan, largely shut off from the rest of the world, was full of variety. This modest calligraphy by Uno Meika, like many others in this volume, demonstrates that people born to lower levels of society could attain the highest levels of artistic mastery.

NOTE

1. Translation by Jonathan Chaves.

124

Poem on Mount Fuji

Hanging scroll, ink on paper, 171.8 x 53.3 cm.

Ritsuzan, born in Takamatsu (Kagawa province), studied Confucianism with Gotō Shizan (1721–1782), Nakamura Ranrin (1697–1761), and Hayashi Ryūkō (1681–1759). After additional study of *kokugaku* (national learning) in Kyoto, Ritsuzan served the Awa domain as a scholar and teacher. In 1788 he moved to Edo to join the academy run by the Hayashi family (see Hayashi Razan, #27), where he helped strengthen Chu Hsi neo-Confucianism. Ritsuzan seems to have been the main force behind the "Prohibition of Alien Teachings," instituted by the government in 1790, an edict that made it impossible for scholars teaching other forms of Confucianism to attract students (see Kameda Bōsai, #37).

Ritsuzan's strong personality is evident in his poetry and calligraphy; one of his most famous verses praises the mountain that represents his nation:

Mount Fuji

Who took water from the Eastern Sea,
And washed this lovely lotus so clean?
The mountain bestrides three provinces,
A mound of eight petals piercing the skies.
Clouds and mist ring the great foothills like steam;
The sun and moon shun her central peak.
Alone she stands, ever without peer,
The grandest mountain of them all![1]

The poem consists of eight five-character lines, but the format of the scroll shows four columns of 13-12-12-3 characters, followed by the title and signature in smaller script. Once again we have visual counterpoint, in this case with the added feature that the start of the third column of calligraphy also begins the sixth line of the poem ("sun and moon," 日月). The unusual height of Ritsuzan's scroll may suggest the height of the mountain, which is not mentioned by name in the poem but appears in the title on the left. Here "Fuji" is written as *fu-ji* (不二, "not two" or "not second"), a form of praise for the celebrated mountain.

The calligraphy itself is strong, heavy, and confident, well matching the subject of the poem. Using a brush suffused with ink ("wet brush") on highly absorbent paper, Ritsuzan creates an expressive fuzzing of ink as characters begin, especially on the heavy opening strokes. There is still occasional "flying white" when the brush runs dry, as for instance in the seventh character of the first column. When the next word begins with a wet, heavy, short horizontal, it creates a strong contrast that adds to the rhythm of the calligraphy.

Ritsuzan used a variety of scripts. Some characters are written fully cursively, such as the first word of column two, "province" (州), a six-stroke character that is here written in one gesture. Three characters later, however, the word for heaven/skies (天) is written in standard script with four strokes, including even a hint of clerical in its left and right diagonals. Although most

誰將東海水灑出玉芙蓉
容幡地三物老擇天八葉
重雲霞蒸大慈雇日月繞
中峰拂立原無議有為眾
嶽宗

右詠不二山峰

栗山郑元彦

35

of the characters are in running script, the use of some cursive and standard modulates the rhythm of the brushwork—now faster, now slower—within the distinct and orderly spacing of the words. In this scroll, Ritsuzan has celebrated the power and majesty of Mount Fuji, but he has also expressed his personal character.

NOTE

1. Translation by Timothy R. Bradstock and Judith N. Rabinovitch, *An Anthology of Kanshi (Chinese Verse) by Japanese Poets of the Edo Period (1603–1868)* (Lewiston, N.Y.: Edwin Mellen Press, 1997), p. 181.

36 KOGA SEIRI (1752–1817)

Magnolias

Hanging scroll, ink on paper, 124.7 x 48.8 cm.
Harnett Museum, University of Richmond, Va.

Born in Saga in the southern Japanese island of Kyushu, Koga Seiri began his career as an adherent of the Wang Yang-ming tradition of Confucianism, which emphasized personal morality and individual choice, but he later switched to the more orthodox Chu Hsi style of neo-Confucianism favored by the Tokugawa government. Seiri primarily served and taught in his native Saga domain (now Chikugo), where he was also known for his cultural accomplishments. In particular, he became celebrated for calligraphy in standard, running, and cursive scripts; he also wrote an introduction to *So-i*, a four-volume dictionary of cursive script, in 1817, demonstrating his knowledge of Chinese masters and styles.

Here Seiri has written out the "Poem about Magnolias" by Li Shang-yin (813?–858), composed at an informal gathering in Ch'ang-an when Li was challenged to write something about the Chinese magnolia (literally "tree orchid"). Considered one of the great masters of the late T'ang dynasty, Li was also one of the most complex and difficult of all Chinese poets. Although this verse contains fewer ambiguities than many of his works, it includes the Zen-like notion of searching for something outside oneself when it is actually right at hand. Just to confuse the issue, however, this poem is also included in a book of ten thousand quatrains from the T'ang masters, edited by Wang Shih-chen (1634–1711), in which it is attributed to Lu Kuei-men (died c. 881).

> The waves of Lake Tung-t'ing stretch vastly, without limit;
> Day after day, on journeying sailboats, distant travelers are seen off.
> How many times have I gazed upon this scene from my "boat of
> magnolia wood,"
> Not realizing that it was always the body of this flower?[1]

Like many Chinese literati poems, this quatrain has echoes from the past. Li Shang-yin (or Lu Kuei-men) may be referring to the earlier poet

洞庭波浪渺無津日日征

飄飖遠人幾度木蘭舟上

望不知原是此花身

Ch'u Yuan, who wrote about flowers with magical symbolic qualities in his *Ch'u tz'u* (Songs of the South). If it is indeed by Li, he was writing this quatrain in Ch'ang-an, far to the northwest of Lake Tung-t'ing (which is part of the idyllic locale of the *Ch'u tz'u*), so he might have considered himself one of the "distant travelers."

This scroll may have originally been one of a pair, accompanied by a painting of magnolias. In any case, perhaps to compensate for the poem's referential meanings, the calligraphy is straightforward in style and spirit. Although the scroll is now somewhat rubbed and worn, the characters appear in a clear, orderly fashion, with regular spacing from one word to the next. With controlled brushwork, Seiri here organizes the poem in firm columns with a generous span between them. For the sake of variety, however, he moves from regular to running script and, in a few cases, to cursive. One cursive example is the second word in the middle column, meaning "to see off" (送), which is contrasted by the firm and blunt regular-script rendition of "distant" (遠) below it. The following word is "person" (人); these three characters are significant because they may describe the poet, as well as those people he sees at a distance, as a searcher or wanderer (fig. 36.1). Indeed, the lightly brushed and vastly simplified "see off" in cursive script almost seems lost in comparison with the other characters. There is one moment of erudite playfulness in Seiri's calligraphy; at the beginning of the middle column, he substitutes an archaic character combining the graphs for "horse" (馬) and "wind" (風) for the more modern character for "sail" (帆).

The total organization of the calligraphy is also appropriate to the text. The three columns have a different rhythm than the 7-7-7-7 quatrain, containing 10-10-8 characters, with the eight-word line ending with two seals. Since the final two characters of the poem are the interesting and ambiguous "flower body" (花身), which might also be translated "flower self" or "flower itself," the viewer has space, and therefore time, to contemplate their meanings.

A long cultural lineage extends from Ch'u Yuan to Li or Lu, and then to Koga Seiri, who is even farther from Lake Tung-t'ing—except in his poetic imagination. This calligraphy therefore stands as evidence of how thoroughly and deeply the literati world spread its net of imagery, emotion, and beauty for more than a millennium, first from China to Japan, and now to the Western world.

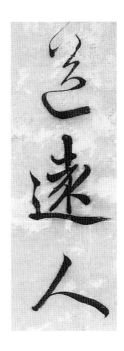

Figure 36.1.

NOTE

1. Translation by Jonathan Chaves.

Old Trees

Hanging scroll, ink on paper, 132.4 x 47.3 cm.

Kameda Bōsai began his career as a Confucian scholar and teacher, and ended it as a free-spirited literatus adept at poetry, calligraphy, and painting.[1] In many ways his life mirrored the changes taking place in Japan during the eighteenth and early nineteenth centuries. For example, his ancestors had been farmers, but his father moved to Edo and managed a shop specializing in tortoise-shell products such as combs (the name Kameda means "tortoise fields"). This move reflects the gradual urbanization of Japan, particularly the growth of the new capital city.

Although education past a primary level was generally restricted to children of the samurai-official class, the gifted young Bōsai studied the Confucian classics with Inoue Kinga (1732–1784) and calligraphy with Mitsui Shinna (#19). In or around 1774, Bōsai opened his own Confucian academy, and over the next two decades he is reputed to have attracted more than one thousand students. However, his form of eclectic Confucianism, stressing individual choice and responsibility, was not popular with the shogunate, which preferred the loyalist doctrines of the Chu Hsi school. Bōsai's proposals in 1781 for governmental improvements were ignored, and in 1790 the regime issued a "Prohibition of Alien Teachings" that severely criticized the eclectic school. Bōsai kept lecturing for seven years, but he gradually lost his pupils because they could not secure official positions without the proper pedigree. He finally closed his academy in 1797.

For the final three decades of his life, Bōsai wrote scholarly works, composed poems, traveled, painted, and above all became celebrated for his calligraphy. An extended journey to the northwestern Niigata region of Japan in 1809–1810 allowed him to meet and befriend the Zen monk-poet Ryōkan (#76), whose free cursive script had an influence on Bōsai; indeed, Ryōkan might have been the reclusive monk who forms the subject of the quatrain in this scroll:

> Old trees are imbued with the face of spring;
> Cold waterfalls arouse mysterious reverberations.
> I am thinking of a mountain hermit
> Who can appreciate the wind and dew without restraint.

The poem, in four lines of five characters each, is written in columns of 8-7-5, with the signature "Bōsai" and seals completing the final column. Although cursive script is sometimes thought of as rapid and relatively unstructured, this calligraphy shows a great deal of structural "bone" as well as surface "flesh"; the movement of the brush is sometimes quick, sometimes slow, with curved strokes alternating with straighter and blunter lines. If we compare the first words in each column, for example, we see a freely structured "old" (老) at the top right spiraling down to the next word, "trees" (樹), contrasting with an architectonic "mysterious" (幽) in the center column and a flowing "wind" (風) on the top left.

The most significant three words in the calligraphy, however, are those that end the central column, "mountain amid person" (mountain hermit, 山

中人). These characters were originally pictograms: "mountain" is composed of a central peak with a smaller peak on either side, "amid" is a rectangle cut in half with a vertical stroke, and "person" represents a basic stick figure with two legs. In this scroll, the "mountain" seems to bounce upward, the "amid" curls around and sweeps down, and the "person" creates a strong base. Although all three *kanji* are simple rather than complex (taking only three, four, and two strokes in regular script), Bōsai gives them extra space so the movement of the calligraphy can broaden out at this crucial structural point, the lower part of the middle column.

The signature of the artist is usually much smaller in size than the other characters, but here the two *kanji* are almost as large as all but the pair to their right. *Bō* (鵬) is the graph for "phoenix," made up of three vertical divisions: "moon" (月) on the left, another "moon" in the center, and "bird" (鳥) on the right. Bōsai here joined the three as though they were leaning upon each other, while the *sai* (hall, 斎) beneath them has a strong "roof" radical at the top but then begins to deconstruct below. Both are complex characters, requiring nineteen and fourteen strokes in standard script; but as often happens in signatures, they are here presented with considerable idiosyncratic verve. If we examine a signature from a forgery of Bōsai's calligraphy (fig. 37.1), we can see by comparison that Bōsai's genuine cursive script does not merely bend and twist like limp spaghetti but maintains a lively balance between fluency and architectural strength.

Figure 37.1. Forgery of Kameda Bōsai's signature.

NOTE

1. For more information on Bōsai's life and reproductions of his painting and calligraphy, see Stephen Addiss, *The World of Kameda Bōsai* (New Orleans Museum of Art, 1984).

38 RAI SAN'YŌ (1780–1832)
The Ballad of Sanjō Bridge
Hand scroll, ink on decorated paper, 15.6 x 43.8 cm.

One of Japan's major literati artists of the early nineteenth century, Rai San'yō came from a noted Confucian family. His father Rai Shunsui (1746–1816) and his uncle Rai Kyōhei (1756–1834) were both well-known teachers, but as a youth San'yō was rebellious. After studying for a year at the Hayashi Confucian academy in Edo, he returned to his family home in Aki, Hiroshima, where he led a dissipated life. An arranged marriage to a young bride failed, and in 1800 he left Aki without official permission, a serious offense at the time. Caught in Kyoto, he was returned for three years of house arrest in Aki. During this time he began his unofficial history of Japan, *Nihon gaishi*, which he finally completed in 1827. His emphasis on emperors rather than shoguns became popular with literati, but not with the Tokugawa government. San'yō's son Mikisaburō continued the anti-shogunal movement and was beheaded in 1859.

Beginning in 1811, most of San'yō's career was spent as an independent scholar-artist in Kyoto, where he was extremely active in practicing and promoting Chinese-style poetry, calligraphy, and painting. Traveling extensively and meeting with like-minded scholars and artists, he became the close friend of Shinozaki Shōchiku (#44) and the teacher and would-be husband of Ema Saikō (#45).

Because Kyoto's Sanjō Bridge leads in and out of the ancient capital, it is a symbol of many historical moments in Japanese history. In this long poem, San'yō praises the two pre-Tokugawa shoguns who reunited Japan, Oda Nobunaga (1534–1582) and Toyotomi Hideyoshi (1536–1598), especially noting Hideyoshi's construction of Sanjō Bridge and his subduing of the far north in 1590. By praising these two shoguns, San'yō was directly criticizing those who had neglected or derided them; in an indirect way he was perhaps also criticizing the Tokugawa government of his own day.

The Ballad of Sanjō Bridge

Sanjō Bridge—ah! The road to the Seven Circuits.
Folk who live in the sixty provinces flock here like ducks.
The Kamo River suddenly rises, banks about to burst.
But this bridge stands proud and tall, its rock foundations firm.
Look at the stone plinths all along the bridge—
They go into the ground to a depth of five *jin*.
Those carved dragons never decaying, cast of the finest copper.
Who was it who constructed this? Lord Toyo[-tomi] was his name.
'Twas in the eighteenth year of Tenshō [1590], the *kō-in* cyclical year.
In the springtime, the first month, the project was completed.
Inscribed words, ten lines long, the characters still fresh.
Damming the flow, they dug out the flood-dragons and water-lizards
 from their holes.
They flogged the stone, extracting its blood—who among them shrank?
According to the historical records, it was the third month of the year
That our sterling lord received an edict to join the Eastern Expedition.
At that time, the chariots of war had just begun to move.
The pennants and halberds that he took up were as vast as the back of
 a whale.
The cavalry and foot-soldiers numbered 150,000 men.
Armor and lances shone in the sunlight—oh, so very bright.
One can visualize their false whiskers, which lent them martial
 splendor.
The panorama!—they packed the bridge, spilling out onto Kujō-dori
 [Ninth Avenue]!
In their eyes, the Eight Provinces simply did not exist;
To the armies who chased down the enemy, those troops were but slaves
 and lackeys.
The road to the "maggot states" had for ages been impassable;
[But] with his hand holding the ceremonial sword, he cut his way
 through the brambles.
Afterwards, with their bearskins and their arrows made from reeds,
They all assembled on the east side of the Sanjō Bridge.

Don't you see how all these men put the world in order?
Several lords working together,
Jointly achieving peace!
For the Great Wall, the men of Han depended upon Emperor Ch'in.
For the Kaifeng ramparts, the men of Sung relied upon their Chou
 ancestors.
In military campaigns one is not without the achievements of previous
 ages;
Otherwise, the historical records would all have been destroyed.
How is it that vulgar Confucianists and men of a petty stripe
Could perversely want to vilify O-[da] and Toyo-[tomi]?
Anyone who has fixed his attention on reading the words inscribed,
Would surely notice the enduring hoof-marks and wheel ruts east
 and west.
I have come to lay my hands on the bridge and tarry here awhile;
The sound of the water against the pillars is speaking to me now.[1]

San'yō writes out his poem in twenty-five columns, with an average of eleven characters per column, on paper decorated with a plant motif in gray-blue. He uses small, running-cursive script, with variations of thicker-thinner and heavier-lighter brushwork. San'yō stresses the opening of the poem, which begins with the same three words, "San-jō Bridge" (三条橋).

Although the size and format of the hand scroll is modest, the calligraphy reveals an individual personality. Character sizes vary, for example, with a few vertical strokes extended downward; one such example concludes the fifth column of the poem: the three characters "eighteenth year" (literally: ten-eight year, 十八年). The total effect of the fluent calligraphy is to emphasize the ballad nature of the text, inviting the viewer to tarry with San'yō at the famous bridge, enjoying his story and listening to the sound of the river.

NOTE

1. This translation was graciously provided by Timothy Bradstock and Judith N. Rabinovitch.

Calligraphy by Literati Poets and Painters

The support of the Tokugawa government spawned an ever-increasing number of Confucian scholars and followers. However, many of these turned their primary attention away from Chinese philosophy and ethics to devote themselves to the study and practice of poetry, calligraphy, and painting in the Chinese style. The latter was called *nanga* (southern painting) or *bunjinga* (literati painting), and its practitioners *(bunjin)* were often equally skilled in calligraphy and poetry. In some ways it is surprising that Japanese literati painting did not take hold earlier, since it was well established in China by the twelfth century; but after a small proto-literati movement in the fourteenth century,[1] it was not until the early modern era that the cultural climate was ripe for Japanese painters to emulate their Chinese poet-painter colleagues.

The way into the literati world was led by Ishikawa Jōzan (1583–1672, #39), a warrior-scholar who retired early to a villa and garden of his own design, where he could admire Chinese poets of the past and create distinctive verse and calligraphy of his own. Jōzan particularly excelled at clerical script, which had been little practiced in Japan before his time but perfectly suited his reverence for the Chinese past as well as his personal sense of elegance.

Chinese-style poetry and calligraphy were seriously practiced for some decades before painting was taken up by the new Japanese literati. It was not until the end of the seventeenth century that Sinophile scholar-artists began to depict subjects such as landscapes and the "four gentlemen" plants: bamboo, orchid, plum, and chrysanthemum. Each of these was considered symbolic of some sagelike behavior or characteristic.[2] The leading pioneer of Japanese literati painting was Gion Nankai (1676–1751, #40), but he was more celebrated for being an outstanding calligrapher and the finest Chinese-style poet of his era. Because painting subjects such as bamboo required brushwork much like that of calligraphy, Nankai was able to move fluidly from one art to the other; however, his paintings are far outnumbered by his calligraphies, which are usually of his own poems but occasionally utilize a Chinese verse.

The next generation of Japanese literati artists included Yosa Buson (#48), who was also a major haiku poet, and Ike Taiga (1723–1776, #41), a child prodigy who became one of the most inventive painter-calligraphers in Japanese history. As a youth Taiga was taken to meet the Ōbaku monks at Mampuku-ji, whom he impressed with his lively spirit and great skill with the brush. These visits also gave the precocious artist an opportunity to observe the Chinese customs and artifacts at the temple, which was a bas-

tion of Chinese culture during an age when foreigners generally were not allowed out of Nagasaki. Occasional visits of Korean embassies were another exception to this rule, and Taiga followed Nankai's lead by interacting with members of the Korean literati who traveled with these missions. Unable to speak each other's languages, their primary contact was through written Chinese, which of course means calligraphy. Throughout his life, Taiga was interested in many brushwork traditions and styles; when he sold fans as a young man, he is said to have kept his account books in seal script.

A generation later, the confluence of literati arts reached another high point with Uragami Gyokudō (1745–1820, #42). Born into the samurai-official class, he studied the seven-string zither (ch'in), an instrument loved by sages and poets, and became one of the few Japanese to compose his own music for this instrument. He also published two volumes of kanshi (poetry in Chinese) and developed a style of calligraphy all his own, featuring creative variations of running and clerical scripts. Giving up his official position after his wife died, he traveled through Japan with his ch'in and gradually turned more and more to landscape painting in a style that is highly appreciated today, though it was too individualistic for most people of his own time. Subtle but unmistakable features connect his music, poetry, calligraphy, and painting—constantly shifting patterns, tones, and touches, all within the refined aesthetic of the ch'in.

By the mid-nineteenth century, bunjin painting and calligraphy had become established forms of art, especially in the old capital of Kyoto, where Gyokudō lived his final years, and the new capital of Edo, where Kameda Bōsai (#37) wrote and painted. Another form of art associated with the literati was sencha, a Chinese-derived style of tea presentation. The small pots and cups for this form of steeped tea were occasionally inscribed with kanshi, such as one porcelain set enhanced by verses in red glaze by the leading Kyoto calligrapher, Nukina Kaioku (1778–1863, #43). We can imagine a small group of convivial bunjin gathering together, sipping tea, and discussing poetry and calligraphy.

Literati artists added calligraphic inscriptions to paintings, whether their own or the works of friends, and calligraphy was also occasionally written to accompany a previously painted work. One example is a poem by the Kyoto literatus Shinozaki Shōchiku (1782–1851, #44) that was composed to form a pair with a landscape painting by the nanga artist Sugai Baikan. Unfortunately, the painting is lost; but the calligraphy survives to testify to the lively interaction between arts during this period and to reveal Shōchiku's skills in poetry and brushwork.

More personal uses of calligraphy were also frequent, especially since one literati ideal was to create art as the natural outpouring of one's spirit. Rai San'yō's pupil and close friend Ema Saikō (1787–1861) became a noted painter-poet-calligrapher, and as she reached the age of fifty, she wrote a poem about her life on subtly decorated paper (#45). Her poignant and slightly rueful feelings are expressed both in words and in the calligraphy, which conveys her own personality and breath rhythm.

Another leading member of the Kyoto literati in the mid-nineteenth century was Yanagawa Seigan (1789–1858, #46). Like San'yō, he supported the cause of the emperor over the shogunate, and at the time of his death he was about to be arrested for his political outspokenness. Seigan's calligraphy

shows the forceful temperament that got him in trouble with the authorities, although his brushwork seems more bold and dynamic than subversive.

Examining these works from the early seventeenth to the later nineteenth centuries, one sees many common features in literati calligraphy, including an interest in different scripts and styles. For example, Jōzan and Gyokudō both worked often in clerical script, although running script seems to have been the most popular among poet-artists. What is consistently notable is the emphasis upon personal expression more than adherence to rules. Some works by literati are especially hard to read, in fact, because of unusual character forms and stroke order; however, Japanese poet-artists for the most part adhered to Chinese traditions.

Admiration for Chinese masters and styles by Japanese calligraphers was genuine, as is attested by the many woodblock books of Chinese works they edited and published. Nevertheless, the literati of the island nation never hesitated to transform their continental models into vehicles for individual artistic expression. This combination of appreciation and transformation makes calligraphy by poet-painters among the most creative of Japanese arts from the early modern era.

NOTES

1. For example, aside from Zen themes, there was a brief interest in depicting the literati subjects of bamboo and orchid by such monk-artists as Gyokuen Bompō (c. 1348–c. 1420), but the interest soon shifted to a semiprofessional style of landscape painting that culminated in the work of Sesshū (1420–1506).

2. Bamboo bends but does not easily break; plum trees blossom during the cold of late winter; (Chinese) orchids are modest plants that send their scent out to the world; and chrysanthemums continue to flower in late autumn when other plants have shriveled up.

Draft in Clerical Script

Hand scroll, ink and red ink on paper, 27.8 x 208.8 cm.

The world of the literati in Japan was developed and, to an extent, defined by Ishikawa Jōzan. Coming from a family of warriors, he was lauded for his part in the famous battle of Sekigahara in 1600, in which Tokugawa Ieyasu (1543–1616) unified Japan under his rule. This must have been heady praise to a young man of seventeen; but twelve years later when he was offered a position as personal retainer to one of Ieyasu's sons, he declined in order to lead a more independent life. Eventually, and not without difficulty, he left the shogun's service entirely, retiring to the Kyoto Zen monastery of Myōshin-ji. His interest did not lie in Zen, however, so much as in Chinese literature and culture, which he studied assiduously. When his mother became ill, he took on another post as a retainer for a feudal lord to support her; but after she died in 1635, he returned to Kyoto. In the hills above the old capital, Jōzan built a retreat that he named the Shisendō (Hall of Poetic Immortals); there he installed portraits of famous Chinese poets, cultivated his garden, and devoted himself to poetry and calligraphy in the Chinese style.[1]

Jōzan was the first Japanese calligrapher to focus primarily upon clerical script. Although clerical script had been known in Japan earlier, no one had developed and mastered it as a personal script. Why, then, did it appeal to him so strongly? Probably because of its flavor of antiquity, and perhaps its rarity as well. The fact that it required special attention to the total character composition, with every stroke written separately, also fascinated Jōzan. In any case, his clerical script set him apart culturally, just as his rustic retreat did physically.

Jōzan maintained friendly relations with Sinophile scholars, especially Hayashi Razan (#27). At one point, very likely when Jōzan built the Shisendō, Razan and his younger brother Nobuzumi (1585–1683) sent six presents to Jōzan (each with a poem): a Buddhist monk's bamboo *nyoi* scepter, a whisk of palm tree hair, an armrest, a wooden "K'un-lun Mountain" style incense burner, an iron vase, and a "Duke Mei" *ch'in* (a zither that had belonged to the important Chinese scholar Ch'en Chi-ju, 1558–1639). These were indeed magnificent literati gifts and were highly treasured by the recipient; in his portraits, Jōzan is seen leaning on the armrest and holding the scepter or the whisk.[2]

In this scroll, Jōzen is preparing a reply of thanks to the Hayashi brothers, beginning with a long prose section in which he compares each object to a gift received by a famous recluse of the past. He then writes an elaborate poem with recondite references, here translated by Jonathan Chaves:

"As You Like It" scepter, elbow-rest, iron flower vase:
I would not exchange them for a hundred treasures—all are superb!
Old *ch'in*, fly-whisk, wooden K'un-lun incense stand:
The Nine Tripods are nothing to them! I'm at a loss for words.
And the poems about these six gifts are worth thousands in gold:

其詩四

肆意隳几砂礪鈍百寶不換皆稱

善古珽棱拂木崑崙九鼎愈輕難

具展六器郭謡直千金二妙胄

膽書萬卷元方同行歲季方德瑾

卿穌睦休璉鄒壤驤壇設雅論鳴

簫瓶圍彈故典淡濃肥瘠筆縱橫

前後長短辟乖篤災星轄旗云粲

熒辯瀾瀁湯勢河污交狙龐融過

茫懷才府軾甶念天顯幽林竅谷

陸沈淹唉苑談叢世緣淺世景迅

速嘆頹頹冠信遲迴恨邐緬更出

正寓書一封望無邊裏層巘巀

悄詩篇渾漫興愛情伊心使鬢撚

39

You two wonders within your hearts hold ten thousand volumes
 of books!
Yüan-fang and his brother—cherishing Chi-fang!
Te-lien full of harmony—close to Hsiu-lien!
Playing the *hsün*-ocarina, on the altar of poetry establishing elegant
 discourse!
You set singing the *ch'ih*-flute, in the garden of arts fulfilling the classics!
Pale or dark, full or sparse, your brushes freely move;
Former and latter, longer, shorter, your phrases always outstanding.
The Star of Letters moves through your work, praised as scintillating;
The richness of argument overflows, so vast in power!
This friendship, like that of Ni Heng and K'ung Jung—
 communicating oldest feelings;
Talent like that of Su Shih and Su Ch'e—it must be Heaven sent.
In hidden forests, concealed valleys, utterly buried away;
In the gardens of humor, the copses of banter, your worldly ties are few.
But time flies by, and I lament that I am fading:
News from you has been slow to come; alas, you are so far!
Feelings of the countryside—I would send a sprig of plum blossom,
But as I gaze out at the vastness, limitless are the snow-covered peaks!
I feel ashamed that this, my poem, is so slapdash in feeling:
But who could I get to twist his poet's beard, and write it for
 me instead?[3]

The poem is, of course, anything but slapdash in feeling, and the calligraphy demonstrates Jōzan's meticulous clerical script. What makes it especially interesting is that it includes his corrections, written in red. Usually these are changes of words or additions to the text; but in a few cases he also corrects the composition of the characters, fully demonstrating the care he took in making his calligraphy as handsome and elegant as possible.

The hand scroll is extremely well organized, with thirteen words per column, each character being given equal space. As is typical for clerical script, the *na* stroke �‿ is the most notable form, made either horizontally or diagonally down to the right. When the brush increases and decreases pressure near the end of this stroke, the line thickens and then thins evenly to a point, creating a triangular form; Jōzan handles this firmly but does not exaggerate the effect. This scroll testifies both to his love of the Chinese literati tradition and to his determination to create a place for himself within it. In many ways Jōzan became Japan's first complete Chinese-style literatus.

NOTES

1. For a full discussion, see J. Thomas Rimer et al., *Shisendo: Hall of the Poetry Immortals* (New York: Weatherhill, 1991).

2. Ibid., pp. 181, 195; the *ch'in* is shown on p. 185.

3. This poem is full of allusions to famous brothers and auspicious ancient music. Yüan-fang and Chi-fang (Ch'en Chi and Ch'en Shen) were siblings famous for rivaling each other in literary talent during the late first and early second centuries. Te-lien and Hsiu-lien (Yin Tang and Ying Ch'u) were also famous literary brothers, living and writing in the third century. The *hsün* and *ch'ih* were archaic musical instruments representing the beauty of antiquity, while Ni Heng, of the second century, was a celebrated and eccentric drummer. Su Shih (Su T'ung-po, 1037–1101) and Su Che (1039–1112) were the most brilliant literati brothers in Chinese history.

Autumn View

Hanging scroll, ink on paper, 126 x 41.4 cm.

An Autumn View from a Boat on the Ki River

The waves enfold their pure white silk, the wild geese come down
 in pairs,
Here in the boat of Li and Kuo, wine now fills our jars.
Gulls and egrets already have forgotten the seaside visitors;
As for perch, what need to go to River Wu?
Through evening bell and drizzling rain, the travelers strive to cross;
Red smartweed and white duckweed fill autumn stepping-stones.
Fishermen's flutes waft on the wind—the tunes play without cease;
On view of sandbanks and new-risen moon, we open cabin windows!

If Jōzan was the first full-fledged Japanese literatus in Chinese style, Nankai was the pioneer poet-calligrapher-painter who brought these "three treasures" to a high level. While others had mastered poetry and calligraphy, Nankai added the painting of literati subjects such as landscapes and "four gentlemen" (bamboo, orchid, plum, and chrysanthemum) themes, which required brushwork much like that of calligraphy.

Nankai was the son of a doctor who served the daimyo of Kishū (Wakayama); his father had been friends with Ōbaku Zen monks and received the seal of enlightenment from Tetsugyū (#62). As a young man, Nankai studied Confucianism in Edo with Kinoshita Jun'an (1621–1698) and quickly became known for his Chinese-style poetry; but when he returned to serve his Kishū domain he got into trouble for "dissipated conduct," and in 1700 he was banished to a fishing village. A decade later, his skill in poetry and calligraphy would help to restore his standing: the visit of a delegation of Korean officials to Japan was approaching, and one of the few ways to communicate with them was through Chinese literati arts. Nankai was officially pardoned in 1710 in time for the delegation's arrival in 1711, and the following year he returned as a retainer to the Kishū daimyo.[1] The rest of his life was more peaceful; he developed his brushwork in calligraphy and painting while continuing to write poetry, usually choosing "regulated verse" of five or seven words per line.

Composed in fluent running-cursive script, this calligraphy pauses near the end of the first column for the two words, "boat within" (舟中), that set the main theme of the poem; these two words also appear at the end of the title, on the far left just over the signature. The eight lines of seven *kanji* are divided into columns of 12, 14, 15, 14, and 1; the final character of the poem is followed by the eight-word title and three-word signature, giving the final column a total of twelve characters. This arrangement creates an arch shape (12-14-15-14-12) that is saved from too much consistency by the differing spatial breaks in the opening and closing columns. The counterpoint of seven-word poetic lines against this structure is strengthened by Nankai dipping his brush for the first character of each poetic line, though he does so other places as well, such as for the word "autumn" (秋) near the end of the central

渡淼淼柳依依雁雙雙、李郭舟中漁

海紅露語已能言海雲能真タ呂四

吳江瞋雉徐テ人ラ渡孤鶩白萩秋一

座漁笛風氣弘る街江汀新月撚蓬

宏秋日堂於紀川舟中 祝渡瑜

column. "Autumn" is followed by the single-stroke character "one" (一), here relatively small but exhibiting great strength in its cell of empty space.

Nankai's expressive brushwork is entirely natural, showing a great deal of individual flavor without striving for effect. Some of the more interesting individual characters are the third and fourth words of the fourth column, the firmly structured "flute" (笛) followed by the flowing "wind" (風). These individual graphs, however, are fully integrated into the total rhythm of the scroll, in which a sense of continuity is created by not allowing much space between words or columns. The calligraphy therefore becomes a shifting mosaic in which the forms flow like waves, enfolded on white paper rather than the silk of sails. Nankai is today best known as the first major *nanga* (literati) painter, but his poetry and calligraphy form the inner core of his art.

NOTE

1. For more information, see Stephen Addiss, "Shadows of Emotion: the Calligraphy, Painting, and Poetry of Gion Nankai," *Kaikodo Journal*, Autumn 1998, pp. 9–29.

41 IKE TAIGA (1723–1776)

Couplet on a Fan

Fan, ink on mica paper, 17.6 x 48.9 cm.

Perhaps the most naturally talented and central figure in *nanga* (literati painting), and equally gifted in calligraphy, Taiga lived a free artistic life in Kyoto with his wife, Gyokuran (#9). Known as eccentrics, they seem to have cared little for worldly things; many anecdotes report that the couple devoted themselves to nature and the arts rather than pursuing money, reputation, or acclaim.[1]

Taiga was a prodigy in brushwork; as a child he was taken to demonstrate calligraphy for the Chinese and Japanese Ōbaku Zen monks at the monastery of Mampuku-ji. As a mature artist, he combined equal parts of imagination and creativity, mastering many kinds of brushwork (as well as painting with his fingernails) and becoming expert in all five Chinese scripts as well as Japanese. His visit to the elder literatus Gion Nankai (#40) greatly encouraged Taiga, who went on to become friends with many of the leading literati of his day. Taiga also composed some underrated *kanshi* and *waka*, but for his calligraphy he usually chose well-known verses from the past.

Both Taiga and Gyokuran excelled at painting and writing on fans, particularly enjoying the effects of slow-drying or merging ink when using a mica surface. In this case, Taiga has written out a couplet by Sung Chih-wen (656?–712) of 7-7 words in nine columns across the curving surface.

Layered peaks: from of old, here grow trees, thousands of feet tall;
Distant ravines: from the origin, here fly waterfalls, hundreds of
 fathoms high.[2]

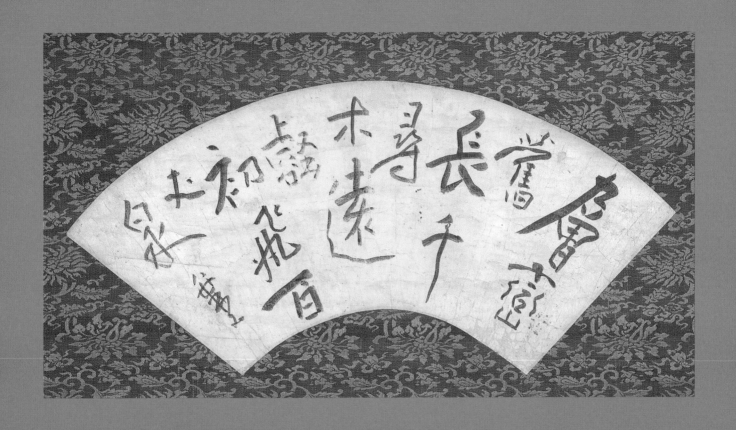

This couplet comes from a long poem entitled "Dragon Gate: Composed in Response to Imperial Command," in which Sung Chih-wen responded to Empress Wu Tse-tien during an excursion to the great Buddhist site of Lung-men (Dragon Gate). The empress, having commissioned an immense Vairochana Buddha sculpture for the largest cave at this site, commanded her courtiers to compose a poem, offering the prize of an embroidered robe for the poet who finished first. Tung-fan Ch'iu won this honor and recited his verse, but before he had time to sit down, Sung Chih-wen presented his poem. Since it was clearly superior, the robe was whisked off Tung-fan's back and placed on Sung's shoulders.

Choosing regular script with occasional traces of running script, Taiga has divided the two lines into irregular columns of 2-1-2-1-2-1-3-1-1, creating a visual counterpoint with the 7-7 word poem. Taiga enhanced this rhythmic diversity by dipping his brush for the first and tenth words, rather than at the beginning of each poetic line. Lest the poetic parallels be lost, however, these first words are the largest—"layered" (層) as column one, word one, and "distant" (遠) as 5/2. Appropriately, "layered" is constructed as a series of vertically stacked forms, while "distant," in gray ink tones, appears farther away.

Taiga's brushwork at first seems more plain and rustic than elegant. A few strokes stand out, however, such as the long diagonal descending to the left on the first word and the wriggling vertical that completes "thousand" (千, 3/2). Taiga's characteristic sense of invention is equally visible in the composition of other characters. "Long/length" (長, 3/1), for example, has a jaunty opening hook, the strokes seldom touch, and the entire graph seems to be in profile facing to the right. "Hundred" (百, 7/3), on the other hand, opens with a powerful horizontal, under which the rest of the form huddles on the right. This should make the character unbalanced, but the way it supports the two words above it, while following the curving shape of the fan, allows the horizontal stroke to act more as a catapult than a seesaw. The final word, "waterfall" (泉, 9/1), made up of "white" (白) over "water" (水), completes the composition with a curving diagonal to the right (opposite to that of the first word), under which Taiga adds his ironic signature, "no-name" (無名), in smaller running script.

This is exactly the kind of calligraphy that literati have most enjoyed creating and viewing. Beneath its straightforward, almost naive facade, there is a great deal of inventiveness, skill, and visual drama. The calligraphy dances boldly to Taiga's own quirky but confident rhythm; and his combination of childlike playfulness and technical mastery makes his brushwork unique.

NOTES

1. For biographical information on Taiga, see Mori Senzō, *Mori Senzō chosaku-shū* (Collected Works of Mori Senzō), vol. 3 (Tokyo: Chūō Kōron, 1971), pp. 5–156, and Melinda Takeuchi, "Ike Taiga: A Biographical Study," *Harvard Journal of Asiatic Studies* 43, no. 1 (June 1983): 141–186.

2. Translation by Jonathan Chaves.

Evening View

Hanging scroll, ink on paper, 22.2 x 21.4 cm.

Although Taiga may have been the most gifted of all Japanese literati masters, excelling in a wide range of painting styles and calligraphic scripts, Gyokudō was the most focused and perhaps deepest in expression. Born to a samurai family serving the daimyo of Okayama, he accompanied his lord for the required yearly attendance in Edo, a method that the Tokugawa government utilized to keep watch over any potential political or military unrest. In the new capital, Gyokudō studied and practiced the literati arts of poetry and calligraphy but most of all enjoyed the music of the seven-string *ch'in*, the Chinese instrument favored by sages and poets for its soft, low, subtle, and meditative tones.[1]

As he mastered the instrument, Gyokudō became one of the few Japanese to compose his own music for it, reviving a form of early court singing called *saibara* in a manner that combined Chinese and Japanese aesthetics. For example, he used the variety of touches on the instrument that Chinese *ch'in*-players had developed, but he added asymmetrical rhythmic phrasings that were Japanese in spirit. During this time, Gyokudō published a book of his compositions as well as two volumes of his Chinese-style poetry. He seems to have been more interested in artistic pursuits than his official duties, and at the age of fifty, his wife having died, Gyokudō resigned his hereditary position to become a wandering literatus. He spent seventeen years traveling through nature, visiting friends, playing music, writing poems, and painting his own vision of trees, mountains, and waters with powerful brushwork that few people of his own day understood. His final decade was spent in Kyoto with his painter son, Shunkin (spring *ch'in*, 春琴, 1779–1846).

In calligraphy, Gyokudō was the first literatus since Ishikawa Jōzan (#39) to make a specialty of clerical script, but he also developed a personal style in running script. His outstanding characteristic is rhythmic diversity through changes of touch, leading to a subtle sense of movement within highly disciplined structures (much like *ch'in* music). He combined outward formality with inward energy; here, for example, the columns respectfully follow the lines of the 7-7-7-7 word quatrain, but the calligraphy is full of life.

> Green mountains, red leaves, an evening view—
> White hut, no people, autumn colors chilly.
> Suddenly I see on my paper window the shadows of twisting pines;
> One sliver of new moon has risen above the balustrade.

Instead of creating a counterpoint between lines and columns, Gyokudō develops his rhythmic tension through the different sizes, weights, and constructions of the characters. For example, while the first word ("green," 青), is large and heavy, the second ("mountain," 山) is small and crisp. The smallest of all graphs here is "rises" (上, 4/5), but its strong form and heavy ink make it in some ways the most substantial of the entire calligraphy. This word received a new dipping of the brush, which we can also see on characters 1, 3, and 5 in the first column, 1 and 5 in the second, 1 and 3 in the third, and 1 and 5 in the fourth. Gyokudō has thus created an irregular pattern in

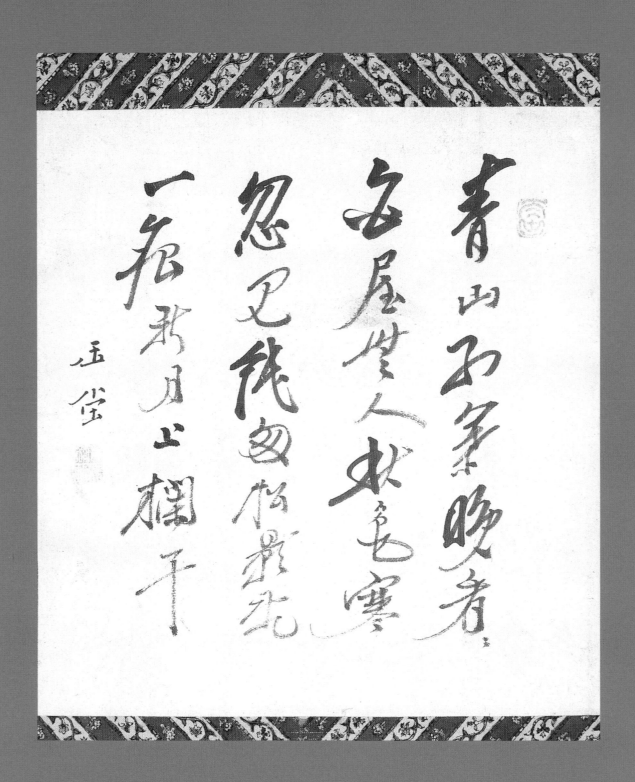

青山不厭晚看
白屋雙人我意寒
忽見倦鳥迴枝光
一卷秋月上欄干

正堂

which, reading horizontally, the top row of words are all emphasized but the stronger characters below them give a sense of movement that ebbs and flows across the surface of the poem.

In addition to these rhythmic changes, Gyokudō has used different scripts and varying forms of brushwork in this calligraphy. Some words are fully cursive, such as "red" (紅, 1/3), while others are written in regular-running script, for example, "chilly" (寒, 2/7). Even more apparent is how some strokes are emphasized, including long swirling diagonals to the left in words such as "view" (看, 1/6), "hut" (屋, 2/2), and "moon" (月, 4/4), as well as "chilly." The left diagonal in "autumn" (秋, 2/5) is balanced by the opposing diagonal above it in "person/people" (人, 2/4), but in general the calligraphy has a strong slant up to the right and down to the left.

Another feature of this calligraphy is its occasional use of "hidden tip," where the brush circles around both ends of a stroke. Gyokudō then contrasts this style of brushwork with "open tip," where one may clearly see the entrance and exit of the brush. This appears in many characters, including "person/people" and the consecutive characters "new" (新, 4/3) and "moon." "Hidden tip" tends to add a formal sense of pause to a work, while "open tip" conveys a feeling of spontaneity and movement.

When writing in clerical script, Gyokudō follows an even stricter sense of structure but continues his subtleties of brushwork (fig. 42.1). For example, the triangular "na" ⟍ stroke endings are all different from each other, variously longer, shorter, thicker, thinner, straighter, more curved, more diagonal, or more horizontal in composition.

In addition, the same kinds of rhythmic asymmetry displayed in the running script poem can be seen here in the heavier and lighter characters dancing across the square format. These varied touches with the brush give Gyokudō's writing a distinctive and personal sense of movement. His early training in music is apparent; like his calligraphy, the sounds of the *ch'in* are restrained and subdued, yet constantly changing in tone and touch.

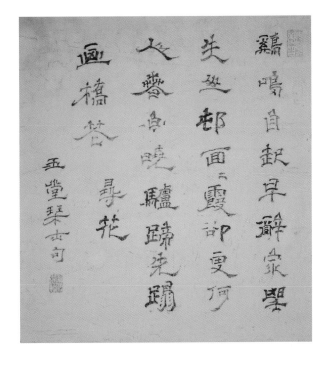

Figure 42.1.
Uragami Gyokudō,
Searching for Blossoms.

Placed to the right of the signature, beneath the final word of the poem, is the poem's title, "Searching for Blossoms."

The cock crows, I rise and leave the house early,
In every direction the mountain village is lost in mist;
And yet someone is already out in this spring dawn—
A donkey's hooves have stamped fresh flowers on the painted bridge.

—Gyokudō the *ch'in*-player

In these two works of calligraphy, it is clear that whether plucking silk strings or wielding a brush, Gyokudō creates a musical rhythm all his own.

NOTE

1. For more information on Gyokudō's life and arts, see Stephen Addiss, *Tall Mountains and Flowing Waters: The Arts of Uragami Gyokudō* (Honolulu: University of Hawaii Press, 1987).

43 NUKINA KAIOKU (1778–1863)

Poems on Sencha Set (1859)

Red glaze inscriptions on teapot, 7.6 x 13.7 cm., and on five cups, 3.6 x 8.1 cm.
Porcelain by the fifth-generation Waki Kitei (1808–1871)

Although the tea ceremony, *cha-no-yu,* has become well known in the West, another form of tea was also practiced in Japan's early modern period. *Sencha,* steeped tea to be served in tiny cups rather than powdered tea whisked in tea bowls, represented Chinese literati culture to Japanese poets and artists.[1] Stimulated by the arrival of Ōbaku monks from China in the mid-seventeenth century, *sencha* has maintained a place in Japanese culture to the present day. Although there are more than one hundred schools of *sencha* with different traditions, in general their rituals are less formal than those of *cha-no-yu*. Nevertheless, the appurtenances of *sencha* are highly valued, and both Chinese and Japanese ceramics have been used for the gatherings of cultivated Sinophiles. In terms of its place in society, to some extent *sencha* might be compared with *kanji* calligraphy as opposed to writing in Japanese *kana*.

Nukina Kaioku, born to a samurai family in Shikoku, was given a thorough Confucian and artistic education. As a young man he also served at the Shingon sanctuary on Mount Kōya, where he received Buddhist training and investigated the calligraphy of Kōbō Daishi (Kūkai, 774–835). An ardent traveler, Kaioku first taught in Osaka but then settled in Kyoto; his many journeys included one in 1836 to Nagasaki, where he studied briefly with a Chinese calligrapher. During his life he attended many *sencha* gatherings and assembled an extensive collection of *sencha* objects as well as more than eleven thousand scrolls of literati painting and calligraphy. By the time of his death, Kaioku was considered one of the major literati poet painters and the leading Chinese-style calligrapher in Kyoto.

43

The poems that Kaioku has brushed on these vessels celebrate one of the "four gentlemen," the orchid. Unlike the showy plant known in the West, the East Asian orchid has been celebrated for its modesty, growing in the remote mountains and sending its fragrance out in the breeze. Two of Kaioku's poems begin with the *kanji* for "hidden" (幽), which also carries the meanings of deep, mysterious, and subtle.

> This hidden fragrance flows like jade,
> The wind wafts it among streams and rocks.
> It is certainly not the cassia in the moon;
> It can be poured but not plucked.[2]

> The hidden plant depends upon mountain rocks;
> Deep-rooted, it lives in solitude.
> Its fragrant heart is not imprisoned—
> It's just blown away by the breeze.

This tea set, inscribed "for my elder brother Chikuyū," is signed by Kaioku with his art name of "Sū-ō" (old man pine) at the age of eighty-two. The calligraphy is modest but fluent, ranging over the white of the porcelain in confident running-cursive script. There are one or two characters per column (once, on the teapot, three), adding a relaxed sense of linear flow to the three-dimensional ceramics.

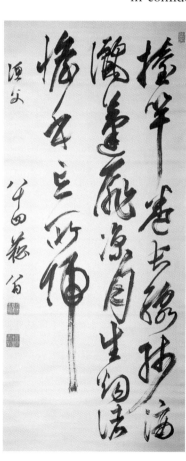

In larger formats such as the hanging scroll, Kaioku often writes in a more loose, rough, and dramatic style. In a four-line poem written at the age of eighty-four (fig. 43.1), Kaioku displays his ability to create dramatic tension in bold cursive script, with some characters larger, some smaller, in columns of 7-8-5 for the 5-5-5-5-word poem:

> Holding my fishing pole and reeling in the line,
> I pour the remaining wine at the rustic door.
> The cold moon rises from the misty shore—
> So pure and serene that I forget to return home.

While this calligraphy creates a counterpoint with the generally serene mood of the poem, for the small *sencha* set Kaioku adapts his writing perfectly, not only to the size of the ceramics but also to the "hidden orchid" of his poetry. Much like the "jade gentleman" that his poems celebrate, Kaioku does not strive for effect, but allows his inscriptions to add a touch of literati flavor to the refined porcelain of the well-known ceramicist Waki Kitei, the fifth generation of potters of that name. This set well demonstrates the elegant use of poetry and calligraphy to enhance the enjoyment of friends gathered to drink steeped tea together.

Figure 43.1.
Nukina Kaioku,
Poetic Quatrain (1861).

NOTES

1. For more information, see Patricia J. Graham, *Tea of the Sages: The Art of Sencha* (Honolulu: Hawaii University Press, 1998).

2. To "pluck the cassia in the moon" is to become an official.

Still Bright (1851)

Hanging scroll, ink on paper, 143.5 x 47.6 cm.
Helen Foresman Spencer Museum, University of Kansas

One of the leading poet-calligraphers in Kyoto during the first half of the nineteenth century, Shōchiku was extremely active in the world of the arts. The closest friend of the scholar-poet-calligrapher-painter Rai San'yō (#38), he also interacted with many other leading literati of the day. Here, at the request of a friend or patron, Shōchiku has written out a calligraphic poem to complement a landscape painted by Sugai Baikan (1784–1844) in the *nanga* (Chinese-style) tradition. Shōchiku's poem follows the four-line, "regulated-verse" style, with seven characters to each line.

> In the shade of dense trees I enjoy reading books;
> When I get tired, the book-covers make a pillow for an afternoon nap.
> Waking from a dream, I don't doubt that the sky will soon darken,
> But the setting sun is still bright on the mountains beyond the trees.

The inscription in smaller characters tells us that the poet has seen a "Summer Scene" by Baikan and that Shōchiku, at the request of the owner, has written this poem to make a pair of scrolls. He then adds the date, a summer day in 1851, and his signature, "Old Man Shōchiku." Unfortunately, the landscape that inspired this work has become separated or lost, and only the calligraphy remains. We therefore cannot know the relation of painting and poem, but we can still examine the work as calligraphy.

Artists writing a quatrain of twenty-eight characters often used the format of three columns. This established a contrapuntal rhythm, with the 7-7-7-7 pattern of the poem set against the visual structure of twenty-eight words in three columns. Here the characters are divided 12-12-4, and the final column is completed by the smaller double-column inscription and signature.

There is also a third rhythm, consisting of the particular movement of the artist's brush in this work, which is worth examining. For this poem Shōchiku chose running script, with an occasional hint of cursive when he joins two characters together by not completely lifting his brush between words. Just where this linkage happens is significant: in the first poetic line between characters 1+2, 3+4, and 6+7; in the second between 1+2 and 3+4; in the third between 1+2, 3+4, and 6+7; and in the fourth between 5+6+7, the final words of the poem. Since in seven-character lines there is usually an implied small break after the fourth character, we can see how Shōchiku has emphasized the structure of the poem in his calligraphic joining of words, even if it is sometimes so visually subtle that it requires close observation and can be invisible in a photograph.

Another form of rhythm in this work is created by slightly emphasized characters, such as "heaven/sky" (天, 2/7) in the middle of the work, which seems to dance toward the left, only to be anchored by a strong final diagonal line to the lower right. This contrapposto might be compared with a dancer leaning in one direction but balancing by stretching out one leg the other way. Several other strong diagonal strokes echo this sense of movement, such as in characters 1/7 and 1/9, and equally significant are the powerful

密樹陰中書好看
倦來枕候午眠
宵夢醒春渝天將暮
科陽猶明樹外山

梅樹寧集以夏景一幀
蒼風勁老筆墨清潤因并
錄此詩以伏化渓翁

辛亥夏日小峤老人弼

verticals in characters 1/4, 1/12, and 2/10. These compositionally offer a little extra breathing space and create still another visual rhythm, in which the characters vary in size. Although the poem is structured in the traditional form of "regulated verse," the calligraphy shows enough freedom of spirit to give an extra sense of life to the words.

The quatrain itself evokes an idyllic summer day spent in nature, but it may have a further meaning when we consider that it was written in the poet's sixty-ninth and final year. With his death approaching, Shōchiku continues to enjoy books—not only to read but also as pillows; when he wakes, he finds that although the sky is ready to darken, it is "still bright on the mountains beyond the trees." No one could wish for more.

45 EMA SAIKŌ (1787–1861)

On Becoming Fifty (1836)
Hanging scroll, ink on decorated paper, 17.2 x 46 cm.

Ema Saikō was one of the leading literati of the nineteenth century, a time when there was a great deal of interaction among Chinese-style poets, painters, and calligraphers. She was originally taught by her father, a doctor and scholar in Ogaki. Saikō then was tutored in poetry by Rai San'yō (#38). San'yō intended to marry Saikō, but her father refused, perhaps not knowing his daughter's feelings. By the time her father sent someone to Kyoto to discuss the matter with San'yō, he had married someone else. Nevertheless, he and Saikō remained good friends; while residing primarily in her family home in Ogaki, she continued to visit San'yō and his wife in Kyoto until his death in 1832. Through San'yō, she met and befriended many outstanding poets and painters of the day, joining them for excursions into nature and sharing poetry with them. Saikō never married, devoting her life to the family household, sojourns in Kyoto, and her own practice of poetry, painting, and calligraphy.

In this Chinese-style poem, written on elegant blue paper with a delicate design of bracken, Saikō takes a tone of melancholy resignation as she reaches one of life's milestones:

> As I become half a hundred, I begin to understand past mistakes;
> Slowly, slowly, my intentions have been thwarted.
> Cranes are tall, ducks short—it is not humans who made them so.
> Fish leap, hawks soar—all following the course of nature.
> My desires have faded away like spring snow,
> Old friends have vanished like stars at dawn.
> In the end, there is no use in potions for longevity,
> I only love to paint bamboo, its verdure reflected on my robe.

Whether Saikō is discussing her feelings for San'yō here in the first two lines is not clear, but since San'yō had died before this poem was written, he is surely one of the old friends who has "vanished like stars at dawn."

半百初告暇日

飛偉〻皆与壯懷

遠鶴長鳴延丘

人作美蹤鳶飛

擇化機有念老

以春雪法故閒

散似毫星稱原

來無用還丹鍊藥

愛畫葯綠映云

五十自击作

細書

Saikō's calligraphy, like the poem, is muted and refined but neverthe-less intensely personal. Over the horizontal format, she wrote in running (and occasionally cursive) script, with 6-7-6-6-6-6-6-7-6 words in the nine columns of the poem. Since her verse is composed of eight lines of seven characters each, no column but the first begins a line of the poem, creating a visual counterpoint that is enhanced by the irregular placement of charac-ters in heavier ink. These include significant words such as "desires" (念) in column five, "snow" (雪) in column six, and "dawn" (暁) in column seven.

During an age when Chinese studies and arts were mostly undertaken by men, Saikō is notable as an outstanding female literatus who remains highly admired to this day.[1] Although her autobiographical poem has a sense of melancholy, she succeeded in becoming a productive part of an artistic world that nourished her spirit, just as her poetry, painting, and calligraphy have done, and continue to do, for others.

NOTE

1. For translations of her poetry, see *Breeze Through Bamboo: Kanshi of Ema Saikō,* trans. Hi-roaki Sato (New York: Columbia University Press, 1998).

46 YANAGAWA SEIGAN (1789–1858)

Rain over the Stream

Hanging scroll, ink on paper, 124 x 52.2 cm.

Yanagawa Seigan was one of a group of literati at the end of the Edo period who worked toward the restoration of power to the emperor. Born in Mino, he moved to Edo in 1807 to study the eclectic Confu-cianism of Yamamoto Hokuzan (1752–1812). But the city's "floating world" of drinking parties and brothels proved so appealing to him that he amassed a large debt and avoided prison only by shaving his head as a Buddhist priest, although he did not seem to have formally become a monk. He then became a wandering poet, eventually marrying a talented pupil named Yanagawa (Chō) Kōran (1804–1879), who shared his interests in *kanshi* and calligraphy. Unlike most men of the time, he took his wife with him on his travels (he was therefore called a "camel") until they finally settled in Edo in 1832. In that year he heard of the death of his friend Rai San'yō (#38), whom he eulogized in an elegy, writing that "nobody will ever equal your knowledge of history; your poetry, stripped to bare bones, has great depth of spirit."

Like San'yō, Seigan was highly critical of the Tokugawa government, writing that after days of glory it was now "helpless to expel the contentious foreigners." He moved back to Mino in 1845, and the following year to Kyoto, perhaps to be near the emperor and certainly to gain distance from the shogunate. Implicated in an assassination plot, Seigan was due to be ar-rested when he died of cholera in 1858. His wife, Kōran, herself now also an

十年把酒所逢春
海西黄沙雨振搖孫
把柱之弦口語口世曾
孤舟莫人知

excellent painter as well as poet and calligrapher, was arrested instead; she was kept in prison for six months.[1]

The force of Seigan's personality is readily apparent in his cursive script calligraphy, of which this is an especially strong example. The poem, a quatrain of 7-7-7-7 characters, invokes the image of the seven-string *ch'in*, the musical instrument with a low, quiet and meditative timbre that made it beloved of Chinese and Japanese literati for more than a millennium.[2]

> For ten years I have idled my time alone like floating clouds,
> On my face of yellow sand, both sideburns have turned to cotton.
> Holding my *ch'in*, I converse with my heart:
> In this world, who can know this feeling?

Cursive script is often written with relatively thin brushwork in order to emphasize a rapid and seemingly ephemeral quality of line and form. In contrast, Seigan here uses rather thick brush strokes that, combined with the small amount of negative space between columns, result in a dark, powerful, and personal expression. Despite the forceful tone of the work, however, there is variety within it, including some characters with slightly thinner lines, such as in column two, word six (鬢, sideburns) and 3/5 (語, converse). There are also some curving squiggles of brushwork with "flying white" such as at the ends of 1/6 (雲, clouds) and 3/2 (琴, *ch'in*); this effect is appropriate in both cases, suggesting the floating quality of clouds and of music.

While the poem is in four lines of seven words, the columns have 7-8-8-5 characters, so that the two rhythms at first coincide and then gradually move apart. Since the calligraphy is heavily inked almost throughout, there are only a few times when a third rhythm is manifested by thicker brushwork, most notably the words "both" (両, 2/5) and "mouth/words" (口, 3/6). The calligraphy ends with slightly attenuated brushwork, as though the final question in the poem—"who can know?"—were a bit plaintive.

Seigan's political aim of returning power to the emperor was to come to fruition a decade after he died, but he would not be there to enjoy the new Meiji era, which began in 1868. His wife, Kōran, however, continued her career as a painter, poet, calligrapher, and teacher until her death in 1881, twenty-three years after that of her husband and mentor.

NOTES

1. For more information on Kōran, see Patricia Fister, *Japanese Women Artists, 1600–1900* (Lawrence, Kans.: Spencer Museum of Art, 1988), pp. 104–105.

2. For more information on the *ch'in*, see Stephen Addiss, *The Resonance of the Qin in East Asian Art* (New York City: China Institute in America, 1999).

The Haiku Calligraphy Tradition

The calligraphy of haiku masters is usually modest, like their poetry, but full of subtle and individual flavor. Frequently one major feature of interest is how the calligrapher arranges the composition in the available space. Individual poems were often written on *shikishi* (squarish poem-cards, about 11 by 9½ inches) and *tanzaku* (tall thin poem-slips, approximately 14 by 2¼ inches), while groups of poems were usually written on horizontal or vertical scrolls. Each format influenced the composition of the calligraphy; poets often enjoyed setting up visual patterns and then deviating from them in various ways, resulting in the creation of asymmetrical forms.

When writing in their own language, Japanese poet-calligraphers sometimes used a technique of beginning verses at the top of the paper or silk, then continuing with columns starting lower, creating a stepped effect like a linear waterfall. In a complex style called *chirashi-gaki* (scattered writing), this technique often involves, one poem beginning over the end of a previous one. But even in its simpler form, this kind of irregular structure is very different from the even columns of most calligraphy in Chinese, which seems to proceed stylistically from the balanced (4, 8, 16, 32, and so on) lines of regulated Chinese verse.

Why did Japanese calligraphy develop this unique form of compositional structure? There may be several reasons, the first being the Japanese preference for asymmetry, as seen in five-line *waka* and three-line haiku. This preference takes many forms: foreign visitors are often surprised that sets of plates are sold in groups of five in Japan. The usual explanation given is that the words for "four" and "death" have the same pronunciation (*shi*), but this is by no means enough to explain the taste for asymmetry. Another example of this Japanese predilection occurred when *waka* were divided during group poetry sessions: the 5-7-5 grouping developed into the celebrated haiku form, while the remaining 7-7 couplet languished.

Second, *waka* and haiku have syllable counts of 5-7-5-7-7 and 5-7-5, instead of the balanced Chinese quatrain of 5-5-5-5 or 7-7-7-7. Irregular spatial endings therefore result with the Japanese forms if the poet wishes for each column of calligraphy to correspond to a line of verse. And if the columns are to be irregular, why not have them start at different levels on the paper rather than merely ending unevenly?

Third, the use of *kana* syllables in Japanese poetry has meant that calligraphers are not constantly choosing among more than fifty thousand characters in five different scripts, as they did with Chinese poetry. When there is less variety of calligraphic forms, more changes in their spacing can become

artistically appealing; this also may explain the greater use of decorated papers than in Chinese calligraphy.

Finally, and more broadly, there has been a taste for suggestion rather than direct statement in Japanese poetry, particularly in haiku, that seems to invite the empty areas that uneven spacings create. Whether writing one poem or several, it is through exploiting the use of space, as well as developing personal styles of brushwork, that haiku masters have created their distinctive forms of calligraphy.

Like the poetic form itself, haiku calligraphy developed out of *renga* (linked verse), in which poets shared the composition of *waka* by composing alternate 5-7-5 and 7-7 syllable sections that would be added together to create long series of poems. The first of the great haiku masters, Matsuo Bashō (1644–1694), brought the 5-7-5 form into full prominence as a poetic genre capable of deep expression. He had studied calligraphy with Kitamuki Unchiku (1632–1703), who was a master of the dramatic Daishi-ryū style, which features bold and fluid flourishes of the brush (see #4). Bashō, however, confined his writing to small-scale calligraphy that echoes his modest and unassuming personality; he was devoted more to the poetry itself than to its dramatic visual expression (fig. E.1).

Several of Bashō's pupils and followers developed personal calligraphic styles, although generally within the influence of his small-scale brushwork. Kaga no Chiyō (1703–1775, #47), a leading women poet of her day, stayed in this tradition but added flavorful accents of her own. Her work features an asymmetrical balance of heavier and lighter characters interspersed with *kana,* creating a strong personal style that belies the myth of her delicate "feminine" sensibility.

The second of the greatest three haiku masters, Yosa Buson (1716–1784) was equally expert as a painter in the literati style. His command of both Chinese and Japanese brushwork gives his calligraphy a range of expression that can be seen in his letters, a format that is highly admired in Japan for its

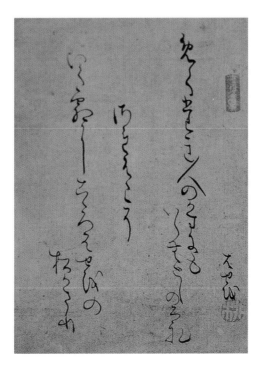

Figure E.1.
Matsuo Bashō, *Poems.*

naturalness and lack of artistic intentionality. Introducing haiku into these letters gave Buson a chance to vary the spacing with visual accentuations that mirror the differences between poetry and prose (#48).

Several poets of the following generation developed individual styles in calligraphy, often in conjunction with painting. For example, the Nagoya doctor-poet Inoue Shirō (1742–1812, #50) wrote in a larger-scale and freer manner than most of his predecessors, in part to complement his evocative ink paintings. Den Kikusha (1753–1826) also had an exuberant personality, judging from her life and art; her calligraphy makes an interesting comparison with that of Chiyō, whom she greatly admired. While Kikusha's writing is bolder, both poets used wet and dry, thickening and thinning lines to create heavier and lighter characters in distinctive rhythms (#51).

Sakai Hōitsu (1761–1828) and Takebe Sōchō (1761–1814) were poet-painter friends who lived in the new capital of Edo. While Hōitsu, the son of a feudal lord, became a major artist in the *rimpa* (decorative) tradition, Sōchō was known for his *haiga* (poem-paintings), and both developed distinctive styles of calligraphy that accorded well with their paintings. Hōitsu displays a sharp, clear, elegant style of calligraphy (#52), while the bolder and slightly rougher style of Sōchō was appropriate for his *tanzaku* (#53) and informal, often humorous paintings.

The third of the greatest haiku masters was Kobayashi Issa (1763–1827), whose empathy extended to all living creatures, including fleas and lice. Despite his difficult and sometimes tragic life, he conveyed the gentle warmth of his personality in his calligraphy, which perfectly suited his poems. For example, on a *haiga* about a butterfly, his calligraphy also seems to twist and flutter through space (#54). His absolute lack of pretension is also apparent in his writing, which shows no apparent skill but upon repeated viewings offers something more important—Issa's personal spirit.

Other haiku poets also conveyed their individual character through calligraphy, whether on the small scale of *tanzaku*, such as the autumn haiku of Ōemaru (1722–1805), or the larger scale of the vertical hanging scroll, here represented by the four seasonal haiku of Sakurai Baishitsu (1769–1852). Both show the use of space to enhance their poems. Ōemaru does so by dividing his three-section poem into two columns, giving a contrapuntal rhythm to his work (#49). Baishitsu also writes each poem in two columns but places two haiku over the other two for a more complex visual composition (#55).

The apparent simplicity of the poetic form of 5-7-5 syllables is matched by the informal simplicity of haiku calligraphy, but in both cases unexpected depths can be discovered. The fact that haiku can suggest so much while saying so little is one of the reasons that many poets have explored, and continue to explore, this genre all their lives; haiku is now the best-known and perhaps most-practiced poetic form in the world. The calligraphy of early modern Japanese poets also conveys more than its modest surface effects. Much of this nonverbal content is due to the varied compositional use of each format; but as in all calligraphy, personally expressive brushwork is a means to convey more through line, form, and rhythm than just the words. Through their effective visualizations of seventeen syllables, haiku poets have added their own modest, informal, and flavorful chapter to the history of Japanese calligraphy.

Six Spring Haiku
Hanging scroll, ink on paper, 15.8 x 44.1 cm.

The daughter of a scroll mounter in Kaga, Chiyō studied haiku with two pupils of Bashō and was recognized as a promising poet at an early age. When she was in her thirties, however, her parents, older brother, and sister-in-law all died within a few years, and Chiyō felt the responsibility to take over the family business. She did not resume her poetic career until she reached fifty, when she became a Buddhist nun. Writing that she had not renounced the world but merely wanted to purify her heart, Chiyō was now free to travel and fraternize with other male and female poets, an opportunity not available to most women. Skilled in brushwork, she created *haiga* (poem paintings) as well as haiku and *haibun* (combinations of haiku and prose). This example reads:

I was troubled for about three years, but the melody of this morning's spring breeze brought forth a new tune. I felt, indeed, it was the sky of early spring— my heart was encouraged and so I happily took up my brush.

chikara nara	in terms of strength
chō makesasemu	the butterfly yields
kesa no haru	to this morning's spring

Shunkyō — **Spring Pleasure**

uguisu ya	a warbler
uguisu ni naru	becoming a warbler—
mizu no oto	the sound of water
wakakusa ya	young grasses
mada dochira e no	have not yet bent
kata yorazu	in any direction
okame mono	Okame
miru asa asa ya	every morning views
haru no niwa	her spring garden
kiji nakite	a pheasant sings
yama wa asane	and the mountain's morning sleep
wakare kana	comes to an end
ame no hi mo	even on rainy days
nani omoidete	perhaps remembering something—
naku kaeru	the frog sings

This spring scroll may indicate the beginning of Chiyō's second period of creativity, which took place after she completed her duty of running the family business. The calligraphy begins with a prose introduction and continues with six haiku, one with a title. Okame, mentioned in the fourth poem, is the Shinto-derived prototype of a plump, good-natured, often middle-aged woman.

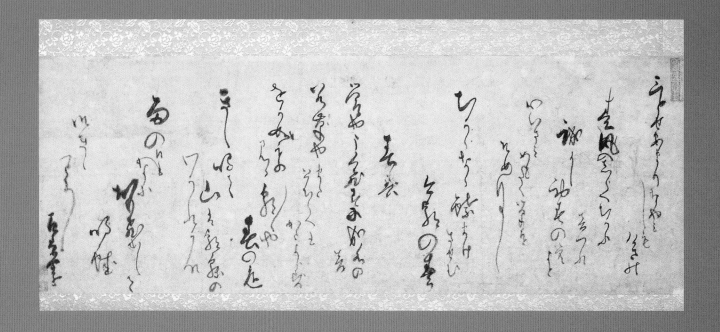

Chiyō's calligraphy is somewhat compressed and gnarled, with a sense of the poet's intensity brought forth by the heavier and lighter forms, the former created when the brush has been redipped in ink. Because this re-dipping does not always occur at the beginning of a column, asymmetrical variations enhance the total visual expression.

The nine-stroke word *haru* (春, spring), composed of a sun (日) coming up through trees (木), appears five times in the work, most notably as the first character of the two-word title in the middle of the scroll. After its initial, three-stroke appearance at the top of the second tall column, *haru* is rendered in cursive script with a single brush stroke, usually heavily inked, helping to give the work a certain amount of visual and textual unity.

In order to create a sense of structure, each haiku begins a new tall column, and the poems usually conclude with two more partial columns. This pattern is not totally consistent, as the six haiku have 3-2-3-3-3-4 columns, respectively; and although these columns generally coincide with the 5-7-5 syllabic poetic structure, even here there is some variation. For example, the second poem, just after the two-word title, is written in a single column except for the final word, *oto* (音, sound). The result of the artist's creating patterns but not consistently following them is that the calligraphy takes on a feeling of life's own irregular repetition and change. Her joy restored by the melody of the spring breeze, Chiyō is composing both haiku and calligraphy in her own personal rhythm.

48 YOSA BUSON (1716–1784)

Letter to Kitō (1774)

Hanging scroll, ink on paper, 16 x 22 cm.
The Ruth and Sherman Lee Institute
for Japanese Art at the Clark Center, Calif.

Although many East Asian literati were accomplished in more than one art, Yosa Buson is unique in that he is considered to be among the three greatest masters of all time in both haiku (with Bashō and Issa), and in *nanga* painting (with Taiga and Gyokudō). This letter was written to one of his most significant haiku pupils, Kitō, who seems to have sent his *New Year's Poem Sheet* for 1775 to Buson for approval.

Buson's letter is composed in four parts. In the first two-and-a-half columns on the right, he politely congratulates Kitō. Then come six columns, indented as though Buson were speaking in a more hushed voice, in which he criticizes a haiku by Kitō that must have originally read:

Wild mouse
scratching its face
under a plum tree

Next Buson writes seven columns of more general news, in which he speaks of the infirmities of his age (he was then fifty-eight and lived another

ten years). After dating and signing the letter, Buson concludes with a two-column postscript. The entire text is as follows:

> I have received and read your New Year's poem sheet, which is very interesting; I have no more to say than to offer you my congratulations.
>
> The poem about the wild mouse, however, loses some meaning in the beginning because of emphasizing "scratching its face." This is not like a pheasant scratching its face, and so it is disappointing. The haiku could have been a fine one, but you have tried for too much and thus the feeling is lost.
>
> This winter I have been suffering from old-age sickness. It is difficult to come up with ideas for poems, and I have not written even one haiku; however I am not so ill as to think about death. As I receive your letter I am sick in bed; while rubbing my eyes that are dim with age, I hurriedly answer you since you have asked for my immediate response. I'll talk to you more when I see you.
>
> —on the seventeenth day, Yahan

P.S. My foolish poem on the Kitano printed sheet looks quite appropriate; the woodblock copy has come out in an interesting way. In fact it is quite unique.

Although the letter, as usual, does not specify the year, it can be confidently dated to the seventeenth day of the twelfth month of 1774 because Kitō seems to have heeded his teacher's criticism; and for his *New Year's Poem Sheet* of 1775, Kitō changed the poem to:

> Wild mouse
> not coming out for a long time
> from under a plum tree

Later that year Kitō published the poem in his *Kitō Kukō*, this time changed again:

> Wild mouse
> staying a long time
> in the shade of a plum tree

Why did Buson reject Kitō's original idea? Perhaps because he thought that the image had been done better earlier; when he referred to a pheasant scratching his face, he may have been thinking of a haiku by Bashō's pupil Kikaku:

> scratching
> its beautiful face—
> the spurs of the pheasant

Buson's letter was not written to be admired as calligraphy, and yet for some viewers its lack of conscious artistry makes it even more admirable. With no thought of art, Buson has simply allowed his brush to move over the paper in a perfectly natural manner, letting the columns meander down to the left and making some characters or *kana* larger than others, just as his thoughts moved him. He redipped his brush when it ran dry; but we may

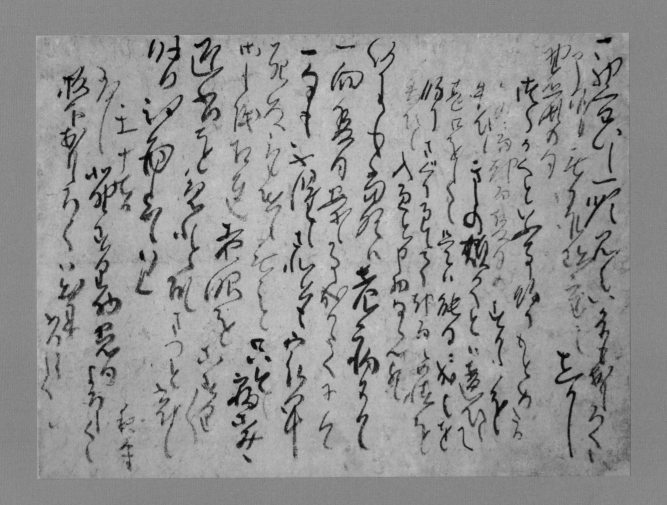

note, as for example in the seven-column section, that the words written after the redipping are significant: first, in the middle of the first column in this section, "old-age sickness"; second, at the top of the third column, "not even one haiku"; third, in the middle of the fifth column, "old eyes"; and finally, at the top of the sixth column, "hasten to reply."

The natural emphasis that these words receive by being darker and thicker in brushwork helps to accentuate the meanings in Buson's letter, even if he was not consciously choosing where to dip his brush. We can simply feel the natural rhythm of his ideas as they were being written, and sense the inner nature of the master poet-painter as he writes to a favorite pupil.

49 ŌEMARU (1722–1805)

Fallen Leaves

Tanzaku, ink on decorated paper, 36.2 x 5.7 cm.
Helen Foresman Spencer Museum, University of Kansas

Haiku poets in Japan practiced a number of different occupations. Ōemaru ran a courier agency in Osaka, and in the course of his work he met many haiku masters, including Buson. He wrote, however, that his most significant moment came at the age of thirteen when he carried a letter to the poet Tantan. That was enough to engage Ōemaru's serious interest, and he became a master of haiku. His works were often written with a touch of humor and sometimes accompanied by his own paintings.

Here Ōemaru has written out one of his verses on a *tanzaku* decorated with horizontal bands suggesting clouds; as we shall see, the calligraphy enhances and adds levels of meaning to the haiku.

kumo wo kanu	Gathered into clouds
takane mo miete	like mountain peaks—
ochiba kana	fallen leaves

The final line, succinct in this translation, is even more so in Japanese since the final word, *kana,* is merely a sound giving a hint of emphasis to what has come before. Although it might sound self-consciously poetic, the final line might translated as "fallen leaves, ah!"

Both Ōemaru's poem and the calligraphy at first seem to be rather simple, but they both contain subtleties. The strongest visual elements are the *kumo* (雲, cloud), written in the single *kanji* that begins the haiku, and *ochi* (おち, fallen), written in two *kana* at the top of the second column. Therefore a structural reading of the poem could simply be "clouds fallen" since the accentuations suggest "CLOUDS of gathered leaves like mountain peaks have FALLEN."

In the English-speaking world, haiku are usually considered to be poems in three lines; but some scholars insist that in Japan they are one-line poems that should be translated as such in English. They are indeed usually printed

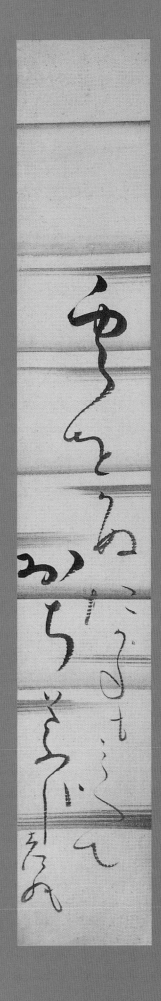

かくとをもおもひさしらすといへとも

49

in a single line in Japan. But to complicate the matter, Japanese poets have written their haiku as calligraphy variously in one, two, or four columns. Here Ōemaru has visually divided his poem into two parts, leaving the final line of the poem and his signature for the second column; the poem visually can be read as:

Gathered into clouds like mountain peaks
 fallen leaves Ōemaru

Adding even more emphasis to the division of the poem into two parts is the use of ink, heavy at the start of each column and becoming more thin and dry as the brush moves down the *tanzaku* surface. We can see this in the calligraphy of *takane mo miete*, which begins about halfway down the first column with the *kana* for *ta* (た). This seven-syllable phrase is written in rather wispy lines that seem to mock the meaning of "[looking] like mountain peaks." In effect, Ōemaru has deliberately de-emphasized the image by letting the calligraphy fall in gentle curves toward the bottom of the *tanzaku*.

Does the two-part calligraphic presentation mean that Ōemaru has composed a two-line poem? Perhaps not. The two-column visual expression reinforces the most important division in the poem, but the haiku is still written as 5-7-5 syllables. This work can therefore be understood as another case of visual counterpoint, here of two against three, adding rhythmic complexity to the work.

Traditional haiku often have a similar two-part structure underlying their three-part division, and sometimes the final line can be seen as the answer to a riddle posed by the first two lines. Examples of this style include: "running across the altar / and stealing a chrysanthemum / the temple rat" (Takamasa); "exhausted by / the cries of children / a sparrow" (Issa); and "favored by both / the waning moon and the sun / poppies" (Ōemaru).

In this case, the first two lines of Ōemaru's poem, expressed through a single column of calligraphy, might lead us to expect something very grand for the final line. But there seems to be an anticlimax: these gathered clouds and mountain peaks are, after all, only leaves in a pile. And yet for Japanese readers, the leaves themselves serve as the expression of autumn melancholy. Clouds pass, leaves fall—the year, like an individual human life, is coming to an end.

50 INOUE SHIRŌ (1742–1812)

Falling Rain

Fan, ink on mica paper, 16 x 41.5 cm.

By profession a doctor in Nagoya specializing in gynecology, Shirō studied haiku with Shirao (1735–1792) and early Japanese literature with Motoori Norinaga (1730–1801). Skilled at combining his verse with simple and flavorful painting, Shirō became one of the leading haiku and *haiga* artists of the early nineteenth century. Within his large poetic output, there are a number of verses about the moon, perhaps even more than

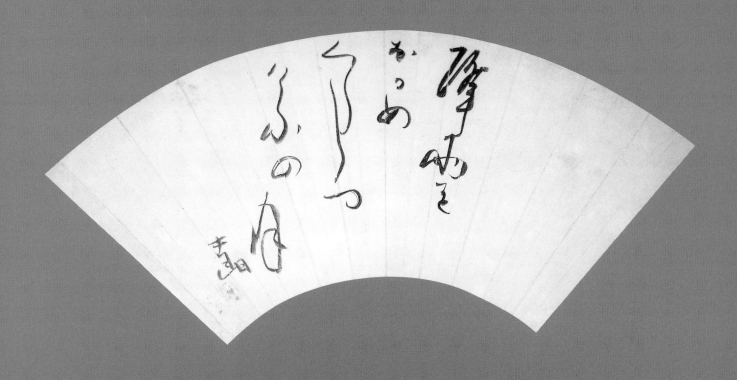

50

other haiku masters, several of which end with the line, "tonight's moon." One example accompanies a single-stroke painting of a mountain:[1]

Yorozu-yo ya	Through the ages
yama no ue yori	rising above the mountains
kyō no tsuki	tonight's moon

In this case, the character for "moon" (月), originally a pictograph of the crescent moon, becomes both a word and a picture. Shirō's sense of the everlasting nature of the moon is given another expression in the haiku on this fan:

Furu ame o	Falling rain
nagame kurashitsu	watching all day
kyō no tsuki	tonight's moon

Although there is no direct pictorial content in this work, the final character "moon" is separated a little from the column in which it appears and placed at a slight angle, as though floating in the sky. Another character that originated as a pictograph is the Chinese character for "rain" (雨), the second graph in the first column. In regular script, this word includes four dots, presumably the rain itself; in Shirō's cursive script there are only two dots, one of them almost hidden by the movement of the brush creating the form that surrounds it.

Shirō emphasizes the fan shape by seeming to deny it. Until the final "moon," the columns are all generally squared against the curving fan shape. There is only a slight bend to the first column; later, the "moon" curves against the movement of the fan; and finally there is the bending signature at the lower left. Other poet-calligraphers might have angled the calligraphic columns to conform to the curved format, as was common in Chinese calligraphy on fans. Instead, Shirō has created a visual counterpoint that once again emphasizes the Japanese predilection for creative tension.

This visual effect is reinforced by Shirō's other use of calligraphic contrasts. For example, the second line of the poem is rendered in two columns, one short and compressed and the other long and expansive. Yet there is a unity to the calligraphy that comes from its continuous sense of movement; it is clear that the entire poem was written in a single dipping of the brush. The haiku therefore flows naturally from the dark ink of "falling rain" to the lighter and more transparent ink of "moon"; the meaning of the text and the expression of the calligraphy join as one.

NOTE

1. See Stephen Addiss, *Haiga: Takebe Sōchō and the Haiku-Painting Tradition* (Richmond, Va.: Marsh Art Gallery, in association with the University of Hawaii Press, 1995), pp. 102–103.

51 DEN KIKUSHA (1753–1826)

Flowers of the Four Seasons

Hanging scroll, ink on paper, 24.7 x 56.6 cm.

Kikusha, whose name means "chrysanthemum hut," was one of the most interesting poet-artists of the early nineteenth century. Born to a samurai family, she married at the age of sixteen but returned to her parents' home eight years later when her husband died. Her father was a Chinese-style poet, and Kikusha too became known for *kanshi*; but she was also talented in haiku, *waka*, calligraphy, *haiga* (poem-paintings), the *ch'in* (Chinese seven-string zither), and the tea ceremony. In 1780 she took Buddhist orders as a nun, giving her more freedom to travel; she spent a good deal of the rest of her life moving from place to place in Japan, enjoying nature and the arts. One of Kikusha's most celebrated haiku was composed after a visit to the Chinese-style Ōbaku Zen monastery of Mampuku-ji in the tea-growing area of Uji:

Sanmon o	Leaving the temple gate
izureba nihon zo	I discovered Japan—
chatsumi uta	the tea-picker's song

In 1813, a book of Kikusha's poems entitled *Taoriku* (Handpicked Chrysanthemums) was published in Kyoto; in this volume she writes that "I have the enjoyments of a thousand years . . . I entertain myself equally with people I know and those I don't; I enjoy years spent traveling and also take pleasure in returning home."[1]

The four haiku of Kikusha's scroll *Flowers of the Four Seasons* were published in *Taoriku*, and each of the four contains the word *hana* (花, flowers/blossoms). Following the cherry blossoms of spring, the flowers of the seasons are, respectively, bindweed, rose of Sharon, and winter snowflakes.

As I spend my life wandering, I keep in my thoughts only the flowers of the four seasons:

Mukau kata ni	For the traveler
konjin wa nashi	no spirit of ill fortune—
hana no kumo	clouds of blossoms

I enjoy learning from common things:

Suna ni hautemo	Creeping on the sand
hirugao no	even the bindweed
hana sakinu	blossoms

Yesterday has passed and tomorrow is still uncertain:

Kyō wa kyō ni	Today, just for today
saite medetashi	blossoming happily—
hanamukuge	the Rose of Sharon

Even at the end of the four seasons, I have something to believe and enjoy:

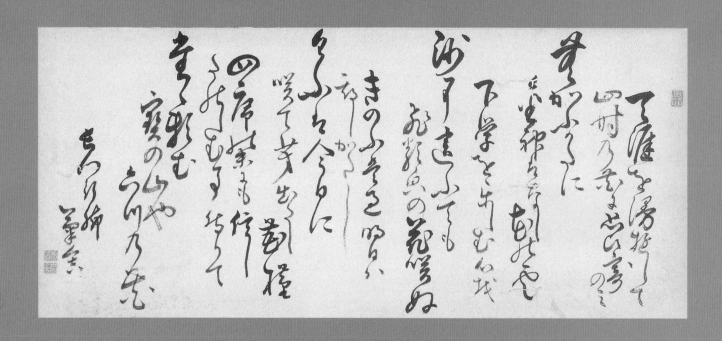

Tada tanomu
takara no yama ya
mutsu no hana

I only plead for
the treasure of the mountains—
six-petal blossoms

—Written while traveling in Nagato, Kikusha

Although Kikusha's haiku generally follow the conventional phrase structure of 5-7-5 syllables, her second poem is 7-5-5 and the third is 6-7-5, since the word *kyō* (today) counts as two syllables. The calligraphy also shows Kikusha's sense of variety and freedom. For example, when the word *kyō* repeats in the eighth column, it is written in different combinations of *kanji* and *kana*. The writing is bold and confident throughout the scroll, with dramatic variations in line width, between wet and dry brushwork, and in rhythmic structure.

Further exploring the composition of this work, we see that Kikusha's pattern is to write her introductions in two even columns, followed by haiku in three staggered columns. The only exceptions are the second introduction, composed in a single column, and the second haiku, written in two columns (with the brush redipped for the third line of the poem). The visual structure Kikusha creates is complex. But with the tallest columns consistently marking the beginning of a haiku and featuring a redipping of the brush, the visual emphasis upon her poetry gives an overall sense of order to Kikusha's diversiform scroll. Like her peregrine life, Kikusha's calligraphy exhibits a dynamism that defies the norms of an age when women were mostly confined to their homes.

NOTE

1. Translation by Stephen Addiss in Patricia Fister, *Japanese Women Artists 1600-1900* (Lawrence, Kans.: Spencer Museum of Art, 1988), p. 65.

52 SAKAI HŌITSU (1761–1828)

Haiku on a Fan

Fan, ink on mica paper, 15.8 x 44.6 cm.

Sakai Hōitsu was the younger son of a feudal lord, but he had little interest in his domain and preferred the convivial life of the arts in Edo, including the joys of the "floating world." He was friendly with people of many walks of life, from Kabuki actors to such poet-painters as Kameda Bōsai (#37) and Takebe Sōchō (#53). Hōitsu experimented with several painting styles before settling upon the *rimpa* (decorative) tradition, a style practiced in Kyoto before he transferred it to the new capital. Hōitsu is now celebrated as a master of bold and colorful screens and scrolls; his status as a haiku poet and calligrapher is less well known today, but he was equally skilled in these arts.

Here Hōitsu has written one of his haiku upon the highly decorated surface of a folding fan.

Susamajiki
semi no ha oto ya
kake andon

How amazing,
the sound of cicada wings—
hanging lamp

We can imagine the well-loved sound of cicadas coming unexpectedly from the paper-covered lamp, a symbol of sophisticated urban entertainments rather than rustic pleasures. The *andon* (行灯), literally a "traveling lamp," was often carried on evening excursions.

Unlike many of the poet-calligraphers in this book, Hōitsu has written the haiku in three columns that follow the divisions of the poem, with his signature at the end; and all three columns begin at the same level of the fan format. Was this because he was less visually adept than his colleagues? Surely not. The reason must lie in the concentrated program of decorations on the fan surface, against which a more complex calligraphic structure might be confusing.

The various patterns on the fan, including a series of painted blossoms that seem to float on water, are all strongly horizontal in their visual impact. The three vertical columns of calligraphy make a significant contrast, while their asymmetrical placement to the left of center almost makes it seem as though the poet were enjoying the moment and only writing about it as an afterthought. Perhaps he was visiting the pleasure quarters, arriving by boat to the scattered blossoms of the night.

Although the writing is small in scale, the sharp lines in dark ink make it stand out, even when a calligraphic line deliberately crosses one of the painted blossoms in the second column. There is a significant difference between some of the more strongly brushed characters and the more wispy *kana*, but the downward flow of the writing keeps the calligraphy unified in its sense of continuous movement. Hōitsu was clearly not only an excellent poet and calligrapher but also a connoisseur of visual effects, even on the modest format of a folding fan, itself an appurtenance of the world of relaxed enjoyments that he here celebrates.

53 TAKEBE SŌCHŌ (1761–1814)

Charcoal Kilns

Tanzaku, ink on decorated paper, 35.6 x 5.7 cm.

Takebe Sōchō was the son of the calligrapher and haiku poet Yamamoto Ryūsai, who served the shogunate in Edo by providing laborers and relay horses. As a young man, Sōchō studied both haiku and painting, as well as flower arranging and the tea ceremony. He became friends with other poet-artists of the new capital, including Kameda Bōsai (#37) and Sakai Hōitsu (#52), who often gathered together to share their verses and brushwork. An expert at *haiga* (haiku-painting), Sōchō also

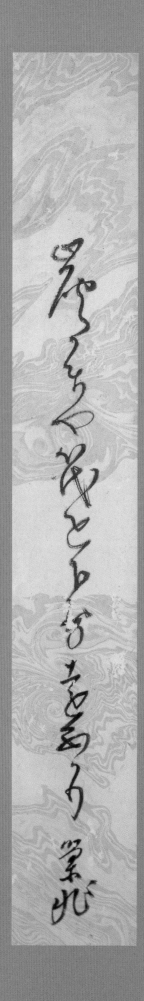

53

compiled more than thirty haiku-related books; he eventually became known as one of the leading *haijin* (haiku masters) of Edo in the early nineteenth century.[1]

Sōchō's home in Edo was located very near the Sumida (literally "charcoal field") River, and Sōchō no doubt had many opportunities to observe rafts—loaded with wood for the kilns on the other shore—being lowered into the river at night.

<div style="text-align:center">

Sumigama ya
ikada o kudasu
tōakari

Charcoal kilns—
rafts are lowered
to distant brightness

</div>

Although the calligraphy is written in a single column down the *tanzaku* (narrow poem-card), Sōchō has reinforced the haiku's syllable sections of 5-7-5 simply by keeping the brushwork continuous in each "line" of the poem. Therefore the brush lifts from the paper only after *ya* (や) and *kudasu* (下す), and once more before the simple signature, "Sōchō."

The effect of the fluent calligraphy is greatly enhanced by the appropriate wave-and-swirl background of the *tanzaku*. This was originally made by floating oil on top of water and then dipping paper quickly to pick up a momentary configuration of the ever-changing pattern. The freedom of the resulting shapes—flowing and spiraling across the tall, narrow surface—contrasts with the fluent movement of Sōchō's single column of calligraphy down the paper. Together, the two create a contrapuntal effect that harkens back to the eleventh and twelfth centuries, when Japan's greatest *waka* poets and calligraphers wrote on paper highly decorated with a rich variety of techniques that included collage, painting, block printing, and scattering of gold or silver leaf.

Why did Japanese artists develop decorated paper for calligraphy more creatively than the Chinese? It may be that the variety of more than fifty thousand characters in five different scripts was beauty enough for Chinese calligraphers, while the more limited use of characters with a few dozen *kana* forms led Japanese to desire more visual variety through the use of decorated paper. Another factor might be the Japanese love of contrast, here between the black ink lines of calligraphy and the colorful potentials of paper designs. A third possibility is the limited size and scope of *waka* and haiku, in contrast with the generally longer Chinese poems. Whatever the reasons for the popularity of this medium, Sōchō's haiku on decorated paper takes full advantage of the opportunity for lively contrast between writing and decorating, form and ground, control and randomness, and, ultimately, human and natural forms.

NOTE

1. For more information and many examples of Sōchō's work, see Stephen Addiss, *Haiga: Takebe Socho and the Haiku-Painting Tradition* (Richmond, Va.: Marsh Art Gallery and University of Hawaii Press, 1995).

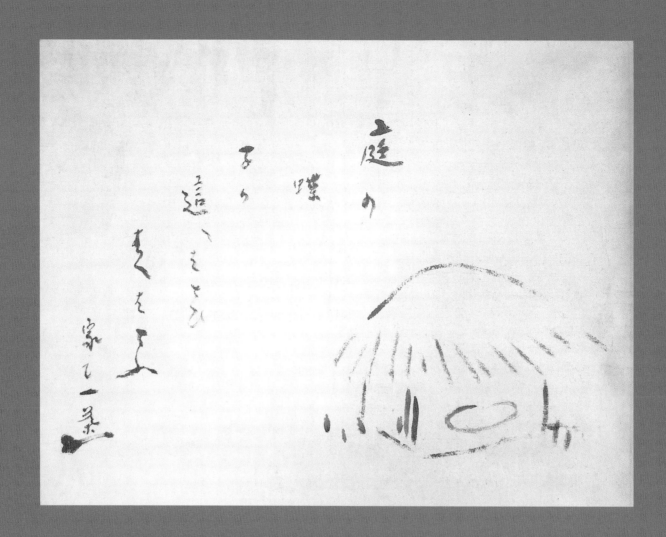

庭の
蝶
子か
這へばとび
たつ\
家こ一茶

54

54 KOBAYASHI ISSA (1763–1827)

Garden Butterfly

Hanging scroll, ink on paper, 28.6 x 37.6 cm.

Now perhaps the most beloved of haiku poets, Issa led a tragic life; his mother died when he was two, and all four of his own children died in their infancy or childhood. His haiku are known for their great empathy for all living creatures, expressed directly in simple language.

Issa's calligraphy reveals his total modesty, lack of self-aggrandizement, and—equally—his remarkable sensitivity to the meanings of the text. This *haiga* (poem-painting) features one of his most famous haiku:

Niwa no chō	Garden butterfly
ko ga haeba tobi	as the baby crawls, it flies
haeba tobu	crawls close, flutters on

As with many of the most interesting *haiga*, the visual image does not reproduce the text but adds another element; is this perhaps a setting for the miniature scene that Issa describes? In fact, until we examine the calligraphy more closely, there seems to be no direct connection between word and image.

Written in gentle, dark-gray ink, Issa's haiku occupies five columns, followed by the comment "the house also Issa" (家も一茶) and a cipher-signature. Although it is actually rather small, *niwa* (garden, 庭) is the first and largest character of the scroll. To its left the complex *kanji* for butterfly (*chō,* 蝶) is given a column of its own; both words are written freely, without ostentation. Similarly, the house is simply brushed with a curving line for the roof and nothing but dashes and dots to complete the seemingly childlike painting.

We may well ask, why are this poem and its expression here as *haiga* so admired in Japan? Certainly their expression of Issa's honest and unpretentious character accounts for this in part, but there is more to the work than that. Issa's empathy for the child and the butterfly extends into the composition and brushwork. First, the calligraphy keeps an even distance from the hut, just as the butterfly keeps its distance from the child. Second, the calligraphy itself seems to waver, twist, tremble, and flutter, becoming the path of the butterfly through space.

One interpretation of this haiku sees the poem as a Buddhist teaching not to grasp or cling to anything in life, recalling a saying of the Zen Master Chao-chou (Jpn., Jōshū, 778–897) "as people move closer, the Way moves farther away."[1] There is also a personal element at work here, since Issa's sympathy and compassion pervade this work. The empathetic interaction of humanity and nature—a major theme for Issa—is brought forth in his brushwork with an art that hides art.

NOTE

1. James Green, trans., *The Recorded Sayings of Zen Master Joshu* (Boston: Shambhala Publications, 1998), section 119, p. 49.

Four Seasons Haiku (1850)

Hanging scroll, ink on silk, 124.4 x 36.5 cm.

Many different visual and verbal rhythms are created here by the haiku poet-calligrapher Baishitsu. A pupil of Barai and Rankō, he gave up his knife-grinding business at the age of thirty-six to become a full-time poet; along with Sōkyū and Hōrō, Baishitsu was considered in his time to be one of the "Three Masters of Kyoto." Here he has freely written four haiku, one for each season, on finely woven silk. This is unusual because silk was more expensive and considered more elegant than paper; it was more commonly used for courtly *waka* than for haiku.

Baishitsu's first haiku is written in two columns on the upper right, the second haiku below it, the third on the upper left, and the fourth on the lower left; the signature with the artist's age of eighty-two adds a small fifth calligraphic element at the far left. The four poems express the familiar seasonal references—spring cherry blossoms, the summer cuckoo, the mid-autumn moon, and winter snow—in new ways:

Matsukaze mo	The pine wind
tashika ni futte	is sure to blow—
hanazakari	full blossoms

When the cherry blossoms are at peak maturity, the wind often carries them off, an example of earthly transience.

Murakumo wo	Patches of clouds
misete wa matsuka	shown us as we wait—
hototogisu	cuckoo

The cuckoo is a harbinger of summer; while awaiting its first call, many Japanese would be watching the sky.

Meigetsu ya	Mid-autumn moon—
kusaki ni otoru	beneath trees and grasses
hito no kage	someone's shadow

The harvest moon always attracts many viewers, but here one or more people (*hito* can be either singular or plural) may be interested in other pursuits.

Sara wareta	Breaking a dish
oto wa izu kozo	where has the sound gone?
yoru no yuki	evening snow

It is visually striking how Baishitsu has arranged the four 5-7-5–syllable poems over the surface in a visually striking composition. He writes each of them in two columns rather than three and divides them not between poetic lines but near the middle of the second (seven-syllable) line. In the first three poems the syllable break is therefore 9-8; but in the final poem, in order not to split a word in the middle, Baishitsu makes the syllable break 8-9. In the first poem, the columns are broken thus: *matsukaze motashika ni / futte hanazakari*. This lineation gives a new rhythm to the familiar haiku format;

but to make sure we don't read these as two-line poems, Baishitsu always dips the brush before the third poetic line, emphasizing the final image of each haiku: full blossoms, the cuckoo, someone's shadow, and evening snow.

Baishitsu uses several other calligraphic devices for visual effect. For example, in the two upper haiku (the first and third of the sequence) the second characters are the words for "wind" (風) on the right and "moon" (月) on the left. "Wind" swings outward with three dots in the center, while "moon" curves back inward with two dots. Originally an image of a crescent moon, this character became less pictorial over the centuries, although here its slight angle suggests floating in space. Baishitsu's "wind" also becomes pictographic, with its breezy expansiveness made stronger by the narrowly composed *kana* syllable *mo* (も) below it.

Finally, we may suspect that Baishitsu has given us a visual pun at the start of the fourth poem. The first word is written in a way that closely resembles the word for "four" (四), but it is in fact the character for "plate" (皿). Occurring just below the center of the total composition, this character presents a horizontal accent that helps the viewer keep the poems distinguished from one another while suggesting the haiku virtue of multiple meanings. The word "four" in Japanese has the same sound (*shi*) as "death," and therefore groups of four are not usually well liked; but since there are unavoidably four seasons, Baishitsu has found a way to "break" this "four" as well as the dish. And, to carry this little fantasy into the realm of the Zen *kōan,* if the "four" haiku are broken, then where is the sound? This may take us back to the splash made by Bashō's famous jumping frog and remind us once again that the sense of play has long been a vital element in Japanese culture.

Zen Calligraphy

As the Tokugawa government consolidated power over Japan in the seventeenth century, Buddhism came to a crossroads. On one hand, it became partially controlled by the shogunate, which insisted upon regulating matters such as the appointment of abbots at important monasteries. In addition, the regime demanded that every citizen register at a temple, creating a kind of census bureau; an underlying purpose was to ensure that the populace remained settled in place and that travel could be restricted. In addition, the shoguns shifted their support from Zen monks to Confucian scholars as advisers and teachers, thus reducing the power of clerics to participate in larger political and social issues. In effect, the Tokugawas used Buddhism as part of their governing strategy without welcoming the kind of influence and advice that earlier shoguns had sought from cultivated Zen monks such as Sakugen Shuryō (1501–1579, #56).

Buddhist prelates found three ways of responding to the new situation. One was to attempt to continue their interactions with the elite, which could still be done through the tea ceremony and occasional invitations to visit government leaders. This choice was made by several Zen monks from Kyoto's Daitoku-ji, which retained an important connection to the court as well as hot-and-cold relations with the regime in Edo, depending upon who was shogun at the time. Among the most significant of these monks was Takuan Sōhō (1573–1645, #58), who at one point was exiled for protesting the government's regulations of monks, and then was not only pardoned but also befriended by a later shogun.

Another response was to abjure the powerful and retreat to the countryside. Fūgai Ekun (1568–1654, #57), for example, left his country temple to live for some years in a cave in the mountains. Perhaps he was emulating the first Zen patriarch, Bodhidharma (Jpn., Daruma), who was said to have meditated in front of a wall for nine years, and the monk Hotei, who preferred wandering through the countryside to living in a temple. Fūgai painted many images of Daruma and Hotei, but he also brushed calligraphy with a very individualistic spirit.

The most important of the three choices made by Zen Masters, however, was to reach out more than ever before to ordinary people. They did this by setting up large public meetings and talks, publishing woodblock books of Zen essays, biographies, poems, and anecdotes, and creating painting and calligraphy. Before this opening up to the public took place to any large degree, however, there came the influx of Ōbaku monks from China, as mentioned in earlier essays.

The monks who arrived from China considered themselves part of the Lin-chi (Jpn., Rinzai) tradition, but because their Zen was somewhat different from that of Japanese Rinzai monks, incorporating elements of Pure Land Buddhism, they formed a new sect, known as Ōbaku.[1] Led by Yin-yuan (Jpn., Ingen, 1592–1673), they were granted special permission by the government to leave Nagasaki and build the monastery Mampuku-ji in the Uji mountains near Kyoto. At a time when the Japanese were cut off from the outside world, the cultural impact of the Ōbaku was significant, probably even greater than its religious influence. Chinese monks brought with them Ming-dynasty styles of everything from chanting to vegetarian food, robes, temple architecture, painting, tea presentation, and calligraphy. Several of the monks were highly skilled in brushwork, and they also carried from China paintings, calligraphy, and books, including a set of volumes that showed thirty-three variations of seal script.

The influence of Ōbaku monks on Japanese calligraphy was stronger upon laypeople than upon Japanese monks. The emigree literatus Tu-li (Jpn., Dokuryū, 1596–1672; see fig. B.1) has already been cited as a teacher of several important Japanese calligraphers who were eager to learn the latest ideas and styles from China. In return, there was also some Japanese artistic influence upon Chinese-born Ōbaku monks. For example, single-column calligraphy in China was primarily done in pairs of scrolls, which might be hung on either side of a door. However, the Japanese taste for asymmetry, as well as the use of the *tokonoma* alcove in homes and tea houses, led Ōbaku monks to follow Japanese custom and brush a large number of single column scrolls, usually Zen texts but also literati phrases that could have Zen interpretations.

The second abbot of Mampuku-ji, Mu-an (Jpn., Mokuan, 1611–1684), displayed an especially broad and forceful style in his calligraphy, as can be seen in figure F.1, "Longevity Mountain Flourishing a Thousand Ages." Other masters of the brush from this sect include the fifth abbot of Mampuku-ji, Kao-ch'uan (Jpn., Kōsen, 1633–1695), who completed the building of the monastery. Kao-ch'uan was a master of the single-column form, which he used for succinct Zen phrases written in a very fluid style.

Japanese-born Ōbaku monks added to this calligraphic legacy; after training with Chinese masters at Mampuku-ji or in Nagasaki, they were sent to lead new temples of their own. The popularity of the powerful and fluent Ōbaku styles of calligraphy, in single columns as well as other formats, spread through the Japanese populace as these temples were built or converted for the new Zen sect. Among the native masters were Tetsugen Dōkō (1630–1682, #63), who was most famous for having thousands of woodblocks carved to print a complete set of the Buddhist canon, and Tetsugyū Dōsa (1628–1700, #62), who used calligraphy in various ways, including giving a Buddhist name to a pious follower. Another use of Zen calligraphy was for death poems; an example by the Ōbaku monk Kakuzan (1640–1717, #64) keeps alive the traces of his brush from moments before he passed away.

Despite the energy and interest gained through the new Ōbaku sect, Japanese Zen began to decline as society became increasingly mercantile in the seventeenth and eighteenth centuries. Three major masters appeared, however, who were able to revitalize the Sōtō and Rinzai traditions. The first was Gesshū Sōkō (1618–1696, #61), who brought back the teachings of Dōgen (1200–1253), the founder of Sōtō in Japan. Next came the Rinzai monk Bankei Yōtaku (1622–1693, #65), who studied with both Japanese and Chinese masters, and then reached out to the public through large meetings where he taught his concept of "the unborn."

Most important of all was Hakuin Ekaku (1685–1768, #68), who thoroughly revived the Rinzai sect through his strict training methods for monk pupils and his ability to express Zen to people at every level of society in Japan. He taught in part by creating hundreds of paintings and works of calligraphy to be given to farmers, artisans, merchants, and samurai-officials, as well as to monks. In addition to writing famous Zen aphorisms, Hakuin composed many poems and sayings of his own, just as he supplemented his paintings of Zen paragons such as Daruma and Hotei with the invention of an astonishing range of new Zen painting subjects.[2] He was able to add humor to many of his works, but by his later years he had also mastered a brushwork style of unprecedented depth and strength.

Hakuin's pupils and followers continued his lead in using painting and calligraphy as a Zen activity that could communicate to the broader public, although no one was quite as wide-ranging in imagination or scope. Nevertheless, monks such as Tōrei Enji (1721–1792, #69) and Inzan Ien (1754–1817, #74) brushed works that well display their own personalities as well as their "Zen mind," which the current Chief Abbot of Tōfuku-ji, Keidō Fukushima (born 1933), describes as pervading the brushwork of Zen Masters.

Buddhist calligraphy was not restricted to Zen, however. Not only was copying sutras a continuing practice for both monastics and laypeople, but monks of other sects also brushed works in larger scale for their followers. Three of the major masters of calligraphy in the early modern period were members of esoteric Buddhist sects. The first, Tominaga Jakugon (1720–1771, #70), followed literati traditions and became known as an excellent *karayō* poet. The second, Jiun Onkō (1718–1804, #71), was Japan's greatest master of Sanskrit as well as a leading Shingon-sect monk who also studied Zen. His calligraphy has been highly admired for its dramatic boldness and use of "flying white," where the paper can be seen through the rough brush strokes. The third, Gōchō Kankai (1739–1835) was a Tendai-sect monk who also practiced Zen meditation. His brushwork, like that of Jiun, is included in most considerations of *zenga* (Zen brushwork after 1600) because of its dynamic style and frequent use of Zen themes.

Zen calligraphy is usually written on paper (more rarely on silk) in hanging scroll, hand scroll, fan, or album format. However, other media have also been utilized. Gōchō not only wrote calligraphy on ceramics but created his own; a tea bowl he made in the *shino* tradition shows his handiwork in both the vessel and the calligraphy upon it (#72).

One of the most beloved of all Zen poet-monks of the early modern period was Daigu (Taigu) Ryōkan (1758–1831, #76). In the "Snow Country" near Niigata, Ryōkan was content to live in a small mountainside hut rather than a temple and was more likely to stop and play with local children than

to give lectures on Buddhism. Unlike most Zen monks, Ryōkan wrote in a gentle, modest style, expressing his unassuming personality. Although he was highly skilled in both Chinese- and Japanese-style calligraphy, he hid his expertise while writing in seemingly childlike *kana*, as well as regular, running, and cursive scripts, usually working within small formats. He once commented that one of the things he did not like was "calligraphy by a calligrapher," and his own work has a direct appeal that shows no trace of professional techniques. Although his life seems quite different from that of Hakuin, they both found ways to reach everyday people through personal brushwork that expressed their Zen spirit.

The purposes of creating Zen calligraphy were vital to the development of its styles. When the early modern period began in the later sixteenth century, major Zen monasteries often housed ateliers that provided Zen paintings and calligraphy for temples, palaces, mansions, and even for trade with China. But after neo-Confucianism gradually replaced Zen as the major cultural and educational force supported by the government, monasteries no longer needed to produce works of art for the elite. Semi-professional artist-monks such as Sesshū soon disappeared; Zen brushwork in the new era was created by the major Zen Masters themselves to be given to their followers.

The result was a change of emphasis in both subject and style from complex to simpler, from professional to more personal, and from high culture to full culture in scope. This change is especially visible in Zen painting, which in some ways anticipated minimalism and conceptual art by eliminating everything but the most crucial brush strokes and by featuring a bold use of empty space. Many monks, however, remained comfortable with traditional styles of calligraphy, which they had practiced since childhood, when they had learned how to read and write. The audience of followers who wanted traces of a master's Zen mind led to an outpouring of works that emphasized direct communication rather than expertise. As a result, Buddhist calligraphy both continued and somewhat diverged from the artistic heritage of previous centuries. In the hands of outstanding Zen Masters such as Takuan, Bankei, and Hakuin, it blossomed as a vital new artistic force in early modern Japan.

NOTES

1. For a discussion of Ōbaku art, see Stephen Addiss, *Obaku: Zen Painting and Calligraphy* (Lawrence, Kans.: Spencer Museum of Art, 1978).

2. See Naoji Takeuchi, *Hakuin* (Tokyo: Chikuma Shoten, 1964) for more than eight hundred examples of Hakuin's brushwork. For English-language sources, see Kazuaki Tanahashi, *Penetrating Laughter* (Woodstock, N.Y.: Overlook Press, 1984), and Stephen Addiss, *The Art of Zen* (New York: Harry N. Abrams, 1989).

The Voice of the Raindrops

Hanging scroll, ink on paper, 52 x 88 cm.

Although most of his life falls slightly before the early modern period (1568–1868), Sakugen represents some of the forces that were beginning to invigorate Japanese calligraphy, including renewed influences from China as well as rejuvenation of the Zen tradition. Sakugen served as abbot of the major Zen monastery Tenryū-ji in Kyoto through one of the most turbulent times in Japanese history, the end of the Muromachi era (1392–1568) and the advent of the great military leaders who brought forth the Momoyama period (1568–1615). Active in worldly matters as well as in religious affairs, Sakugen made two journeys on trade missions to China, each lasting more than a year; in his diary he recorded meetings where he and Chinese literati had occasion to discuss their mutual interest in poetry and calligraphy.[1] His writing reflects both the influence of Chinese styles and the personal freedom of a Zen Master.

Here Sakugen has written out the forty-sixth *kōan* (Zen conundrum used for meditation) from the well-known *Hekiganroku* (Blue Cliff Record), a collection compiled in the eleventh century by Hsueh Tou, who added a poem after each *kōan*.

> Ching Ch'ing asked a monk, "What is this voice outside the gate?" The monk replied, "The voice of the raindrops." Ching Ch'ing said, "Humans are topsy-turvy; deluding themselves, they chase after things." The monk asked, "What about you?" Ching Ch'ing replied, "I have reached not deluding myself." The monk asked, "What does that mean, 'I have reached not deluding myself?'" Ching Ch'ing said, "Going out from the body is easy, but explaining how to escape the body must be difficult."

> An empty hall with the voice of raindrops—
> Even a master finds it hard to answer.
> If you say you understand entering the stream,
> You still don't understand.
> Understanding, not understanding—
> Southern mountains, northern mountains more and more suffused
> with rain.

Monks in training meditate on such *kōan*, sometimes for months or years; and since this is one of the more complex but evocative examples from the *Hekiganroku,* it has become well known in Zen circles. Sakugen has written the *kōan* and accompanying poem primarily in cursive script, but for contrast he mixes in some characters in running script and even a few in standard. What is most striking is the constant creative flow with which he writes. The characters are small and seemingly modest, but each one is given its own unique form and sense of movement. This creativity is most visible when the same character appears more than once, and we can examine here two examples.

First, there are two versions of the important character for "rain," which has the pictorial element of four dots (suggesting four raindrops) within

its form (雨). Sakugen's first version of this character in the second column (fig. 56.1) begins with a dot representing the upper horizontal stroke. With a single swirl of the brush he then circles around, with the four dots represented by a Z-shaped hook. The brush actually leaves the paper during the circling, but the gesture continues, making it choreographically a single stroke. The next "rain" appears in the eighth column, where Sakugen repeats the top dot and swirl but adds a vertical stroke and three dots; the character has now almost become a face (fig. 56.2). Originally requiring eight strokes of the brush, "rain" is here created with first two and then six strokes.

The first and third characters in the eleventh column are the word for "mountain," which was originally based upon a pictograph of a tall central peak with smaller hills on either side (山). For his first version, Sakugen has begun with the central vertical, then swung left and across, with a final dot on the right; the word is centrally balanced (fig. 56.3). The second version, however, is quite different. Sakugen has allowed the brush to leap lightly down from the previous character (north, 北) to begin on the left side and move across and up, finally hooking down on the right. This ending movement of the brush is so strong that it depends for balance on the long, slightly bending horizontal left and center; otherwise the character would seem to tip over.

Examples of this kind of creativity can be found throughout the scroll. For example, when at the end of the ninth column Sakugen reaches the characters "enter the stream" (入流), he continues the movement of the brush from the two-stroke, regular-script "enter" to the first dot of the more complex, cursive-script "stream." Usually when one word is continued visually to the next, the ink line is very light and thin; but here the connection is bold and strong, combining the words as though we were in fact entering a stream. To reinforce the interaction, Sakugen has ended the "stream" with a long angular hooking stroke that relates to the right angles of "enter" above it.

Looking at the scroll as a whole, we can see how the varied rhythms of darker and lighter accents interact with the sometimes more and sometimes less simplified forms of the characters. Perhaps most noticeable are the occasional large swirls that Sakugen makes with the brush, especially in his cipher-signature at the end on the left. However, these flourishes are balanced by the smaller, simpler, and more angular characters seen throughout the scroll. Many admirers of Japanese calligraphy are most struck by large-character writing, such as in single-column vertical scrolls; but as this remarkable dance of the brush makes clear, the joys that come from repeated viewings of smaller calligraphy can be at least as great.

NOTE

1. For further information, see Makita Tairyō, *Sakugen nyūminki no kenkyū,* 2 vols. (Kyoto, 1959).

Figure 56.1.
Sakugen Shuryō,
"Rain."

Figure 56.2.
Sakugen Shuryō,
"Rain."

Figure 56.3.
Sakugen Shuryō,
"Mountain,
north mountain."

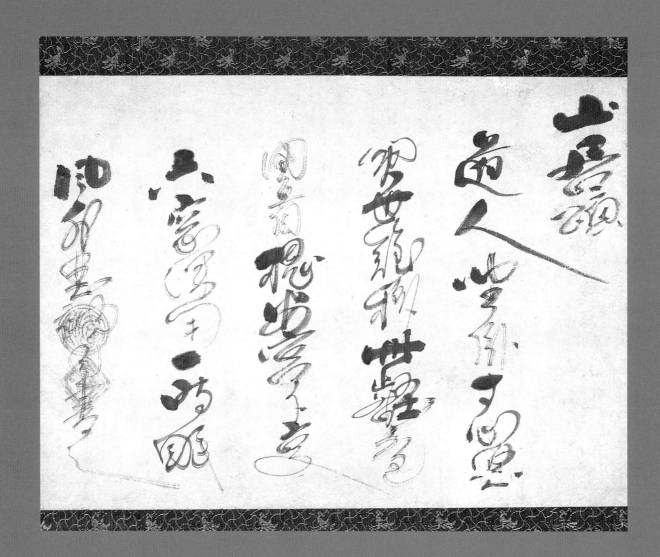

Six Windows Shut

Hanging scroll, ink on paper, 28.5 x 40.3 cm.

How much does format influence calligraphy? The answer varies case by case, but if we examine a poem by the Sōtō Zen monk Fūgai in both horizontal and vertical formats, we can see a few intriguing differences, although his basic style remains consistent.

Fūgai was one of the most unusual monks of the Edo period. After thorough Zen training, he was put in charge of a country temple. A few years later, however, he left to live in a small cave in the side of a mountain. Local farmers would occasionally leave food at the cave mouth, and he would respond with an ink painting or calligraphy for them to take. In this poem he calls himself a *dōnin* (道人, monk, man of the Way), with his "six windows" (六窓, six senses, including thought) closed.

Praising My Mountain Home

A man of the way, sitting and lying down with one inch of steady mind,
I viewed the world's troubles, and moved to this valley.
Turning my head, the Huai-an Dream Palace is below me;[1]
Six windows deeply shut, I take an hour's nap.
—Fūgai Rustic Robe's writing

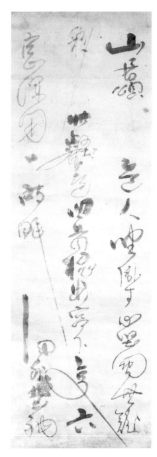

Figure 57.1.
Fūgai Ekun,
Six Windows Shut
(vertical format).

Examining the poem in its horizontal format, we can see Fūgai's idiosyncratic cursive script style, which features inventive character shapes, wet-to-dry brushwork, and wide ranges of line widths varying from very thin to notably thick. The many curving strokes contrast with occasional short, heavy horizontals, adding to the sense of tensile power. This compressed energy in Fūgai's brushwork finds release in occasional swirls or long diagonals, only to build up internal force again in the following characters. The result is Fūgai's intensely personal brushwork rhythm.[2]

Certain characters here are accented by thick and heavy ink, usually where the artist has redipped the brush. These include "mountain" (first word of title), "Way" (first word of poem), "inch" (column 1, word 5), "world" (2/2), "this" (2/5), "Huai" (3/3), "six" (4/1), "one" (4/5), and "wind" (beginning of signature). In addition, three characters end with long diagonals: "man" (1/2), a variant character for "this" (3/7), and the end of the signature. With such dramatic rhythm in his brushwork, Fūgai is content to let the four lines of the poem match the four columns of calligraphy.

Comparing this scroll with the same poem by Fūgai in vertical format (fig. 57.1), what is repeated and what is different? The basic structure is the same: a three-word title in the upper right, the poem clearly separated in the center, and finally the signature on the left. The style is also similar, although not always at the character-by-character level, where we now see some variations.

Some changes are clearly inspired by the different format, such as the new column division of the poem into 10-12-6 characters. In terms of elaborations,

Fūgai now writes "man" (人, 1/2) without the long diagonal, since there is no space for it in this format; but he again uses a long diagonal ending for "this" (此, 2/11) and adds similar strokes for "move" (移, 2/1) and for the poem's final word, "sleep" (眠, 3/6). He also now has room to extend the thick vertical stroke that begins his signature. We can conclude that specific flourishes and emphases are not always integral to Fūgai's conception of the poem but in individual cases are added where he feels it appropriate.

Fūgai creates special emphasis by using heavy, thick, wet ink for some characters, here mostly repeating those seen in the horizontal format. Again the words "mountain" (title), "way" (1/1), "this" (2/2), "Huai" (2/11), "six" (2/12), and "one" (3/4) are brought forth, although now "turn" (2/5) and "thing" (2/11) are also strongly presented. In both scrolls, however, neither the start of a poetic line nor the beginning of a column is always emphasized. Instead, the visual stressing of certain words, along with the creation of unique compositional and brushwork rhythms, becomes the basis of Fūgai's style. His name, literally meaning "beyond the wind," is appropriate for a monk who lived much of his life away from all worldly matters and whose individual strength of character is apparent in every stroke of the brush.

NOTES

1. The Huai-an (Locust-Tree Peace) Palace relates to a story from the T'ang dynasty about Shun Yu-fen, who lay down under a locust tree and dreamed that he traveled to the "Land of Locust-Tree Peace," which was ruled by a beautiful woman whom he married.

2. This sense of individual spirit can also be seen in his paintings, usually of Hotei or Daruma, most of which are accompanied by his calligraphy. For more information on Fūgai and reproductions of his paintings, see *Fūgai Dōjin ibokuten* (Fūgai's Ink Traces Exhibition, Odawara, 1982), *Fūgai Ekun sakuhin-ten* (An Exhibition of Works by Fūgai Ekun, Hiratsuka Museum, 1992), *Zen Gahō,* no. 12 (Zen Graphic, 1990, on Fūgai Ekun), and Stephen Addiss, *The Art of Zen* (New York: Harry N. Abrams, 1989), pp. 44–58.

58 TAKUAN SŌHŌ (1573–1645)

All Things Revolve

Hanging scroll, ink on paper, 118.8 x 27.4 cm.

The Kyoto temple Daitoku-ji has a special tradition in calligraphy that stems in part from its founder Daitō Kokushi (1282–1338) but even more from the eccentric Zen Master Ikkyū (1394–1481). Distressed with the Zen of his own day, which he considered overly connected with power and politics, Ikkyū deliberately behaved in strange and unexpected ways, for instance criticizing the religio-political establishment and celebrating a love affair with a young woman during his elderly years. This independence is also evident in his poetry, painting, and calligraphy. In an age when many monks sought to cultivate refined artistic skills, he rejected an emphasis on technique; his calligraphy in particular is written with no regard for "grace" or "beauty" as generally understood.

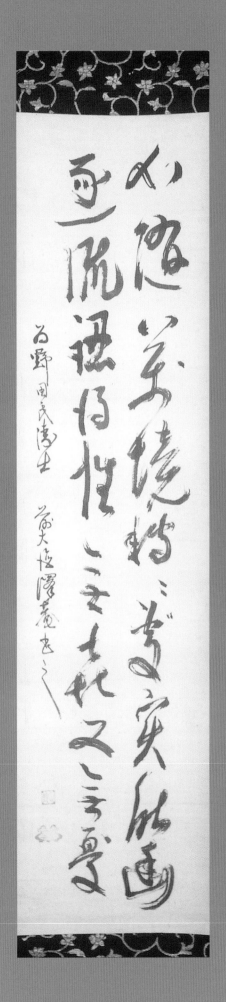

Two hundred years after Ikkyū, Takuan also experienced difficulties regarding government interactions with Zen. Along with three monk colleagues, he protested shogunal interference in temple succession, for which he was banished in 1629 to northern Japan. In 1632, however, he was summoned to Edo, and the new shogun, Iemitsu, soon invited him to lecture on Buddhism. In 1638, Iemitsu asked Takuan to open the temple Tōkai-ji in Edo, which he did the following year after a leisurely journey back to Kyoto and Daitoku-ji.

A friend and teacher of many leading monks as well as lay pupils such as Emperor Gomizuno-o and the courtier Nobutada (#2), Takuan was well known for his Chinese and Japanese poetry and Zen writings in prose. He was also a pioneer in the revival of simplified Zen painting, which deconstructed the more elaborate styles of painter-monks of the previous century.

Takuan's calligraphy is bold and personal, as this hanging scroll attests. The tall, thin format is divided into two columns of ten characters each, followed on the left by an inscription of six characters, "written for the Imperial Guardsman Noda," and a seven-character signature, "formerly Daitoku [-ji abbot] Takuan's writing." The poem by Madora Sonja, in four lines of five characters each, expresses Zen beliefs about enlightenment:

> Following mind, all things revolve;
> Dwelling in this change—a truly deep accomplishment.
> Attaining the flow, see your own nature:
> Empty of joy and empty of grief.

From the very first word (mind/heart, 心) it is clear that Takuan is rejecting any attempt to make the calligraphy "artistic." Compared with the same character in the scroll by Daidō (#67), "mind/heart" draws no attention to itself here. The following words in cursive script are also rough and ready, empty of graceful flourishes, and the ink tone dark gray rather than lustrous black. Brush strokes begin and end rapidly, often with "flying white," and the characters tilt slightly to the left or right as though written that way without conscious intention. The straightforward honesty of the calligraphy, avoiding any extraneous effects, exemplifies the Zen teaching of "right here, right now, just as I am."

As an example of the unpretentious nature of this work, the character for *Mu* (無, no/nothing/emptiness) appears as the sixth and ninth words of the second column. In Zen art, *Mu* is often written either with great force and architectonic power in twelve strokes or with great fluidity in a single stroke of the brush. Takuan, in contrast, divides *Mu* into simple horizontal planes written with four strokes that lead directly to the words below. Indeed, if one word is given extra visual emphasis in this final line of the poem, it is the third-to-last character (and/also, 又), as if to suggest a translation even simpler than that given above:

> No joy—AND—no grief.

196

You Are Leaving (1629?)

Hanging scroll, ink on paper, 55.5 x 108.5 cm.

The son of a merchant and tea master, Kōgetsu started his study at Daitoku-ji at the age of six. When his father Sōkyū built Daitsū-an in Sakai for the monk Shun'oku, the young Kōgetsu studied with him, later accompanying Shun'oku back to Daitoku-ji to take Buddhist orders at the age of fifteen. Six years later Kōgetsu was invited to become abbot of a new temple in Shiga, but he returned to become abbot of Daitoku-ji in 1610. In the following years he established or reestablished no fewer than twenty-one temples and subtemples at Daitoku-ji and in other parts of Japan.

Known as a tea expert and teacher like his father, Kōgetsu was also strongly interested in painting and calligraphy. He kept extensive diary-style notebooks on brushwork, forty of which are still extant. His own calligraphy, considered exemplary for tea gatherings, powerfully expresses his Zen mind.

Here Kōgetsu has written out a seven-word poetic line that conveys sadness at a friend's departure. Does he also perhaps invite the viewer to become the "you" who, through enlightenment, could become his colleague?

The original quatrain was composed by the eighth-century poet Liu Shang for Wong Yong:

> You are leaving, with whom can I enjoy the spring mountains?
> Birds sing, flowers fall, the river emptily flows—
> Now it's best to say farewell as we face the waters,
> In the days ahead, when I think of us, I will come to this riverbank.

Kōgetsu's calligraphy sets forth the poem's first and most famous line. Because the most important word here is "you" (*kimi*, 君), Kōgetsu gives it large-scale prominence on the right through strong dry-brush work in a blunt style typical of the Daitoku-ji masters. Especially notable are the "flying white" and the spontaneous "open tip" of the brush as it roughly begins and ends each stroke. The next two columns have three words each, followed by a column with the four-character signature "Murasakino Dōnin" (Purple-field Person of the Way).

Examining the first full column to the left of *kimi*, the top word, "leaving" (去), shows the intensity and strength of Kōgetsu's brushwork. He contrasts three broad horizontal slashes, each at a different angle, with a long diagonal and a concluding bold, curving dot. The following word, however, provides a remarkable contrast. The first stroke of "spring" (春) begins far to the left of normal and is relatively slowly and thinly brushed; the stroke disappears for a moment before Kōgetsu applies more pressure to the brush as he moves it horizontally. This character concludes with a stroke that continues down to the next word, "mountain" (山), which visually anchors all three graphs with its wide base.

The calligraphy in the next column emphasizes verticals and curving strokes, rather than horizontals. A further contrast is offered on the far left by the slightly lighter strokes of the signature, which begins with curving

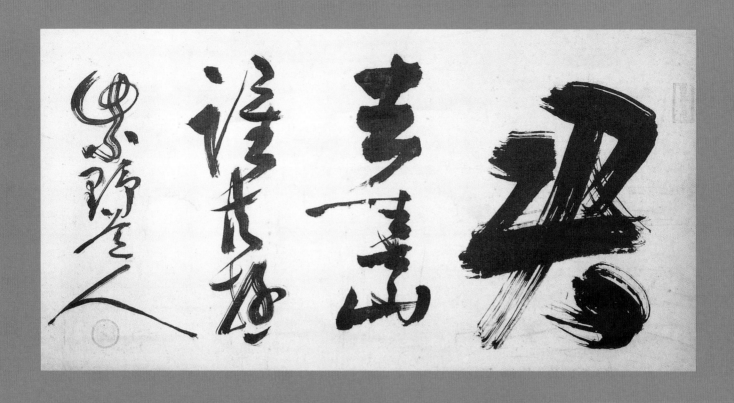

lines but ends with an extended pair of thinner diagonal strokes for "person" (人). These relate back to the long beginning horizontal of "spring," and their thinner and longer lines, deployed at strategic points in the total composition, offset the intense power and blunt energy of Kōgetsu's broader strokes.

Poems of farewell have long been a tradition among literati in China because many scholars who worked in government positions were periodically sent to distant posts, far from their friends. This poetic tradition was also used by Zen monks, especially when leaving Japan for China or vice versa. In Kōgetsu's day, however, travel to China was prohibited by the government, so we may wonder where the recipient of the poem was going. In addition, three other special questions can be raised. First, who was the friend who was leaving? Second, why is this calligraphy written in such large size and bold, rough style? Third, why does Kōgetsu emphasize the signature "Purple-field Man of the Way"? Daitoku-ji is located in a section of Kyoto known as Murasakino, but in other works Kōgetsu does not use this signature, much less emphasize any signature as much as here.

Audrey Yoshiko Seo has suggested a fascinating possibility that might answer these questions. Like his monk friends Takuan (#58) and Gyokushitsu, Kōgetsu in 1629 protested governmental interference with Daitoku-ji, particularly the shogunate's new regulation that it, rather than the emperor, would appoint abbots to the purple robe of office. Unlike his two friends, however, Kōgetsu was not exiled. Might the departing monk have been Takuan or Gyokushitsu (or perhaps both)? And might the large thrust of the "Purple Field" signature be partly a reference to this "Purple Robe" incident? This theory explains the choice of the poem, the special signature, and the bold, rough calligraphy style, all of which certainly convey Kōgetsu's forceful and determined personality. Does this dramatic work demonstrate his defiant spirit at this important moment of his life?

60 GYOKUSHŪ SŌBAN (1600–1668)

The Mosquito Bites the Iron Bull
Hanging scroll, ink on paper, 132 x 32.2 cm.

One of the leading Zen Masters in Kyoto during the mid-seventeenth century, Gyokushū studied at Daitoku-ji under Gyokushitsu Sōhaku (1572–1641), by whom he was granted the first character (玉, jade) of his Zen name; he then became abbot himself in 1649. Gyokushū was a close friend of the Katagiri Iwami-no-kami, founder of the Sekishū school of tea ceremony; when Katagiri established Jikō-in in Koizumi, Gyokushū became its first abbot. In 1661 he also became abbot of Tōkai-ji in Edo, established by his predecessor Takuan (#58).

Gyokushū's close association with the tea ceremony doubtless enhanced his reputation as a calligrapher and provided him with abundant requests for his brushwork. In general, his scrolls demonstrate the broad, blunt, and

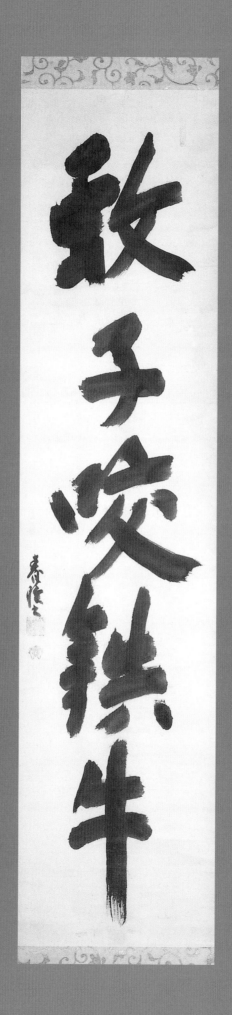

牧子喫鐵牛

dynamic style that is associated with Daitoku-ji masters, although some features are distinctly his own.

The phrase Gyokushū has written here is used in several Zen discourses to suggest the difficulty of achieving enlightenment. For example, Bassui Tokushō (1327–1387) told a questioner that "trying to perceive the great dharma from one's narrow viewpoint is like a mosquito trying to bite an iron bull."[1] We encounter the phrase again in a story quoted by the Japanese master Dōgen Kigen (1200–1253): upon reaching enlightenment under the auspices of his teacher Daji, Yaoshan exclaims, "When I was studying with Shitou, it was like a mosquito trying to bite an iron bull."[2]

The five characters of the phrase represent "mosquito" (蚊子), "bite" (咬), "iron" (鉄), and "bull" (牛). Three of the five graphs are constructed of two parts: a radical on the left and another form on the right. In these *kanji*, Gyokushū narrows the left side and extends the right; this characteristic is especially notable in the words "bite," with its "mouth" radical (口) squeezed to the left, and "iron," where the complex left "metal" radical (金) is reduced to a leaning vertical on which a series of short strokes cluster.

Gyokushū's brushwork in regular script only occasionally softens into running script, in which strokes continue and join rather than being entirely separate. In a single case, two words join each other; appropriately these are "bite" and "iron." Gyokushū generally moves the brush in a decisive if slightly truncated manner, using "open tip," in which the hairs of the brush are visible as they enter and leave the paper; however, the very first stroke of the scroll demonstrates the rounded forms of "hidden tip." The entire work ends with the final stroke of "bull" deconstructing into "flying white." This vertically extended character creates the sensation of a pole holding up the entire calligraphy, or a tree trunk supporting all the foliage above it.

Despite the subtleties of character composition in this work, perhaps the dominant impression given by Gyokushū's scroll is one of powerful simplicity. The lack of elaboration, the blunt brushwork, the pithy text, and the straightforward strength of the characters all combine to create a scroll that would be equally appropriate in a temple or at a tea gathering. Inviting viewers both to empathize with the mosquito's seemingly impossible task and to consider the iron bull's imperviousness to the vicissitudes of daily life, Gyokushū's scroll serves as a direct expression of Zen teaching.

NOTES

1. Adapted from Bassui Tokushō, *Mud and Water,* trans. Arthur Braverman (San Francisco: North Point Press, 1989), p. 30.

2. From *Moon in a Dewdrop: Writings of the Zen Master Dōgen,* ed. Kazuaki Tanahashi (New York: North Point Press, 1985), p. 81.

Huang-po's Buddha-Dharma

Hanging scroll, ink on paper, 127 x 26.4 cm.

Although Sōtō is numerically the largest Japanese Zen sect, its monks have been less prolific than Rinzai monks in creating paintings and calligraphy. The differences between the two sects are largely historical, although Sōtō promotes meditation as a form of gradual enlightenment more than Rinzai, which stresses *kōan* study as a means toward sudden enlightenment.

Gesshū, one of the leading Sōtō masters of the later seventeenth century, had his first experience of *satori* while meditating on *mushin* (literally, "without mind") and encountering a great doubt:

> Sitting in an outhouse, I concentrated on this doubt; as time passed by I forgot to leave. Suddenly a violent wind came, first blowing the outhouse door open and then shut again with a loud crash. My spirit instantly advanced and ripped apart my previous doubt, like awakening abruptly from a dream or remembering something forgotten. I began to dance in a way I had never learned, and there are no words to convey my great joy.[1]

After a subsequent, deeper enlightenment experience—reached through sustained meditation on *Mu*—Gesshū became abbot of several important Sōtō temples. He revived the strict teaching methods of the sect's Japanese founders, Dōgen (1200–1253) and Keizan (1268–1325), and republished their Buddhist writings; these efforts earned him the epithet Restorer of the Sōtō Sect. Gesshū had several significant pupils, including Tekisui and Manzan, to whom he emphasized that everyone is born with a visionary eye, although it can become lost in the cloud of desires.

Gesshū's powerful and idiosyncratic calligraphy combines boldness and finesse. Here he has brushed seven words that form part of a story about Huang-po (Jpn., Ōbaku, died c. 850) and Lin-chi (Jpn., Rinzai, died 866).[2] Curiously, although there were five main Zen "houses" in China, in Japan there are only three: Sōtō, Rinzai, and Ōbaku (itself originally a branch of Rinzai). That a Sōtō monk used this Rinzai phrase for his calligraphy attests to the unity underlying the various Zen traditions.

The story relates that Lin-chi went to study with Huang-po and after three years was encouraged to ask the master, "What is the essence of the Buddha-dharma?" However, before Lin-chi completed the question, Huang-po hit him; and the same thing happened two more times when he approached the master. Discouraged, Lin-chi left and traveled onward to see the monk Ta-yu (Jpn., Daigu), to whom he told this story. Ta-yu assured him that he had been treated with the kindness of a grandmother, and Lin-chi suddenly reached enlightenment. "After all," he said:

> Huang-po's Buddha-dharma is not all that special!

Gesshū writes the seven characters in groups of 2-2-1-2. The first two words, "Huang-po," are joined in swirling cursive script, while the next two, "Buddha-dharma," are integrated spatially, although the word "Buddha" (佛) is less cursive and more architectural. The fifth word, *Mu* (無), given the

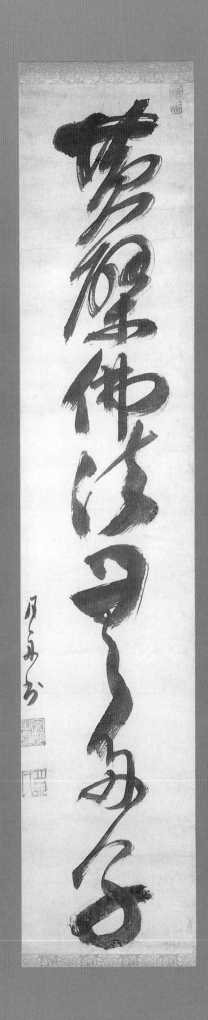

space of two characters, is visually the most significant; it spirals down in cursive script toward the final two words—literally, "many children"—which are connected with thinner brushwork until the final broad hooking stroke.

Although there is little room between words, the negative spaces inside the characters are full of energy, such as the ovals bending in different directions within the first, second, third, and final two graphs. Perhaps most notable is the negative space in the beginning of *Mu*, which can be seen as two overlapping ovals, a blunt arrow, or even the head of an animal.

Another feature that adds flavor to this calligraphy is the asymmetrical balance among the few powerful upward-leaning horizontals (such as the first strokes of the first and fifth characters), the less stressed verticals, and the primarily curved strokes that complete the single column of graphic shapes. We can also note the varied thickness of line and use of "flying white"—or should we desist from analysis, follow the rhythm of the brush strokes, and just say, "Gesshū's calligraphy is not all that special!"

NOTES

1. From Sōgen Tekisui, *Gesshū Oshō iroku* (Records of the Monk Gesshū), 1704, pp. 18–19.

2. For more information on the two masters, see John Blofeld, *The Zen Teaching of Huang Po: On the Transmission of Mind* (New York: Grove Press, 1958), and Burton Watson, trans., *The Zen Teachings of Master Lin-chi* (Boston: Shambhala Publications, 1993). For a more extensive biography of Gesshū and photographs of his work, see Stephen Addiss, *The Art of Zen* (New York: Harry N. Abrams, 1989), pp. 64–69.

62 TETSUGYŪ DŌSA (1628–1700)

The Paper-Buddha Statue (1693)

Ink on silk, 93.7 x 34.8 cm.

Tetsugyū was born in Nagato and became a monk at the age of ten, studying first with the Rinzai Zen monk Teishū and then with Ryūkei Shōen (1602–1670), abbot of Myōshin-ji in Kyoto. When Ryūkei heard that the Chinese Zen Master Yin-yuan (Jpn., Ingen, 1592–1673) had come to Nagasaki, he and Tetsugyū went to meet him; Tetsugyū remained as a pupil of Yin-yuan and of his succesor Mu-an (Jpn., Mokuan, 1611–1684, see fig. F.1). When his training was complete, Tetsugyū established no fewer than seven Zen Ōbaku-sect temples. He was admired for his help to farming families as well as for his powerful and lively calligraphy.

Here Tetsugyū, at the age of sixty-four, has written a document at the request of a Buddhist layman of the Pure Land sect. The use of silk rather than paper demonstrates the formal nature of the work, which celebrates an unusual form of Buddhist sculpture:

> Mr. Kaihō Shinji, whose Buddhist name is Tonbo Jōen, was born in Kyoto. He traveled to Edo, and over time he and his family have prospered. His nature is serious and benevolent, and he is a devout Buddhist, deeply

海保氏居士法名頓參常圓北京人也少遊東都寓為豪家天禀質慧志行善良

深歸淨土常業念佛或曾於院陸或土佛名號如此有年後之為維

因塑彌陀瑞像一體以經糊之以號貼之至裝慈像以佛舍利一顆納之於佛

肚肉求予讃辭輙玄以誅而久讃曰

主佛全經即身以名於筆末塑芒糊紙營不假雕刻以綵圓求佛

哉壽佛
　　廣利群情

　　　元祿五年壬申臘月望日

佐廣三君第二十四世永福鐵牛機雲謹書

respecting the Pure Land of Amida Buddha. He has often copied the *Amida Sutra* and also has frequently written out the *nembutsu* [praise to Amida]. Over the course of many years, his devotional writings piled up like a small mountain, and so he decided to make a statue of Amida. Pasting together the sutra and *nembutsu* papers to create the image, he then put stone jewels within it as relics of Shakyamuni's bones. He has asked me to write an inscription, and since I can understand his pure mind, I now write:

Buddhas and sutras have different names depending upon their form.
This Buddha is not made of wood or of gold but of sutra paper
 and paste.
By good fortune it is now completed, truly a grand achievement.
This wonderful Buddha statue can help to save many people.

> —The fifteenth day of the twelfth month of the fifth year of Genroku [1693].[1] Respectfully written by the thirty-fourth generation from Rinzai, Tetsugyū Ki of Kōfuku-ji.

The text is composed of four sections: an introduction in four columns, the appreciation in two, and one shorter column each for the date and the signature. At this stage of his life, Tetsugyū was confident and bold in his calligraphy; and although this work is a formal document rather than a Zen saying or poem, the brushwork exhibits a great deal of energy. The Ōbaku master uses a variety of means to establish rhythms in the piece: varying column lengths; irregular alternation of regular, running, and cursive scripts; and a wide range of thinner and thicker lines, which result in lighter and heavier characters. Word sizes also vary, especially when Tetsugyū extends vertical lines, such as in the third and sixth characters of the sixth column. The first of these is the word "Buddha" (佛); in each of its six appearances the (originally) eight-stroke character is treated a little differently (fig. 62.1). Such variety lends visual interest to a scroll that might otherwise have been merely conventional; Tetsugyū's calligraphy adds a creative touch to the unusual story of a papier-mâché Buddha.

Figure 62.1.
Tetsugyū, Buddhas.

NOTE

1. The fifth year of Genroku mostly overlaps with 1692, but this date would actually correspond to early 1693 in our calendar.

Moon-Mind

Hanging scroll, ink on paper, 24.7 x 50.6 cm.

One of the leading Japanese monks of the Ōbaku sect, Tetsugen was born in Kumamoto, joined Buddhist orders at the age of thirteen, and at the age of twenty-six studied in Nagasaki with the recently arrived Chinese Zen Master Yin-yuan (Jpn., Ingen, 1592–1673). Tetsugen also studied with Yin-yuan's chief follower, Mu-an (Jpn., Mokuan, 1611–1684), and received the seal of transmission, formally allowing him to teach, in 1676. Tetsugen is most famous, however, for his determination to print the entire Buddhist canon, the *Daizō-kyō*. Tetsugen devoted considerable effort to raising funds and hiring artisans for this massive project, which entailed carving ninety-six million Chinese characters into sixty thousand woodblocks. His vision was fulfilled, and the blocks are still preserved—and sutras are still being printed from them—in a subtemple of Mampuku-ji in Uji. Unfortunately, while still in his prime as a Zen Master, Tetsugen fell ill and died in 1682 while helping people during a famine.

Tetsugen's calligraphy is highly respected in Japan for its combination of skill and sincerity. Here, in primarily cursive script, he has written an *ichijikan* (one-word barrier), a form of Zen calligraphy that features one large character, either by itself or with an inscription in smaller size. The main *kanji* is "moon" (月); the Zen teaching that follows it is from the eighth-century Chinese master Pai Chi (P'an-shan). Although the inscription is in prose, it is printed here in lines following the five columns of Tetsugen's calligraphy:

Moon

The mind-moon, solitary and round, shines,
illuminating the ten thousand images. Shines but does not
illuminate objects, since objects also do not exist.
When shining and objects are both forgotten:
What is this?

Tetsugen's large-character "moon" is forcefully written, leaning slightly to the right and retaining some of its pictographic origin as a crescent moon. Figure 63.1 shows many styles and scripts in which this character can be written, but Tetsugan's version is not quite like any of them.

Following the large initial graph, the five columns of smaller characters before the signature, "Jiun Tetsugen," are made up of 5-5-6-5-3 *kanji*, including a dot as a repeat mark in the third column. The first four characters of the inscription, written in one continuous gesture, create a feeling of flow from the short "mind" (心) to the thin "moon" (月) to the broad "alone" (孤) to the large circular "round" (圓), after which the brush is dipped again for the triangular "shines" (光). Throughout this inscription Tetsugen redips his brush every four characters, creating an asymmetrical rhythm of heavier forms, which fall at column one, word one, 1/5, 2/4, 3/3, 4/1, 4/5, and 5/1. By placing the final three words in their own column and visually lengthening

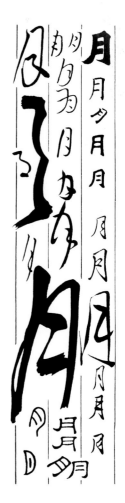

Figure 63.1.
Varieties of the character for "moon."

207

the middle word of the three, Tetsugen makes this text into a *kōan* (Zen meditation question), literally writing, "this WHAT thing?"

The straightforward nature of Tetsugen's calligraphy is illustrated by the fact that—unlike some calligraphers who alter the styles of repeating characters to emphasize their skill—he does not hesitate to repeat forms without changing them. For example, the word "shines" (光) looks much the same in the first, second, and fourth columns, with only the ending of the final stroke changing—from a hook (1/5) to a blunt end (2/4) to a movement down to the next character (4/1). Similarly, the *kanji* for "objects" (境) can be seen side by side in 3/2 and 4/2 in the same formation, while the character for "and/also" (亦) appears simplified into an L shape over a horizontal line in both 3/3 and 4/5.

Pai Chi's text comes from a longer sermon, much of which is preserved in Yuan Wu's commentaries on case thirty-seven of the *Hekiganroku* (Blue Cliff Record), the important twelfth-century compendium of one hundred *kōan* texts. The sermon continues: "Ch'an worthies, it is like hurling a sword into the sky; do not speak of reaching or not reaching: then the wheel of the void is without a trace, the sword's blade is without a flaw. If you can be like this, mind and mental conditions are without knowledge. The whole mind is identical to Buddha; the whole Buddha is identical to man. When mind and Buddha are not different, then this is the Way."[1]

NOTE

1. Translation by Thomas Cleary and J. C. Cleary, *The Blue Cliff Record* (Boston: Shambhala Publications, 1992), p. 606.

64 KAKUZAN DŌSHŌ (1640–1717)

Death Poem (1717)
Hanging scroll, ink on paper, 27.2 x 91.8 cm.

One special form of Zen calligraphy is the *yuige* (death poem), written by certain monks and nuns just before dying.[1] Although the style of most *yuige* is necessarily rough, often with weakened lines and erratic structure, the viewer's knowledge that this calligraphy represents the final words, the final teaching, of a master is enough to make each such work especially respected.

The date of this work is indeed the day of Kakuzan's death, and the text is his own final statement, including the Zen shout "TOTSU" (咄):

Seventy-eight years—
a single dream!
TOTSU
The sun, at dead of night,
rises over the eastern peak

—written on the eleventh month, eighth day

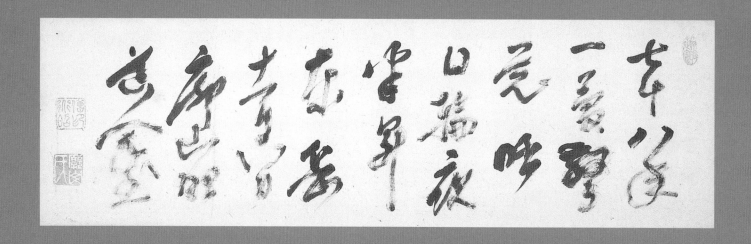

Kakuzan, a monk of the Ōbaku sect, was born in Izumo, famous for its ancient Shinto shrine, and first became a Sōtō Zen monk at the age of fourteen.[2] Five years later, while on pilgrimage, he met the second Ōbaku patriarch, Mu-an (Jpn., Mokuan, 1611–1684, fig. F.1), and began to study with him; in 1678 he became Mokuan's temple assistant. Two years later, shortly after Mokuan retired as patriarch and abbot of Mampuku-ji, he gave Kakuzan the seal of transmission, meaning the forty-year-old monk was now ready to teach as a Zen Master.

Living for a time at the subtemple Shōrin-ji, Kakuzan served as a precept master at several large meetings at Mampuku-ji, where Chinese monks continued to lead the sect. The growing popularity of Ōbaku Zen, however, led to many Japanese-born monks opening new or renovated temples throughout the country. In 1693, Kakuzan was selected to found a new temple in Ise, home of a famous Shinto shrine. On this spot there had once been a temple named Ontoku-ji, but it was almost entirely burned down by the forces of Oda Nobunaga during the warfare of the 1560s. Only a "Miscanthus Reed Hall" with an image of Yakushi, the Healing Buddha, remained. Kakuzan restored and renewed the temple, renamed it Keitoku-ji, and presided over its emergence in the Ōbaku lineage. After three years of intense effort in Ise, he was chosen in 1696 to become the fifth abbot of Zuishō-ji in the capital city of Edo. After arranging and leading his own large-scale precept meeting there in 1700, Kakuzan retired at the age of sixty-one and spent his final years at Keitoku-ji.

Like many Ōbaku monks, Kakuzan became known for his calligraphy. His mature style can be seen in an inscription (fig. 64.1) for an anonymous painting of the wandering monk Hotei ("cloth bag") who is regarded as an incarnation of Maitreya (Jpn., Miroku), the Buddha of the future.

The 5-5-5-5 quatrain is written in columns of 7-6-7 characters, followed by a column with Kakuzan's signature.

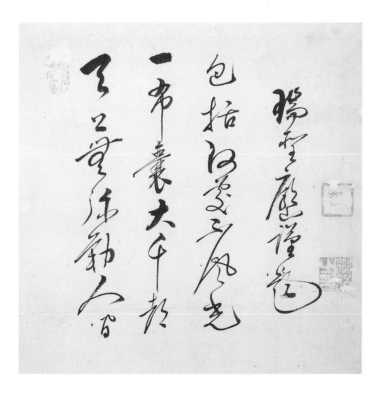

Figure 64.1. Inscription for a painting of the wandering monk Hotei.

No Miroku in heaven,
One cloth bag on earth.
With the vast universe in his bag,
Is there any place not marvelous?

—Respectfully inscribed by Zuishō Kakuzan

Since Hotei in the painting faces to the left, the inscription also begins on the left. The characters, smaller than those of the *yuige*, are written in fluent cursive script that varies between broader lines in characters such as "heaven" (天, 1/1) and "one" (一, 2/1), and thinner lines for others, such as *Mu* (無, 1/3). Often joined together with continuous brushwork, the graphs are of different sizes, and the brush lines are generally rounded with occasional strong diagonals for emphasis. Because the calligraphy was written while Kakuzan was at Zuishō-ji, it can be dated between 1696 and 1700, perhaps twenty years before the death poem.

In contrast, Kakuzan's *yuige* is compositionally expansive, with thicker lines and less fluently rounded brushwork. In this horizontal format, he utilizes the first six columns of calligraphy for his sixteen-word poem and three more columns for the date and signature, creating a sense of space and breath. The nine columns are constructed of 4-3-2-3-2-2-5-3-2 characters, and this compositional freedom is also seen in the inking: Kakuzan redipped his brush at irregular word intervals (6, 2, 3, 1, 3) in the poem and then twice more for the month, day, and signature.

After, the first word "seven" (七, 1/1), Kakuzan adds visual emphasis to the redipped *kanji* "realize" (覚, 3/1), "TOTSU" (咄, 3/2), "night" (夜, 4/3), "half" (半, 5/1, together with 4/3 means midnight or dead of night), and "peak" (岳, 6/2), all significant words in his poem. In addition, the character for "sun" or "day" (日) is written twice (4/1 and 7/5) with the center stroke either missing or pushed down to join the lower horizontal, suggesting the open square of the word "mouth" (口).

The individual character of Kakuzan's final calligraphy comes in large part from the personal rhythms that he creates through his asymmetrical composition and wet-to-dry brushwork. Although his writing is fully cursive, only a few *kanji* in the poem are joined to the following graphs, notably "seven-tens" (七十) and "eight-years" (八年) in the first column. The following characters of the poem, through which his paradoxical meaning is expressed, are all given their own space, especially the Zen shout "TOTSU," until the date and signature at the end, where the characters are again partially joined. The fluency of his earlier calligraphy has now become more measured, with greater spatial eloquence. It is as though Kakuzan, at the precipice of death, is making his final Zen message both fully personal and abundantly clear.

NOTES

1. For further examples, see Yoel Hoffmann, *Japanese Death Poems* (Rutland & Tokyo: Charles E. Tuttle, 1986).

2. Kakuzan's biography is given in Ōtsuki Mikio, Katō Shōshun, and Hayashi Yukimitsu, *Ōbaku bunka jinmei jiten* (Biographical Dictionary of Ōbaku Personages) (Tokyo: Shibunkaku, 1988), pp. 57–58.

Leisurely Clouds

Framed panel, ink on paper, 32.5 x 63.2 cm.

Born to a samurai-level family in Hamada, Bankei did not confine himself to interacting with those of his own social class; he became one of the first Zen Masters to take his teachings frequently to the broader public, accomplishing this through constant travel and large-scale open meetings. He was famous for not taking any beliefs for granted, but investigating everything for himself. His father, a Confucian doctor, had died when Bankei was only ten years old, and perhaps as a result he was unruly as a child and remained an individualist all his life.

Bankei's early lessons in Confucianism did not satisfy him, so he studied Buddhism and focused on Zen, moving from teacher to teacher before going off on his own to practice. Fourteen years of intensive meditation almost wrecked Bankei's health, but he finally experienced enlightenment. He then practiced for a time with the visiting Chinese monk Tao Che-yuan (Jpn., Dōshagen, 1599–1662) in Nagasaki; they communicated through written Chinese, since neither spoke the other's language. In 1679, Bankei began what was to become his tradition of giving Zen talks and training sessions that were open to the general public, which he continued until his death.

Bankei's Zen was rooted in the concept of "the unborn." He taught, "What I call the unborn is the Buddha-mind . . . [which] deals freely and spontaneously with anything that presents itself to it. . . . Not a single one of you people at this meeting is unenlightened. Right now, you're all sitting before me as Buddhas. . . . This inherited Buddha-mind is beyond any doubt unborn."[1]

Bankei also tried to explain how suffering comes from illusions: "Despite the fact that you arrived in this world with nothing but an unborn Buddha-mind, your partiality for yourselves makes you want to have things move in your own way. . . . Your self-partiality is at the root of all your illusions. . . . When you have no attachment to self, there are no illusions."[2]

Although Bankei had rejected calligraphy lessons when he was eleven, he later took up the brush to express his Zen vision, creating works notable for their power. His writing reflects the broad fluency of the Ming-dynasty style brought to Japan by Ōbaku monks, but it also expresses his own forceful personality. In this work he writes only the two words "leisurely clouds" and omits his ignature and seals."[3] Clouds are often a metaphor in Zen poetry for the life of nonattachment, and here Bankei is expressing visually the freedom that he describes in one of his sermons: "You have to realize that your thoughts are ephemeral and, without either clutching at them or rejecting them, just let them come and go of themselves. . . . If the Buddha-mind is realized, that's enough. You need do nothing else. . . . You'll be free . . . [the unborn] is simply being as you are."[4]

These two characters in regular script have twelve and eleven strokes, but Bankei writes them each in three. The first stroke of "leisurely" (閒) swings around in a graceful loop to the bottom, where it is supported by two diagonal dots—one moving up and one down. This *kanji* is well balanced,

Leisurely Clouds

Framed panel, ink on paper, 32.5 x 63.2 cm.

Born to a samurai-level family in Hamada, Bankei did not confine himself to interacting with those of his own social class; he became one of the first Zen Masters to take his teachings frequently to the broader public, accomplishing this through constant travel and large-scale open meetings. He was famous for not taking any beliefs for granted, but investigating everything for himself. His father, a Confucian doctor, had died when Bankei was only ten years old, and perhaps as a result he was unruly as a child and remained an individualist all his life.

Bankei's early lessons in Confucianism did not satisfy him, so he studied Buddhism and focused on Zen, moving from teacher to teacher before going off on his own to practice. Fourteen years of intensive meditation almost wrecked Bankei's health, but he finally experienced enlightenment. He then practiced for a time with the visiting Chinese monk Tao Che-yuan (Jpn., Dōshagen, 1599–1662) in Nagasaki; they communicated through written Chinese, since neither spoke the other's language. In 1679, Bankei began what was to become his tradition of giving Zen talks and training sessions that were open to the general public, which he continued until his death.

Bankei's Zen was rooted in the concept of "the unborn." He taught, "What I call the unborn is the Buddha-mind . . . [which] deals freely and spontaneously with anything that presents itself to it. . . . Not a single one of you people at this meeting is unenlightened. Right now, you're all sitting before me as Buddhas. . . . This inherited Buddha-mind is beyond any doubt unborn."[1]

Bankei also tried to explain how suffering comes from illusions: "Despite the fact that you arrived in this world with nothing but an unborn Buddha-mind, your partiality for yourselves makes you want to have things move in your own way. . . . Your self-partiality is at the root of all your illusions. . . . When you have no attachment to self, there are no illusions."[2]

Although Bankei had rejected calligraphy lessons when he was eleven, he later took up the brush to express his Zen vision, creating works notable for their power. His writing reflects the broad fluency of the Ming-dynasty style brought to Japan by Ōbaku monks, but it also expresses his own forceful personality. In this work he writes only the two words "leisurely clouds" and omits his signature and seals."[3] Clouds are often a metaphor in Zen poetry for the life of nonattachment, and here Bankei is expressing visually the freedom that he describes in one of his sermons: "You have to realize that your thoughts are ephemeral and, without either clutching at them or rejecting them, just let them come and go of themselves. . . . If the Buddha-mind is realized, that's enough. You need do nothing else. . . . You'll be free . . . [the unborn] is simply being as you are."[4]

These two characters in regular script have twelve and eleven strokes, but Bankei writes them each in three. The first stroke of "leisurely" (閒) swings around in a graceful loop to the bottom, where it is supported by two diagonal dots—one moving up and one down. This *kanji* is well balanced,

but the "cloud" (雲) to its left seems to be floating freely in space. It begins with an extended dot, continues with a broad horizontal hooking stroke, and concludes with a wriggling diagonal/vertical that ends with a twist back toward the center.

Bankei's use of relaxed cursive script conveys the meaning of the words very simply, directly, and clearly. The space around the characters is itself energized by the bold but unpretentious brushwork, leaving viewers to share in the leisure of a floating cloud, unattached to self and free from illusion.

NOTES

1. Quoted from *The Unborn: The Life and Teachings of Zen Master Bankei,* trans. Norman Waddell (San Francisco: North Point Press, 1984), pp. 52, 51, and 35.

2. Ibid., pp. 38, 49, and 62.

3. On the reverse of the panel is an inscription by Bankei's follower at Ryūmon-ji, Haryō, informing us that this is a genuine work by the master.

4. Waddell, *The Unborn*, pp. 117, 103, and 123.

66 KOGETSU ZENZAI (1667–1751)

Not Thinking Good or Evil
Hanging scroll, ink on paper, 27.6 x 41.2 cm.

Entering a village temple at the age of seven, Kogetsu Zenzai (not to be confused with the Daitoku-ji monk Kōgetsu Sōgan, #59) moved to Kyoto's Myōshin-ji at the age of twenty-one for further Zen training. While in the old capital, he also studied Confucianism and Chinese-style poetry. Kogetsu then continued his Zen training with several masters, eventually being told by Bankei (#65) that his quest for enlightenment was complete; he received the seal of transmission from Kengan Zen'etsu (1618–1696).

Living in countryside temples in western Japan, Kogetsu became, along with Hakuin (#68), one of the two most important Zen teachers of his time; his pupils include Tōrei (#69), Seisetsu (#73), and Sengai Gibon (1750–1838). Unlike Hakuin, Seisetsu, and Sengai, Kogetsu did not paint, and his calligraphy is almost always modest in scope, consisting primarily of horizontal works written in small characters. Clearly his main intent was to teach Zen, and his brushwork quietly demonstrates his inner strength of character.

This work, written "by the old monk Kogetsu at the request of Ikan Zenjin," paraphrases a text attributed to Hui-neng, the sixth Zen patriarch.[1] Its message has often been used to penetrate to the heart of Zen, as for example by Daitō Kokushi (1282–1337), founder of Daitoku-ji in Kyoto: "See the original face which was before father or mother was born . . . before you received human form."[2] Kogetsu puts this in poetic form; his quatrain reads:

Not thinking good or evil,
Right at this moment, who is this?

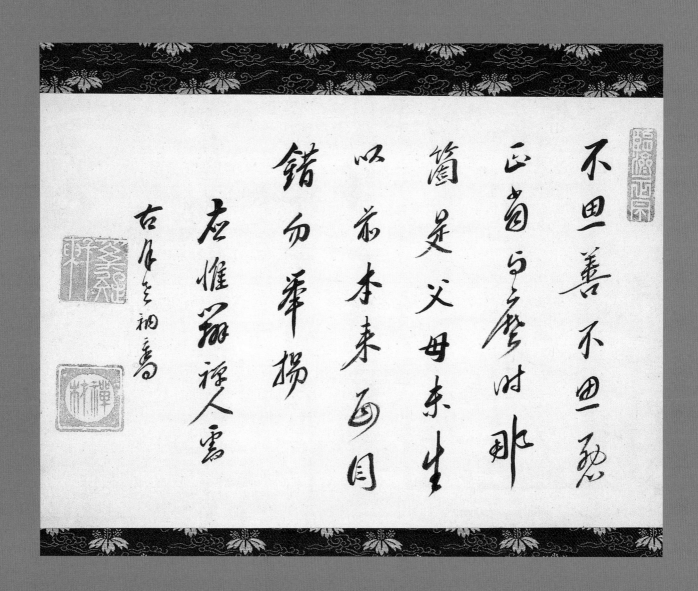

不思善不思惡

正當與麼時那

簡是父母未生

以前本來面目

錯勿舉揚

右惟羅禪人書

古月主人書

Before your parents were born,
What was your original face?

Kogetsu's calligraphy is clearly organized in running script, with the occasional use both of regular and cursive characters. The first column is primarily running and regular; but at its end, and into the second column, the writing becomes more cursive, as though Kogetsu were gaining intensity in asking this fundamental question about identity and nonidentity. Nevertheless, his firm and disciplined calligraphy never loses its clarity of expression; and as he moves to the second question in the third, fourth, and fifth columns, his brushwork maintains its power and sense of controlled movement. The generous spacing between the characters is balanced by the internal momentum that can be seen in every word.

For example, the third word in the third column, "father" (父), composed of two dots and two diagonals, could be written as a rather static form. Kogetsu's brush, however, has created a dance of contraposed forces in which each dot and line moves in a different direction, yet works together with the other strokes to create a dynamic and integrated form. This combination of vital energy and spatial unity gives each character a sense of inner strength. The seals are larger than usual for a piece of this size, but perhaps Kogetsu felt they were needed to match the compressed energy of the brushwork. His Zen mind is at work as much in the calligraphy as in the text, both offered as a teaching originally for his follower Ikan, and now for us.

NOTES

1. This appears in Sung-dynasty editions of the *Platform Sutra* of Hui-neng but not in the earliest known edition. It also is given as case twenty-three of the Song-dynasty *kōan* collection *Mumonkan* (Gateless Gate).

2. See Trevor Leggett, trans., "The Original Face" by Daitō Kokushi, in *A First Zen Reader* (Rutland & Tokyo: Charles E. Tuttle, 1960), p. 21.

67 DAIDŌ BUNKA (1680–1752)

Heart-Mind

Hanging scroll, ink on paper, 41.7 x 51.5 cm.

A single character in Chinese and Japanese means both "heart" and "mind," suggesting that they are not seen as a duality, as they are in the West. In this *ichijikan* (one-word barrier), the Zen Master Daidō has written a large character on the right side and an inscription to its left, followed by a signature. The large word here is his original variation for the graph "heart/mind"; and with the five-word phrase to the left, the calligraphy reads from right to left, top to bottom, "no heart/mind peace pleasure law."

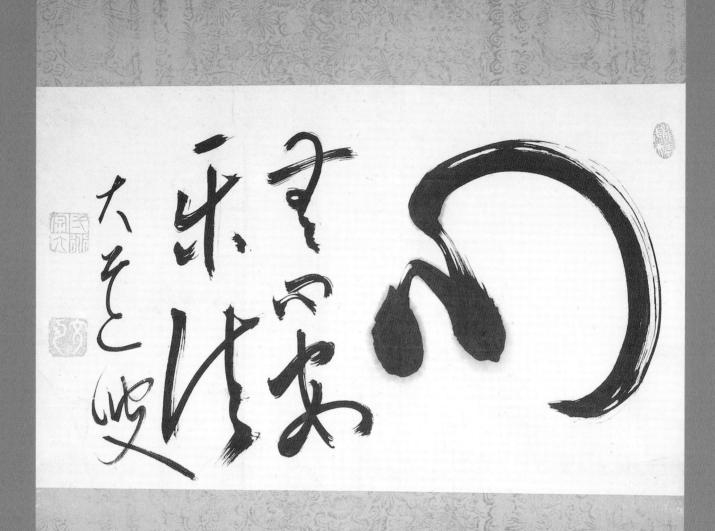

楽 pleasure　　無 no　　　　　　心 HEART/MIND
法 law　　　　心 heart/mind
　　　　　　　平 peace

Before translating this phrase, however, we should note that the first two characters, pronounced in Japanese *mushin*, represent an important Zen principle. Sometimes rendered in English as "no-mind," *mushin* has a resonance that goes far beyond any single translation; its implications range from "beyond intention" to "without clinging" to "eliminating conscious thought."

Further, the third and fourth characters together mean "peaceful" or "serene," so we might now translate this calligraphy as:

HEART/MIND: *mushin* is the way to inner peace

Leaving further Zen interpretations to the viewer, here is a brief biography of the monk-artist and an examination of the actual work. At the age of fifteen, Daidō was prompted by the death of his father to study Buddhism; he formally became a monk four years later. He then studied with followers of both the recently imported Chinese Ōbaku sect and of the influential Japanese monk Bankei (#65), finally becoming a dharma heir of Kengan Zen'etsu (1618–1696). Settling down in the temple Jōjō-ji in Tamba, not far from Kyoto, Daidō became distinguished as a leading teacher of Zen monks; he was known as "Ōni Daidō" (Demon Daidō) for the strength of his character and the severity of his training methods.

Here the large character for "heart/mind" is written with great verve and energy. Instead of beginning as usual with a dot on the left, continuing with a hooking stroke to the right and a high middle dot, and finishing with a final right dot (心), Daidō starts with two dots, the second representing the hooking stroke, and then continues with a circular stroke representing the final two dots; the brush never leaves the paper during this bold gesture. Initially, the brush was fully loaded with ink, so on both the initial dots and the beginning of the rounded stroke, one can see the ink fuzzing where brush met paper and paused. However, the rapid movement of the rounded stroke leads to the effect of "flying white," where the paper shows through the brush hairs. Thus in a single character we can see both wet and dry styles of brushwork. The use of space in this large character is especially notable, as though the emptiness, the *Mu* within the heart, were ready for everything that the two moist dots can create; they seem to pulse with energy within the space created by the half-circle.

This evocative "heart/mind" takes up half the horizontal format, with the following five characters and signature filling the left side of the scroll. When Daidō repeats the word "heart/mind" as the second word of the inscription, however, it is now the smallest character, although still composed of two dots and a curving stroke, the latter much reduced in gestural energy as well as size.

Investigating the five smaller characters further, we note that the first three, constituting a column, all lean toward the right, as though attracted by the energy of the large character. In contrast, the final two characters of

the inscription, which form the next column, are more securely anchored in space. The signature dances freely, continuing a diagonal sense of movement that seems to pull downward to the left over the entire scroll, with the final stroke being a contrasting diagonal to the lower right. Central to the work, however, are the opening dots; from this fecund beginning, everything else springs forth. We may well ask, was this calligraphy created with the mind, with the heart, or with *mushin*?

68 HAKUIN EKAKU (1685–1768)

Kotobuki

Ink on paper, 120.2 x 56.8 cm.

Hakuin is considered the most important Zen Master of the past five hundred years. Through his teachings, he revitalized the Rinzai tradition in Japan; today monks of both Rinzai and Ōbaku sects are trained in methods that he developed. He also invented the famous *kōan* "What is the sound of one hand?"

Born in the village of Hara, Hakuin as a child resolved to become a monk after hearing a frightening sermon about the pains of hell. Seeking the strictest Zen teachers, he practiced with great intensity, finally achieving a series of enlightenment experiences, which he later described in his writings.[1] Returning to his home village, he spent the rest of his life at Shōrin-ji rather than moving to a large metropolitan monastery.

As well as teaching a large number of pupils, Hakuin reached out to the public with many writings, ranging from letters, folk songs, and poems to learned treatises on Zen.[2] Although he had abandoned as egoistic his youthful ideas of becoming a well-known calligrapher, in his fifties and sixties he took up the brush again, realizing that brushwork was another way to spread Zen teachings. Despite having an increasing number of Zen pupils to train, he found time to create several thousand works of painting and calligraphy; in the process, he reinvented the visual language of Zen to reach people of all classes, ages, genders, and occupations. Hakuin's brushwork style gradually shifted over the years from lighter and more playful to remarkably bold and forceful; this work, which consists of one large character, *kotobuki* (寿, long life), comes from his final years and shows the immense power of his late brushwork, which stemmed directly from his character.[3]

By comparison, Hakuin's "Inscription on Anger," from perhaps twenty years earlier, has a more specific Buddhist message: anger is one of the six passions that obstruct the path to enlightenment (fig. 68.1). Appropriate for the time, the teaching here is couched in Confucian terms; but in typical Hakuin Zen style, it ultimately points to examining one's own self.

When a man is enlightened about Principle, then no anger arises in him; when he is confused about Principle, then anger does arise in him. In general, anger arises from opposition, and dies out in acquiescence. All cases under the sky are like this. Now, if a man opposes me, it must be

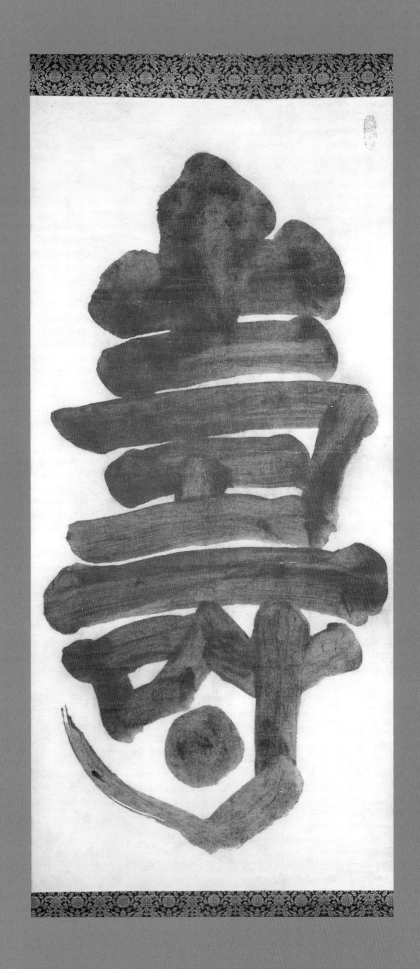

68

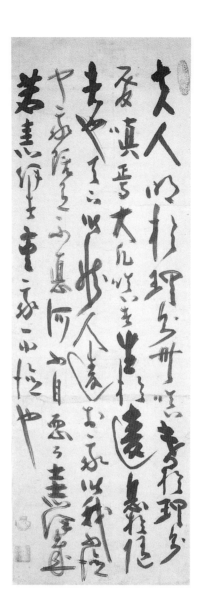

because I am lacking in virtue. And since I am lacking in virtue, would I not feel ashamed of myself, and get angry at him? And if I get angry at him, that would only exacerbate my lack of virtue.[4]

Balancing curved with angular strokes, this brushwork exhibits a range of character weights from light to heavy, depending upon both the thin-to-thick range of brush lines and the differing sizes of the characters. This rhythmic pulsation, along with the variety of scripts—ranging from regular (man, 人, 1/2) to cursive (bright, 明, 1/3)—enlivens the scroll. However, Hakuin makes no attempt to display calligraphic skill; the forms and brush strokes are relaxed and sometimes almost naive. For example, the "na" stroke ＼ that ends certain characters is here transformed into a seemingly child-like, hooking V shape, evident in the character "oppose" (違) that appears, once heavy (2/10), once light (3/8), in the lower sections of the second and third columns.

Returning to *Kotobuki*, we can see how Hakuin's style has evolved. First, the lines are thick but never flat, since they show a wide range of ink tones from gray to black. Hakuin was said to have used old (rather than

freshly ground) ink; but it would also seem that he chose coated paper that was less absorbent than usual, so that the ink would dry more slowly and unevenly. Second, the beginnings and endings of strokes are made with the brush curling around ("closed tip"), giving a feeling of immense bones that are self-contained rather than moving out into space. Third, there is very little negative space between the brush lines, so that the total shape of the character becomes a massive oval within the rectangle of the scroll.

Looking further, however, we can see within the composition a variety that keeps the work from being ponderous. The top two-thirds of *kotobuki* are dominated by six powerful horizontal strokes, each slanting slightly upward to the right; two shorter verticals help to anchor this part of the character in place. The lower third of the graph, however, is quite different. It includes diagonals, a V-shaped form, and a circle of ink situated centrally and creating lively empty spaces around it. In effect, the lower part of the character conveys a sense of movement that helps to activate the massive architecture of the horizontal and vertical strokes above it. The expression is unique; no other early modern Japanese calligraphy can match the power and energized vitality of Hakuin's late work.

NOTES

1. See, for example, *Wild Ivy: The Spiritual Autobiography of Zen Master Hakuin,* trans. Norman Waddell (Boston: Shambhala Publications, 1999).

2. Further English translations of Hakuin's Zen writings include *The Essential Teachings of Zen Master Hakuin,* trans. Norman Waddell (Boston: Shambhala Publications, 1994); *Zen Words for the Heart,* trans. Norman Waddell (Boston: Shambhala Publications, 1996); and Philip B. Yampolsky, *Zen Master Hakuin* (New York: Columbia University Press, 1971).

3. This work has an opening seal on the top right but no closing seals on the lower left, a clue that it may once have been the first panel of a twelve-fold screen, followed by smaller characters on the other panels.

4. Translation by Jonathan Chaves.

69 TŌREI ENJI (1721–1792)

Mantra to Kokūzō

Hanging scroll, ink on paper, 32.5 x 10.3 cm.

First a Zen student of Kogetsu Zenrai (#66), Tōrei later became one of the major pupils of Hakuin (#68), carrying on his master's teachings and also producing a good deal of brushwork, including many paintings and an even greater number of calligraphic works. In many ways the strongest and most individual of Hakuin's followers, Tōrei exhibits in his brushwork a truly untrammeled personality. This characteristic was shown early in his life when he became determined to be a Zen monk and later when he vowed to meditate to the point of death if he could not find enlightenment. Indeed, in the course of his practice he became so ill that he felt he could not last much longer; and in order to do "at least one useful thing" in his life, he wrote a record of Zen practice and presented it to

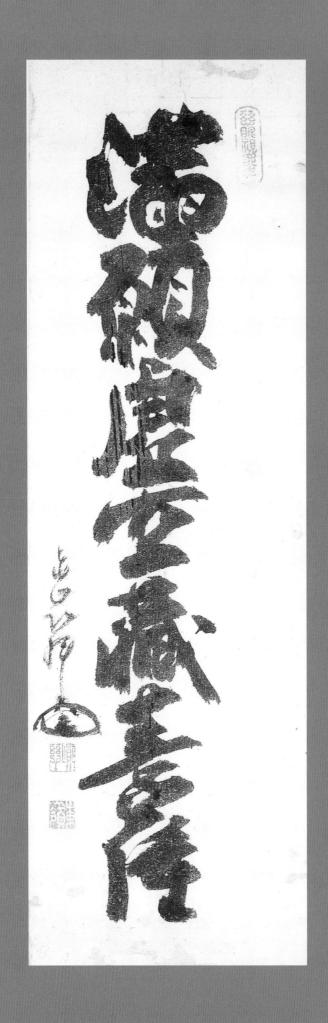

Figure 69.1.
Tōrei Enji,
Poem for the New Year.

Hakuin. The master found it so valuable that he urged his pupil to publish it; it was later printed as *Shūmon mujin tōron* (The Inexhaustible Lamp).[1] Fortunately, Tōrei recovered from his illness and led an exemplary Zen life, first reviving the temple Muryō-ji and then establishing Ryūtaku-ji as a major Zen teaching monastery in its rural setting outside Numazu, far from metropolitan centers.

Tōrei's dynamic personality is evident in his works, which exhibit neither the charm of Hakuin's earlier brushwork nor the massive depth of the master's later work. Instead, even in a small format such as this mantra, which is only four inches wide and a little more than twelve inches tall, there is a feeling of unbridled energy; from the photograph, one could easily imagine this to be a large hanging scroll.

The "Boddhisattva of Space," Kokūzō is considered to embody a wisdom as vast as the universe. Although he is an important deity for the esoteric Shingon sect, his popularity in Japan extends to other forms of Buddhism; and he has been worshipped by all those seeking knowledge and wisdom (including many students before college entrance and other examinations).

Tōrei's calligraphy reads "All vows fulfilled, Kokūzō Bosatsu"; these words serve as a mantra, the written version of a chanted prayer. The seven characters, written very close to each other, also show little internal negative space, conveying architectonic power. Nevertheless, there is still a vibrant sense of movement since Tōrei has left the rough openings and endings of his brush strokes visible. Comparing this work with Hakuin's *Kotobuki* (#68), we see in both cases how thick lines and the lack of large negative spaces create forceful images; but the rounder nature of Hakuin's brush lines, especially as they begin and end, gives them a feeling very different from Tōrei's more direct sense of energy. Tōrei's work is a little more dynamic but less massive than Hakuin's. We can see the strong influence of his teacher, but Tōrei's own personality is also fully evident in his work.

Tōrei's smaller-size writing shows equal freedom (fig. 69.1). Here his unique calligraphic rhythm is apparent in the changing heaviness and lightness of the characters, with asymmetrical accentuations where Tōrei redipped his brush. Throughout this New Year's text, irregular in line length and paradoxical in meaning, the work dances with its own special energy.

Daruma comes from India, Prince Shotoku is Japanese;
Within and without this world, ultimately it is the same.
In noontime moonlight, nothingness blooms in the spring wind.
How is the Buddhist Law spread in the New Year?
KATSU!
Young people enjoy the moon,
Elders enjoy flowers, even at age eighty!

Examining both works, would we be far off the mark if we also sense animism in Tōrei's calligraphy? His mother was a fervent believer in Shinto, which teaches that deities can be found in many aspects of nature; and Tōrei himself was famous for combining Buddhism and Shinto in some of his teachings. In his *Mantra to Kokūzō*, the dots in the first and second characters, each a different shape and angle, have a powerful sense of life, almost as though they could be eyes looking out at us. In contrast, the single dot on the right side of the fifth character, *zō* (蔵), seems to fly off and also reach back to the character, as well as pointing toward the end of the signature.

Tōrei ends both works with his unique cipher-signature, which many observers describe as a clam, although its exact meaning is not known. One may even imagine a small figure seated in profile inside the clam, possibly Tōrei himself, although this may be stretching imagination too far. What these speculations demonstrate, however, is that there is a strong sense of animistic life in Tōrei's calligraphy, as if the forceful spirit of the master could hardly be kept within the ink and paper of his calligraphy.

NOTE

1. For an English translation of this text, see *The Discourse on the Inexhaustible Lamp of the Zen School*, trans. Yoko Okuda (Boston, Rutland & Tokyo: Charles E. Tuttle, 1996).

70 TOMINAGA JAKUGON (1702–1771)

Wind Arises

Hanging scroll, ink on paper, 129.3 x 50.5 cm.

Born in Okayama, Jakugon left home at the age of nine to train assiduously in many aspects of esoteric Buddhism, ultimately concentrating upon Sanskrit texts. He is also said to have studied calligraphy with the Kyoto master Kuwahara Kūdō (1673–1744). As a monk, Jakugon served at Hōtō-ji in Okayama; he retired in 1767 to Gyokusen-ji in Kurashiki. Famous in his own day as a Sanskrit scholar as well as a Chinese-style calligrapher and poet, Jakugon became known as one of the "Four Monks" of his era, along with Ryōkan (#76), Jiun (#71), and Meigetsu (1727–1797).

In this quatrain of five characters per line, Jakugon blends his two worlds as monk ("my meditation") and literatus, since this is essentially a Chinese-style nature poem:

Wind arises, cooling the tall bamboo,
Rain sends forth the aroma of the young lotus.
As fish swim, well aware of the net,
Birdsong flavors my meditation.

—written by the old retired monk Kifu Gon

Figure 70.1.
Tominaga Jakugon,
"Wind."

The calligraphy itself is written in fluent cursive script, with the exception of the third-to-last word of the poem and all of the signature except the first character. These are written in standard script, and the distinct difference of scripts is notable, suggesting that Jakugon is more formal with his names than with the poem itself.

As often happens, a visual counterpoint between the lines of the poem (5-5-5-5) and the columns of calligraphy (7-7-6) allows Jakugon to create different patterns of movement and stress. For example, the first two characters, "wind arises" (風生), are written in a single gesture of the brush, which almost but not quite leaves the paper both within the "wind" and between the two words. This written "wind" (fig. 70.1) certainly flows like a breeze.

Similarly, the first two characters of the second column are created with a connecting brush stroke, which then continues to the first stroke of the third word.

Although most of the words of the poem are written in large size, equally important visually are the smaller characters, such as "rain" (雨), the penultimate word of the first column, and "fish" (魚), the fourth word in the second column. Each of these two words begins a line of the poem; and because they have extra space around their forms, they are at least as significant as the larger characters. Also of note is how the first column ends with a large, freely curving character for "send forth" (送), while the second column ends with a horizontal formation of the word "this/the" (此) that effectively anchors the entire calligraphy.

Perhaps any one of the characters in this work could have been written just as well by another artist, but the continual variations of size and movement give Jakugon's writing its unique music and dance. This personal sense of brushwork rhythm is the special feature that led him to be celebrated as one of the major individualist calligraphers of his age.

71 JIUN ONKŌ (1718–1804)

Horses

Hanging scroll, ink on paper, 31.6 x 53.3 cm.

Although he is considered one of the most dynamic calligraphers in the Zen tradition, Jiun was actually a Buddhist monk of the Shingon sect. His samurai father followed Confucianism and Shinto but was anti-Buddhist, and so as a young man Jiun trained in Confucianism, martial arts, and calligraphy. His mother was a devout Buddhist, however, and when his father died, Jiun entered a Shingon monastery at the age of thirteen so

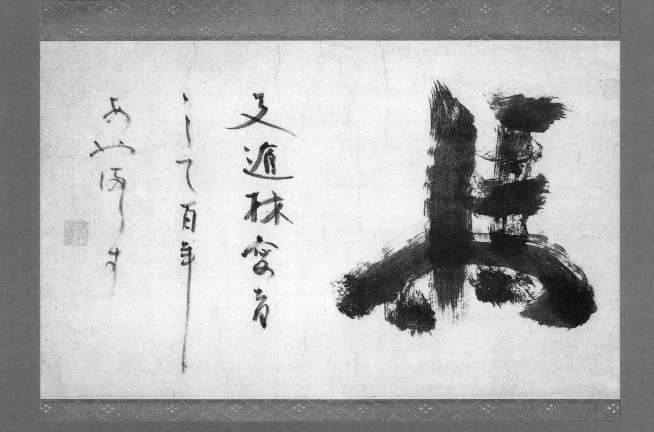

she would not have to support him. At first he merely went through the motions during Buddhist rites, but by the age of fifteen he became fervent in his beliefs; and in order to examine original Buddhist texts, he began a lifelong study of Siddham, a written form of Sanskrit.

Jiun did not give up Confucianism, however, and at the suggestion of his Buddhist teacher he studied with Itō Tōgai (#31). The focus in the Itō school upon mastering original texts encouraged Jiun in his Siddham studies. He eventually became the greatest East Asian master of Sanskrit, writing a thousand-volume study, *Bongaku shiryō* (Guide to Sanskrit Studies).[1] He also published a popular text on morality entitled *Jūzen hōgo* (The Ten Buddhist Precepts), which reached out to everyday people and was often reprinted.

As if this were not enough, Jiun also entered into full-time Zen practice at the age of twenty-four under the Sōtō monk Hōsen Daibai (1682–1757) and achieved an enlightenment experience the following year. For the rest of his life Jiun stressed the importance of combining *vinaya*, adherence to Buddhist regulations for monks, with the cultivation of intuitive wisdom through the practice of meditation. Jiun believed in the original teachings of Shakyamuni Buddha—much as the Itō school stressed the authentic teachings of Confucius—and he eventually organized his own esoteric sect, Shōbō Ritsu, to harmonize current doctrines with original Buddhist principles; late in his life he attempted to merge these with Shinto beliefs as native manifestations of Buddhist truths.

Jiun's distinctive calligraphy has been highly appreciated from his day to ours. He wrote in Siddham as well as *kanji* and *kana*, always with force and confidence, and his style has influenced many later calligraphers.[2] Here he has chosen the horizontal format of *ichijikan* (one-word barrier), which has been especially popular in Zen calligraphy since it offers a dramatic image for contemplation and meditation.

Horses

Chih Tao-lin nourished them
One hundred years without error

Jiun is here referring to anecdote sixty-three from *A New Account of Tales of the World* by Liu I-ch'ing (403–444). It tells of Chih Tun (Chih Tao-lin, 314–366), the founder of Chi-se (Emptiness of Matter), one of the "Six Schools" of Chinese Buddhism; Chih numbered among his pupils the great calligrapher Wang Hsi-chih.

> The monk Chih Tao-lin always kept several horses. Someone remarked, "A holy man and raising horses don't go together." Chih replied, "This humble monk values them for their divine swiftness."[3]

Jiun's characteristic broad, dry brushwork can be seen in the word for "horses" (馬). He has reinvented the character subtly, changing the four bottom dots (originally representing legs) into two dots and two extended endings of other strokes, one horizontal and one vertical. The sense of movement at the bottom of the character balances the architectonic strokes above, as though the strong body of the horse were ready to move at any moment.

The three lines of smaller calligraphy on the left, brushed with a single dipping of the brush, contain a sequence of five *kanji*, two *kana*, two *kanji*,

and five *kana,* respectively. Jiun creates a clear visual distinction between them, not only emphasizing the simpler form of the *kana,* but also making them thinner, lighter, and more cursive in touch. The *kanji* maintain relatively square shapes except for "years" (年), which stretches down to the bottom of the format. The *kana,* however, vary in their orientation from vertical "shi" (し, 2/1) to the horizontal "ya" (や, 3/2). By moving from one large character to much smaller graphs and then from *kanji* to *kana,* Jiun starts powerfully and then lightens the forms until they disappear into empty space, punctuated only by a single seal.

NOTES

1. See Robert van Gulik, *Siddham: An Essay on the History of Sanskrit Studies in China and Japan,* Sarasvati-Vihara series, no. 36 (New Delhi: Jayyed Press, 1936).

2. The Zen Master Shibayama Zenkei (1894–1974) is one example of a calligrapher who modeled his style after that of Jiun. See Audrey Seo with Stephen Addiss, *The Art of Twentieth Century Zen* (Boston: Shambhala Publications, 1998), pp. 167–178.

3. See Liu I-ch'ing, *A New Account of Tales of the World,* trans. Richard B. Mather (Minneapolis: University of Minnesota Press, 1976), p. 61.

72 GŌCHŌ KANKAI (1739–1835)

Striking the Bamboo (1828)
Iron underglaze on ceramic tea bowl, 9.4 x 11.6 cm.

Gōchō is considered a master of Zen painting and calligraphy, although like Jiun (#71) he was not a Zen monk. He was born the second son of a Shin-sect priest in Kyushu but trained as a monk of the esoteric Tendai sect. He continued his study for twelve years on Mount Hiei near Kyoto, where he practiced Tendai-style meditation. In 1769 he received a seal of enlightenment and the rank of *risshi* (super-intendent), by which he was later known. Gōchō became celebrated as a healer and also admired as a painter and calligrapher. His images range from elaborate depictions of Buddhist deities to ink paintings in Zen style, and his calligraphy is notable for its fluent power.

Gōchō produced works in a wide range of formats, including a tea bowl that he made and inscribed at the age of eighty. By this time he had left his native Kyushu to become abbot of a temple just northeast of Nagoya Castle, near the pottery area of Seto, which produced *shino* and *oribe* ceramics. Gōchō constructed this bowl by hand; it is rounded somewhat asymmetrically to fit well in the palms, and his calligraphy is covered with a creamy semitransparent *shino* glaze. On the bottom of the bowl, Gōchō carved "made by the eighty-year-old Gōchō" into the clay. While monks and other calligraphers have inscribed ceramics from time to time, this is a rare case of a leading master also constructing the tea bowl.

The two large characters are "strike bamboo," followed by eight *kanji,* reading "Hsiang Yen has come, a bird sings in the empty sky," and the signature "eighty-year-old-man Gōchō." The inscription refers to Hsiang Yen

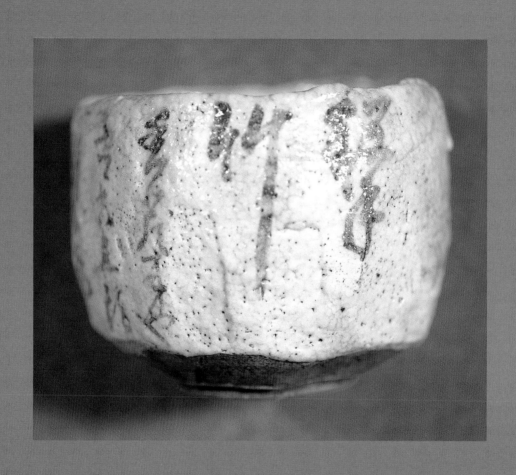

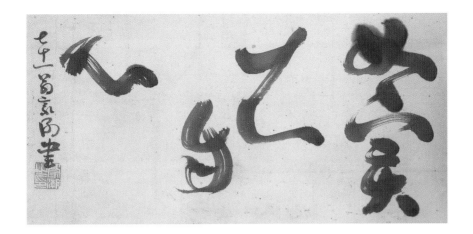

Figure 72.1.
Gōchō Kankai,
*Truly Know One's
Own Heart* (1809).

(Jpn., Kyōgen), who was told by his Zen teacher I-shan that his exceptional intelligence was no use past the point of analytic comprehension; instead, he needed to understand his own being before his parents had given him birth. He implored his teacher for an explanation, but was told that he had to find his own understanding. Discouraged, Hsiang left the monastery and built a hut where he could live in solitude. One day while clearing off the ground in front of his hut, he swept away a pebble that struck a bamboo, making a small sound; suddenly his mind broke free and he achieved enlightenment. Hsiang felt great gratitude to I-shan for insisting that he experience his own *satori*.[1]

Gōchō's calligraphy is strong and confident, with both large characters extended vertically, especially the final stroke of the character for "bamboo" (竹). Even though the calligraphy is written on an unevenly rounded surface and covered with glaze, the moment of enlightenment is well conveyed in powerful brushwork that seems to shine forth from the tea bowl as well as residing deep within it.

Almost a decade earlier, at the age of seventy-one, Gōchō had written out a five-word scroll, "Truly Know One's Own Heart" (fig. 72.1). Here in cursive script Gōchō creates a unique composition in which the first two characters remain decorously within the opening column, but the following three *kanji* flow dramatically through space. The feeling of spontaneity is enhanced by the use of gray ink, which is blurry wet and yet shows "flying white" due the rapid movement of the brush. Each of the final three characters is constructed differently. "Know" (知) broadens out into a horizontal Z shape, "self" (身) curls in on itself more vertically with two central dashes joining together like the shape of a butterfly, and the final "heart" (心) leans down diagonally toward the other two characters.

The freedom of spirit that Gōchō showed both in making and inscribing a tea bowl at the age of eighty and in this unusual five-word scroll is evident in all his works, which feature the same broad, curving, confident, and fluent calligraphy. Although he was not a monk of the Zen sect, Gōchō boldly demonstrates in his brushwork the drama, energy, and depth of spirit that characterize the best Zen-style calligraphy.

NOTE

1. This story is given in D. T. Suzuki, *An Introduction to Zen Buddhism* (New York: Ballantine Books, 1973), pp. 91–92.

西子晚秋此诗亭

　即事

稻畦　　　　　禾稻生

胡床

三谿　人

One More Katsu (1816)

Hanging scroll, ink on paper, 29.9 x 37 cm.

Seisetsu was only three years old when his father died; four years later he began his Buddhist studies at a local temple in Uwajima. When he was sixteen, he embarked upon a series of travels; two years later he achieved enlightenment, continuing his practice afterward under several major Zen Masters. He also studied calligraphy from Chō Tōsai (#21) and *waka* poetry with Kagawa Kageki (1768–1843). A man of many accomplishments, Seisetsu became a noted authority on the tea ceremony and wrote a treatise named *Mucha-ron* (Essays on No-Tea). During his busy life he lectured in many parts of Japan, rehabilitated several monasteries that were in decline, published books of poetry and Zen commentaries, and taught a number of significant monks and lay followers including physicians, Confucian scholars, and poets.

Celebrated for both his Chinese- and Japanese-style verse, here Seisetsu at the age of sixty has brushed a Chinese quatrain in seven-character lines. Belying the magnitude of his accomplishments, his calligraphy seems very gentle, not only because of the small size of the characters but also because Seisetsu used gray rather than black ink. The serene mood is enhanced by the lack of seals; instead, there is a cipher-signature at the end. Appropriate to the calligraphic style, the poem describes a peaceful scene, although it includes the Zen shout "KATSU" in the final line to remind us that this is indeed a Zen Master's work, in which the changeless and the instantaneous occur simultaneously.

1816, early autumn, at Forgotten Road Cottage

Just This

Rice shoots half-grown in the yellow paddies,
I sit alone, silently facing the setting sun;
White herons flock beyond the undulating wheat—
Yet still one KATSU from my Zen seat!

—Master of the Forgotten Road, Seisetsu (cipher)

The four lines of the poem are divided into columns of 9-9-8-2 characters. With few exceptions, Seisetsu has utilized cursive script. Significantly, however, when he reaches the words "one KATSU" (一喝) toward the end of the final full column, he changes to standard-to-running script, perhaps indicating that these words are especially important. Underneath the gentle exterior of the calligraphy and poem, there is an accomplished Zen Master who has no need to demonstrate his prowess but simply lets his personal character appear in modest and fluent brushwork.

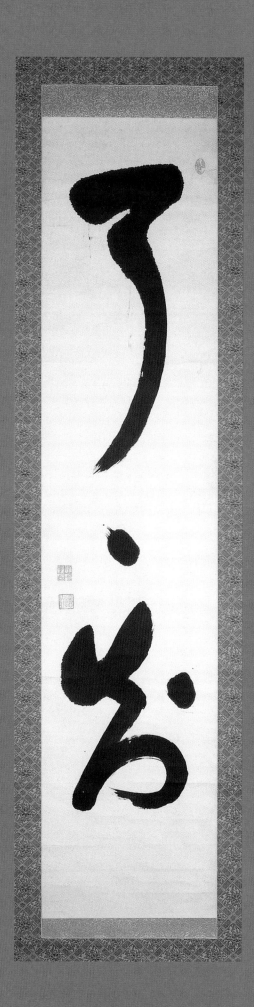

74

74 INZAN IEN (1754–1817)

Complete Understanding

Hanging scroll, ink on paper, 129 x 29.3 cm.

Inzan was one of the most important teaching Zen Masters in the Hakuin tradition, and today all Rinzai monks trace their lineage through either Inzan or his contemporary Takujū Kosen (1760–1833). Inzan did not study with Hakuin directly but rather through his pupil Gasan; previously he had studied with two other major masters, Bankei Yōtaku (#65) and Gessen Zenne (1701–1781). Inzan therefore represents several of the strongest currents of Zen thought and training in early modern Japan.

Here Inzan has written three characters RYŌ 了 RYŌ 了 CHI 知 with the middle character represented by a dot that acts as a repeat mark like a ditto. *Ryō* can mean "complete" and also "finally;" *chi* means "knowing" or "understanding;" thus, another possible translation of the three characters might be: "finally, finally, understanding."

The calligraphy is masterful in its creative spatial proportions. Specifically, the opening *ryō* balances its strong, fuzzing horizontal at the top with a long, curving stroke downward, ending with a touch of "flying white." This character, occupying almost half the scroll, seems to give birth to the single dot below it, which shows a trace of how the brush began it from the upper left. The dot evenly divides the first from the third character, and yet it also relates to the lower dot, giving a sense of continuity. The lower dot, however, has a slightly different and more stable shape and nicely divides the spaces around it. *Chi* is also a marvel of balance, swinging from upper left up again to the right, moving down with an angular zigzag to the lower left, and finally curving around and back to the right. It is so secure in space that one might imagine a floor below it, but there is nothing but empty paper; Inzan does not complicate matters with a signature but merely adds three seals. Is this work a dance, or imaginary architecture? Certainly both, and much more.

75 DAIEN BUTTSU (D. 1825)

Mumonkan Kōan (1808)

Hanging scroll, ink on paper, 30.4 x 55.9 cm.

Most of the Japanese monk-artists who are famous today were from the Rinzai sect, which had many major monasteries in large cities; but the Sōtō sect is actually larger in Japan, although generally concentrated away from population centers. Two of the best-known Sōtō monk-artists were named Fūgai (#57 and #77); several other monastics of this sect were very talented in calligraphy, including Daien Buttsu. In the countryside temples where he lived all his life, Daien became especially known as a fierce teacher, earning the nickname "Tora Buttsu" (Tiger Buttsu). His birth date is unknown, but he died in 1825 on the

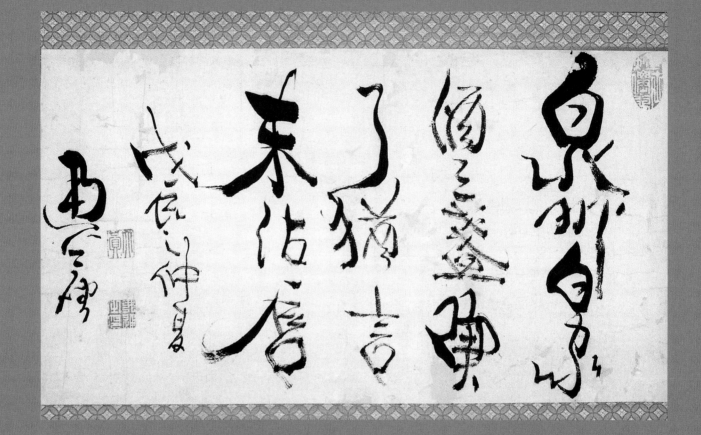

sixteenth day of the second month, the same day on which Buddha is said to have achieved enlightenment.

Daien created bold, expressive calligraphy that seems to alternate freely between wet and dry, large and small, thick and thin, and firm and meandering strokes of the brush. He may have been influenced by the style of the literatus Ike Taiga (#41), who himself was influenced by Zen brushwork. Here Daien has written out a *kōan* (Zen meditation question), case ten from the *Mumonkan* (Gateless Gate) collection. In this conundrum a monk has come to a Master for wisdom, but he is told:

> Of Ch'uan-chou's "White House" wine you have drunk three cups,
> But you claim not to have even moistened your lips.

For some reason Daien has changed the name of the place from Ch'ing-yuan to Ch'uan-chou (Jpn., Senshū), but the rest of the text is exactly as given in the Chinese Zen collection.

The calligraphy, composed in four columns of 4-4-3-3 characters, is highly eccentric. The first character (泉), literally meaning "spring" or "waterfall," is made up of the graph for "white" (白) over the one for "water" (水); the next character means "province" (州). Daien partially echoes these graphs in the concluding words of the column, "white" (白) and "house" (家). Daien plays on similarities of shapes and forms, creating a certain sense of visual order despite the loose and seemingly awkward brushwork, almost like finding fractals in chaos.

The second column, literally reading "wine three cups," is written in dry brushwork, while the third column ends with the lightest word in the calligraphy, "say" (言), which stands alone in its dry symmetry. The final column of the poem begins with "not-yet" (未), written in the heavy ink of a redipped brush, and ends with a strong diagonal to the left that leads from the final word to the date (1808, midsummer); finally, the closing seals and signature appear at the far left.

This work does not show the discipline and balance of most Zen calligraphy, but it has so much flavor that we may wonder if Daien here was deliberately expressing a form of drunkenness. If so, the metaphor of the *kōan* becomes visual, and we can consider whether we too have imbibed deeply, or have only moistened our lips in this flow of calligraphy.

76 DAIGU (TAIGU) RYŌKAN (1758–1831)

On the Road in Shinshū

Hanging scroll, ink on paper, 27.3 x 18 cm.

One of the most beloved of all Zen monk–poets, Ryōkan spent most of his life in the cold and snowy region of Niigata, near the Inland Sea. Born the first son of a town official who was also a noted haiku poet in the Bashō tradition, he received a Confucian education but did not follow his father as a local administrator. Instead, he chose in

信州道中

我自發京洛千今十二支無雨不下
如何其勿無恩鴻雁翅應重桃花
紅轉坐舟人朝失渡游子夏逶迆歧
行殊未歇引領一頓眉月如去年秋
一風三日吹路邊拔喬木雲中飛旁
茨米價爲之貴今兹復如斯尚不
止奈

Figure 76.1.
Shizen.

1775 to become a monk. After beginning his training in a local temple, he studied Sōtō Zen for ten years under Kokusen at Entsū-ji in Tamashina, four hundred miles from his hometown of Izumozaki, until the master's death in 1791.

Ryōkan spent the next five years wandering, including a visit to Kyoto for his father's memorial service in 1795, but the next year he decided to return to his native area. Rather than serving as a temple priest, he lived an extremely simple and modest existence, begging for his daily food and playing with the local children. Until ill health forced him to move to a cottage by a Shinto shrine, he lived in a small hut in the mountains, an exemplar of the East Asian tradition of the solitary monk-poet-calligrapher. His *kanshi*, *waka*, and occasional haiku are now considered to be among the finest ever written in Japan.[1]

Ryōkan's calligraphy is also highly admired today, especially his Japanese *kana* and Chinese cursive script, which share the qualities of understated expertise and graceful fluency. These qualities can be seen in the two-character horizontal rubbing *Shizen* (自然, fig. 76.1).

As a compound the meaning of *shizen* is "nature," but singly the words indicate "self-suchness," suggesting that human nature is also included. This calligraphy and many others were carved into stone in public places so visitors could not only enjoy viewing them but also make rubbings. Ryōkan's calligraphy thus reached a large audience in an era before public museums.[2]

Ryōkan also wrote often in small regular script, which despite (or perhaps because of) its extremely unpretentious nature, is equally treasured. This poem, written in 1795 or 1796 after he left Kyoto and traveled through Shinshū (Nagano), follows the literati tradition of compassion for the rural populace.[3]

On the Road in Shinshū

Since I set out from the capital
Twelve days have gone by,
And not one of these has been without rain—
How can I help but worry?
Wings of wild swans and geese grow heavy,

Peach blossoms droop lower and lower;
Boatmen can't ply their morning ferries,
Travelers at evening lose their way.
It's impossible to halt my journey,
I crane my neck and knit my brows.
Will it be like autumn last year,
When the wind blew three days on end,
Huge trees were uprooted by the roadside,
And thatch from rooftops flew into the clouds?
Because of that the price of rice soared—
Will it be the same this year?
If these rains don't let up,
What?[4]

The poem is unusual in breaking its Chinese five-word line format at the end, where the single character "what?" (奈) constitutes the entire final line. Also, while Chinese regulated verse is composed in regular multiples of four, eight, sixteen, or thirty-two lines, this poem has eighteen. These changes demonstrate Ryōkan's freedom of expression, even when following Chinese poetic traditions in both theme and structure.

The calligraphy could not be more light and modest. Ryōkan has mastered the style of T'ang-dynasty exemplars in terms of balanced character composition, but he makes no effort to use such calligraphic techniques as thickening and thinning the strokes. After the four-word title, Ryōkan maintains columns of thirteen or fourteen words each until the end, and he only slightly alters the visual rhythm by subtle redippings of the brush.[5] Although Ryōkan's writing is different in many ways, it has the same intensely personal quality as that of the haiku poet Issa (#54), who also shunned any overt aesthetic effects. Ryōkan once stated that he didn't like cooking from chefs, poetry by poets, or calligraphy by calligraphers, and his own work shows the simplicity, akin to "beginner's mind," that he preferred.[6]

What makes this writing of Ryōkan anything more than unadorned, childlike regular script? First of all, there is no need for it to be anything more. A simple style is actually very difficult to achieve, requiring control of the brush and a lack of either internal tension or artistic ambition. But there is more: the openness of the forms, gentleness of touch, and subtle freedom of character compositions are all special features of Ryōkan's calligraphy, surely because they were also hallmarks of his own Zen spirit.

NOTES

1. Ryōkan's poetry has proved popular in English as well. Books of translations include: Burton Watson, *Ryōkan: Zen Monk-Poet of Japan* (New York: Columbia University Press, 1977); John Stevens, *Dewdrops on a Lotus Leaf* (Boston: Shambhala Publications, 1993); John Stevens, *One Robe, One Bowl* (New York: Weatherhill, 1977); Ryūichi Abe and Peter Haskel, *Great Fool: Zen Master Ryōkan* (Honolulu: University of Hawaii Press, 1996); and Nobuyuki Yuasa, *The Zen Poems of Ryōkan* (Princeton, N.J.: Princeton University Press, 1981).

2. This work is at the temple Shōnen-ji in Mishima; for this and sixty-seven other examples, including maps to their locations, see Watababe Hideei, ed., *Ishibumi Ryōkan* (Stone Monuments of Ryōkan) (Niigata: Rōkodō, 1972), pp. 166–167.

3. The tradition of sympathy for farmers was a feature of much Chinese verse, including that of Po Chu-i (772–846), whose works were consistently popular in Japan.

4. The translation is based upon one made by Burton Watson for a slightly different version of the poem. As Kera Yoshishige (1810–1859) wrote in *Ryōkan zenji kiwa* (Curious Accounts of the Zen Master Ryōkan), "The Master would write his poems from memory, and that is why there were sometimes missing characters and some small variations in wording." See Abe and Haskel, *Great Fool*, p. 97. For another version of the poem, also in small regular script, see Yoshida Saigen, ed., *Ryōkan* (Tokyo: Chikuma Shobo, 1975), p. 161.

5. A few words, such as "wings" (3/9) and "years" (5/13), were inked more heavily, but this seems to have happened naturally rather than deliberately.

6. See Watson, *Ryōkan*, p. 116. In one of Ryōkan's Chinese-style verses, he wrote, "My poems are not poems at all." Ibid., p. 11.

77 FŪGAI HONKŌ (1779–1847)

The Mountain Spirit (1839)

Hanging scroll, ink on paper, 106.2 x 42 cm.

Fūgai Honkō, like the earlier Fūgai Ekun (#57),[1] was a Sōtō sect Zen monk, but his artistic inspiration seems to have come as much from the works of literati artists as from Zen brushwork traditions.

Born in Ise, Fūgai became a Buddhist novice at the age of eight; his artistic interests were encouraged when at the age of fourteen he obtained a scroll by the monk-artist Tanke Gessen (1721–1809), who painted in the literati manner. Fūgai then studied Zen for eleven years with Genrō Oryū (1720–1813), known as "Wolf Genrō" for his strict teaching, eventually receiving Genrō's Zen transmission.

During these years Fūgai maintained his interest in art. On a visit to Kyushu in 1802, he studied the paintings of the young literatus Tanomura Chikuden (1777–1835) and also examined works by Taiga (#41) in the Katsube Collection, On a later visit to Kyushu, in 1829, he again studied paintings by Chikuden. Meanwhile, in 1818 Fūgai had become abbot of Osaka's Entsu-in, and in 1834 he was appointed abbot of Kōshaku-ji in Mikawa; he retired in 1842 and spent his final years in Osaka. Fūgai wrote several books, including a commentary on the Chinese *kōan* collection *Hekiganroku* (Blue Cliff Record), and he also became known for his poetry, calligraphy, and painting.

Here Fūgai has written out a quatrain that mostly conforms to the seven-character regulated verse style but has three extra words added to the last line, creating the form of 7-7-7-10.[2]

> Anxiously having summoned the god to give him "upper-pond" water
> to drink,
> Pien Ch'ueh has come again to cure me of my illness!
> Do not wonder that in midwinter here in this hidden valley
> The Mountain Spirit conjures in profusion the songs of orioles!
>
> —Summer 1839, to cure the pain of my boils

Pien Ch'ueh was the most famous physician of Chinese antiquity; according to the *Shih chi* of Ssu-ma Ch'ien (second century B.C.E.), Pan was instructed in medicine by an immortal who gave him "upper-pond" (heavenly) water of magical powers. This poem therefore testifies to Fūgai's sinological scholarship as well as his somewhat unfortunate state of health. The major impact of the calligraphy, however, comes from Fūgai's use of varying tones of ink as well as the loose and relaxed flow of his running-cursive script; he seems to have been willing to sacrifice some sense of structure in order to express his freedom of spirit.

It is unusual to see calligraphy with so much deliberate and continuous changing of ink tones, although Taiga sometimes used this device in painting and the Zen Master Sengai Gibon (1750–1837) occasionally did so in both painting and calligraphy. We can easily follow the darker-and-lighter rhythm of Fūgai's brush as it dips into ink on the first and fifth character of each poetic line, creating a syncopated pattern of 4-3, 4-3, 4-3 until the end, when it becomes 4-6. This visual accentuation creates a counterpoint to the other two rhythms in the scroll, the four lines of the poem and the columns of 9-8-8-6 characters. While the ink tones generally follow the rhythm of the poetic lines, they create dynamic accents irregularly in the total composition, with the darkest characters occurring at 1/1, 1/5, and 1/8; 2/3 and 2/6; 3/2 and 3/5; and 4/1.

One of the most notable characters is "mountain" (山), the fifth word of the third column. In standard script it is composed of three strokes, suggesting the picture of a central peak with small peaks on each side; but here Fūgai has joined two semicircles left and right with a central hooking stroke, fashioning a dramatic rounded form that continues down to the character below it. Also important is the negative space in the fourth column between the seven final characters of poem and the signature of the artist, which is the scroll's only concession to a pause for breathing space. Finally, to the left Fūgai has added his inscription, written in slightly smaller brushwork even more cursive than the poem.

With his emphasis on curved lines and changing tones of ink, as well as the reduced amount of empty space between either the characters or the columns, Fūgai has created a unique style of calligraphy that seems to alternate continuously between floating and undulating. Indeed, it seems to exist in a world that echoes the literal meaning of the name Fūgai: beyond the wind.

NOTES

1. Fūgai Ekun is sometimes called "Cave Fūgai" because he spent some years living in a cave, while Fūgai Honkō is known as "Octopus Fūgai" since his signature is thought to resemble the shape of an octopus.

2. Translation by Jonathan Chaves.

GLOSSARY

BONE The structural quality of a brush stroke, often straight or angular, as opposed to its surface "flesh."

CLOSED TIP Visual effect created by the circling of the brush around the beginning or ending of a stroke so that the tip is not apparent, as opposed to "open tip."

DAIMYO Feudal lord.

FLESH The surface effect of the brushwork, including fuzzing ink and flourishes that are not intrinsic to the character, as opposed to "bone."

FOUR GENTLEMEN The four plants that represent Chinese and Japanese literati values: bamboo, orchid, plum, and chrysanthemum.

HAIGA Haiku-paintings, usually done with minimal brushwork.

HAN The territory of a daimyo (feudal lord).

ICHIJIKAN Literally, "one-word barrier," a form of Zen calligraphy where a single character is written in large size, followed by an inscription in smaller characters.

KANA The *hiragana* and *katakana* syllabaries developed from Chinese characters that are used, along with *kanji*, for writing in Japanese.

KANJI Chinese characters.

KOKUGAKU The "National Learning" school, in part a reaction against Chinese-style Confucianism.

LITERATUS A scholar-sage-poet-calligrapher, known in Japan as a *bunjin;* the plural and adjectival form of the word is literati.

MAN'YŌGANA The use of Chinese characters merely for their sound, as written in early versions of the *Man'yōshū.*

MAN'YŌSHŪ The earliest collection of Japanese poetry.

NANGA The Chinese-influenced paintings of the literati.

OPEN TIP Visual effect that results from the brush entering or leaving the surface directly so the action of the tip of the brush is visible, as opposed to "closed tip."

SHIKISHI A poem-card, approximately 17 x 16 cm., often chosen for writing Japanese *waka.*

TANZAKU A tall, narrow poem-card, approximately 36 x 6 cm. used primarily for Japanese *waka* and haiku.

WAKA The classical poem of Japan, also called *tanka* and *uta,* composed of five lines with 5-7-5-7-7 syllables.

SELECTED BIBLIOGRAPHY

Addiss, Stephen. *The Art of Chinese Calligraphy*. Philadelphia: Running Press, 2005.

———. *The Art of Zen*. New York: Harry N. Abrams, 1989.

———. *Haiga: Takebe Sōchō and the Haiku-Painting Tradition*. Richmond, Va.: Marsh Art Gallery, in association with the University of Hawaii Press, 1995.

———. *Obaku: Zen Painting and Calligraphy*. Lawrence, Kans.: Spencer Museum of Art, 1978.

———. *The Resonance of the Qin in East Asian Art*. New York: China Society, 1999.

———. *Tall Mountains and Flowing Waters. The Arts of Uragami Gyokudō*. Honolulu: University of Hawaii Press, 1987.

———. *The World of Kameda Bōsai*. New Orleans Museum of Art, 1984.

———. "Hakuin, Tōrei, and Jiun: Calligraphy as Mantra." In *Calligraphy of China and Japan: The Grand Tradition*. Ann Arbor, Mich.: University of Michigan Museum of Art, 1975.

———. "Shadows of Emotion: The Calligraphy, Painting, and Poetry of Gion Nankai." *Kaikodo Journal*, Autumn 1998.

———. "The Three Women of Gion." In Marsha Weidner, ed., *Flowering in the Shadows: Women in the History of Chinese and Japanese Painting*. Honolulu: University of Hawaii Press, 1990.

Bankei Zenshi ihō (Remaining Works of Zen Master Bankei). Kyoto: Bunkazai Kenkūjō, 1992.

Ban Kōkei. *Kinsei kijin-den* (Lives of Modern Eccentrics). Kyoto, 1790. Repr., Tokyo: Iwanami Shoten, 1940.

Blofeld, John, trans. *The Zen Teaching of Huang Po*. New York: Grove Press, 1958.

Blythe, R. H. *A History of Haiku*. 2 vols. Tokyo: Hokuseido Press, 1964.

Bokubi (Ink Beauty), on Ryōkan. Nos. 2 (1951); 14 (1952); 85, 88, 89 (1959); 99 (1960); 141, 143 (1964); 163 (1966); 167, 174 (1967); 189–91 (1969); 206, 208, 210–11, 213, 216 (1971); 218, 220–21 (1972).

Bokubi, on Bōsai. No. 148 (1964).

Bokubi, on calligraphy of the Edo period. No. 181 (1968).

Bokubi, on death poems. No. 233 (1973).

Bokubi, on Fūgai Ekun. Nos. 101, 104 (1961).

Bokubi, on Gōchō. No. 95 (1960).

Bokubi, on haiku *tanzaku*. No. 224 (1972).

Bokubi, on Hakuin. Nos. 9 (1951); 77–79 (1958); 90 (1959).

Bokubi, on Jiun. Nos. 25 (1953); 50 (1955); 127 (1963); 228 (1973); 259, 261, 264–65, 267 (1976); 271, 273 (1977); 281, (1978); 287 (1979).

Bokubi, on Kaioku. No. 115 (1962).

Bokubi, on Kōetsu. Nos. 227, 228, 229 (1973); 274–75 (1977).

Bokubi, on Mitsuhiro. No. 185 (1968).

Bokubi, on Ogyū Sorai. No. 284 (1978).

Bokubi, on Rengetsu. No. 103 (1961).

Bokubi, on Setsuzan. Nos. 118 (1962); 272 (1977).

Bokubi, on Setsuzan, Gyokuzan, and Gōchō. No. 168 (1967).

Bokubi, on Taiga. Nos. 86 (1959); 154 (1965); 204–205 (1970).

Boudonnat, Louise, and Harumi Kushizaki. *Traces of the Brush: The Art of Japanese Calligraphy,* trans. Charles Penwarden. San Francisco: Chronicle Books, 2003.

Bradstock, Timothy R., and Judith N. Rabinovitch. *An Anthology of Kanshi (Chinese Verse) by Japanese Poets of the Edo Period (1603–1868).* Lewiston, N.Y.: Edwin Mellon Press, 1997.

Brasch, Kurt, and Takayashi Senzoku. *Die kalligraphische Kunst Japans.* Tokyo: Japanisch-Deutsche Gesellschaft, 1963.

Bruschke-Johnson, Lee. "The Calligrapher Konoe Nobutada." Ph.D. diss., Leiden University, 2002.

Bunjin Ishaikawa Jōzan no sekai (The World of the Literatus Ishikawa Jōzan). Aichi: Yasunari-shi Rekishi Hakubutsukan, 1992.

Bunjin shofu (Calligraphy Records): no. 1, on Kōetsu; no. 2, Jōzan; no. 3, Ikkyū; no. 4, Jiun; no. 5, Takuan; no. 6, Ryōkan; no. 7, Taiga; no. 8, Sengai; no. 9, Hakuin; no. 10, Bashō; no. 11, Rengetsu; no. 12, Tessai. Tokyo: Tankōsha, 1979.

Chan, Wing-tsit, trans. *Instructions for Practical Living by Wang Yang-ming.* New York: Columbia University Press, 1963.

Cha-no-yu to kakemono II; Daitoku-ji no bokuseki wo chūshin ni (The Tea Ceremony and Scrolls; vol. 2, Focusing on Ink Traces from Daitoku-ji). Kyoto: 1982.

Chaseki bokuhō (Tea Ceremony Ink Treasures). Tokyo: Nezu Bijutsukan, 1992.

Chinese and Japanese Calligraphy Spanning Two Thousand Years: The Heinz Goetze Collection. Munich: Prestel, 1989.

Daitoku-ji bokuseki zenshū (Collection of Daitoku-ji Monk Ink Traces), vol. 3. Tokyo: Mainichi Shinbunsha, 1986.

Daitoku-ji kinsei bokusekiten (Exhibition of Ink Traces by Early Modern Daitoku-ji Monks). Kyoto: Daitoku-ji, 1983.

Daitoku-ji meihōshū (Collection of Famous Treasures from Daitoku-ji). Kyoto: Benridō, 1933.

Daitoku-ji no meihō (Famous Treasures from Daitoku-ji). Kyoto National Museum, 1985.

Daitoku-ji rekidai bokuseki seisui (Collection of Historical Ink Traces from Daitoku-ji). Tokyo: Yomiuri Shinbunsha, 1977.

Donegan, Patricia, and Yoshie Ishōibashi. *Chiyo-ni: Woman Haiku Master.* Tokyo, Boston & Singapore: Charles E. Tuttle, 1998.

Edo jidai no shoseki (Calligraphy of the Edo Period). Chiba: Naritasan Calligraphy Museum, 1993.

Edo no meisō: Takuan (The Famous Edo Period Monk Takuan). Tokyo: Shinagawa Rekishikan, 1939.

Edo no shūkyō bijutsu (Edo Period Buddhist Calligraphy). *Nihon bijutsu zenshū,* vol. 23. Tokyo: Gakken, 1979.

Fischer, Felice. *The Arts of Hon'ami Kōetsu.* Philadelphia Museum of Art, 2000.

Fister, Patricia. *Japanese Women Artists, 1600-1900.* Lawrence, Kans.: Spencer Museum of Art, 1988.

———. "Tōkai Okon." *Calligraphy Idea Exchange* 3, no. 4 (Summer 1986).

Fūgai Dōjin ibokuten (Fūgai's Ink Traces Exhibition). Odawara, 1982.

Fūgai Ekun sakuhin-ten (An Exhibition of Works by Fūgai Ekun). Hiratsuka Museum, 1992.

Fu Shen, Glenn D. Lowry, and Anne Yonemura. *From Concept to Context: Approaches to Asian and Islamic Calligraphy.* Washington, D.C.: Freer Gallery of Art, 1986.

Gōchō. Kumamoto: Kenritsu Bijutsukan, 1981.

Gōchō. Kyushu Bukku Center, 1972.

Gōchō Risshi ibokushū (Remaining Works from the Reverend Gōchō). Tokyo: Kabushiki Kaisha, 1982.

Graham, Patricia J. *Tea of the Sages: The Art of Sencha.* Honolulu: Hawaii University Press, 1998.

Haijin no shoga bijutsu (Calligraphy and Paintings by Haiku Poets). 12 vols. Tokyo: Shueisha, 1979.

Haikai jinmei jiten (Dictionary of Haiku Poets). Tokyo: Gannandō Shoten, 1987.

Haiku jiten: Kindai (Haiku Dictionary: Early Modern Period). Tokyo: Ōfūsha, 1977.

Hakuin iseki (Remaining Ink Traces of Hakuin). *Bokubi,* nos. 77, 78, 79, and 90 bound together. Kyoto: Bokubisha, 1977.

Hakuin Oshō ibokushū (Remaining Works of the Monk Hakuin). Tokyo: Minyūsha, 1914.

Haruna Yoshie. *Kan'ei no sanpitsu* (The Three Brushes of the Kan'ei Period). Tokyo: Tankōsha, 1971.

Hatano Yukihiko. *Honmono nisemono chakai no sho* (Genuine and Fake Tea Ceremony Calligraphy). Tokyo: Shufu no Yūsha, 1987.

Hito to sho (People and Calligraphy). Tokyo: Century Museum, 1989.

Inoue Tetsujirō. *Nihon Yōmeigakuha no tetsugaku* (Philosophy of Japanese Scholars in the Wang Yang-ming Tradition). Tokyo: Fuzambō, 1932.

Ishikawa Kyūyō. *Sho de toku Nihon bunka* (Japanese Culture Explained through Calligraphy). Tokyo: Mainichi Shinbunsha, 2004.

Iwasaki Haruo. "The World of 'Gesaku': Playful Writers of Late Eighteenth-Century Japan." Ph.D. diss., Harvard University, 1984.

Jakugon Jiun ten (Exhibition of Jakugon and Jiun). Kyoto: Shibunkaku, 1979.

Jiun Sonja bokuseki shūsei (Collection of Ink Traces of Jiun Sonja). 3 vols. Tokyo: Shibunkaku, 1989.

Jiun Sonja ihō (Remaining Treasures of Jiun Sonja). 2 vols. Tokyo: Nichibo Shuppansha, 1980.

Kaji. *Kaji no ha* (Mulberry Paper [Kaji] Leaves). Kyoto: 1707.

Kana no bi (Art of Kana-Letters). Kyoto National Museum, 1992.

Kan'ei meihitsu-ten (Exhibition of Major Kan'ei Period Calligraphers). Nara: Yamato Bunkakan, 1973.

Karayō (Chinese-Style). *Nihon no sho,* vol. 12. Tokyo: Chūō Koronsha, 1983.

Karayō no sho (Chinese-Style Calligraphy). Tokyo National Museum, 1996.

Keene, Donald. *World within Walls: Japanese Literature of the Pre-modern Era, 1600–1867.* New York: Holt, Rinehart & Winston, 1976.

Kinami Takeuchi. *Itō Jinsai: shiseki, jimbutsu, shisō* (Itō Jinsai: Calligraphy, Life, and Thought). Teichōzan University Bulletin, no. 22 (February 1981).

Kinsei jōryū shodō meika-shi (Famous Early Modern Women Calligraphers). Tokyo: Tokyodō, 1935.

Kinsei kōsō ibokushū (Remaining Treasures of Early Modern Zen Monks). Kyoto: Art-sha Shuppan, 1976.

Kinsei Zenrin bokuseki (Early Modern Zen Ink Traces). 3 vols. Kyoto: Shibunkaku, 1974.

Kogetsu Zenshi (Zen Master Kogetsu). Miyazaki: Hyuga Bunka Hanko-kai, 1952.

Kojima Masayoshi. *Ryōkan no sho no sekai* (The World of Ryōkan's Calligraphy). Tokyo: Kōbunsha, 1987.

Kokoro no sho: Jiun Sonja (Calligraphy from the Heart: Jiun Sonja). Osaka: Osaka Shiritsu Bijutsukan, 2004.

Komatsu Masao. *Edo ni sempū, Mitsui Shinna no sho* (Edo Whirlwind: The Calligraphy of Mitsui Shinna). Nagano: Shinano Mainichi Shinbunsha, 2004.

Komatsu Shigemi. *Nihon shoryū zenshi* (Complete Collection of Japanese Calligraphy Schools). Tokyo: Kodansha, 1970.

———. *Nihon shoseki taikan* (Survey of Japanese Calligraphy), vols. 14–25. Tokyo: Tankōsha, 1979.

Korezawa, K., ed. *Edo jidai no sho* (Edo Period Calligraphy). *Nihon no bijutsu,* no. 184. Tokyo: Shibundō, 1981.

Kōsō ibokushū (Remaining Ink Traces by Leading Monks). 12 vols. Tokyo: Hakurinsha, 1930.

Lishka, Dennis E. "Buddhist Wisdom and Its Expression as Art." Ph.D. diss. on Takuan. Ann Arbor, Mich.: University Microfilms, 1977.

Marceau, Lawrence E. "Ninjō and the Affective Value of Literature at the Kogidō Academy." *Sino-Japanese Studies* 9, no. 1 (1996).

Maruyama Masao. *Studies in the Intellectual History of Tokugawa Japan.* Tokyo: University of Tokyo Press, 1974.

Masuda Takashi. *Chajin no sho* (Calligraphy by Tea Masters). Tokyo: Bunnan Deppan, 1985.

———. *Nihon kinsei seiritsushi no kenkyū* (Studies in Early Modern Japanese Calligraphy). Tokyo: Bunken Shuppan, 1996.

Miura Yasuhiro. *Jiun Sonja ihō ten* (Exhibition of Remaining Treasures of Jiun Sonja). Tokyo: Junior Arts Dealers Association, 1987.

Mori Senzō. *Mori Senzō chosaku-shū* (Collected Works of Mori Senzō), vol. 3. Tokyo: Chūō Kōronsha, 1971.

Murase Miyeko, ed. *The Written Image: Japanese Calligraphy and Painting from the Sylvan Barnet and William Burto Collection.* New York: Metropolitan Museum of Art, 2002.

Najita Tetsuo and Irwin Scheiner, eds. *Japanese Thought in the Tokugawa Period 1600–1868.* Chicago: University of Chicago Press, 1978.

Nakata Yujiro. *The Art of Japanese Calligraphy.* New York: Weatherhill/Heibonsha, 1973.

Nihon kōsō iboku (Ink Traces of Famous Japanese Monks), vol. 3. Tokyo: Mainichi Shinbunsha, 1971.

Nihon no bijutsu. No. 82, *Tegami* (Letters). Tokyo: Shibundō, 1966.

Nihon no bijutsu. No. 83, *Momoyama jidai no sho* (Momoyama Era Calligraphy). Tokyo: Shibundō, 1981.

Nihon no bijutsu. No. 130, *Kana.* Tokyo: Shibundō, 1977.

Nihon no bijutsu, No. 184, *Edo jidai no sho* (Edo Period Calligraphy). Tokyo: Shibundō, 1981.

Nihon no sho (Japanese Calligraphy). Tokyo National Museum: 1978.

Nihon shodō taikei (Outline of Japanese Calligraphy), vol. 7. Tokyo: Kodansha, 1972.

Nihon shoron shūsei (Japanese Calligraphy Studies Collection). Tokyo: Kuko Shoin, 1978.

Ōbaku bunka (Ōbaku Culture). Kyoto: Bokubi-sha, 1970.

Ohki Sadako. *Ike Taiga's Karayō Calligraphy.* 2 vols. Ann Arbor, Mich.: University Microfilms, 1984.

Old Zen New Hat: Sermons of Tetsugen. Himeji: Art Press Publications, 1977.

Otagaki Rengetsu. Tokyo: Kodansha, 1982.

Ōtsuki Mikio, Katō Shōshun, and Hayashi Yukimitsu. *Ōbaku bunka jinmei jiten* (Biographical Dictionary of Ōbaku Personages). Tokyo: Shibunkaku, 1988.

Rengetsu. Tokyo: Kodansha, 1971.

Rengetsu-ni zenshū (Complete Works of Rengetsu). Kyoto: Shibunkaku, 1980.

Rimer, J. Thomas, et al. *Shisendo: Hall of the Poetry Immortals.* New York: Weatherhill, 1991.

Rosenfield, John M. *Extraordinary Persons.* Cambridge, Mass.: Harvard University Art Museums, 1999.

Rosenfield, John M., Fumiko E. Cranston, and Edwin A. Cranston. *The Courtly Tradition in Japanese Art and Literature.* Cambridge, Mass.: Fogg Art Museum, 1973.

Ryōkan-san. Tokyo: Nihon Keizai Shinbun, 2000.

Ryūichi Abe and Peter Haskel, trans. *Great Fool: Zen Master Ryōkan.* Honolulu: University of Hawaii Press, 1996.

Sato Hiroaki, trans. *Breeze Through Bamboo: Kanshi of Ema Saikō.* New York: Columbia University Press, 1998.

Sato Shuichi. *A History of Japanese Literature: The Years of Isolation,* trans. Don Sanderson. Tokyo & New York: Kodansha International, 1983.

Seisetsu Oshō ibokushū (Collection of Remaining Works by the Monk Seisetsu). Tokyo: Zenshū Shiryō Chōsakai, 1920.

Shimizu Yoshiaki and John M. Rosenfield. *Masters of Japanese Calligraphy, Eighth–Nineteenth Century.* New York: Japan Society and Asia Society Galleries, 1984.

Shodō zenshū (Complete Calligraphy Collection), vols. 22 and 23. Tokyo: Heibonsha, 1966.

Shokin Furuta. *Kōgetsu Oshō iboku* (Remaining Ink Works of Kōgetsu). Tokyo: Benridō, 1950.

Sho no bi (The Beauty of Calligraphy). Tokyo: Idemitsu Bijutsukan, 1985.

Sho no Nihonshi (Japanese Calligraphy History), vols. 5–7. Tokyo: Heibonsha, 1975.

Sho: Pinselschrift und Malerei in Japan vom 7–19. Jahrhundert. Cologne: Museen der Stadt Köln, 1975.

Sho to jimbutsu (Calligraphy and People). 7 vols. Tokyo: Mainichi Shinbunsha, 1978.

Sōgen Ōmori and Terayama Katsujō. *Zen and the Art of Calligraphy.* London: Routledge & Kegan Paul, 1983.

Sōgen Tekisui, *Gesshū Oshō iroku* (Records of the Monk Gesshū). 1704.

Sōtō-shū jinmei jiten (Biographical Dictionary of Sōtō Sect Monks). Tokyo: Kokusho Kankō-kai, 1977.

Stevens, John. *Sacred Calligraphy of the East.* Boulder: Shambhala Publications, 1981.

Sumi, no. 4. *Tegami no sho* (Calligraphy in Letters). Tokyo: Geijutsu Shinbunsha, 1975.

Taiga no sho (Calligraphy by Taiga). Tokyo: Chūō Koronsha, 1970.

Taiyō, no. 16 (1976). Special issue on haiku.

Takamatsu Matsudaira-ka no shoseki (Ink Traces from the Kōmatsu Matsudaira Family). Kagawa: Kagawa History Museum, 1999.

Takeuchi Naoji. *Hakuin*. Tokyo: Chikuma Shoten, 1964.

———. *Kinsei no Zenrin bijutsu* (Early Modern Zen Art). *Nihon no bijutsu,* no. 47. Tokyo: Shibundō, 1972.

Takuan. Niigata: BSN Museum, 1974.

Takuan, Kōgetsu to sono jidai (Takuan, Kōgetsu, and Their Era). Sakai: Sakai-shi Hakubutsukan, 1983.

Takujū Zenshi ihō (Remaining Treasures of Zen Master Takujū). Nagoya: Tokugen-ji Sōdō, Eibunsha, 1982.

Tanahashi Kazuaki. *Penetrating Laughter*. Woodstock, N.Y.: Overlook Press, 1984.

Teika-yō (Teika Style). Tokyo: Gotoh Museum, 1987.

Tetsugen Zenshi (Zen Master Tetsugen). Osaka: Bōrinsha, 1923.

Tetsugyū. Chiba: Tadaya Shiten, 1913.

Tōrei Enji. Otsu: Shigaken Biwako Bijutsukan, 1972.

Tōrei Enji no shogai (The Life of Tōrei Enji). Kyoto: Sankyūsha, 1790.

Tōrei no Zen no sho (The Zen Calligraphy of Tōrei). Otsu: Shiga Kenritsu Bunka-kan, 1993.

Tōrei Oshō nenpu (Yearly Record of Tōrei). Kyoto: Shibunkaku, 1982.

Tōrei Zenshi ten (Exhibition of Tōrei Zenshi). Mishima: Mishima Insatsujo, 1986.

Tsuchida, N. *Gakusha* (Scholars) *Sho no jimbutsu,* vol. 5. Tokyo: Mainichi Shin-bunsha, 1978.

Tsunoda, Ryusaku, W. Theodore de Bary, and Donald Keene, eds. *Sources of the Japanese Tradition*. New York: Columbia University Press, 1958.

Waddell, Norman, trans. *The Essential Teachings of Zen Master Hakuin*. Boston: Shambhala Publications, 1994.

———. *The Unborn: The Life and Teachings of Zen Master Bankei*. San Francisco: North Point Press, 1984.

———. *Wild Ivy: The Spiritual Biography of Zen Master Hakuin*. Boston: Shamb-hala Publications, 1999.

———. *Zen Words for the Heart*. Boston: Shambhala Publications, 1996.

Watson, Burton. *Japanese Literature in Chinese*, vol. 2. New York: Columbia University Press, 1976.

———, trans. *Ryōkan: Zen Monk-Poet of Japan*. New York: Columbia University Press, 1977.

———, trans. *The Zen Teachings of Master Lin-chi*. Boston: Shambhala Publications, 1993.

Watt, Paul B. *Jiun Sonja: Life and Thought*. Ann Arbor, Mich.: University Micro-films, 1982.

Yamanouchi, C. *Kinsei jusha no sho* (Calligraphy of Early Modern Scholars). Tokyo: Gurafikkusha, 1980.

Yampolsky, Philip B., trans. *Zen Master Hakuin*. New York: Columbia University Press, 1971.

Yoneda Yatarō. *Kinsei Nihon shodōshi ronkō* (A Study of Early Modern Japanese Calligraphic History). Tokyo: Yanagihara Shoten, 1991.

Yoshida Saigen, ed. *Ryōkan*. Tokyo: Chikuma Shobo, 1975.

Yoshikawa Kōjirō. *Jinsai Sorai Norinaga*. Tokyo: Tōhō Gakkai, 1983.

Zen Bunka, nos. 1–200. Kyoto: Zenbunka Kenkyusho (Institute for Zen Studies), 1955–present.

Zen Gahō, no.12, on Fūgai Ekun. Zen Graphic, 1990.

INDEX

Japanese names in the index are given under the best-known art names or, in the case of Zen Masters, by their best-known Zen name.